INDIGENOUS MEDIA
ARTS IN CANADA

INDIGENOUS MEDIA
ARTS IN CANADA

Making, Caring, Sharing

Dana Claxton and
Ezra Winton, editors

WILFRID LAURIER
UNIVERSITY PRESS

Inspiring Lives.

This book has been published with the help of a grant from the Canadian Federation for the Humanities and Social Sciences, through the Awards to Scholarly Publications Program, using funds provided by the Social Sciences and Humanities Research Council of Canada. Wilfrid Laurier University Press acknowledges the support of the Canada Council for the Arts for our publishing program. We acknowledge the financial support of the Government of Canada through the Canada Book Fund for our publishing activities. Funding provided by the Government of Ontario and the Ontario Arts Council. This work was supported by the Research Support Fund.

LIBRARY AND ARCHIVES CANADA CATALOGUING IN PUBLICATION

Title: Indigenous media arts in Canada : making, caring, sharing / Dana Claxton and Ezra Winton, editors.
Names: Claxton, Dana, editor. | Winton, Ezra, editor.
Description: Includes bibliographical references and index.
Identifiers: Canadiana (print) 20220282056 | Canadiana (ebook) 20220282234 | ISBN 9781771125413 (softcover) | ISBN 9781771125420 (EPUB) | ISBN 9781771125437 (PDF)
Subjects: LCSH: Indigenous art—Canada. | LCSH: New media art—Canada. | LCSH: Indigenous films—Canada. | LCSH: Indigenous peoples in art.
Classification: LCC N7433.94 .I53 2023 | DDC 770.897/071—dc23

Cover and interior design by Sandra Friesen.
Front cover image: *Indian Candy: Blue Headdress* by Dana Claxton, 2013.
© 2023 Wilfrid Laurier University Press
Waterloo, Ontario, Canada
www.wlupress.wlu.ca

This book is printed on FSC® certified paper. It contains recycled materials and other controlled sources, is processed chlorine-free, and is manufactured using biogas energy.

MIX
Paper from responsible sources
FSC® C103567

Printed in Canada

Wilfrid Laurier University Press is located on the Haldimand Tract, part of the traditional territories of the Haudenosaunee, Anishnaabe, and Neutral Peoples. This land is part of the Dish with One Spoon Treaty between the Haudenosaunee and Anishnaabe Peoples and symbolizes the agreement to share, to protect our resources, and not to engage in conflict. We are grateful to the Indigenous Peoples who continue to care for and remain interconnected with this land. Through the work we publish in partnership with our authors, we seek to honour our local and larger community relationships, and to engage with the diversity of collective knowledge integral to responsible scholarly and cultural exchange.

Contents

CONCLUDING THOUGHTS

Acknowledgements

When we set out to make this beautiful book we optimistically (naively perhaps?) told all the contributors the process would be faster than usual, so the volume could respond to the particular fired-up moment we were in. We ourselves were fired up and that was in 2017, but of course things took longer than expected, and that combustible moment was but one of many more that continue careening sparks into media arts and activist communities across Canada and beyond (and a global health pandemic also did its best to degrease the wheels). We are therefore first and foremost grateful to all the amazing, talented, and dedicated contributors whose research and writing is featured in this volume, and who have patiently waited to see and share their provocative arguments and ideas in print. We'd also like to send our sincere gratitude out to Heather Igloliorte, who encouraged Ezra to connect with Dana, thus forging our first project together.

To the countless Indigenous and non-Indigenous scholars, artists, thinkers, writers, activists, and commentators who have inspired this book's ethic and passion—we are indebted to you and your work. We are particularly grateful to Alanis Obomsawin for the time she took to lend her keen and discerning eye, offering some reflections and advice regarding one of the chapters that engages with her work. Another individual with a careful and deeply considerate approach, Lucas Freeman, helped with some much-needed restructuring of a selection

of chapters—thank you for sharing your invaluable talents to this group effort.

A special shout-out to the folks at imagineNATIVE who enthusiastically welcomed and hosted our panel on Insiders/Outsiders—it was a jam-packed room, energized with the ferocity of spirit and ethic of collective care that can only be felt at that incomparable festival. And of course, we extend a huge thank you to the speakers on that very panel, whose wise and unflinching words appear as the political-ethical fire in Chapter 1 of this volume.

Thank you to the folks at Wilfrid Laurier University Press, and in particular Siobhan McMenemy, who carefully stewarded us along the winding publishing path. We are grateful to the University of British Columbia's Scholarly Publishing Fund for contributing to the index and to the Department of Art History, Visual Art, and Theory Head's research allowance. We are also so thankful for the thoughtful and generous feedback from the peer reviewers of the manuscript. Not only were the comments and suggestions supportive and constructive, but we were delighted to receive a revised pathway from which we could confidently make changes, improvements, and new incursions. We are grateful to the National Film Board of Canada and various filmmakers and rights holders for giving permission to use images throughout the volume; in particular, thank you Emily Gan and Shani Koumalainen for use of your gorgeous images. This book is beautiful because of all of you.

Lastly, we thank our kin—our chosen and birth families. Dana thanks Robert, whose love nourished her editing, Ezra is eternally grateful to his life partner—and accomplice in all things media, art, and politics— Svetla Turnin, who far too many times had to ask: "Is it finished?"

—Dana Claxton and Ezra Winton

Seeing, Knowing, Lifting

Dana Claxton and Ezra Winton

The question now is, will Euro-Americans want to hear the Aboriginal stories and come to accept them?
— Gerald McMaster and Lee-Ann Martin, *Indigena: Contemporary Native Perspectives in Canadian Art* (1992, 17)

For Indigenous people the "media landscape" becomes just that: a landscape, replete with life and spirit, inclusive of beings, thought, prophecy, and the underlying connectedness of all things—a space that mirrors, memorializes, and points to the structure of Indigenous thought.
—Steven Loft, "Decolonizing the 'Web'" (2014a, xvi)

INSIDE AND OUTSIDE

From the four directions of Indigenous visual representation, this book digs deep into the ethics and politics of visual culture production, circulation, and representation as they intersect with Indigeneity.[1] It is inspired by questions, both urgent and ancient, concerning relations among people and to the land. These are questions of relationality, of images and stories. What does a decolonized media arts[2] look like? What are the struggles over not only the making of images, but the caring for and the sharing of images in colonial Canada? What do the

ethics of how we tell and travel with stories, along with who tells them, have to teach us? What does an Indigenous ethics of representation look like? It is queries like these that have led to our choice to gather writing about how Indigenous media arts in Canada is made and how we might re/concile our way beyond a landscape of harmful images and historical hauntings toward a more just, equitable society. Controversies old and new concerning representation and appropriation drew us to the "insiders/outsiders" binary, and as such, texts in this volume explore and probe this dyadic thematic. Settlers are the obvious "outsiders" in the storying of Indigeneity, and their ambition and exuberance to translate, interpolate, and represent Indigenous lives, cultures, and histories continues apace, with commendable forays into reciprocal relationship-building across and through representational lenses, as well as marshalling a legion of reprehensible expeditions into the well-trodden terrain of speaking about and for *Others*.

Whether we call it extractive filmmaking, settler cinema, colonial media, or Indigenous film and media, the production, circulation, curation, and reception of NDNs[3] on screens across Turtle Island[4] remains a crucial site of inquiry and discovery in the larger project of justice and liberation, especially for those *represented*: First Nations, Métis, and Inuit living inside the political borders of what is known as the country of Canada. The continued circulation of exploitive images of Indigenous bodies haunts not only the Canadian/North American[5] landscape, but the global sphere of images. Through this circulation and display, the ghosts of the past and spirits of the future clash, dance, mourn, perpetuate, disallow, and contest. Their spectral motions signal triumph, survival, struggle, and creation while marking out a pathway both nourished and beleaguered by those who make, care, and share.

A focused look at the dimensions of Indigenous representation behind, in front of, and beside/around the camera is vital for the non-Indigenous majority, including those of us yet unable to deprogram the pathological colonial circuitry from mind, body, and spirit. When we two volume editors first came together and discussed these issues, we were both provoked by flashpoints in settler-Indigenous representational politics in our respective communities and geographies. Many of the discussions we witnessed or participated in (and continue to) started with the important question of who gets to tell whose stories and

the attendant (and erroneous) refrain that the most privileged among us "can't say or do anything anymore." This devolution reached one of many reprehensible low points with the settler suggestion of an appropriation prize in Canadian literature.[6] Centuries of white privilege and settler domination had become seemingly fragile and at risk overnight. Despite the barstool, dinner table, water cooler, and social media chatter, we know this sentiment is of course not true. Settler colonialism remains firm, if slightly exposed and bruised from all the unwanted, critical attention, including high-profile blockades and battles over pipelines and deforestation increasingly covered by mainstream media, and of course organized action—most of it Indigenous-led and occurring in learning environments, the arts, media institutions, on the ground in communities, and online.

Thinking more widely (beyond media arts making, circulation, and reception), "insiders" in Canada remain a settler majority of European ancestry who are afforded, among many privileges, the space to create, tell, and share the stories of those who are not part of their kin, community, or shared narrative. "Outsiders" are in this wider notion of a state-wide club, effectively non-members who are increasingly enacting a *politics of refusal*, a concept explored at length by Mohawk anthropologist Audra Simpson in *Mohawk Interruptus* (2014), which she positions in contradistinction to a politics of recognition, and which she links to the (persistent) power of story and imagination here in her book's conclusion:

> How to stop a story that is always being told? Or, how to change a story that is always being told? The story that settler-colonial nation-states tend to tell about themselves is that they are new; they are beneficent; they have successfully "settled" all issues prior to their beginning. If, in fact, they acknowledge having complicated beginnings, forceful beginnings, what was there before that process occupies a shadowy space of reflection; ... Indians, or Native people, are not imagined to flourish, let alone push or interrupt the stories that are being told. (177)

Refusal here, from "outsiders" to the dominant culture, comes forcefully as interrupting the "story of settlement" (Simpson 2014, 177) or as

a denial of knowledge disclosure, especially in academic and creative practices of recording and documentation. Dene scholar Glen Sean Coulthard's discussion of refusal complements this political imperative when he writes of "enacting Indigenous alternatives on the ground [that] will bring us into productive confrontation with the colonial structures of exploitation and domination" (qtd. in Gardner and Clancy 2017). Some therefore are uninterested in or reject the clubhouse altogether, while others find innovative ways to claim/hold/transform space within colonial institutions. This insider/outsider dynamic, as recent turmoil around makers' fraught claims to Indigenous identity in film, television, literature, curation, and education fields make painfully real,[7] is indeed a livewire circuit of its own, criss-crossing history and igniting flashpoints across the country's media arts and creative sectors almost daily.[8] In all this contested and creative terrain, where the earlier mentioned pathway of understanding and representation continues to be used and abused, we sought to invite a group of talented and thoughtful media arts makers, writers, teachers, and researchers to contribute to this discussion, and help us, we hope, move past stuck spots of devolution, discord, and antipathy in explorations and revelations of making, caring, and sharing.

With our book's theme chosen, we sought chapter submissions on the heels of well-known flare-ups such as the Indigenous identity "shape-shifting" case of Joseph Boyden,[9] and lesser-known troubled moments such as Montréal's Rencontres Internationales du Documentaire de Montréal (RIDM) screening (and continued circulation) of the 2015 Québécois film *of the North* (Dominic Gagnon), the latter of which is addressed at length in Chapter 2 of this volume. While debates and discussions about the politics and ethics of Indigenous storytelling and image-making had of course percolated long before this period, the new tools and platforms for communication and connectivity, such as Indigenous Twitter, have greatly shifted discourse and amplified critical voices. As such, we found the summer of 2017 to be a timely moment to seek critical reflections on both *the story* of Canada *and* the stories of Canada: Idle No More turned five; the scandalous "Appropriation Prize" was rightfully critiqued on national television by Ojibwe producer, writer, and broadcaster Jesse Wente (who is featured in Chapter 1 of this volume);[10] resistance to the half-billion-dollar government celebrations

of Canada's sesquicentennial, or "Canada 150," was forcefully ubiquitous; a landmark Sixties Scoop settlement was brokered; and the first community hearings into Murdered and Missing Indigenous Women and Girls (MMIWG) began.[11]

A perceptible change was in the air across colonial Canada, and we were grateful to receive an abundance of submissions for our small contribution to these shifting winds. From the many chapter proposals received, we chose eleven to include in the book based on the engagement with our themes, passion, and dedication to progressive, anticolonial knowledge-sharing and meaning-making, and diversity of focus, lived experience, and perspective. In addition to these chapters, which are both single-authored and collaborative works, we helped organize and invited the participants of a roundtable at the imagineNATIVE Film + Media Arts Festival to include their rousing discussion on "Insiders/Outsiders" as opener to the volume, as well as including two existing texts featuring the unshakable voices of Alethea Arnaquq-Baril (Chapter 2) and Lisa Jackson (Conclusion), respectively. As our project seeks to deepen and widen the scope of discussions already well underway in the summer of 2017 (and beyond) vis-à-vis dialogue and productive engagement with the issues of Indigenous storytelling and meaning-making, we have approached this collection guided by principles of mutual respect, reciprocity, truth-telling, community-building, and plurality. As Samia Mehrez reminds us, "Decolonization ... understood as an act of exorcism for both the colonizer and the colonized ... can only be complete when it is understood as a complex process that involves both the colonizer and the colonized" (qtd. in hooks 1992, 1). With these words in mind, we are humbled to share writings from both Indigenous and non-Indigenous contributors who animate these values in their work. We have found the productive promise of attentiveness, care, and curiosity in each and every contribution.

SEE(K)ING ANEW, LETTING GO

Seeing! How do we collectively see? How do writers and their readers see together? Through collective seeing we are ... being. Ways of seeing become ways of being. And through these ways of being we seek anew—denying the spectre of the stereotype and engaging in the diverse intricacies of lived experience. These chapters collectively are a body

of knowledge that purport to a way of seeing the Indigenous body and story and all the complexities that have resulted from colonial-settler violence—and the continued permeation of that violence. This collective way of seeing/seeking is also about lateral love—the ways in which we can all lift each other up.[12] Perhaps this book is, at its core, really about caring and love—loving Indigenous peoples and our collective capacity for truth.

If our beloved country now known as Canada does not collectively and fully know the impact of settler colonialism (past, present, and future) then will it not persist in its myriad methods/systems of imperial image-making/knowing? Canada urgently needs to shed and disavow its imperial image of Indigenous peoples and the false/misinformed/skewed knowledge that reflects and perpetuates that image. The colonial imaging of NDNs has a specific history and a "genesis of the stereotypes," as Jacquelyn Kilpatrick (Choctaw, Cherokee, Irish)[13] has so carefully mapped (Kilpatrick 1992, 1). But how long will (we allow) this fraught, noxious image to linger? How does this injurious imaging continue to impact/shape social relations between our nations and peoples? How does it continue to negatively impact/shape social hierarchies and the continued exploitation of Indigenous bodies, land, air, water, and all the beings that inhabit those spheres? How does it continue to colonize imagination and ways of knowing? Or ways of seeking? In 1992, Randy Fred (Tseshaht) observed: "Native people live within a world of imagery that isn't their own" (n.p.). The dominant culture in Canada is blatantly—unrepentantly even—attached to the dehumanization and misrepresentation of the Indigenous image, but we must ask why and for how long?

Attachment issues? It's high time to see(k) anew, take meaningful action, and let go. Because with new ways of seeing and being comes the doing. Indigenous creatives have been making and doing on these lands well before the invaders came. In her article on Indigenous aesthetics and (digital) storytelling, Candice Hopkins (Carcross/Tagish) argues there is also a history and enthusiasm to embrace new storytelling tools, no matter the epoch or technology: "Storytellers in indigenous communities are continually embracing new materials and technologies, including video and digital media. I would suggest that this shift does not threaten storytelling traditions in these communities but is

merely a continuation of what aboriginal people have been doing from time immemorial: making things our own" (2006, 342). And so, the doing and making will continue, and we offer this book in that spirit of regeneration and always-seeking.

It is said that seeing is believing. We are taught to see, to look, and to be seen and looked at. But how can we see differently and seek collectively? How can we un-see and be un-seen, manifest detachment from the ways that have positioned Indigenous peoples as instrumentalized "subjects" for conquest and devalued "objects" for ideology? Again, how do we see/look anew? In *Practices of Looking*, Sturken and Cartwright situate looking as a social practice that is always in relation to power and ideology. They argue this practice is socially learned:

> We use many tools to interpret images and create meanings with them, and we often use these tools of looking automatically, without giving them much thought. Images are produced according to social and aesthetic conventions. Conventions are like road signs: we must learn their codes for them to make sense, and the codes we learn become second nature. (2009, 26)

Never before have the tools to create, circulate, and interpret images (and their cascades of meaning) been in the hands of so many. In the pages that follow these tools are front and centre, as are the road signs[14]—the codes and conventions of colonial imaging and the bountiful, creative responses to centuries of their anchoring as second nature. Half a millennia of ideological programming, hegemonic enculturation, and systemic violence has sowed a tenacious social attachment to arcane, contaminated ideas and images of Indigenous peoples. Yet, in order to decolonize we must detach. Regarding detachment—and while we don't necessarily follow mainstream psychology—we agree with the following characterization:

> Holding on to an idea just because you have become attached to it creates anxiety. Once you detach from a desired outcome, you can stop worrying about it. The truth is that most attachment is about control, and control is an illusion. So it's better to get on with your life, even when you don't get exactly what you want. When you

release your desire for control over the lives of others, it sets every-
one free. Those endless hours of frustration can be turned into
fruitful days of creativity.[15]

With the audacity of seeing, knowing, and doing differently, and in con-
testation of an overculture that has imposed its will on living cultures
formed thousands of years before contact, we therefore embark on a
detachment journey of creativity and imagination, cross-talk, deep dia-
logue, and critical analysis.

COMMON GROUNDS

We are two humxns who were raised under the imperial image: Dana,
an Indigenous womxn raised on the Plains as a Canadian, mixed blood,
and NDN with shadows and ghosts of colonialism and empire, and
Ezra, raised in the settler privilege of a British Columbian town where,
growing up, it was indeed "normal" to dehumanize Indigenous peoples
through images and social relations. In these divergent, yet similarly
located lived experiences, we both saw/felt/noticed that something was
up/wrong/off when it came to Indigenous and settler realities/relations,
but perhaps could not articulate what we saw. We have found common
ground in dedicating ourselves to this dynamic, and to a hope/fight for
justice and understanding, as well as a love for and commitment to fair-
ness and truth.

And what of the common ground? Can one's oppression fuel
another's privilege, and by doing so, does the reversal of one's oppression
become another's? Consciously or not—the circulation of the stereotype
inevitably crosses boundaries and borders, whether they are material,
ideological, political, marginal, mainstream, or cast upon the shadows
that dance on the walls of relationality and *conciliation*.[16] With this in
mind, we are both hopeful of the ties of commonality despite difference,
the undoing despite centuries of wrongdoing, and the proactive doing in
our historical moment when truly knowing only seems to be in decol-
onial infancy.

Ezra grew up on Vancouver Island in K'ómoks territory,[17] where
logging companies have decimated ancient forests to feed the settler
economy, making certain British Columbian families very wealthy,
and where illegal European settlements dot the island, enshrouded
in enduring national mythologies sprung from the colonial conceit of

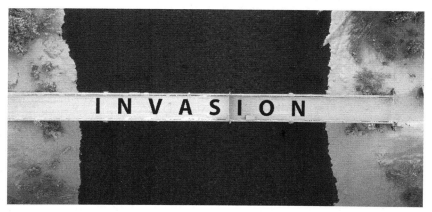

FIGURE 0.1 Title sequence of the short film *Invasion* (Mutual Aid Media, 2020). Frame grab courtesy Franklin Lopez.

terra nullius and the *doctrine of discovery*.[18] At the time of writing, yet another historical battle between land defenders and settler institutions plays out along familiar storylines on that very island. While Indigenous and settler activists put their bodies on the line to protect 1,000-year-old trees at Fairy Creek, logging companies and the RCMP continue to trespass on unceded lands in order to violently secure the last "resources" of ancient forests for the state-sanctioned extraction industry, against the stated wishes of the Ditidaht, Huu-ay-aht, and Pacheedaht First Nations. And while the provincial government has postponed some logging in the area, the sanctity of the forests and Indigenous lands remains precarious at best. The colonial attachment to the dominant story of environment versus economy wilfully obscures considerations of Indigenous sovereignty, rights, and liberation, but the will of the land defenders is unbreakable and allies arrive at Fairy Creek each day. *That* story continues and we hope for an ending that breaks from colonial narrative convention. Here we are reminded of the importance of alliances and accomplices, both at land-defending blockades and in media arts representations—and in that spirit we draw readers' attention to the excellent short film (currently being made into a feature documentary) *Invasion* (Mutual Aid Media, 2020), which shares the story of the Unist'ot'en struggle for self-determination, also in British Columbia.[19]

Ezra now lives and writes from Tiohtià:ke, Québec, and in this context is also reminded of the history of the Québec sovereignty movement and the attendant discourse of a country divided by "two

solitudes," which for decades erroneously described the shape of a nation with two valid stakeholder groups—(settler) Anglophones and Francophones—whose cultural differences and inability to reconcile resulted in two societies forever at odds. This discourse, which began in the mid-1940s, morphed by the 1960s into a discourse of "biculturalism," a liberal term describing the transcendence of the two solitudes into a more agreeable, but still estranged nation. Left out of this "national" discussion, which dominated newspapers, bookstores, television, and workplace coffee rooms across the country, were Indigenous peoples. The two solitudes configuration also made wholly invisible non-Franco and non-Anglo settler migrants, many of whom are people of colour and who continue to face particular structural and cultural barriers to societal inclusion and justice (including the arcane, racist Bill 21 in Québec, which bans "religious symbols" like head scarves for public employees in the province). Of course, in a liberal widening of the symbolic net, biculturalism was eventually replaced with multiculturalism in Canada and given a capital M as it was made official by the Canadian Multiculturalism Act in 1988. Now, everyone is apparently free ... to be part of the multi-solitudes.

Canadian Multiculturalism, referred to critically as Benetton Multiculturalism (meaning agreeably symbolic in nature), is a set of policies and leading ideology that has steadily sought to incorporate "Others" at the edges of the Anglo-Franco settler colony into the internationally marketed and celebrated patchwork quilt of inclusive Canada (juxtaposed always and superiorly with America's identity-subsuming melting pot). Canada now has special designated days, parades, and funding envelopes meant to celebrate diversity. Everyone, no matter the colour of your skin, the language on your tongue, or the ancestry you claim, is encouraged to take an equal footing in this bold, renewed Multicultural state. In 1971, two years after Indigenous people received the legal right to vote in the province of Québec and two years after his drafting of "The White Paper," which proposed total assimilation of Indigenous peoples in Canada, Prime Minister Pierre Elliott Trudeau claimed: "There is no such thing as a model or ideal Canadian. What could be more absurd than the concept of an 'all Canadian' boy or girl? A society which emphasizes uniformity is one which creates intolerance and hate." Inclusion and diversity thus beget tolerance, understanding, and unity, qualities that can seemingly only be achieved via governmental

policy. As the Indigenous-drafted counter-proposal, "The Red Paper," pointed out in 1970,[20] political rhetoric is indeed often at odds with policy in colonial Canada. Son of Trudeau and Canada's newly (and narrowly) re-elected Prime Minister Justin Trudeau has moulded his political brand on similar political sentiments to those of his father, and in particular has presented himself as a champion of Indigenous issues and the supporting corollary of peace and friendliness (also expertly marketed to the world). Yet the new Trudeau tableau, or "Trudeau Formula" as Martin Lukacs has called it,[21] has been rightfully pilloried for paving over these considerations in the service of fossil fuel companies and weapons manufacturers (or more bluntly, pipelines and fighter jets), as well as avoiding real re/conciliation efforts (it has recently come to light that while Trudeau publicly mourns the bodies of Indigenous child victims of the residential school system, his government continues to spend millions fighting survivors seeking justice in the courts).

And Québec today? The province's newest premier, François Legault, told the governor of California that all French Canadians are Catholic[22] and continues to deny the existence of structural racism in Québec, even after the death of Joyce Echaquan, a 37-year-old Atikamekw woman, sowed outrage across the province and wider country for the blatant medical racism she endured while on her deathbed in a Québec hospital.[23] Colonial attachment issues continue to order the day, it would seem. At least for now.

Dana writes from Vancouver, British Columbia, where she is a visitor to the unceded territory. Her home place is Saskatchewan and she is a member of the Wood Mountain Lakota First Nation. The very name of her new province harkens to the long British imperial hangover in this country. The situation has gotten very old: a few years ago, Coast Salish artist Lawrence Paul Yuxweluptun Lets'lo:tseltun created a petition to change the name of his beloved "province." Vancouver is the ancient homeland of the Coast Salish People: the mountains, water, and sky all have Salish names and meanings, as do many land, sky, and water formations in Kanata. The myth that "Canada" is a young country with no ancient history also contributes to the delegitimization of NDN lands/peoples/histories. Living on the West Coast, one is surrounded by Northwest Coast Indigenous aesthetics, which fill the land, culture, art market, and museums. While at the same time three generations of non-Indigenous anthropologists continue to uncritically dredge up

the problematic 1914 salvage ethnography film *In the Land of the Head Hunters*, with the latest iteration claimed and touted as an indie production with an all-Indigenous cast.[24]

Dana is also living and working in proximity to Gustafson Lake, where the Canadian Army, sanctioned by the state, destroyed a sacred Sundance site, not unlike the Canadian state's armed offensive against Mohawks at Oka in 1990 (a pivotal point in Indigenous-led anti-colonial resistance in Canada, where development of a golf course threatened a sacred burial site). Dana resides 350 kilometres from the Kamloops Residential "School" where the bodies of 215 child victims were discovered in May 2021—this story, which has shocked many non-Indigenous people living in Canada, broke while the editors were revising the final draft of this introduction. And more children are being discovered as all residential school perimeters are being tested across Canada and the United States. Despite the media attention to this and other similar stories, anti-Indigenous racism and its companion, misrepresentation, continue to mix with the waters of compassion and understanding.

Both editors have noted the persistence of a kind of fear of Indigenous people, as well as a combination of desire, intrigue, pity, and even deep respect. All at once, fear, loathing, and love for NDNs permeates Canadian culture and society, and that strange, complicated mix surfaces in both the historical and contemporary image-making of NDNs. In the colony outpost that still venerates the British Royal Family, this volatile temperament manifests in comparatively passive and well-meaning ways: the possessive "our Natives" or "Canada's Indigenous people" is regularly deployed by appeasing but misguided settlers across the land, and the era of newly "woke" settlers has ushered both real, effective allies/accomplices as well as those who are no longer completely ignorant but still completely unwilling to relinquish power, control, and the growing bounty of extracted/stolen resources and riches (as in: many settlers are "stepping up," but too few are "stepping back" let alone joining the #LandBack movement). Aggression—whether structured, lateral, micro, discursive, bodily, or by any other form—remains a defining feature of dominant culture, even if it is delivered with a placating "please," "I feel so bad for you," or the national lingual mascot, "sorry."

Settler disavowal,[25] intolerance, ignorance, fear, and "moves to innocence" (Tuck and Yang 2012) continue to shape status quo settler culture,

education, media, and politics. And much of these qualities, the exist-
ence of which are mostly denied and therefore pushed further into
"unofficial" spaces by the settler governments, corporations, and insti-
tutions sett(l)ing the agenda in the country, coalesce against the cultures
whose ancestors have called this place home for millennia prior, to
the period of mass murder, dispossession, and exploitation that began
in 1492. Five hundred and twenty-three years later, Canada's national
broadcaster, the CBC (Canadian Broadcasting Corporation), made an
announcement that would shock many settler Canadians but come as
no surprise to the majority of Indigenous-identifying people living in
Canada. In an editor's blog entitled "Uncivil Dialogue: Commenting
and Stories about Indigenous People," CBC General Manager and
Editor-in-Chief Jennifer McGuire announced that the broadcaster had
made "the difficult decision to temporarily close comments on stories
about indigenous people." McGuire pointed out that comment sections
for online CBC articles discussing Indigenous issues and stories had
"drawn a disproportionate number of comments that cross the line and
violate our guidelines. Some of the violations are obvious, some not so
obvious; some comments are clearly hateful and vitriolic, some are sim-
ply ignorant. And some appear to be hate disguised as ignorance (i.e.,
racist sentiments expressed in benign language)."[26]

As Canadians attempted to make sense of the stark reality of a
national public forum having been forcefully shuttered due to hate
speech in the year 2015, colonial Canada continued the project of set-
tler Multiculturalism with parades and pageants, hopes and prayers,
lip service and symbolic inclusion. The closing of the comments is an
important moment in the country's history, one in which Canadians
should have been forced to confront the deeply entrenched, culturally
hardwired circuitry of settler racism and colonial oppression. It was a
moment to acknowledge, realize, and organize against anti-Indigenous
racism and injustice in Canada. A moment to initiate detachment.
Instead, the colonial machinery tweaked the engine design, made
micro-adjustments, and continues whirring along, bringing us to the
supposed era of "reconciliation." And as Indigenous peoples continue to
do the hard work and heavy lifting needed to confront and end the long
era of dispossession, exploitation, and injustice, settler allies, accom-
plices, and newcomers continue to want to know and do more. Because,
following writer and educator Taiaiake Alfred (Mohawk): If we "allow

the colonizer to hold on to his attitudes and mentality" without challenging the colonizer's behaviour toward Indigenous peoples and the land, then "reconciliation" is really just "recolonization" (2017, 11).

So, we two editors have decided to lift together. To lift up communication and ponder the possibilities of how (re)conciliation might work/happen/shape/confirm/guide the next generation of scholars and practitioners. As a settler scholar from a white, working-class background, and as an Indigenous/mixed blood artist also from a working-class background, both now in academia, we start this collective lifting with this book, and with this co-created introduction. This is where shifts happen, where one simply has to send a note, make a phone call, and say: *How can we work together? How can we care deeply together?* Ezra sent that note to Dana and here we are.

IT ALL COMES DOWN TO (COUNTER)STORY

Many voices have asked (and answered) similar questions that have preceded this moment. We are reminded of important work in the early nineties, such as Barry Barclay's *Our Own Image* (1990), wherein the Māori filmmaker and writer brings together the personal and the political in an Indigenous self-representation manifesto, adding "fourth cinema" to the lexicon. We are also reminded of early settler incursions, such as by historian Daniel Francis, whose objectives for *The Imaginary Indian* we find still pointedly relevant: "to understand where the Imaginary Indian came from, how Indian imagery has affected public policy in Canada and how it has shaped, and continues to shape, the myths non-Natives tell themselves about being Canadians" (1992, 22). Myths are maintained through systems of signification, and storytelling is front and centre. The same year Francis's book was published and on the 500-year anniversary of the mythic "discovery" of the Americas, Gerald McMaster (Plains Cree) and Lee-Ann Martin (Mohawk) argued:

> Cultural performances and mass displays are snapshots of what differentiates one cultural grouping from another. Thus, these events reflect and confirm certain values and characteristics of a particular culture. This being the case, what can the outside world conclude from these planned quincentennial celebrations about what motivates and binds Western culture? (1992, 12)

We are also reminded, in these crucial questions, of much more recent snapshots, such as in 2017, when the Canadian government celebrated the aforementioned sesquicentennial of Canadian Confederation. The state marketing by-line "Canada 150" was quickly subverted (along with the official logo) to "Colonialism 150" as Indigenous-led interventions effectively punctured the taught balloon of selective history and national mythology.[27]

We acknowledge and are grateful to the critical and courageous voices—from cognate and diverse fields including Native American studies, First Nations studies, Indigenous studies, decolonial studies, postcolonial studies, and everything in between and outside—who marked out the path we are now on—one in which we are exploring Indigenous image-making, colonial logics, and settler-Indigenous relations on Turtle Island. Images, myths, representation, education, history—these potent elements of culture and society are at their heart concerned with and connected by *story*. Who has told the story of "Canada" and with which objectives in mind? Who has told the stories of the First Peoples of this place, and with which motivations in mind? How does story serve the colonial project on the one hand, yet provide the creative and critical space to reshape or dismantle it on the other? Again, we turn to McMaster and Martin:

> Much of the colonialist existence of the past few hundred years has silenced Native voices. The stories which we would have liked to tell were largely appropriated and retold by non-Aboriginal "experts" in such fields as anthropology, art and history and especially in the political realm. Not surprisingly, the appropriated stories distort the realities of our histories, cultures and traditions. Underlying this paternalistic and damaging practice is the supposition that these "experts" have the right to retell these stories because of their superior status within the cultural and political constructs of our society. (1992, 17)

Here we are three decades after this astute argument was eloquently made, and yet the dynamic described remains relevant, its enduring timeliness troubling and indicative of the ways in which (illegitimate) power never cedes willingly. And undeniably, a large part

of colonization's symbolic power lies in story: who tells it, to whom, on which stage/platform, to which effect, and guided by which agenda, bias, and lived experience. While the paternalistic colonial dispossession of NDN stories continues apace with that of land, relations, and lives, we do see cracks in the white supremacy façade as Indigenous storytellers expose and refuse the "experts," and allies/accomplices learn that the fight for human rights and liberation is not just an international project conducted far from the borders of Canada. Looking and leaning inward is always vital, as Jeanette Armstrong invokes: "Imagine how you as writers from the dominant society might turn over some of the rocks in your own garden for examination" (qtd. in McMaster and Martin 1992, 17). Imagine.

Imagination. Images. Stories. Sovereignty. Again, the argument connecting self-determination to the right to tell one's own stories on one's own terms isn't new, and has long been linked to the concept of sovereignty, as McMaster and Martin make very clear: "Self-determination and sovereignty include human, political, land, religious, artistic and moral rights. Taking ownership of these stories involves a claim to Aboriginal title over images, culture and stories" (1992, 17). There is a long history of Indigenous artists and storytellers claiming ownership and exercising story stewardship, as well as employing a kind of self-representational empowerment even when not in total control of said stories or images. The carefully researched, illuminating work by Michelle H. Raheja (Seneca) in *Reservation Reelism* (2010) documents this powerfully—as Indigenous actors in the silent movie era eschewed stereotypes and became their own directors and producers, manifesting what Raheja names a kind of "visual sovereignty." In conversation with this early cinema history, Beverly R. Singer (Santa Clara Pueblo, Tewa, Diné) charts less mainstream iterations of Indigenous-made film and video from the 1970s on, arguing for a framework in which to view Indigenous moving image participation as "cultural sovereignty" in *Wiping the Warpaint Off the Lens* (2001).[28] Exercising sovereignty over storytelling, as carefully discussed in these path-breaking works, allows for the dismantling of mis-representations, including the myth of the "Vanishing Indian"—a trope exhausted by 19th- and early 20th-century writers and artists working in Canada. Cole explores this cultural myth in their historical examination of iconic Canadian painter Emily Carr

and the artist's relations with Indigenous people during her lifetime in *The Invented Indian/The Imagined Emily*:

> The "disappearing Indian" was an entrenched belief, one that has been dealt with superbly by University of Victoria historian Brian W. Dippie. He shows that a fully rounded version of the "vanishing American Indian" had won public acceptance in the United States by 1814. By its logic, Indians were doomed to "utter extinction." Poets, novelists, orators, and artists found the theme of a dying Aboriginal race congenial, while serious students of "the Indian problem" provided corroboration for this particular construct. Opinion was virtually unanimous: extinction was inevitable. (2000, 149)

Visibility is inextricably linked to power in a culture emphasizing visual culture, as is the case with dominant settler society for well over a century. The "Vanishing Indian" trope provided an enticing and unexamined, cynical creative outlet for settler image-makers—a good story with dramatic arc for Canadian audiences that tantalized while propping settler supremacy myths. Story power telegraphs to other kinds of power in society, such as the power to set cultural mores, values, and even truths. *Nanook of the North* (Robert J. Flaherty, 1922) is, after all, still positioned as the first "documentary" feature, despite its staged *mise-en-scène*. And as it goes, our values reflect value we assign to cultures, stories, and people. Cree filmmaker and professor Tasha Hubbard (featured in Chapter 1) makes the link between value, storytelling, and visibility undeniably crucial here:

> Indigenous people have not been seen as having value, and that translates to our stories. And so, a lot of our stories implicate Canada and implicate those who benefit from injustice. And that's the majority of Canadians. So that's an uncomfortable truth, and sadly not enough people are courageous enough to face that. And I think storytelling has potential to create some cracks in that kind of a wall. ... So how do we get through that so that people see the value and see the strength in Indigenous stories. We've been taught so much over the years and over the decades, through residential schools or various policies, that we aren't valued. I make films and

I think a lot of us are in the same position, where we want to share
our stories with each other too, because, again we're always taught
only stories by white people have value. We need to go back to
valuing our own stories too. (qtd. in Winton 2020, 187)

In linking the concepts of value and story to injustice, Hubbard argues
for a need to tell Indigenous stories, not just to "Canadian" audiences,
but to and for Indigenous audiences and communities. This is a power-
ful notion that echoes one of the most vigorous and essential essays on
Indigenous culture and colonial Canada, also published in 1992 (what
a year!), by Loretta Todd (Cree/Métis). Todd discusses the inherent
risks in using the colonizer's tools to dismantle/decolonize the coloniz-
er's house, and asks: "How can we, then, create our own scholarship
and practice of art and aesthetics in the face of what would appear to
be positions that are opposed to our world view, and where there is a
real risk of assimilation, at worst, or serving the agenda of the dominant
culture's own critics at best?" (1992, 76). Here we gesture to an earlier
section's theme—"common grounds." Ground obviously invokes land,
and we are undeniably, regardless of subject-position, ancestral lineage,
or personal journey, all on the land. Ground is also, when paired with
the word *common*, a metaphor for shared affinities, kinship, and com-
munity. Through the commanding work of path-making writer-artists
like Todd, we call to question once again the binary of insiders and out-
siders, realizing one can be on the "outside" of their own culture, and
despite all efforts to work with, conform, or adopt "insider's" tools and
languages, also remain on the outside of dominant culture's carefully
policed borders. As such, perhaps the very notion of *insiders and out-
siders* needs to be exploded, collapsed, dismantled (detached?) as a very
defining politic/ethic for Indigenous and non-Indigenous relations in
colonial Canada. In its ashes we could grow a new unity of lateral love,
collective understanding, radical imagination, and reciprocal relational-
ity. Todd asks, "Should we seek a unity? I do not mean a unity of Native
nations in pan-Indianness, but rather a unity that asserts our rights to
our imaginations and how we imagine and name ourselves" (1992,
76). This tenet, the right to imagining, naming, and therefore *imaging*
oneself, is crucial, lest the common ground we stand on continues to
be defined, organized, and imagined by one dominant culture at the
expense of all others. Because, "in the end it is subjectivity that matters:

our world views as they proclaim us, in images from our lives" (Todd 1992, 76).

Writing only three years after Todd and addressing representa-tion, which is at its core the notion that something is re-presented (which is a markedly different way to approach the ethics and politics of image-creation), Theresa Harlan (Santo Domingo Pueblo and Jemez Pueblo) connects sovereignty to survivance:

> Native survival was and remains a contest over life, humanity, land, systems of knowledge, memory, and representations. Native mem-ories and representations are persistently pushed aside to make way for constructed Western myths and their representations of Native people. Ownership of Native representations is a critical arena of this contest, for there are those who insist on following the tired, romantic formulas used to depict Native people. Those myths ensure an existence without context, without history, without a reality.(qtd. in Peers 2007, 179)

Existing without context is a powerful evocation of losing story power and self-representational force. Indigenous storytellers and theorists have worked to resist and reverse this kind of colonial damage. In the final year of the 1990s, a resounding, foundational text by Linda Tuhiwai Smith (Māori) was published that connects Indigenous knowledge to story power. *Decolonizing Methodologies: Research and Indigenous Peoples* provided a thorough and bold critique of the Western, colo-nial tradition of researching Indigenous peoples, while highlighting Indigenous research, methods, and "counter-stories" via 25 Indigenous research projects. Smith launched an unapologetically political and Indigenous approach to academic research, proclaiming: "It is from within these spaces that increasing numbers of indigenous academics and researchers have begun to address social issues within the wider framework of self-determination, decolonization and social justice" (Smith 1999, 4). In the same introduction Smith speaks to the insider/ outsider dynamic, yet from another perspective—that of working in the academy, where researchers who identify as Indigenous are "insid-ers" with regards to their own (researched) community, yet "outsiders because they are often marginalized and perceived to be representa-tive of either a minority or a rival interest group" in colonial research

institutions (5). Eve Tuck (Unangax̂), commemorating Smith's game-changing text on its 15th anniversary, eloquently states: "It has given us an anti-colonial lexicon of research, and an ethics of *making space and showing face*" (2013, 365, original italics). One year after Smith's *Decolonizing Methodologies* shook academic pillars, theorist and educator Marie Battiste (Mi'kmaq), building in part from her innovative theory of "cognitive imperialism" (where one knowledge source is discredited so another may dominate through public education),[29] published *Reclaiming Indigenous Voice and Vision*, where, as editor of the collection, she writes in the introduction: "Indigenous scholarship, along with research that requires moral dialogue with and the participation of Indigenous communities, is the foundation for postcolonial transformation" (2000, xx). From 2012 to 2018 that foundation was fortified by the indispensable, "undisciplinary" journal *Decolonization: Indigeneity, Education and Society*,[30] which staked out its territory as such: "Colonial power affects all areas of life and thought—this journal seeks to engage and confront that power at every level."[31]

We would be remiss to not highlight the incredible, accessible research of the Yellowhead Institute, who have contributed immensely to efforts at decolonizing research and circulating Indigenous knowledges and ways of knowing inside and outside the academy. Their last two agenda-correcting "red papers," *Land Back* (2019)[32] and *Cash Back* (2021),[33] continue the tradition of mapping colonial injustice while productively suggesting reparative, restitutive, liberatory, and forward-looking pathways teeming with tools, resources, and critical analyses.

Indigenous research in the media arts field, as separate but at times in conversation with Indigenous media arts research in academia, has been conducted at and through Indigenous-run institutions like the imagineNATIVE Film + Media Arts Festival in Toronto (est. 1998). Their 82-page *On-Screen Protocols and Pathways: A Media Production Guide to Working with First Nations, Métis and Inuit Communities, Cultures, Concepts and Stories*, published in 2018, is a visionary framework for working with Indigenous peoples in media arts. As stated in the guide:[34] "Protocols provide appropriate and ethical ways of working with Indigenous cultural material, and interacting with Indigenous people and their communities. Protocols provide appropriate and ethical ways of working with Indigenous cultural material, and interacting

THIS IS NOT A MAP

"We are becoming another resource. They have taken timber and gold and fish and now they want our stories. They are continuing to take our resources and profit from it."
Darlene Naponse, Filmmaker

There was resounding consensus from participants during the engagement process that these protocols should be considered a living document and not serve as a static checklist on how to make productions with Indigenous content. Rather, these protocols are intended to inform policies, processes, and practices, but they are not a map for non-Indigenous practitioners to access Indigenous stories. In this spirit, the following checklist has been developed for non-Indigenous practitioners:

- If it is not representative of your culture or background;
- If it has anything to do with Indigenous history or culture;
- If you have to question your belongingness to a group or community;
- If you are uncertain your good intentions will deliver balance and respect; or
- If you are unsure this is a story you should be telling; then…
-

DON'T DO IT.

"If you really need to have us in your story, tell the truth of your history, as difficult as that may be. Find the intersections of truth in the history of settlers. There are as many Indigenous stories as there are settler stories. You cannot tell a story truthfully if you do not come from this place."
Catherine Martin, Filmmaker and Educator

The non-Indigenous production community should consider the ways in which they can reinforce Indigenous narrative sovereignty and what roles they can play to promote Indigenous cultural industries, rather than reinvent Indigenous stories in their own image.

SCREEN-BASED PROTOCOLS PRINCIPLES
Screen storytellers described the following principles as fundamental to the execution of protocols.

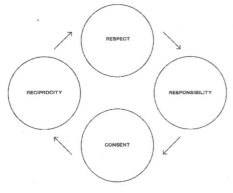

FIGURE 0.2 Diagram from *Protocols and Pathways* publication—"Screen-Based Protocols Principles," imagineNATIVE Film + Media Arts Festival. PDF screen grab.

with Indigenous people and their communities" (Nickerson 15). This essential guide provides the pathways for makers to learn, understand, and enact the protocols that will lead to a more just, ethical media arts field in Canada. The framework privileges grounded research and the central tenet of sovereignty, as Jason Ryle, in the introduction, reinforces: "In our work at imagineNATIVE we have witnessed first-hand the importance, impact, and vitality of Indigenous narrative

sovereignty and the urgent need to support Indigenous screen storytellers" (10). Once again, it comes back to, or down to, *story*.

Protocols and Pathways isn't imagineNATIVE's first or only research-based publication. The festival also commissioned an important 59-page report in 2013, *Indigenous Feature Film Production in Canada: A National and International Perspective*,[35] which was led by filmmaker Danis Goulet (featured in Chapter 1) and Kelly Swanson.

Earlier in 2005, and across the land to the West Coast, IMAG—the Vancouver-based Indigenous Media Arts Group (1997–2005), co-founded by Dana Claxton, Cleo Reece, and Marie Ann Hart Baker (among others)—co-published *Transference, Tradition, Technology* with the Walter Phillips Gallery Editions and the Art Gallery of Hamilton. The 223-page book includes 12 essays of either commissioned or republished works that all consider the activity of Indigenous media arts in Canada and how the practices maintain Indigenous knowledges and philosophies of life through visual storytelling. While we are currently living in a vigorous era of Indigenous media arts, social media, research, and cultural leadership that has been described on multiple occasions as an "Indigenous resurgence," and we highlight some of these important incursions, we point to what we would rather call a historical, continuing *surge*. We end this section with a quote from *Indigenous Feature Film Production in Canada*:

> The proliferation of Aboriginal stories and perspectives has a vital outcome—it enables Canada to carve out a new legacy that celebrates and includes Indigenous stories and perspectives. ... The work of Aboriginal storytellers also counters the history of misrepresentation and appropriation that has plagued the representation of Indigenous people on screen for the past century. From the proliferation of stereotypes to the reinforcement of false narratives, the work of Indigenous filmmakers, in the words of Jesse Wente, Head of Film Programmes for TIFF Bell Lightbox, "consciously establishes itself as a counter-cinema ... or rebuke to a century's worth of falsities propagated by mainstream cinema." (Goulet and Swanson 2013, iii)

It is serendipitous that Wente may no longer be at TIFF and is instead the Executive Director of the newly formed Indigenous Screen Office in

Canada,[36] as well as having been appointed chair of the board at the Canada Council for the Arts in 2020. New legacies and new opportunities for counter-stories—these are among the bold new pathways forward.

CROSSROADS

Indigenous ways of seeing, knowing, and being are captured in the stories that come from the land; that circulate, constitute, and configure culture; and that nourish survivance and prosperity in the face of enduring settler colonialism.[37] These ways, articulated through story, are still seemingly up for grabs for settlers, who continue to steal, sample, and pillage freely and for the most part with impunity. What has perhaps changed from the age of the two solitudes to present day is threefold: (1) an astounding abundance of dynamic, prodigious work is being created, shared, and cared for in the Indigenous literary, visual, and media arts, broadcast, and film fields, aided by new digital tools and platforms; (2) good-intentioned settler Canadians (whether politicians, civil society organizers, educators, academics, or artists) are launching and participating in more Indigenous-themed and focused projects and interventions directed at settler Canadians, including and crucially around the need to self-educate;[38] and (3) a greater number, while still far from a majority, of settler Canadians are acknowledging the injustices of colonization publicly, which includes the relatively new self-identifying label "Settler Canadian" (Lowman and Barker 2015). Yet Canada is at a new moment of identity crisis, one in which the old dualities have in part transmuted into a fierce discourse of inclusion, pluralism, and refusal that has yet to wholly reckon with an overculture still steeped in denial and attachment issues.

These are exhilarating times of upheaval and reckoning, yet we still have a long path to forge in order to end anti-Indigenous attitudes (which fuel anti-Indigenous racism) and settler (whether established or newcomer) ignorance, prejudice, and privilege. Recent structural and programming changes promised at settler media and arts institutions (some of which are mentioned by Hubbard and Goulet in Chapter 2) have been encouraging developments. A spate of Indigenous hires in academia is finally reconfiguring higher learning and research.[39] Indigenous cultural and educational workers in some provincial educational systems are radically changing the space of settler education. Yet, as some political terms and practices gain in popularity and are

appropriated/adopted by institutions and movements, we also want to push against "decolonization" becoming a symbolic gesture or, following Tuck and Yang, a mere metaphor,[40] and land acknowledgements becoming to decolonization what recycling is to environmentalism.[41] Cultural extractivism and exploitation are the kinder, gentler manifestations of settler colonialism, signalling the political progression of the passive-aggressive liberal society to which Canada remains under social lock and key. Of course, the picture is not only dark—hope and promise in the form of Indigenous-led social movements, knowledge-building, and art/media-making are shining the light, collectively lifting and regeneratively bringing forth Indigenous ways of knowing and being now impossible to ignore or subsume. For instance, at the time of writing, Indigenous faculty and students have called for Ryerson University in Toronto to be renamed, given the current namesake's role in developing Canada's racist residential schools system. Still, we've got a long way to travel on the restorative path.

A selective snapshot from the Canadian media arts world since the closing of CBC comments may help provide context: In 2015, a settler-directed collage film from Québec was released to festival acclaim despite calls from Inuit activists and artists who pointed to not only the theft of Indigenous images, but the misrepresentation of Inuit;[42] that same year, a third iteration by a non-Indigenous anthropologist who released *In the Land of the Head Hunters* made a comeback that was welcomed with a lack of critical reflection on Canada's West Coast. In 2016, Montréal's most prominent film festival opened with a feature film by a settler director that furthered the clichés and "southern gaze" of Inuit territory and culture in the North. In 2017, Toronto's Hot Docs film festival opened with a settler-made feature documentary about Indigenous children participating in a Canadian spelling bee competition that catalyzed Indigenous filmmakers around the need to push for better representation at the festival.[43] Also in 2017, scores of Canadian artists and journalists supported the idea to create an "appropriation prize" that in part suggested white writers exploring the lives of non-white people should be officially commemorated.[44] Then in 2018, the largest jazz festival in the world—Montréal's Jazz Fest—was forced to pull the production of *Slav*, a musical show based on slave songs, after Black activists drew critical attention to the fact that the producer was white and so was most of the cast—yet this didn't stop the (settler)

creative team from later mounting the Indigenous-settler relations play *Kanata*, described as a superficial settler-saviour narrative by Abenaki filmmaker Kim O'Bomsawin.[45]

One consistently hears the refrain, "Well at least there's dialogue," when it comes to settler-Indigenous relations, yet that dialogue has been shaped by dominant culture and settler institutions for the most part, while paradoxically relying on Indigenous labour and knowledge to move the educational needle. Indigenous artists, activists, and leaders have pushed effectively at places, institutions, and moments, and we may be on the precipice of a critical mass of listeners. We seek to contribute to that groundswell—to the art and discourse that not only challenge settler colonialism, but that also ask complex questions about who we are as a society, how we can think, see(k), know, and act collectively, and differently, for the common purposes and desires between and among us; and crucially, how we can realize a total state shift away from settler colonialism in our lifetimes.

We wish for that moment to come where everyone takes a deep breath and begins to really—meaningfully, thoughtfully, humbly—engage with Indigenous histories/peoples/cultures while asking: What can I learn from Indigenous knowledges in a productive, healing, and reciprocal way, not as appropriations or only as consumables such as books or films? That moment of real engagement, which is already happening but not quite yet as a mass, a collective moment of societal transference and evolution, also beckons: How do I walk upon this amazing earth that so generously gives to us every day? Every day! The land gives to us, and through an understanding of Indigenous lifeways and world-making we can walk with all this creation in a good way, free of domination and oppression. Free of fear. Free of ignorance. Free of exploitation and dispossession. We hope for together *doings* that move us forward, into a future that is happening right now, and we are excited for the change, and to be part of the change, lifting together with so many across this land that has lifted us for millennia. This new but also familiar identity crisis could truly be a good thing—for Indigenous and non-Indigenous folks alike. The problem has been identified. Identities are being claimed, reclaimed, dismantled, and rebuilt. Now, crucially, we ask—how are we identifying with the future and our role in it, together?

We are compelled to think about love—for each other, for ourselves, for mother earth, and all inhabitants—and for futures and cultures

created anew. Indigenous traditions have maintained connections since time immemorial and continue to mix with European and other cultures, and as we consider this present moment and place in the context of love, we also consider the future of mixed relations. Canadians are taught in schools and through the media that it was adventurous and virtuous European men in suits and uniforms who arrived to a barren land and built society from the ground up—a founding myth that conveniently papers over the process of genocide and the historical presence of Indigenous societies. This founding settler story is only now being addressed in some classrooms (the media have been equally slow to correct the national myth record). What is faithfully left out of most history classes is the generous role that Indigenous peoples have played in teaching settlers how to live on/with the land, and little is acknowledged of the matrilineal practices of most Indigenous cultures. And relatedly, what of Indigenous languages as official languages? For instance, Cree is spoken across this sacred land. Are we *wâpahtowin*? (Are we seeing each other?). Do we want to see NDN people ... *thriving*? Can the colonized imaginary grapple with such a radical vision for the future—one boldly outside the policed borders of recognition and existence without context or history? Can we co-create the conditions of a careful and healthy *detachment* from empire and colonization?

We want to see what NDN producers and writers are seeing and writing about. We want to see what non-Indigenous thinkers are thinking and doing when it comes to representations of NDN communities and NDN stories. We hope this modest book can contribute to the dismantling of ignorance, the elimination of fear, and the overcoming of antipathy between settler and Indigenous relations in the country known as Canada. We hope it is used for decolonizing efforts, or by those who wish to eschew such terminology in favour of other novel and similarly radical possibilities. We hope it helps in these ways while contributing to the building (the doing!) of the new path we must all walk to find balance in ourselves, among ourselves, and between all our relations.

WHAT'S IN THE BOOK

Now that we've done some ambling to signal what shape we hope this book takes for you, the reader, we would like to briefly comment on its contents in all the chapters' vibrancy and vision. We're thankful to all the contributors of this volume who answered our call for works that

explore the politics and ethics of Indigenous representation in Canada's media arts on, behind, beside, and around the screen. We are delighted not only that these works met that call with depth, care, and ferocity, but that we have struck our own kind of plurality here, with a mix of settler and Indigenous contributors and with a diversity of backgrounds: writers, filmmakers, students, academics, and media makers.

The book is divided into four sections. Part 1—Decolonizing Media Arts Institutions takes aim at the artform that inspired the book in the first place: cinema. As part of the media arts, filmmaking is a central form of communication in Canada and beyond, and as a very influential truth-teller and emotions-provoker (not to mention affect-producer), film—from making to showing—appears front and centre in this collection. Cinema has also been one of the main sites of contestation and resurgence in this country, with flare-ups around problematic films and their curation a steady reality that intermingles politically and discursively with the steady march of richly diverse Indigenous-made cinema. While the outsider storytelling tradition does continue, there have been gains made in the industry and wider culture that are encouraging; yet colonial legacy practices and pathologies stubbornly persist, and as such their effects are discussed at length in this section, where you'll find a focus on festivals and other media arts institutions.

Cinema is at once a site of colonial reinforcement and decolonial revanchism, where small acts of industry rebellion push back against 130 years of representational violence and the largest actions provide support and shelter in the ongoing battle for representational and material justice. These moments, enacted by filmmakers, curators, and arts managers, and cast into policy (including the development of the Indigenous Screen Office over the course of preparing this manuscript), are explored, celebrated, and discussed in the first section.

The first chapter is a stirring discussion between several celebrated Indigenous filmmakers building off the topic of this original conceit, held at imagineNATIVE in October 2017. Moderated by Danis Goulet and Tasha Hubbard, filmmakers who have each written, directed, and produced cinematic works that combine critical voice with creative virtuosity, this transcribed public discussion passionately probes central questions around who should and who gets to tell whose stories in Canada and beyond. We are honoured to include the (slightly edited for clarity) conversation in this volume.

Chapter 2 continues the discussion of Indigenous representation and decolonization in film and at sites of film circulation by focusing on the production, curation, and circulation of the settler-made Québécois film *of the North* that put into stark relief the deep lack of critical consciousness of non-Indigenous artists, where arguments in favour of the film deployed freedom of expression overtures for the right to make and show problematic and injurious works. Indigenous and allied artists have called for a shutdown once and for all of the continued circulation of harmful film and media that serve to strengthen the colonial project, such as the film discussed in this chapter. Leading that charge is Alethea Arnaquq-Baril, who makes a powerful case for a kind of curatorial colonial detachment in a longer version of an interview published soon after said film's release, when the Inuit filmmaker expertly and ardently shaped the debate, and continues to shape the wider discourse on these pressing issues around the ethics of filmmaking *and* film programming.

In Chapter 3, Claudia Sicondolfo focuses on another film moment, separated in time, place, and political tenor, but equally significant in the discussion around Indigenous representation and decolonization at film institutions. Sicondolfo critically investigates the intersection of film institutions and decolonial acts of Indigenous presence and iteration, drawing much-needed attention to the place and import of Indigenous language in both the cultural and political dimensions of cinema. Further, Sicondolfo positions her research as a challenge to manifest different, more justice-oriented scholarly inquiries that contribute to decolonizing pursuits in meaningful ways, especially as they relate to settlers conducting academic work that interconnects with Indigenous subjects and issues.

Part II—Protecting Culture extends the conversation from film spaces and institutional ethics to the wider arena of culture and its relationship with film. Whether interrogating trauma, reparative justice, regionalism, or youth, Part II circles the notion of cultural stewardship while connecting material realities to the symbolic environment. Indigenous land and water protectors appear in our news feeds for acts of courage and care, yet less spectacular and equally vital acts of cultural protection occur daily, hourly, across Turtle Island. The chapters in this section shine light on these safeguarding acts and celebrate the ways in which cultural makers and protectors provide space and pathways

toward justice for so many, creating kinscapes of care that encourage our collective imaginaries long into future generations.

Margaret Robinson and Bretten Hannam lead the section with a mindful and critical investigation into the representation of colonial trauma in Mi'kmaw film. In Chapter 4 they are concerned with self-representation as a form of cultural safeguarding, as they state succinctly here: "Indigenous culture protects us from some of the impacts of colonial trauma." Focusing on specific films and their directors (including Hannam), with pointed questions for each, the authors divide their analysis into four themes—land, language, violence and gender, and sexuality—which they weave together in an overarching discussion about the fluidity of culture and the self-empowering mechanisms that manifest when cultural protection takes the form of empowered self-representation.

Brenda Longfellow follows with Chapter 5, wherein the film scholar carefully teases apart the intricate layers involved in the representation of residential schools and their survivors through film. Considering issues of framing and interpretation through filmmaking, Longfellow explores the ways in which the harmful, coordinated colonial legacy becomes "sayable" in the visual culture vehicle of cinema. The chapter contextualizes on-screen representations of this brutal history with Canada's Truth and Reconciliation Commission, and the cultural, discursive, and political consequences that emerged after its deployment. Troubling notions of settler-defined healing processes, Longfellow contributes to efforts to connect cultural protection with the ways in which "different institutional sites and public discursive shifts [have] shaped the moving image [of] residential schools."

Continuing the critical focus on representational aspects of cultural stewardship and safekeeping, Karine Bertrand in Chapter 6 considers the intersecting points of Indigenous women and Québec cinema in order "to better understand the nature of these representations and to read them in such a way as to make Indigenous women characters visible." Situating contemporary works in a long history of mis/representations, Bertrand explores in particular Québec cinema and filmic collaboration as a kind of Indigenous cultural resurgence. The chapter links Indigenous representation and expression to the power of self-representation, voice, and visibility in a socio-cultural field that has caused (colonial) harm

while also presenting opportunities to seize the means of production in service of cultural correction, propagation, and preservation.

In the final chapter of this section, Joanna Hearne follows on themes of the previous with an interrogation of "spaces of inclusion" in films by Abenaki filmmaker Alanis Obomsawin. Combining an analysis of wider social, political, and historical forces with close readings of films, Chapter 7 considers "Indigenous strategies of resistance and healing" via "lesser-known films within several larger contexts." Obomsawin is a prolific, critically acclaimed, and canonized filmmaker of whom much has been written, yet Hearne uniquely explores the director's "methodological and aesthetic attention to the ethic of inclusivity" with regards to her films for and about children, drawing conclusions about Indigenous knowledge sharing, teaching, and activism that, through the past and ongoing work of Obomsawin's focus on documentary and education, have profound impacts on the preservation and protection of Indigenous culture and the rights of children.

Part III—Methods/Knowledges/Interventions brings together critical analysis and careful engagement with Indigenous media arts practices, knowledges, and specific interventions in colonial and Indigenous Canada. In *Indigenous Research Methodologies* (2nd ed., 2021), Bagele Chilisa argues that social science research must be emancipated from the dominant voices of Western Europe, while privileging the interconnectedness and relationships of people, especially those who are not members of the dominant culture. We see this as another dual act of detachment and creation. Shawn Wilson (Opaskwayak Cree) writes in the foreword to *Research Is Ceremony: Indigenous Research Methods* (2008) that "Indigenous epistemology is all about ideas developing through the formation of relationships. An idea cannot be taken out of this relational context and still maintain its shape" (8). Later, Wilson expands on this and argues that fulfilling your role as a researcher must involve a kind of relational accountability—that is, being "accountable to your relations" (77). The fostering of relationships with accountability may seem obvious to social science and humanities researchers, but as Māori scholar Linda Tuhiwai Smith so unwaveringly states in the opening pages of the essential *Decolonizing Methodologies: Research and Indigenous Peoples* (1999), the word "research is probably one of the dirtiest words in the indigenous world's vocabulary" (1). As pillaged subjects of non-Indigenous, usually Western-based

research practices, Indigenous peoples are all too aware of the manifestation and deployment of asymmetrical power relations. Research into and about Indigenous peoples has rarely been reciprocal or beneficial to those researched. Thankfully, the tides have shifted since Smith penned her breakthrough volume, and there is an impressive bulk of Indigenous-created texts on research methods, epistemologies, and knowledges published both inside academia (Tuck and Yang's new Routledge series "Indigenous and Decolonizing Studies in Education" is already a rich source) and outside (see Wilson 2008; Vowel 2016; Xiiem, Lee-Morgan, and Santolo 2019). Any internet search of "Indigenous research methodologies" will reward the seeker with enough source material to write a thesis or orient themselves away from a colonial, imperial research architecture that speaks *about and for* Indigenous peoples, to one that speaks from an Indigenous research perspective. Chapters in this section honour this shift and foreground Indigenous research methods, ways of knowing, and ways of building and maintaining relations.

In Chapter 8, filmmaker and scholar Jules Arita Koostachin explores the manifestation of Indigenous epistemologies inside the film world. Dr. Koostachin focuses steadfastly on Indigenous storytellers, and especially those working in the documentary realm, analyzing the ways in which stories may "(re)inscribe the image of Indigenous people in the Western imagination" through various platforms, modes, and methodologies germane to and innovated by the original storytellers. Koostachin considers issues of values, balance, reciprocity, cultural sustainability, and perseverance in light of working within, beside, and against colonial systems for storytelling and sharing. With an emphasis on orality and origination in the nonfiction realm, she links Indigenous storytelling to Indigenous relation-building, self-agency, survivance, and sovereignty.

Chapter 9, by Julie Nagam and Carla Taunton, interrogates the "embodied practices" of land relations, "cultural knowledge, family, and community, as well as bodily experiences" in Indigenous media art-making. Their exploration of two Indigenous media artworks—Ursula Johnson's *L'nuwelti'k (We Are Indian)* (2012–) and Lisa Jackson's SNARE (2013)—resists and refuses the ongoing placement of Indigenous knowledges and practices in an antiquated past, and argues the futurity of Indigenous media art practices is linked to performance and technology as makers innovate, adapt, combine, collide, incorporate, connect,

and create new works. Through a close reading of these two exceptional films, the authors argue works like these "mobilize the performed gendered, colonized body" against the "legacies and continued projects of colonialism."

With Chapter 10, Toby Katrine Lawrence probes multisite, multimedia interventions by Indigenous artists on the West Coast of Canada. Her chapter focuses on a project called *Speaking Outside*, which offers "a point of departure to consider collaboration within curation and art production as an interventionist strategy," as well as probing important issues of who, on these lands, has been historically permitted to speak and in which ways. Considering the ways in which non-Indigenous and Indigenous curators and artists can collaborate, Lawrence—who is a curator—approaches *Speaking Outside* and another performance and screen-based public space installation, *Bondage*, as negotiating boundaries in art and public space realms, while thinking of how these media art and performance interventions constitute decolonial strategies as well.

Michelle Stewart explores the "field of local ecological knowledge" and Indigenous documentary work in Chapter 11. Focusing on collaborative, interactive, and immersive documentary projects, Stewart explores the ways in which Indigenous traditions of oral knowledge keeping and transmission emerge in stories that have found new form in digital media practices. Exploring crucial questions such as, how can Indigenous media art forms, especially those that are interactive, foster "intercultural dialogue," Stewart's research and analysis bridges Section III with Section IV by considering Indigenous-created new media forms and their power in transmitting Indigenous worldviews, languages, and knowledges while asserting a sovereignty over the imagination and agency over the political and cultural realms.

The last section continues with themes of methodology and media arts, with chapters that engage particularly with resurgence and solidarity. Part IV—Resurgent Media/Allies/Advocacy weaves between virtual and material environments, connecting pathways and objectives between art creation, communication, justice, knowledge, and intervention. The glue that binds these relations and practices of resurgence across cultural divides and histories is the expansion of the notion of Indigenous sovereignty. Here sovereignty is broken free of the confines of acknowledgement and friendly assimilation in the overculture, and morphs into critical interventions on and offline that manifest as

projects concerned with Indigenous liberation and allied solidarity.
Allyship must offer more than territorial acknowledgements, hope,
and apologies if it is to meaningfully contribute to the transformation
of Canadian society from settler colony to one of justice and equality,
including Indigenous sovereignty and liberation (and #LandBack). This
last section of chapters shows that this transformation needs the creative
and critical work of artists, activists, lawyers, media makers, teachers,
researchers, and digital denizens.

In Chapter 12, Sasha Crawford-Holland and Lindsay LeBlanc shift
the media arts conversation deep into the digital realm, underscor-
ing the ways in which "digital media can be instruments of Indigenous
resistance and temporal sovereignty." Their work draws attention to
the under-discussed fact that there is a long history of Indigenous new
media creation, and beginning their inquiry in the 1990s, they com-
pellingly draw connections between the hegemony of linear, Western,
"settler time" and the political potential of Indigenous digital media to
"facilitate embodied engagements with alternative temporalities." Their
absorbing discussion of three computational artists' work highlights the
violence wrought by the imposition of settler time's "temporal order,"
where Indigenous peoples were relegated to antiquity, and probes the
liberatory possibilities of self-determined futures inside and beyond
digital spaces created by Indigenous media artists.

Eugenia Kisin and Lisa Jackson, in Chapter 13, share an engaged dis-
cussion around the Gladue Video Project. The authors look closely at
the ways in which video can and has been used as a form of testimony,
and in particular the ways in which community video projects have
innovated the media form as "an attempt to represent offenders through
the humanizing medium of film, situating their actions within a broader
frame of marginalization, ongoing settler-colonial oppression, and
potential for support and repair." Here, Indigenous-led research and
documentation practices contribute to reducing the disproportionate
numbers of incarcerated Indigenous people, and innovative methods
that manifest as alliances cross the legal and carceral boundaries in
order to represent and advocate.

While these chapters were created in relative isolation from one
another, we are delighted to see how they are, in the end, in conver-
sation across pages and chapters, and indeed how they lift together.
As each of the chapters is concerned, directly or indirectly, with the

settler-Indigenous dynamic in Canada, they are not isolated incursions, but rather make up a part of a larger, collective constellation of shared histories, communal values, lived experiences, radical imaginaries, and common dreams. We end the collection with some of our own brief concluding thoughts, as well as a decisive, thundering political-ethical coda from the inimitable Lisa Jackson.

We are optimistic that readers will be curiously drawn to seek out the contents of the book in an approach that speaks to them. Whether one reads the book linearly and all at once, or back to front, or a chapter here and there, we have taken care to order and place each piece in a way that brings cohesion and collaboration to this volume. With that in mind, we leave you now to explore and reflect as you walk forward on your own terms, building your own relations, and turning over rocks as you go.

NOTES

1 We are hesitant to "define" Indigeneity, but in part, it is the study of all that is Indigenous with an emphasis on the acknowledgement of Indigenous oppressions, histories, and futures and the ways in which these communities contribute to life, culture, and societies in multiple ways. A critical (and academic) exploration of this term can be found here: https://philpapers.org/rec/TIMCOI.

2 "Media arts" is a practice of visual art, video art, and interdisciplinary art that incorporates media technologies such as analogue or digital video as a single, multi-channel, or installation work. As technologies develop so too does the definition of the practice. In Canada the Independent Media Arts Alliance (IMAA) " is a member-driven non-profit national organization working to advance and strengthen the media arts community in Canada. Representing over 100 independent film, video, audio, and new media production, distribution, and exhibition organizations in all parts of the country, the IMAA serves over 16,000 independent media artists and cultural workers" (from https://www.imaa.ca/about-us/).

3 "NDN" is used at times to refer to Indigenous peoples by summoning the reclaimed and appropriated colonial misnomer "Indian" with the coded abbreviation that reduces the word to its phonetics. The terms "Indian" and therefore "NDN" are both considered harmful terms out of context and especially when used by non-Indigenous people to describe the First Peoples living in the territory known as North America (see note 5). "NDN"

is also a way of differentiating identity and nationhood from the accurate descriptor for people from India.

4 See note 5.

5 "Canada" and "North America" are used to refer to colonial political territories of what some Indigenous peoples (including peoples of the Haudenosaunee and Iroquois Confederacy) call "Turtle Island," and are by no means meant to indicate endorsement for these place names, which are not only historical markers of empire and oppression (the first a settler misquote of an Indigenous place name, the second derived from an Italian "explorer" following Columbus), but among the most powerful signs in the semiotic frontier of contemporary colonial capitalism. We look forward to the day when they may be changed.

6 A good summary of this story can be read here: https://jezebel.com/what -can-we-learn-from-canadas-appropriation-prize-lite-1795175192.

7 Michelle Latimer's claims to Indigenous heritage and her identity as an Indigenous filmmaker were called into question after a CBC story broke in December 2020. At the time of writing, the director is suing the CBC following the broadcaster's cancelling of the second season of the TV series Latimer was directing, *Trickster*. See the CBC article here: https://www.cbc .ca/news/indigenous/michelle-latimer-kitigan-zibi-indigenous-identity -1.5845310.

8 For an example of but one source focused on these dynamics, check out @NoMoreRedface on Twitter.

9 https://www.aptnnews.ca/national-news/author-joseph-boydens-shape -shifting-indigenous-identity/

10 https://www.cbc.ca/news/canada/toronto/jesse-wente-appropriation-prize -1.4115293

11 Lenard Monkman covers some of these stories here: https://www.cbc.ca /news/indigenous/top-5-indigenous-news-stories-2017-1.4456891.

12 Arnaquq-Baril discusses this concept here: https://nunatsiaq.com/stories /article/65674from_language_shaming_to_lateral_love_what_inuktut _needs_to_grow/

13 We acknowledge the insightful and valuable discussion on "marking" artists, authors, and thinkers in academic works in Max Liboiron's brilliant book *Pollution in Colonialism*. In their introduction, nestled in the best footnotes ever produced in academia (pp. 3–4), Liboiron discusses the common practice of introducing or acknowledging Indigenous authors with their respective nation or affiliation, "while settler and white scholars

almost always remain unmarked." We concur that "this unmarking is one act among many that re-centres settlers and whiteness as an unexceptional norm, while deviations have to be marked and named," but also agree with Liboiron that the marking/unmarking process is difficult and fraught. We are in gratitude to their crucial discussion on these matters (one that draws on Kim Tallbear and la paperson) but have ultimately decided to "mark" Indigenous artists/thinkers/authors when they have self-identified as such, and have otherwise left others unmarked. We hope this footnote at least frames this methodology in a critical light, as per Liboiron, and further hope readers will seek out their book and embark on that journey themselves. See Liboiron 2021.

14 The colonial architecture is explored through roadways and their signification by Michelle St. John and Ryan McMahon in the documentary *Colonization Road*. More here: https://www.colonizationroad.com

15 https://www.psychologytoday.com/us/blog/emotional-fitness/201811/how-best-use-detachment

16 Conciliation is the notion that we need to come together, agree, and resolve conflict before "reconciliation," which McNeil-Seymour says has "been co-opted to serve various governmental, institutional (eyes on universities here), organizational and industrial business-as-usual agendas" (2017).

17 https://www.komoks.ca

18 https://www.afn.ca/wp-content/uploads/2018/02/18-01-22-Dismantling-the-Doctrine-of-Discovery-EN.pdf

19 Watch the video here: https://vimeo.com/371484110; lend your support to the Unist'ot'en camp here: https://unistoten.camp.

20 Read The Red Paper document here: https://caid.ca/RedPaper1970.pdf.

21 http://www.trudeauformula.com

22 https://www.cbc.ca/news/canada/montreal/catholic-quebec-california-fran%C3%A7ois-legault-gavin-newsom-1.5393170

23 For more on this story follow this link: https://indiginews.com/vancouver-island/joyce-echaquan-victoria.

24 As described here: http://societyforvisualanthropology.org/mediafestival/land-head-hunters/

25 See Lowman and Barker 2015 for an excellent discussion on settler identity, including the persistent state of disavowal (of responsibility, among other things).

26 https://www.cbc.ca/newsblogs/community/editorsblog/2015/11/uncivil
 -dialogue-commenting-and-stories-about-indigenous-people.html

27 Pam Palmater, always shaping the anti-colonial public discourse, described
 Canada 150 as "a celebration of genocide." Read the article here: https:/now
 toronto.com/news/canada-s-150th-a-celebration-of-indigenous-genocide.

28 Singer is herself a filmmaker. More here: https://www.wmm.com/filmmaker
 /Beverly+R.+Singer/.

29 More here: https://education.usask.ca/documents/profiles/battiste/divers
 ity.pdf and here: https://www.cbu.ca/indigenous-affairs/mikmaq-resource
 -centre/mikmaq-resource-guide/essays/enabling-the-autumn-seed
 -toward-a-decolonized-approach-to-aboriginal-knowledge-language
 -and-education/.

30 PDFs of all past issues (2012–2018) are available here: https://jps.library
 .utoronto.ca/index.php/des/issue/archive.

31 https://jps.library.utoronto.ca/index.php/des/about

32 https://redpaper.yellowheadinstitute.org

33 https://cashback.yellowheadinstitute.org

34 Download the PDF or purchase the report (in hard cover) here: https://
 imaginenative.org/publications.

35 Download the PDF here: https://telefilm.ca/wp-content/uploads/indigenous
 -film-report-2013-10.pdf.

36 https://iso-bea.ca

37 This term was brought forward by Gerald Vizenor (Anishinaabe) in his
 1999 book *Manifest Manners: Narratives on Postindian Survivance*.

38 Among the many initiatives from participating in #SettlerSaturday to
 #LandBack, we are particularly hopeful for settler-to-settler educational
 projects, such as Reading to Decolonize, https://www.readingtodecolonize
 .ca.

39 But as Chelsea Vowel states in an excellent Twitter thread: "We cannot
 decolonize inherently colonial systems." Find the thread here: https://
 twitter.com/apihtawikosisan.

40 Read Tuck and Yang's influential essay "Decolonization Is Not a Metaphor"
 here: https://jps.library.utoronto.ca/index.php/des/article/view/18630.

41 Read Hayden King's critical take on land acknowledgements here: https://
 www.cbc.ca/radio/unreserved/redrawing-the-lines-1.4973363/i-regret-it
 -hayden-king-on-writing-ryerson-university-s-territorial-acknowledge
 ment-1.4973371.

42 Read an interview with Inuk filmmaker and activist Alethea Arnaquq-Baril, commenting on this issue in this volume, Chapter 2.

43 See Winton's review of *Bee Nation* here: http://povmagazine.com/articles/view/review-bee-nation.

44 More here: https://www.theguardian.com/world/2017/may/13/canadian-journalists-appropriation-prize.

45 See article here: https://www.cbc.ca/news/canada/montreal/kanata-premieres-paris-1.4948755.

Decolonizing Media Arts Institutions

Introduction to Part I

Dana Claxton and Ezra Winton

With this first section we present three chapters that in one way or another engage with questions and strategies around decolonizing media institutions, especially in the realm of moving images. In his essay for IntercontinentalCry.org, "What Is Decolonization and Why Does It Matter?" Eric Ritskes writes: "There are many views of decolonization, often contrasting and competing, but one thing is common: the belief that through action, change can occur. We're all implicated in and through colonialism and how we decolonize is connected to how exactly we are implicated."[1] While "decolonization" has become on the one hand a buzzword sometimes emptied of its justice conveyances and transformational roots, and on the other hand appropriated by allies and activists working in cognate social justice fields such as environmentalism and anti-capitalism, it is also a term that still holds tremendous power and precision. In their indispensable and agenda-setting essay "Decolonization Is Not a Metaphor" (2012),[2] which is referenced at various points in this volume, Tuck and Yang sum it up best: "Decolonization brings about the repatriation of Indigenous land and life; it is not a metaphor for other things we want to do to improve our societies and schools" (1).

So, following Ritskes, we concur that living in a colonial system means we are all implicated in that system and therefore our actions toward dismantling said system, or decolonization, are necessarily varied, diverse,

and dependent on our socio-economic and political positions, subjectivities, and lived experiences. Following Tuck and Yang, those collective actions must at core be concerned with the repatriation of Indigenous land and life, and therefore Indigenous stories as well. The re-centring of Indigenous perspectives in media arts, especially with regards to Indigenous leadership in filmmaking (as directors, producers, editors, writers, DOPs, etc.) and institutions (curators, programmers, commissioning editors, executive producers, teachers, critics, etc.) is therefore an important part of decolonizing efforts and one attuned to the specific culture, politics, and social world of telling stories through the kinds of audio-visual representation that circulate and are presented in the media arts institutions and industries discussed—or implicated—in this section.

Cinema has not only reflected Canadian society back to itself for over a century, it has refracted society as well—gathering the disparate threads and bubbling undercurrents of dominant cultural mores, socio-political norms, controlling worldviews, corporate economics, and colonial imaginaries as kaleidoscopic representations on national screens that give shape and legitimacy to all the component parts. Cinema—as practice, as institution, as discourse and semiotics—has in this country, as with many others, been a key part of the colonial project from the beginning, and continues in its leading cultural role even as attitudinal shifts have normalized directives like "inclusion" and "diversity" in the industry. As industries and institutions adapt to these shifting attitudes and to public pressure, new entities emerge (such as the imagineNATIVE festival, where the discussion in Chapter 1 takes place) while settler and legacy institutions make symbolic gestures or surprise with radical recalibrations (the former of course being the norm). Thus the decolonization of media arts industries and institutions including cinema, despite the inspired efforts of Indigenous artists and makers from coast to coast to coast, remains a work in progress and very much a goal, not a contemporary fact.

We have selected and invited several critical and creative voices working toward the above objective, in concert with these tactical efforts towards decolonizing media arts industries and institutions. Packed into this section are also more teachings for the decolonization medicine bag, and ways in which to centre Indigeneity within the media arts field while privileging this critical dialogue and foregrounding

a fierce discourse of naming root causes and addressing historic and structural barriers to decolonization head on—a decolonizing discussion begun with gusto in Chapter 1.

Taken together this opening section sets us on a path to approaching the question, "What does decolonizing media arts industries and institutions mean?" As with most complex ideas, it means something different to each person (to bring it back to Ritskes). For some it is captured in the edict "nothing about us without us," mentioned in Chapter 1's roundtable. For others it is about taking a fierce, interventionist stand against settler institutions (in this case film festivals) that are perpetuating colonial violence through misrepresentation, as discussed in Chapter 2. Decolonizing manifests as the act of centring Indigenous knowledges, methodologies, and voices, and therefore of reclaiming spaces (discursive, symbolic, material, virtual, and more), such as with the performance of decolonizing "film acts" at screening events, explored in Chapter 3.

Regardless of the interpretative ways in which decolonization manifests in these first three chapters of Part I, this revolutionary and revitalizing concept is about changing colonial structures and systems through modes of representation and forms of relationality, and creating narratives with the objective that new critical understandings and productive relations can gather strength as we dismantle and build simultaneously.

NOTES

1 https://intercontinentalcry.org/what-is-decolonization-and-why-does-it-matter/

2 https://clas.osu.edu/sites/clas.osu.edu/files/Tuck%20and%20Yang%20 2012%20Decolonization%20is%20not%20a%20metaphor.pdf

Our Own Up There: A Discussion at imagineNATIVE

Danis Goulet and Tasha Hubbard with Jesse Wente,
Alethea Arnaquq-Baril, and Shane Belcourt

> I've always felt strongly, our land gets taken, our fisheries and
> forests get taken, and in the same category is our stories. We need
> to see our own up there.
>
> —Māori filmmaker and activist Merata Mita, 1988[1]

INTRODUCTION

The topic of cultural appropriation, talked about in Indigenous creative communities for the past few decades, became part of the mainstream narrative in 2017. As the debate unfolded, many in the mainstream media failed to fully understand why the debate was happening and why Indigenous artists were calling attention to how cultural appropriation continues colonial relationships with Indigenous people. In the context of screen stories, cultural appropriation revolves around the question of who gets access to available film resources in order to tell Indigenous stories and why. At the Insiders/Outsiders panel, held at the imagineNATIVE Film + Media Arts Festival in October 2017, filmmakers Alethea Arnaquq-Baril, Shane Belcourt, Danis Goulet, Tasha Hubbard, and Jesse Wente came together to publicly talk about what we had been discussing among ourselves for many years.

Colonial relationships are defined by genocide, theft, extraction, and exploitation. Colonization involves the *taking*—of culture, language,

land, and stories—for the benefit of others. In North America, this was often done through legal means. For example, the Canadian government outlawed Indigenous ceremonies through amendments to the Indian Act in 1880 and 1895. Similar actions were taken in the United States. Ceremonial gatherings are where stories are told, how people understand themselves and their relationships to the world around them.

Since the beginning of the moving image over a century ago, countless depictions of Indigenous peoples and life have appeared onscreen, with little or no Indigenous involvement or control over how these stories get told. From the biggest studios in Hollywood to the best-intentioned independent art house cinema makers, the vast majority of films made about Indigenous peoples have reinforced a colonial gaze, contributing to years of misrepresentation. Onscreen, Indigenous peoples have been destroyed, reduced to simplistic tropes, or used as a device for a white hero's redemption (often being killed off in the process). Many films overtly reinforce racist and harmful stereotypes such as the vanishing Indian, the noble savage, the mystical Indian, and the Indian princess. Others may be more empathetic to Indigenous characters but remain locked into patronizing and simplistic views that fail to capture the complexity of Indigenous experience. Cliché archetypes and patronizing depictions are harmful because they are ultimately dehumanizing, and these ideas crystallize into cultural consciousness that defines real-world attitudes toward us. At the heart of all these issues is a central question: As creators, as an industry, and as a wider culture, will we continue to perpetuate colonial relationships with Indigenous peoples?

When Indigenous creators address cultural appropriation in the screen industry, we are also referencing the ongoing theft and exploitation of our stories that is inherently situated within a colonial relationship. This led to a rallying cry: Indigenous stories need to be told onscreen by Indigenous people. Or as Jesse Wente, writer, broadcaster, and director of the Indigenous Screen Office, implored the industry: "Nothing about us, without us." The initial pushes to support the early waves of Indigenous filmmakers came out of an urgent need to rebuke the damage propagated by years of misrepresentation in the industry. By the time the imagineNATIVE Film + Media Arts Festival (the world's largest presenter of Indigenous screen content) came into existence in 2000, the mandate of the festival was to show works

directed, produced, or written by Indigenous people, so that the focus was on Indigenous-driven stories and perspectives rather than simply on Indigenous content. The US-based Sundance Institute's Indigenous Program (in existence for over 20 years) has also always been driven to support Indigenous writers, directors, and producers, in recognition of the importance of Indigenous people in key creative roles.

In addition to misrepresentation, Indigenous filmmakers have been addressing questions about how Indigenous stories get made. Many have spoken over the years about their sense of responsibility, not just in terms of what appears onscreen, but also in terms of how Indigenous stories and communities are engaged. Telling Indigenous stories requires a level of cultural competency, which has not been taught in film schools or valued as a part of a filmmaker's' toolkit. This includes respecting cultural protocols, gaining consent from communities, and exploring what meaningful collaboration looks like.[2]

For years following the initial efforts to push for Indigenous-driven stories, Indigenous creators struggled to gain access and opportunity in the industry. In spite of the success and growth of an Indigenous-driven production sector internationally,[3] the richness, uniqueness, and complexity that an Indigenous gaze brings to storytelling continued to be undervalued and underestimated. Numerous reports over the years have documented the barriers faced by Indigenous creators, including racism and ignorance in the industry, as well as a general lack of belief in Indigenous filmmakers' abilities or in their stories' appeal to audiences.

While Indigenous creators struggle to get their stories made, films with little or no Indigenous involvement continue to get made, leaving Indigenous creators frustrated and deeply hungry for a new era in storytelling that would better reflect our realities. Even recently, many of these films have been upheld and celebrated by the rest of the industry (sometimes receiving up to five or ten times the funding), and supported at the highest levels by major institutions. This has highlighted another shortfall that continues colonial storytelling: Indigenous people remain under-represented at decision-making levels at funding agencies, broadcasters, festivals, and film companies.

The outcry against cultural appropriation thus comes after a century of misrepresentation onscreen, a lack of respect for Indigenous stories and cultural protocols, and decades of inequity in the industry for Indigenous creators. In this debate (which has included other

art forms as well), several members of the artistic establishment have doubled-down on their license to tell any story in any way, whether or not Indigenous communities are meaningfully engaged in the process. Some have argued that this is about artistic freedom. However, the argument in favour of artistic freedom is based on the assumption that everyone has the same freedom. Indigenous creators have never had the same artistic freedom. We've had to fight for our rights for cultural expression in Canada and for the very basic freedom to tell our own stories from our own perspectives. We have advocated for decades for access to resources (necessary for any film production) and inclusion in the industry. It is therefore vital to interrogate the notion of artistic freedom to unpack whether it is freedom being defended or, in fact, privilege.

The defenders of cultural appropriation also refuse to engage in the question of whether or not telling Indigenous stories without us continues a colonial relationship in which we continue to be exploited. It rebuffs the need for more cultural competency in Indigenous storytelling and fails to recognize how much ignorance still exists about Indigenous realities and experiences. It turns a blind eye to how much damage, pain, and real-life consequences stem from misrepresentation. It also fails to acknowledge that the theft of our stories is inextricably linked to the theft of Indigenous lands, culture, and language. This doubling down also keeps power firmly in the hands of those who already have it.

So, where do we go from here? The way forward is to ask ourselves as filmmakers and as an industry how to engage with Indigenous stories and communities in responsible and respectful ways. We must continue to support Indigenous people in the industry in key creative roles—as writers, producers, and directors—on projects about us. We must continue to advocate for all major institutions in Canada to have Indigenous strategies and to hire more Indigenous people in decision-making roles. Discussions are underway on how to ensure that resources meant for Indigenous creatives are going where they need to go. And as audiences, we must collectively support Indigenous-driven content, as this underscores a powerful message to the industry that there are audiences hungry for Indigenous perspectives onscreen.

In the past few years, there have been signs of change in the industry. In the same year that this panel took place, Telefilm Canada appointed

a national Indigenous advisory circle and established a targeted fund to support Indigenous-driven feature films that is managed by an Indigenous analyst. Also in 2017, the National Film Board of Canada formed an Indigenous advisory group and announced a three-year plan that included a minimum benchmark for Indigenous-directed films, strategic hiring, and staff competency training. The Canada Council for the Arts stated in their most recent strategic plan that "Canada is at a historic turning point. The relationship between Indigenous and non-Indigenous peoples in Canada, and between Indigenous peoples and the Canadian state needs to be radically transformed."[4] And also that, "The Council is supporting a self-determined approach that respects and appreciates First Nations, Inuit and Métis artistic expression, cultural protocols, rights, traditions, and world-views." The Canada Council also reaffirmed their stance on cultural appropriation by creating a framework for the assessment of Indigenous content.

In 2018, after years of advocacy by Indigenous filmmakers, the Indigenous Screen Office was established as an independent Indigenous-run organization with the support of the Canada Media Fund and other agencies and broadcasters. The Office has a mission to "support and develop Indigenous screen storytellers and Indigenous stories on screen," and to "increase representation of Indigenous peoples throughout the screen industries." The creation of the office is a huge step forward and marks the beginning of a new era of Indigenous oversight in the industry.

All this support has already begun to yield incredible results. In 2018, Gwaai Edenshaw and Helen Haig-Brown co-directed *Edge of the Knife*, the first feature film made entirely in the critically endangered Haida language and in collaboration with the Haida Council. Produced by Isuma, the film premiered at the Toronto International Film Festival (TIFF) and went on to win numerous awards. Also premiering at TIFF in 2018 was Darlene Naponse's *Falls Around Her*, featuring prolific actor Tantoo Cardinal in her first leading role. In early 2019, *The Body Remembers When the World Broke Open*, co-directed by Elle-Máijá Tailfeathers, premiered at Berlin, and Tailfeathers was named as one of Canada's rising screen stars by Toronto's *Now* magazine. Also in 2019, *nîpaw-istamâsowin: We Will Stand Up*, directed by Tasha Hubbard (one of the co-authors of this chapter), became the first-ever Indigenous-directed documentary to open the Hot Docs festival, going on to win the

Canadian Screen Award for Best Documentary. Most recently, 2020–2021 saw the incredible international success of feature films *Beans* by Tracey Deer and *Night Raiders* by Danis Goulet (co-author).

This is an exciting and unprecedented time in Indigenous cinema. These recent successes mark the beginning of a new era in which Indigenous-driven screen stories will become widely available unlike ever before. This era comes from decades of Indigenous filmmakers pressing the industry to shift from a landscape of story extraction to one of story support for Indigenous peoples. There is more work to be done, but the rising tide of Indigenous screen content needs to be celebrated, replicated, and widely supported.

INSIDERS/OUTSIDERS PANEL AT IMAGINENATIVE FILM + MEDIA ARTS FESTIVAL, OCTOBER 2017[5]

FEATURED PANELISTS:[6]

Tasha Hubbard, filmmaker
Danis Goulet, filmmaker, programmer
Jesse Wente, film and pop culture critic, curator, producer
Shane Belcourt, filmmaker
Alethea Arnaquq-Baril, filmmaker
Responder: Dana Claxton, artist, professor

TASHA HUBBARD: We're here today because 2017 has seen a lot of conversations happening around the subject of cultural appropriation. Specifically, these are conversations that we've been having amongst ourselves as Indigenous creators, but of course now seeing it in a very public way with the Cultural Appropriation Prize,[7] and also seeing the Indigenous art world being touched by this. In the film community it's also been a year where organizations and individuals have taken a stand against cultural appropriation, especially with regards to Indigenous film.

Part of that is to push back against what could be understood as a spectrum, from outright racist representations to films made on Indigenous subjects by non-Indigenous creators that are often lacking in nuance, or even a knowledge of the community. So some rallying cries have gone out, including Jesse Wente's "Nothing about us, without us."

Some in the industry are listening and taking steps to determine that this history we know of as misrepresentation, appropriation, and

exclusion—one that's marked the film industry since it began—is to change into a different story, one where Indigenous directors, writers, and producers get to tell our own stories.

On the other hand, films are still being made without us, and some non-Indigenous filmmakers are insisting this is okay in the name of artistic freedom and/or are involving Indigenous consultants, but those of us in the room and otherwise who have worked as consultants, know that that very often means: "We'll ask your opinion, we probably won't listen to it, we'll put your name on the film anyway, and we likely won't pay you."

So this panel really is an opportunity to have a public conversation about an issue that we, again as I mentioned, have been having in private and in venues such as imagineNATIVE.

It's [this conversation] so important for those of us that are Indigenous filmmakers that are spread out across the country, across North America, across the world, and it's only in spaces like this where we have a larger community that we can talk about these issues, and so we thought it was important to start having this conversation in a more public way, and we're therefore so thankful to our group here who are perfectly willing to do so. So, thank you.

DANIS GOULET: I think I'm gonna throw out the first question to Jesse because, Jesse, you did a talk back in January, and I want us to first go broad with the context of colonization to begin with, and Jesse you talked about the notion of extraction and the history of theft of this land, culture, language, but also, of our stories. If you want to start by talking about the notion of theft and extraction and how it relates to storytelling, that would be great.

JESSE WENTE: Sure. You know, I think colonialism and its relationship to neoliberal capitalism requires it to be an extraction business, as in, colonialism is an extraction business.

So, when you see colonial states come in, they extract all the resources out of wherever they are colonizing, and that includes land, people, physical beings, then our stories, the animals and all of that. They extract as much as they can, because it's driven by a capitalist system, so there isn't a reciprocity, or a sense of sustainability; it's really just "take as much as you can," and there's a hierarchal system that then rewards certain people and keeps others down—but that's a much longer discussion.

I think for me though, ultimately there's an interrelation between a narrative sovereignty and actual physical and political sovereignty, and I think we can actually see evidence because when we look at what colonial powers have done to Indigenous peoples all over the world, not just on Turtle Island, they go hand in hand in terms of their colonial approach to assimilation and relocation: they steal the stories, they legalize the theft of stories in the exact same way they utilize the theft of land, imprisonment of people, the theft of culture. And I think that's an acknowledgement by colonial powers that they understand if we kept our stories, it would be much harder to do those other things.

You know, if we had retained our language, if we retained all of that knowledge, it would be much harder for them to dehumanize us, which then allows the overculture to ignore the pressing inequality, the obvious inequality that is the result of that sort of colonial approach.

And so I'm not sure that you can actually attain political and physical sovereignty, which I think you would all love as Indigenous peoples, without also attaining narrative sovereignty.

And I think in many ways the narrative aspect is one where we can, as cultural creators who get to create content outside of political spheres and those spaces where physical and political sovereignty is tough, those that might require not only vast political change, but, let's be honest, physical revolution to actually see those sorts of results.

Narrative sovereignty, however, is a battle of ideas and creation, and I think we're very well equipped even here and now, despite all the disparity and inequality that might exist. We are very well equipped as communities to wage that battle, especially now with social media and digitization, which allows us to get our message out. I think now is the time where we should be claiming, reclaiming, our narrative sovereignty in an effort and as a means to the end for the sovereignty of both our physical and political states.

DANIS: Alethea, I was just thinking of you because your film *Angry Inuk* was very personal and about your community. Why is it so important that we as Indigenous filmmakers get to tell our own stories?

ALETHEA ARNAQUQ-BARIL: Maybe I'll just explain what the alternatives are. Because I'm sure everyone on this panel gets the same thing. But I get contacted a lot by producers and writers (not as often

by directors) wanting to do projects in the Arctic, wanting to access Indigenous funding, wanting to do the exotic far-off Eskimo film, and it's the same fucking story every time.

Usually a woman is sexually assaulted within the first few pages [of the script], or killed, or assaulted in some way, and then there's usually a white male character at the centre of the story; there's always addiction involved, and at some point the white male character is spoken to by a spirit helper, or an animal.[*laughter*]

Or, a stoic wise hunter or Elder gives them some kind of opaque piece of advice that doesn't make sense to the audience, but it sounds really wise. Then the white guy saves the day in the end, or usually the woman that was assaulted in the beginning. It's so formulaic and it's the same story that's told over and over again. I can pull up examples—I've spoken to Ezra about this before [see Chapter 2]—it would be an enormous amount of work to troll through my email and find all of these, but there are dozens and dozens of these scripts or documentaries, concepts, or even just phone calls that I've gotten. I tell these people this all the time.

A couple of weeks ago I was in the edit suite with the director that I'm working with, who is non-native and who I've told about this many times. I got a phone call while she was in the room, and she could hear me talking to this person, and she was just, like, "Wow, it's for real, like, this happens all the time."

So we're constantly having these stories pitched that have these stereotypes that you kind of have to laugh about, but they're also really dangerous because when women are portrayed as sexually available, or promiscuous, I think that's a huge contributing factor to the MMIWG issue; same as when our men are portrayed as violent: they're incarcerated more, they're not believed when they're charged with crimes that they didn't commit. There are real consequences to all these things.

Then when you see films, like the ones many of the people in this room have made, those aren't the stories that are being told: as in, we're shown as three-dimensional. We're shown as people with love and beauty in our lives. The alternative is just not acceptable.

DANIS: That's really great. I want to also hear from you guys if you've had similar experiences. I think we've all had these experiences, but Alethea, what you're talking about is the perpetuation of really damaging stereotypes that continue to marginalize Indigenous people. But I also

want" to point out that you're also talking about just bad creative—those are bad scripts. So that's also just frustrating. But yes, I'd love to hear from Shane as well about your experiences with these challenges.

SHANE BELCOURT: You know, when you sent an email off for this panel, it was a terrifying email to read and I really wanted to open up about it. [*laughter*] Like, I totally want to hang out and talk about this absolutely, but this isn't "Hey everybody, what're you doing?" You know, it's a little different.

But I guess when you brought this up I thought of the movie *Moonlight*, and its script: there is a craft to directing, there's a skillset from pre-production all the way through to post and release, that you acquire as you do things. So, could I apply my craft and skillset to direct *Moonlight*? Would it be anywhere close? I'm not talking talent, Barry's way more talented than me—I'm not talking about that, there's no comparison there. What I'm talking about is I couldn't craft the real fibre of the story. Which makes me ask: Would I be the guy to do that? I'm not from Miami, I'm not from the community, this other community, I have no relationship to that.

And then I think, well, why doesn't anybody else who has the opportunity? Like so-and-so director: We have this script, do you want to direct it, it's about an Indigenous story, it's their cultural legacy that's at stake here. It's that part of it.

It's not like *Goonies* has an Indigenous character in it or in a bad high school film and there's a representation, or a *Glee*-type situation where everyone's part of a United Colors of Benetton kind of commercial thing—that's different. Anybody can do those, it doesn't matter to me and it sounds good.

But something like residential schools will be the other sort of trope that gets dragged out. "Oh, I've got to do a story about that, the story is hot!" I don't understand why somebody—when I think about what I've got to give to direct something, it is so much of my life that goes into that including a loss of time with family, a loss of time with friends, I'm just immersed in the deep dive on that thing. I don't understand the power dynamic going on when somebody who is not from that community will say, "I can totally do that, I'm gonna absolutely direct that film," or "I'm gonna write that film, I'll just do some research ... oh, my heart really goes out to it." You know, like, come on.

A part of this is: we're forced to fight. Jesse and others and my sister and I get online, and they're angry and they have to wage this fight. But, why do they have to fight? One is the other side, and I'd say, you know what? This is totally inappropriate for me to do it. Like, why is it on us now? It kind of pisses me off that here's this panel and we have to sit here and say: Hey, step off our shoes, you know? And at the same time it's like: Why don't you fuckin' step off our shoes already?

Don't tell the story that's a cultural legacy. Do *Goonies* and I don't give a shit. But if someone's gonna do something that's really profound to this community, what gives you the gravitas to say, "I could totally do that." I'm shocked, you know, and a little pissed I guess. This is why I don't want to do this. [*laughing*] [*applause*]

TASHA: Yeah, that's one of the things that I think we think about a lot: the approaches that we take to the work we do. It's not just a project, it's not just a line item, this is something that we all feel, with the stories we tell and when we go into our communities, we have that accountability. I think this is not well understood by a lot of people in the industry who—and this is where we were earlier having this discussion—even sometimes have good intentions. Which brings me to one of the questions I have for people: How do we get past that sense of, "well they have good intentions," but they're still doing damage? And I think about this in terms of people who maybe know how to ask the first two or three questions and are on the right track but haven't necessarily done the work. So, I'm just wondering if there's any comment on that.

JESSE: Well, I struggle with a number of aspects with this, just in terms of the advocacy for the narrative sovereignty, because there are lots of people with lots of great intentions, and there's been movies made in the past with lots of great intentions, which didn't work out so great. But one of the hardest notes to give when I talk about this—it's sort of what Shane touched on—is that intangible note of, well, it just would have been better, it would have felt better.

And there's a movie that's going to roll out in Canada in the very near future that's sort of that style of story, and the movie has already been very well embraced, and that's even a tough note to give to the audience because you know, some of that stuff is subjective, because maybe I'm

more critical of the movie, because I've seen 1,500 movies a year for the last 25 years, so I've seen a lot of movies, so my quality bar is pretty high.

But I think that's a challenge for this ongoing debate—those sorts of projects. And when the projects go to non-Indigenous filmmakers, you know, one of my biggest issues with this new movie is, especially in Canada, we don't ever remake movies in Canada, right? Once a story's been told once, that's sort of it, we don't have those stories that come back and back again, and so when a story like, say about residential schools, is made by a non-Indigenous person, it won't get made again, that version is done and gone, we just don't have those sorts of opportunities again.

And when it comes to residential schools, this is the big topic to tackle, or we're trying to reconcile this, and yet there truly hasn't been that many feature films by First Nations, Métis, or Inuit about residential schools in Canada, if we're truly honest. There's been documentaries and there's been plays and all sorts of other stuff, but when it comes to actually finally making the big movie, we haven't had that opportunity, and I struggle because I feel with all the good intentions, that some of the opportunity slips away.

And now we're getting further and further from being able to make that movie, because other people are adapting them, other people buy the rights to Indigenous books, and we don't have the capacity to necessarily pay the same rights fees, so suddenly we're locked out of properties that maybe should be adapted by Indigenous people. I don't begrudge authors getting their money, but then we're in a cycle where when that happens, that author won't resell that story, like we're not making *Godfathers* or *X-Men*, or movies like that where these big industries are just gonna recycle and recycle and recycle.

For some of these stories, we only got one shot, and I'm just worried because it's so urgent. We haven't had our chance up until now, and we need it now, especially as Canada seems to be in an identity crisis. I think it requires us to sort of remind them a little bit of the pathway here. And so that best intention thing, I really struggle because it's not a note around consultation or consent, or those process-type things, which is when we talk about cultural appropriation. It feels like the overculture is desperate for us to name a process by which they can then just do what they've been always doing, but for us [to] be okay with it. So that you and my sister, your sister and I won't go on Twitter and slam them.

They just want some checklist where that won't happen, whereas I think the debate is much more of an intellectual one, and that's a tough one, because they don't like to hear that they don't actually have the right and we don't feel they have necessarily the right to tell these stories. That's the biggest fear, and I worry that if we say that to them, that closes down this debate because they'll blame, they'll say artistic freedom, and despite the fact that they pass laws telling us that we couldn't do this for decades and decades, they'll slam it all down on free speech. So, I really do worry about how we correctly advocate for that while trying to get our stories made.

TASHA: Yeah. And I just want to briefly add a note that I think what I sometimes hear is when a non-Indigenous person makes a film, well the community consented, someone in that community agreed, and it's like, of course they did because we've been ignored and erased and oppressed, and there's an opportunity to be heard, so of course they're gonna take that opportunity, right? And you can't just rely on that, there has to be a larger issue at stake, or at least an understanding of where we're coming from here. It's so true, we're actually just at a time now where we're really starting to break in and have that access to tell those stories, but we're now competing against producers and directors with, you know, Telefilm film envelopes, and history, and all of that stuff that we don't have. And so, there is an extra layer of challenge.

DANIS: I also just want to say, too, that sometimes when producers come forward to us and they present us with the film that they want us to give notes on and all of that, I mean even if the film is sympathetic, I think the good intentions thing goes so that people think, "Oh well, I'm sympathetic to this cause and that's enough." But colonization means that the history of this land has been robbed from everyone, and so any old Joe that you'll meet walking on the street does not have a deep understanding of what it means to be standing on this land, whether you're an Indigenous person or not, and so how can you give someone a checklist about that? And sympathy is not enough, it's not enough, it doesn't get all the way there, it doesn't get to the depth and nuance and complexity, and so then we see these films get made, and it is what you say, Shane, it's about our legacy, so that then it becomes another thing that is being taken away, and that's been very challenging.

ALETHEA: I'd also like to add: screw their intentions first of all. Not only is it not enough, it's often the most dangerous thing. In addition to these stories not having a chance to be told, again, sometimes even if there's going to be a film done that's actually gonna be pretty good and not offensive and all of that, it's still eating at a limited pot of money that's out there for Indigenous stories, or Indigenous subjects: there's only so much air time for us. It's getting better, but it's still very, very limited. And the stories that are put forward, even if they have good intentions or are well done, it's not necessarily the priorities of the people whose experiences are at stake. So, who gets to decide which stories are most important to be told? Because we only have so much air time, and we need to be deciding that.

SHANE: The other thing about film is that it's a commercial product at the end, and there is an audience that you want to hit. So then you have to promote the film. You can get on the radio and talk about it, you can do interviews. And one of the joys of being a director is obviously connected to the auteur theory, where you author the film work, and because of that authorship, people want the director to go on and promote the film.

So, there is this other opportunity that I find shocking on just a business side, not on a cultural legacy side. You have an Indigenous story, and now *The Current* or somebody is looking for somebody to come on the radio and talk about it. And well we can't really have the director come on and talk about it, right? They're gonna call the bluff at the end of the day in promotion, not in the pre-production, on promotion they're gonna call the bluff and go this is a little inappropriate for this person to get up here and talk about it. So, what we'll do is we'll get Jesse [Wente] or somebody else to come on the radio and talk about the issues of the film that was made by non-Indigenous people but about Indigenous people.

It seems insane to me that that's the way it rolls out, because, if you're gonna ask one of you guys to come out to make it, you made the film and you're gonna come talk about it, you're gonna talk about your personal connection to the subject matter, to the subjects, to the actors, of how you dug deep in your blood memory to pull that story out. If we're talking *Goonies*, who cares, but if we're talking about this stuff, I just don't understand again from the pre-production to the end, you should

want the director and the writer and anyone who's gonna author this story to go out in front of it on the world stage to be from that community. I just don't know how you could do it any other way!

JESSE: I love you, Shane. One thing I do want to say though is I am actively producing an Indigenous *Goonies*, so ... please don't disparage that, and that's the good news, it's going to be great title. [*laughing*] But I think this even applies to when it comes to programming and curation at festivals and TV stations, where you can end up actually as an Indigenous curator or programmer, you end up watching all the movies made about us, but by non-Indigenous people, and they actually do not end up watching the movies made by us, because the opinion they actually end up wanting is the okay on those films, whereas they actually feel totally empowered to judge the others, which is so baffling and has been for me personally incredibly frustrating. But that happens over and over again, not just in film by the way: this is curation, this is the history of curation in all sorts of venues where you have non-Indigenous curators feeling very comfortable to curate Indigenous art, and yet ask Indigenous curators about depictions of us, and I think that also just then feeds into that cycle.

And certainly, if there's an end game, it's the end game that the people that I'm sitting next to, and lots of people I see in this panel event, to stop being called to be consultants on film, and instead be called to make the goddam movies.

I don't understand how these movies get produced, and you guys aren't called, not to consult, but to direct these films, or produce these films, or write these films. If I was the same producer in Canada, this [fellow panelists] would be the Rolodex for these projects. I don't understand why there is any other Rolodex, this isn't 1987, we're 30 years from then, there has been Indigenous cinema being made in this country for 50 years at this point. You are highly trained, skilled artists who can knock these shows out and they will be infinitely better than they are now, and maybe then if we'd done that 10 years ago, we could have been producing a *Goonies* or whatever else, and we wouldn't be feeling that there's a limit on how many access stories we have because we wouldn't just be limited to making stories about Indigenous people, we could make Indigenous movies about all sorts of people just like the overcultures have had the opportunity to do, forever.

TASHA: I'll add that we are all in a position because of our track records to be approached. We have the agency at this point to say no, even though it sucks, that's our currency, but I also worry and have concerns about filmmakers who are just getting started, and, you know, will say no on this pass, and then they'll go to someone who needs the opportunity, and then puts that person in a position of vulnerability because they need that opportunity and they are going to do it, and they may not have the support in place. So I think we start getting played against each other in these situations. I wanted to mention that.

DANIS: Yeah, I think the problem with the consultation model, where we're in this new supposed era of reconciliation where people say, "Oh yeah, we've involved Indigenous people, we've consulted." To consult but not listen to the feedback is one thing, but also how much power and decision-making authority, how much ownership does a consultant have over a project? Or they go to an Elder, and it makes me so angry when I see these films get made, and then the consultant has given the stamp of approval, so called, and then at the screening they have drummers opening up the film, and again, this is Indigenous involvement but is it meaningful and what does that actually mean?

And it means that you cede power, that you make space, that you allow Indigenous people to control our stories, that's what it means, and anything less than that won't do. Because I think we've had a decade of this consultation era, and it's really frustrating, but I love what everyone is saying because what we're talking about is that we're also beyond the question of representation alone. Because I think for a long time we were just so concerned that everything out there is racist and stereotypical, and now we're talking more about: it may not be racist, it may even just be an okay account made by a non-Indigenous person, but does it go deep enough and in the process of making the film itself, does it continue to perpetuate a colonial and patronizing relationship to Indigenous communities?

And that's also what we see people say: "Yeah, but the story wasn't bad." But representation is no longer the bar anymore, it's: Are you continuing to perpetuate a colonial relationship to our communities, to our people? And then Shane, your point about promotion was also amazing, because again, you've gone ahead and made this movie, and then at the end you're getting all this feedback. And I've given this feedback to

non-Indigenous teams, so what are you gonna do when you launch this film? Please tell me you're gonna centre Indigenous voices. And so, they run around at the last minute—and I've seen this happen—where they stick in Indigenous consultation credit really large by somebody who didn't ask to have that done, so that they could add legitimacy to what they've just done, and they start bringing people along for the ride for the promotion that weren't actually that involved in the film. So what it does is continue this process of where we're extracted for our cultural knowledge and our understanding of our own communities. So, I just want to say thank you to you guys, and ask what does meaningful involvement look like, or what is the way to get it right?

ALETHEA: Oh, that's so much harder to do. First of all, I echo what Tasha said, because I come from the Arctic, way in the hell far away from the rest of the country and from the rest of the Indigenous filmmaking community, and the only way I could learn about filmmaking was to work with non-Indigenous people who had come into my town to shoot a film and leave. So, I had a series of horrible experiences and only now that I'm a more established filmmaker, do I have the ability to say, "Nah, I'm gonna do my own project; I'll write and direct and produce my own film." I can do that now because I've established a record with funders, with producers, and I didn't have that in the beginning, I had no choice but to work on really shitty films that were all kinds of problematic, but it was my only access to learning.

Thankfully each project has gotten better and better, and now I'm at the point where, for example, I'm a producer on a drama, and it was funny because I was talking with the director the other day who is non-native and she was saying—it's been an eight-year project that we've been working together on—"You know, this is not the film I would have made at the start of the project." It's really interesting that she's had that learning curve. But there was also a point when we were developing it when she said, "You should be directing this. What the heck is going on? Or like, Stacy, she's also, you know, from Nunavut. You guys should be directing this, like, come on." But we weren't ready, we didn't have that experience, we had never worked on a drama before, so, you know, sometimes that's just not possible.

It's easy to say everything should be written and directed and produced by Indigenous people, but when you don't have that team, and

stories need to be told, it's not always so black and white. So you know we went through a process where we did a short film together, which she directed, and it was our first exposure ever to working on a drama. I mean, of course we have Zacharias Kunuk up in Nunavut, but he's 1,000 kilometres north of me. I never met him until I was going to festivals in the south. So, it's not that easy to learn.

And so my experience has been collaborating with non-native people. It's not just about good intentions, it's about the willingness to go, "Oh shit, I fucked up," and fix what they're doing and listen. And when we say this or that is not acceptable, I can't quite put into words yet what's wrong here, but it doesn't feel right, and they don't move forward until it feels right, that's the kind of relationship that I found healthy and productive, and now I'm starting to feel like I might be able to direct my own drama at some point. And this person, I've known her for nearly a decade, is training me and mentoring me until I'm ready to do so. And so, sometimes projects are not perfect, but they're absolutely a necessary step in the development of the industry.

TASHA: I want to briefly say I think that goes back to what Danis is talking about in terms of absolutely sometimes those set-ups are what's available, but then it's about the people on the team and whether the power is moving over and giving up that auteur status and realizing actually we want to work in a collaborative way, and we need to have that agency within the production. It's difficult because that's not how the industry works. People don't approach projects that way.

The vast majority of people, they're there because they pushed through, and so it's a whole other way of working. I agree there are people out there, I've had both Indigenous and non-Indigenous people bring me on their productions, and some of the non-Indigenous people absolutely gave me decision-making power and input, real input, and other times it's like, "Oh well, thank you for your thoughts and we're gonna do what we're gonna do anyway."

SHANE: Hiring an Indigenous person to be part of your project as you're hearing right now is a pain in the ass. Right? It's like, oh no, I don't really want to get into a whole thing. The filmmaking is fun—it's going to parties, it's all about the celebration of this fun time we had making this story and actors are cool and people are beautiful and it's just this

side, this desirous side of filmmaking. And I get it why somebody would tiptoe around the edges and maybe go: "Oh, I'm just gonna skip all that kind of stuff." But this passion, I think, to go back to the auteur theory, is what you want. Like, how do you not want this?

I know it's difficult because now it's like, "oh the race card," or my personal history card is gonna be on the table when we make this, and that can be frustrating for someone sitting on the other side of the table, in my experience. When you're making something, you're like: No, no, you can't do it, it has to be this way. And they're like: Well, who gives you the authority to say it has to be that way? You know, our metrics are such and such, our board says you can't say cultural genocide in the little thing that I made and so the client was: you can't say cultural genocide, and we have to coax that because was residential school cultural genocide? Let's say "it's been called cultural genocide." It's things like that, where you're just sort of like: No, it's not. But they have to engage in that fight where it's like: Do we really want to do that again? Why don't we get somebody else who's not from the community, because that's a fight we're never gonna have to have. We're never gonna have to sit in a room and have somebody on the verge of tears fighting for this piece, for this one little moment in it, which is so important.

My dad's sitting right there [in the audience at the panel], and it is so important that he feels proud of what I've done. That's the legacy, him to me, right, now my kid. So that's what I'm there in the room with. I'm not there, just like: Oh well, how much does it pay, bro? Let's do it. Yeah, it'll be a good time. It's not a good time, and that's what you want, I would think. You want this made easy, especially as these guys have pointed out. Canadian films are like: Oh well, we're gonna make 700 of these things, we're gonna make maybe five over 20 years of this particular story, so why not get the most out of it, the one that's the most affecting?

DANIS: It's amazing you bring that up, because what you're talking about is also not just the makers, but also those who are the receiving ears on the other side of pitches. I was a part of a study a couple of years back where Indigenous filmmakers all said the number one biggest challenge to getting their films made was a culture gap that they actually had to leap over in order to engage in any relationship in this industry. I once had to defend the inclusion of Cree in a short film that I was making to a broadcaster who kept telling me that it would be so much better

in English, and when I told her how important it was to have the Cree remain there, and the story was themed around cultural resurgence as well—that was the whole theme of the film—she just said: "Oh, but, you know, you are trumping a creative choice with a political argument," which is crazy because it is actually creatively stronger. The power of specificity is a very incredible thing. I said I would walk away (we only can say no). I was two weeks from shooting. I said: "No, I won't do it any other way, so sorry, goodbye." And it did get made with Cree, and then it was selected for Sundance.

So those are the kinds of arguments that we're having over and over again, and it brings me to the next question, which is: Where does the industry fit in all of this? We have been seeing and engaging in many conversations. The CMF [Canadian Media Fund] has been, along with a group of Indigenous filmmakers, championing the establishment of the first-ever Indigenous Screen Office,[8] and I want to acknowledge Marcia Nickerson, because she's been a part of leading that process forward and it's amazing.

Tasha has been a part of the group lobbying the National Film Board of Canada (NFB) and they've got different initiatives that she can talk more about. I've been a part of the group that's been lobbying Telefilm, and they have since put forward the funding of 11 new Indigenous-made feature films funded this year. That's a first. And so, we are seeing change. And I want to ask you guys if you have any more thoughts about what more could be done, or how the industry can fit in to all of this.

TASHA: I'm gonna have to work *Goonies* into the title somehow. [*laughing*] I want to briefly talk a bit about the process that happened with the NFB, and it's really started with people asking questions and being willing to listen, and I wish that it was modelled in all elements of our industry when it comes to this, such as broadcasters, funders, etc., that say: "You know what? We don't know, so please come." And then not just have us come in and put our hearts on the table, but actually recognize the value of our time, and support that as well.

There's an NFB Indigenous Advisory Council that came from that initial question: "Can you come in and talk to us?" And I'm, like, and how honest can I be, right? Because that's the reality too—we speak out about these issues, and we're also really aware that we want to continue to make films, and what we're saying might make people uncomfortable,

and there is that element to it. And so ask: How honest can I be here? And I was told you can be completely honest, and to see that being reflected in action has meant a lot to me. And I think that's really what we're asking for, is to be listened to and then for people to realize they need to make some changes and follow through.

JESSE: I think that the Canada Council for the Arts, which is the single largest arts funder in Canada (and for full disclosure, I do sit on their board), recently came out with a statement around cultural appropriation in terms of how they are going to look at any project that comes in for funding that has an Indigenous element and how that will then be critiqued and judged. It was actually a restatement of a policy that they've had for almost a year and a half now, and it should be noted it's a policy that came about because they hired a First Nations executive—Steve Loft—to run and totally reshape it, from the ground up in terms of how they fund Indigenous art there, and he's completely transformed it and contributed to this policy.

So there you go. I mean, I don't think it's actually that complicated, yet there's tons of people in this room who could be in similar, high—in what I call the "green-light"—positions in these organizations who get to say yes or no, to not just Indigenous things, but all things, and we just need more of that. I think more institutional openness is needed. In both cases, the National Film Board and Canada Council for the Arts, they were really open. Their leadership was very open to this dialogue to confronting their own history when it comes to their complicity in appropriation, if not appropriating themselves in the past, at least owning that history, and then bringing in people to move forward.

I would specifically challenge all of the Crown cultural organizations who are obligated by the nature of how their funding derives—which is entirely derived from basically Indigenous wealth, as all of Canada is derived from Indigenous wealth—to actually do this. And I think my message to all is that they need to do this. Some of them are listening and some are being very slow to listen, and I think we just need to continue to push the fact that equality and inclusion is not just on the screen, it is behind the screen; and it's not just behind the screen on set, it's behind the screen in the offices that decide who even gets to have a say, and that's what we really need to be looking for.

And I think in public cultural institutions in Canada, the time has come where we are in all of these spaces, and I think that the institutions need to understand that part of the reason they get to exist is that sense of they should be inviting us in to do this. And I think what's wonderful is that it presents a great opportunity and a moment when the nation is trying to rethink itself and move forward, and to maybe do that a little more honestly and maybe actually come to a better understanding of what sharing Turtle Island actually means, and not be as fearful about all of these changes. Because I think we are confronted by fear constantly, and realizing this "threat," that in reality we are not a threat—everyone will benefit in the end. And that is the tricky part of arguing for inclusion and equality with the overculture: they don't necessarily always see the benefit. We have to force our way in because it will benefit them too, as much as it benefits us.

DANIS: I just want to ask you one thing, Jesse, because I think some of the fear centres around the fact that if you take a stance against cultural appropriation, you're infringing on artistic freedom. And because the Canada Council [for the Arts] has taken a stance, I just wanted to get your thoughts, not necessarily on behalf of the Council, but your thoughts on the whole artistic freedom counter-argument.

JESSE: I think it's a fallacy. I think it's a conflation of several different issues, because I don't think anyone who is asking for their sovereignty is actually arguing against freedom of expression. You know, if you want to make an Indigenous project that doesn't involve any of these people, as we have seen, you can go do that. It'll suck, you know, so cool, I guess it'll be on you, and it'll then come out and we are going to kill it on Twitter and everywhere else. This isn't 1987 or 1957, so you know, as I like to say, they put my grandmother in a school. I am not in a school, I'm on national radio. People invite me everywhere to say whatever I want, so if you make a shitty movie like that, then guess what? I'm gonna say it very loudly to a very large audience, that you made a shitty movie, and those things will solve themselves.

I think it is an abstraction, an argument meant to have us argue in circles, and I think that's largely because for non-Indigenous people or non-marginalized people, they don't live cultural appropriation. It is an

abstract thought and they don't feel it. It wasn't physically something that was enacted on them that they are still living through, so they just don't get it. It's a limit. It's sadly a limit, for many, of the human ability to have empathy and understand, and granted they condition themselves this way, but that's for another debate.

But I don't actually think that's the debate we're having. And again, I think there's lots of room for collaboration and we've seen enormous successes out of true collaboration. And as Alethea said, that is fundamentally a big plus, not just for Turtle Island, but as we've seen, the development of Indigenous cinema all over the globe, collaboration was fundamental to gain skills and all of that. I think that the Canada Council [for the Arts]'s stance is not that they're all gonna say no. The stance is, well, we're gonna ask, which really, like that's what people are afraid of? I think the free expression argument honestly is a lazy argument. It's actually an argument in favour of laziness, because it's a shame many people have pointed out it might take a little more effort to do it the proper way, more effort in comparison to the way they used to do it, which is to stand still and ignore everyone.

So, it might take a little bit of effort. They just want to be lazy. What we're seeing in the media is: we used to be able to do it like this 20 years ago, and now you're telling me I can't do it like this, or you're gonna tell me if I do it like this, everyone is gonna shit on it, that's too hard on me. And I think what our response back will be, is yeah, well, that's right. You know, where is your house, like what planet are we living on?

I think when it comes to so many arguments that we see spun around cultural appropriation, it comes from a culture that doesn't understand it, that doesn't and isn't invested in it in the same way, has profited from it for decades and decades, has an abstract fear. It's not even a conscious fear of the loss of what that profit might mean, and they turn the actual debate of cultural appropriation into a profit centre.

So the journalists, there's more white journalists writing about cultural appropriation in Canada than marginalized journalists—it's a bigger thing for them. It's them, that's how there's newspapers, there's whole families, legacy journalism families who just do it over and over and over again. Their entire thing is built on this, and so they need to keep this debate going.

I think the sensible people, the people who actually make (and I was about to say make public policy, I won't include them), the sensible

people in the creative industry, well luckily we're gonna sort it out and they'll just go along. Like, with all of those voices not only do they not have a stake in the game, they don't actually really have a say in the game. Who are these people? So I think that my advice to everyone would be to just ignore them because they're pointless people who are at the end of their creative lives, and would definitely be grafting those statements out, and so don't even worry about it. And yeah, free expression is all over the place, and what we're demanding is our own free expression, which honestly has not been freed, and even if we get it now, it has cost an enormous amount to attain it. So there you go.

TASHA: Thank you, Jesse. You know, these conversations are happening, as I mentioned earlier, in lots of spaces, and academia is another, and so I just wanted to give Dana Claxton a moment here to talk about the publication [this book], because these are debates that are also happening in that space, where we've had a history and a legacy of non-Indigenous academics speaking for Indigenous people. This book, I think, is a good step in that we, as Indigenous people, can weigh in and speak about our creative expression, narrative sovereignty and otherwise. So, Dana, if you would like to, please come up.

DANA CLAXTON: Okay, I just wanted to thank everybody so much, all the panelists for that very passionate discussion. I feel like I'm ready to join the revolution and I'm invigorated! Of course cultural appropriation has, as everybody's pointed out, been going on for so long and these conversations have been going on for so long, and people have been addressing it in the industry, which I've been not really a part of, but have sort of had a big toe in, and now listening to all of your experiences.

I was revisiting my own trauma from 25 years ago, thinking, oh, my god, all of those terrible people, what they kept saying to us, such as: "No, you can't have Cree voice-over in your own language." And of course all the funding battles to have Indigenous input into how these structures work.

So, I think that one of the problems is, of course, privilege, but also this assumptive logic, and I keep thinking about that over and over again today and every day really, but the kind of assumptive logic that circulates within around the fear, and the sphere of, of colonialism in

Canada, that it's so unique. We have this beautiful amazing country that we all share, but at the same time there's this disconnect and it's this assumptive logic, I think, that Canadians, whoever Canadians are, have to rid themselves of it in terms of the structural dehumanization that we're up against.

We share a deep, deep cultural wound that I believe the arts has been healing. I believe that Indigenous arts has been healing it for a long time now, and it's still bleeding.

NOTES

1 From the documentary on Mita, directed by her son, Hepi Mita—*Merata: How Mum Decolonised the Screen* (2019).

2 Marcia Nickerson, *On-Screen Protocols and Pathways: A Media Production Guide to Working with First Nations, Métis and Inuit Communities, Cultures, Concepts and Stories* (Toronto: imagineNATIVE, 2019), https://static1.squarespace.com/static/5c4fbd9525bf024265370faf/t/5c9925a808522915fafce219/1553540532745/IN-Rapport02_Mars2018_SA_Fin_web_01+%281%29.pdf.

3 Marilyn Burgess and Maria De Rosa, *Pathways to the International Market for Indigenous Screen Content: Success Stories, Lessons Learned from Selected Jurisdictions and a Strategy for Growth* (Toronto: imagineNATIVE, 2019), https://www.efm-berlinale.de/media/pdf_word/efm/70_efm/div-incl/international-indigenous-scrren-report.pdf.

4 For further reading, see: https://canadacouncil.ca/spotlight/2020/06/indigenous-history-month-a-time-for-truth-and-action.

5 Transcript edited for clarity and length.

6 Michelle Latimer also participated on this panel, but in light of concerns and questions around the filmmaker's Indigenous claims, and the nature of this crucial discussion of Indigenous storytelling and ethics at the roundtable, we—authors and editors—have omitted Latimer's comments from the text.

7 https://www.theguardian.com/world/2017/may/13/canadian-journalists-appropriation-prize

8 https://iso-bea.ca/

Curating the North: Documentary Screening Ethics and Inuit Representation in Cinema

Ezra Winton and Alethea Arnaquq-Baril

In 2015 a Montréal festival's unwise decision to program a Québécois film that perpetuated colonial and racist stereotypes of Inuit rocked the city's and wider Canadian film and media arts communities. A protracted call-out through social media, led by Inuit artists, countered settler calls for the film to be screened, citing freedom of speech. A letter of support for the film, signed by prominent Québec artists, writers, and intellectuals, was even published in *Le Devoir*. As the chasm between Indigenous artists (with allies) and non-Indigenous artists grew ever deeper, a panel was organized at Concordia University. I was asked to host the panel, and it was one of the most emotionally charged spaces I have had the privilege to be part of. I had great difficulty maintaining my composure, in fact, as tensions in the room ran high, and differences seemed to be forever irreconcilable. It took the festival a full year to issue a formal apology for the curatorial mistake they had made in 2015, an apology that was also met with critical voices as it was made the day after (non-Indigenous) musicians invited to play at the festival refused to play—in protest of the lack of an apology or other actions to mend frayed ties. It was a year of endless debates around the film and the ethics of representation as well as curation. For those of us arguing for the film to be shuttered it was exhausting, especially for those who were Indigenous and feeling the familiar double bind of colonialism and having to educate the dominant settler society who is most privileged by colonialism's structures.

The wound was deep and I don't think it was ever healed, but in the beginning one voice rose above the din of debate with clear, cutting, and righteous argumentation. Following Alethea on Twitter and reading her posts, as well as having collaborated in the industry beforehand, provoked me to reach out to her to do an interview. When I contacted her she had indeed been pondering where to send her thoughts on the topic for publication. The interview, which was published on a now-defunct website and eventually on my own site, went viral. It has been widely read internationally, it has been taught in university classes, and it became an authoritative document on the critical side of the debate around the film (which, incidentally, while mostly halted in circulation across Canada, continues to be programmed across Europe).

The text below is the original introduction to the interview, followed by the interview itself. A few years have passed, but unfortunately it remains as relevant as ever.

Documentary festivals are certainly not immune to scandal and controversy, and this year's RIDM [Rencontres Internationales du Documentaire de Montréal], which took place in Montréal in November 2015, was no exception. Following on the heels of the festival's public screenings of Dominic Gagnon's film *of the North*, Inuit artists like Tanya Tagaq and Alethea Arnaquq-Baril took to social media to express their dismay, anger, and frustration over the inclusion of an ethically problematic film in the festival's program. The resulting fallout revealed a chasm in the industry, where limited knowledge of Indigenous peoples and cinema was met with de-contextualized defences of art and proclamations that an overly sensitive public was misguided by their limited knowledge of avant-garde filmmaking practices. As a film programmer and educator, I was compelled to speak about the controversy with filmmaker Arnaquq-Baril from her home in Iqaluit, Nunavut Territory.[1]

EZRA WINTON: Alethea, thank you for agreeing to take time for this important conversation. My first question is: How did you find out about *of the North* and what was your initial reaction to it?

ALETHEA ARNAQUQ-BARIL: A woman saw the film at RIDM and contacted me because she was upset and concerned. She had spent time in the North, and knowing that it was about Inuit I was curious and she

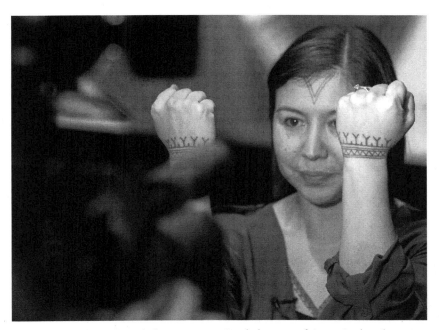

FIGURE 2.1 Filmmaker Alethea Arnaquq-Baril, director of *Angry Inuk* and *Tunniit: Retracing the Lines of Inuit Tattoos*, being interviewed by media at a February 8, 2016, Cinema Politica screening of *Tunniit* in Montréal, Québec. Photo courtesy of Emily Gan / Cinema Politica.

sent me a link to the film. So I hadn't heard anything about it until then, I had no idea this film was made or touring festivals in Canada and Europe or anything until this woman who had been North before and lived among Inuit saw it and spoke out about it.

EZRA: And you watched it and what was your initial reaction?

ALETHEA: I had a hard time finishing it, but I forced myself because I knew, pretty much right away, that I couldn't just sit quiet about it and so I had to see it. But before I'd even seen the film I had read that he [Gagnon] had never been North, had maybe never met an Inuk and that the film was just full of drunken Inuit. So, just knowing that a film like that played at RIDM was pretty upsetting to me. So I forced myself to finish watching the film and I can only say—I can't think of another way to describe my reaction except that I just felt physically ill—starting about 10 minutes into the film I was disgusted, and it just got worse

throughout. I think it hasn't been widely seen by Inuit but all of the Inuit that have seen it used these exact words: they felt physically ill.

EZRA: What was it about the images you were seeing that was causing such an intense affective or bodily reaction?

ALETHEA: To start, I think the nudity with the women really felt dangerous to me. I mean, there were just two clips but they weren't short, and talk about gratuitous, I have no idea what purpose those shots serve besides maybe stirring up some controversy or notoriety for the film, but they were just so disgustingly irresponsible to include for no justifiable reason. And seeing people that I know in the film, at their worst, having hit rock bottom, knowing that they're humans, they're fully formed people with emotions and families, and this man just treated them like anonymous nameless soulless people. Less than people really.

It was difficult to sit there and watch, I mean it's not pleasant to watch anyone who's drunk and throwing up, it's not pleasant just to watch a full minute-long clip of that no matter who the person is. But when you see it over and over again in the film I would think: another one, *really*? And, why this much? These weren't just little clips, they were often long.

It was torture to watch these things.

And throughout the film I kept thinking: it's relentless and this film isn't saying anything except this is what Inuit life is like. It seemed to me that that's what this film was saying, that this is what our society looks like, and that's not what my life looks like, it's not what my family's life looks like. I don't look around me and see that most of the time. It is portraying Inuit society as the stereotype that we've been living with for so, so long.

EZRA: And how do you respond to Gagnon's rejoinder that he wasn't making a film that was meant to be pleasant, that in fact it was meant to be difficult?

ALETHEA: Yes, I found that really condescending. The way he said it, it's like he was implying that I'd rather he just make it a happy, feel-good film and only show the good side of Inuit life, which is not at all the truth. He also spoke as if we don't understand the concept of making a film from found footage, which is also really condescending. I'm

a filmmaker—I understand that. My friend Caroline Monnet is an Indigenous filmmaker who recently made a breathtaking film called *Mobilize* using entirely found footage. She also used Tanya Tagaq's music, but she actually got permission. Maybe Dominic also makes great films from found footage, I just don't think this particular film is one of them.

And, speaking of Indigenous cinema in general, there are a lot of heavy, difficult films out there made by Indigenous people and I would argue that the vast majority of Indigenous films are difficult and facing our issues head on. He was just showing his ignorance, he didn't know. It seems to me he knows nothing about Indigenous cinema and he knows nothing about Indigenous people. That became very clear to me when I saw the film.

And hearing his comments afterwards, I'm shocked that somebody would program his film in a major festival, give it an award, and that prominent people in our industry would stand up and defend this work. I wasn't shocked that someone like him would make the film, but I *was* shocked that it could be programmed. I've never run a festival, but I suspect at least a couple of people would have had to have watched it. Then on top of that, for it to screen and win an award in Switzerland. I thought the Western world was just a little bit more knowledgeable by now, I thought we were farther along in race relations than we actually are I guess. So it was enlightening for me, and depressing, because I thought we were better than that by now.

And it made me question how people see me now.

When I travel outside of my home, I have to feel like I'm always going to be second-guessing what people are seeing in me, if they see me as a human, if they're going to be assuming I'm a drunk, are they going to be assuming that I just can't help myself, and that I have to be saved. I've always been a very optimistic person—I don't want to be miserable and cynical, and the response to this film and the support for it from important people in our industry is making it really hard for me to stay an optimistic Indigenous filmmaker.

EZRA: With that in mind, I'd like to talk about the context of support for the film. Here is part of the description in the RIDM program for *of the North*, written by Bruno Dequen, one of the top programmers at RIDM: "*The roughness of the recordings and fascinating but also unsettling*

throat singing, the film not only presents Inuit self-perceptions, but those of a filmmaker who, driven by the uncanny intensity of a people who live in a merciless environment, exacerbates the violence, culture shock and fierce beauty of a world that becomes, before his eyes, a true Interzone."

ALETHEA: "A true Interzone"?

EZRA: I'm not familiar with that phrase either. I am wondering if he means an Interzone between cultures. I find the write-up illustrative of the way the RIDM programmers perceived the film (as opposed to the filmmaker, the audiences, the people represented). What do you think about these words such as the *roughness* and *merciless environment* and *culture shock, exacerbating the violence,* etc.? It all sounds very spectacular.

ALETHEA: Yes. It makes me think of when they had Inuit in cages in New York City and Paris and all that. It's poverty porn. It's trauma porn. Let's watch these tortured people and feel better about our lives.

EZRA: But then there is Gagnon and the programmers claiming this is an exercise of self-representation/perception—that we non-Indigenous people or non-Inuit are seeing the ways in which Inuit perceive themselves, presumably because they've recorded and captured the images and uploaded them to YouTube. This is one of the central threads in their support and justification for the programming of the film.

ALETHEA: I would say the majority of the people in the film, almost every single one did not necessarily want to be on camera, they were recorded by someone else and uploaded by someone else. So to say it's self-perception is ridiculous. And to try to claim that this is how Inuit perceive ourselves is also ridiculous. We're always fighting against this stereotype.

I was looking at YouTube clips uploaded by Inuit after I watched this film, just to see how quickly a clip of a drunken Inuk came up, and I couldn't find one. I just started scrolling through clips and I couldn't find one. This guy had to really search out clips of drunken Inuit. It's as if he went searching for clips of "drunk Inuit" or "drunk Eskimo." This is a decision he made to portray us this way. He went in with his own

perception; it's not a reflection of how Inuit perceive ourselves. It's not a perception of how I see myself, that's for damn sure.

That's not to say we don't have addiction issues in our communities. We do, we talk about it a lot, we desperately need help, we desperately need funding for addiction treatment centres. We don't have capital funding, even though Inuit are crying out for it year after year after year. It's not like we want to avoid this issue and it's not like we're denying that we have addiction issues at higher levels than the rest of the country. But this film does nothing, *nothing*, to talk about the causes and possible solutions for this problem.

And it paints a picture that we are all addicted, and that's not the truth. We have higher rates of addiction because we have higher rates of trauma. But we are not all drunks, and this film makes it seem like we're all drunks.

EZRA: There are two other reactions that I've encountered from non-Indigenous people, in response to both the festival controversy around the film and to the film itself. In the context of the festival programming, I've heard several people argue that RIDM has sparked a debate and conversation, and isn't that a good thing? And isn't that what documentary is supposed to do? My response to that has been to ask: At whose cost are we having that debate? And what *is* the debate, really? The second reaction that I've heard is, from people who've seen the film and say it's very complex and very beautiful and this is just a typical PC [political correctness] reaction. What do you think about such responses?

ALETHEA: It hasn't sparked quality debate. All it's done is force us to say no we're not all drunks, and it's not right to portray us all as drunks. That's as far as the conversation has been able to go in the mainstream media. People only have so much attention for Indigenous issues. It sucks that when something like this comes up we only have two minutes of airtime, and in that two minutes, the whole moment has to be taken up with the statement: *We're not all drunks.*

I'm so fucking tired of having to take our two minutes of opportunity, of airtime, to say, "I'm not a drunk." I'm done saying that. The conversation should be deeper than that, and we're not getting the opportunity to do that when a film like this is shown.

By that logic, we should be screening films of wall-to-wall Muslim terrorists in order to spark debate on the issue of terrorism. By that logic we should be using films that portray Black people as violent criminals to talk about race. But that is not helpful, it's not the truth, it doesn't portray the people accurately. Rather it enforces really old and really ridiculous stereotypes, and the fact that I have to say that in this day and age is outrageous.

EZRA: I agree and I think saying that it's a PC reaction is linked to this idea that it's a form of censorship in a PC culture where you can't do or say anything controversial, but the discourse around that is privileging the dominant white society, and allowing them to decide the terms.

ALETHEA: Yes.

EZRA: So my reaction is: maybe it's PC with some of the white liberal folks who are morally outraged yet who haven't even seen the film, I don't know. But it's not PC when the criticism is coming from the people whose community is represented. When their reaction is one of hurt and being harmed, how can you call that a PC reaction?

ALETHEA: You know, whoever is calling the critical reaction to this film overly sensitive and PC is so utterly ignorant about life in the North. You cannot watch this film and feel that way. You can't if you have any idea what it's like to live up here, and the issues we face. Not if you're suggesting that this film has pushed boundaries and brings up a good kind of controversy.

The curators at festivals or broadcasters have a responsibility—I mean, it's their job. Films are made all the time about other cultures, and it's something that festivals have to do on a regular basis: to assess whether a film is entertaining, whether it's honest, whether it's helpful. This should be something that festivals should be thinking about with every single film that they program.

Who is the audience and who are the storytellers and do they have a right to tell the story they're telling? Do they understand the responsibility they carry? Does the storyteller understand the responsibility, and do the programmers? It's something that should always be in the front of their minds.

I was looking at that CBC article about the CBC removing the comment section on any story to do with Indigenous people until January at the earliest. It's sad that that's necessary, but I was really happy to see that they're doing that because any story that involves Inuit, the first comments are ... Well, just last night I was looking at one about the Edmonton Eskimos and the first comment was, "Why don't you just go back to your bottle of vodka." And the next comment expanded on that joke, and said, "Wait, don't you mean Lysol?" And that's what I see on a daily basis. *Daily*. So to say that this film is pushing new ground, it isn't: it's old news.

EZRA: It's not just old news, it's not a unique perspective. You can find it anywhere—as you say, in the comments section of CBC.ca, or in many other films or other artworks.

ALETHEA: It's everywhere in our country. And I thought it was just the trolls, but apparently it's our festival programmers, too.

EZRA: That brings me to my next question, from my perspective as a documentary programmer and someone interested in festival/curatorial practices. I'm working on a project around documentary screening ethics and moving the conversation beyond the consideration of the relationship between the artist and the subject, to one that considers the film in the social world and the ways in which it has an impact on cultures and with audiences. It's about the ethical implications of a film that is curated and exhibited, and realizing that it's not just the content of the film we should concern ourselves with. And so, we have documentary festivals that are predominantly run by white people, by those of us from settler culture, where programmers are not Indigenous (unless it's an Indigenous-themed festival). And there's an entire subset of the industry of non-Indigenous people making films about Indigenous culture and politics. Many of these are good, but it needs to be said that we have white people making films about Indigenous people, and then we have white people programming those films.

ALETHEA: Yes.

EZRA: I'm curious what you think about this context, about this ethics gap in the process (where we consider not just the content of the film,

but the context of film programming and exhibition). And what do you think festivals like RIDM and in particular festivals showing Indigenous works or works that portray Indigenous people could or should be doing differently?

ALETHEA: Well, I think it's helpful to be educated about Indigenous cinema first of all. And I agree, first of all, there are plenty of excellent films made about Indigenous people made by non-Indigenous people— that is possible, there are great ones out there. So by no means do I argue that only Indigenous people should make Indigenous films, and I feel that needs to be said.

As an Indigenous person, that's how I feel. Outside perspectives can be helpful. But I've also seen films about Indigenous people made by non-Indigenous people that weren't really saying anything new, or were just steeped in outsider perspective that was full of assumptions that may or may not be true or helpful, or insightful in any way. Sometimes it's like this: oh look, I got to see these exotic people and here is my experience. And as a curator of that kind of content, it's helpful to have seen a lot of Indigenous cinema to know something about it, to know whether that story's already been told a thousand times or not, whether it's saying anything important, whether it's furthering discussion, whether it's cutting-edge or way behind the times.

With regards to Dominic [Gagnon]'s film, it seems both he and programmers thought it was cutting-edge, yet to me it's way behind the times—it's ancient history; it's how people felt about us in the 1950s. So if they had any concept of what life is like, not just what life is like in the North now but what has been said about us in the past, this film would not have happened. I think it's really important for people to get educated, not just about Indigenous people but about Indigenous cinema. Dominic and the entire staff of RIDM should attend imagineNATIVE next year.

And when I first saw the film I thought who the hell did the E&O insurance, because there are prominent figures in the film who obviously didn't want to be in it, they didn't even want to be in the original YouTube clips, never mind in an internationally distributed film. And then I realized maybe this film isn't intended for broadcast and maybe he didn't have to go through the E&O process. In which case I think maybe festivals should be doing some thinking around programming films of primarily found footage whereby they should know

whether or not a film has been through the E&O process. And if the film is primarily found footage, maybe somebody should be taking a second to think: are the people in the clips willing to be in this film? Are they willing to even be in the original clips? Maybe there's an additional onus on the festival to ensure that it's not chockablock full of people who absolutely do not want to be prominently featured in a negative film.

EZRA: So you're suggesting a more pointed conversation with the film-maker about those kinds of ethical and legal implications, especially when it's something like found footage?

ALETHEA: Yes, and maybe they can still decide to take that risk, maybe the film is really important and saying something really important and they can decide to program it anyway, but they should at least be asking those questions, and I do not believe that RIDM did that in this case. I don't think it was given a thought.

And I don't think Dominic expected or wanted an Inuit to see the film. If he had, he might have proposed screening it up here. But when he was asked if an Inuit had seen the film, he said, well, they're going to see it now because of the media attention is all over it (because we— Tanya [Tagaq] and Kelly [Fraser] and I—started making complaints publicly). And that to me said that he wasn't expecting Inuit to see it or maybe hoping that we wouldn't, or he assumes that we live way off in the remote Arctic and how will we ever know, as if we don't have Facebook or Twitter.

EZRA: Maybe there's a way of making the curatorial process more just. At Cinema Politica,[2] we are often unsure about films with regards to representation because of who made the film and how a certain mar-ginalized community is represented. In those moments we reach out to our programming community consultants for advice. These are people from those particular communities, they're often filmmakers and/or activists, and they're willing to watch the films for us and then give us their take. That helps us in the decision-making process enormously. So I'm wondering if you think that festivals could or should be doing some-thing similar?

ALETHEA: Yes, well, I would hope that if they're a larger festival with a large number of staff, that some of that staff might be from another

culture other than the dominant cultures. It's good to have a filter or per-spective, someone who is a visible minority or someone from a different culture or who even speaks a different language, who can bring another view and provide that most basic filter. And that's extremely valuable when your business or organization is showcasing cultural content from around the world—that's a very basic step that can be taken. But also, when something is questionable or asking tough questions or repre-senting a very marginalized people, then yes, at the very least, Dominic or RIDM or whoever could've just said, hey, maybe we should show this film to an Inuk and see what they think. That is a very easy thing to do. So yes, I absolutely think that that would be a very good practice to implement across the industry.

EZRA: It seems like the festival feels that what they just needed to do was have a better screening context in which maybe Indigenous/Inuit people were invited to speak about the film, or something of the sort. I'm wondering if for you that solves the issue of this film being a stereo-typical or racist representation of the Inuit? Would steps like that have done anything to help?

ALETHEA: Yes. I think the value in that is creating dialogue, discussion, debate around the difficult issues we face. And so I find that it was a very questionable decision to screen it and to not ensure there were some Inuit there or at least invited.

But that's beside the point with this film. They completely missed the point with that comment [RIDM's public statement about the hand-ling of the screening of the film]. Yes, you need to think about how you screen a film, and if it's difficult material that brings up issues that need to be discussed, then yes, you need to make that happen, and you need to consider how you present it. But you also need to consider the film itself and RIDM truly doesn't get why this film is so reckless and dam-aging. Their statement, like the film, shows a wilful ignorance and a lack of humility. Rather than consider the possibility that they might have made a mistake, they assume that these Inuit aren't sophisticated enough to understand art at this level.

You know, it's not just the fact that it's chock-full of shots of drunken Inuit, that's not the only thing. It's also the way that industry and develop-ment is presented, and the destructive resource extraction industry, the

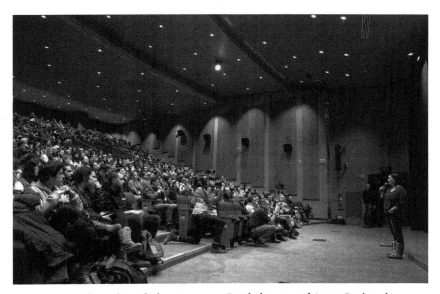

FIGURE 2.2 Filmmaker Alethea Arnaquq-Baril, director of *Angry Inuk* and *Tunniit: Retracing the Lines of Inuit Tattoos*, addresses the audience at a February 8, 2016, Cinema Politica screening of *Tunniit* in Montréal, Québec. Photo courtesy of Emily Gan / Cinema Politica.

way that's portrayed in the film, juxtaposed with what seems to be an Inuit society disintegrating and falling in on itself. The way all of that is cut together, it just feels like the film is saying: look what we're doing, we're just sending these huge faceless corporations up there to extract the wealth, meanwhile we don't give a shit about the people and they're just imploding and disintegrating and why aren't we helping them?

I suspect it's that perceived message that makes the film "beautiful" to some. My guess is that this is the good intention behind the film— Dominic won't explain himself, so I have to guess. I can't imagine why otherwise anyone would think this film is worthwhile, other than suggesting "we should be doing something more for these people."

But I need to explain why this portrayal is so damaging. It's showing a part of Inuit society that is really struggling, portraying it as if that state of things is the way most of society is up here. That's damaging. But also, what I find really irresponsible is presenting our situation as though we've fallen in on ourselves without the help of outsiders. It's saying to me that the role of the rest of Canada in our destruction has been a passive one. It's been one where the damage is incidental: we're

just casualties of development and that without having our hand held, we fall apart and kill ourselves with alcohol.

It takes the responsibility and the history away. Our state of trauma and dysfunction is not a result of being saved or not being saved. It is the result of active destruction by the Canadian government and the Canadian people.

It's as if this film is completely ignoring the fact that we were under attack for decades, a century almost, that there was decisive action meant to wipe us off the face of the planet, trying to kill our culture and assimilate our people and hope that we would integrate and disappear eventually. And this was a conscious decision by the Canadian government and the church that was supported by the Canadian people, and there was wave upon wave of these attacks. These were calculated, purposeful acts of destruction against our people.

And it was not passive, it wasn't incidental, it wasn't accidental, it was a decisive action. And this film makes it feel accidental. And to me that's the most damaging aspect of the film: for our society as a whole.

Now, concerning the individuals in the film, obviously including them without their permission, that's the most damaging for them as individuals. But as a society, as a culture, as a people, in my opinion the most damaging thing is presenting us as if we're helpless and need to have our hands held. And it's a very patronizing view to suggest that it's just industry coming up here without doing anything to save us—that that's the cause of our destruction. When really, it was so much more active than that. I rambled a bit there ...

EZRA: No, it's good. It's about agency and it's also about placating responsibility. It's easier for southerners to think that the North is so broken and the people so broken, the culture so dysfunctional because there are rapacious corporations doing the things that they're doing up there without regard for the people, and that this is the cause of their troubles. And you're right, that evacuates the history and the historical context of colonization and racism by the Canadian government, and with Canadian people supporting it in the south. So I think it's an excellent point.

ALETHEA: They don't want to think that they're culpable in our demise, because they're not the ones who made these harmful decisions. It's still difficult to think that your parents or grandparents or your

ancestors were culpable, that they took part in these decisions and supported them and viewed Inuit as less than human. People don't want to admit that their own families and their ancestors were part of that. And it's understandable; it's a difficult thing to face. Being part Inuk and part French Canadian, I struggle with that internally.

But we need to face it, as a country. And by ignoring that history and denying that your families were a part of that destruction it just continues that trauma, and maybe it's less direct and less actively destructive. Denying its existence and its importance, the importance of recognizing what happened, *today*, is its own violence. Because when people don't know this history, they can't fully understand why we are struggling the way we are. It doesn't make sense, so they think we must be inferior in some way. This film is unconsciously teaching its viewers that Inuit are inferior.

EZRA: I agree. In my film classes we've discussed the notion of burden of representation, with regards to path-breaking filmmakers from marginalized, mis- and underrepresented communities (for example the first Black Canadian to make a feature fiction film). The burden of representation is about the pressures put on these artists to speak for, and accurately and fairly represent their communities. And I sense that this burden of representation has shifted to a kind of burden of interpretation, where settler society and white Canadians make films like *of the North* that are in turn programmed by white institutions, and then the community represented and harmed by the dissemination of these films then have the burden to interpret those representations and to educate the dominant society. And so you hear, for example, African Americans who say, Why do we have to constantly educate white America about stereotypes and race and racism?

And here in Canada there's so far to go: my students say they've learned nothing about Indigenous history, people, and culture in high school, that they're *still* only learning about the fur trade, much like when I was in high school decades ago. So I'm wondering if you could talk about this burden of interpretation and education, the ways in which you, Tanya Tagaq, and other Indigenous and Inuit people have been super engaged in since this RIDM fiasco happened.

ALETHEA: Yes, I mean, we're expected to be experts on everything. For instance, I'm a documentary filmmaker so I feel like it's my job to think

about my society, its place in our country, the state of my culture and my people and the issues we face, so I'm in that headspace already anyway. But someone like Tanya Tagaq who's a vocal artist, she should not have to be an expert on filmmaking and what working with found footage means, etc. And you know, she shouldn't have to be a warrior on behalf of our entire people all the time. She does it, thank goodness for her and her willingness to do that, because she has the platform to do it. People listen when she speaks, so it's wonderful that she does, but it sucks that she has to. It's unfair and it sucks. And until we have Indigenous issues and history and culture taught in all the schools from preschool on, it won't change.

It is great to see what's happening out west now, there are a couple of universities that are putting in mandatory Indigenous studies courses, which is wonderful to see. I hope that happens across the board from preschool through to post-grad studies.

Until we have that, then I have to be pretty well versed on just about anything I can think of, and when something comes up in the news that feels unfair, that doesn't feel right, I have to scurry and read as much as I can about it and find academic articles coming from other Indigenous people's perspectives or from other people of colour—I have to look that up as quick as I can. We don't already have those discussions written down from Inuit society, I learn and borrow from other marginalized peoples and study up on it, the terminology used and schools of thought, and it's extremely helpful to be able to do that. But that's just the way life is and I hope that as the school systems change—and I think they are changing gradually—then hopefully that burden will be less for my son than it is for me.

EZRA: Yes, because it must be exhausting, among other things.

ALETHEA: It is. I talk with Tanya [Tagaq] a lot by Facebook messenger and there are times when we're both so emotionally drained and just want to have the energy at the end of the day to play with our children and be there for them—to be emotionally available for them. And sometimes you're just so fragile and emotionally raw at the end of the day, it's exhausting. Some days are more intense than others, and I feel so sorry that she has had to go through this lately.

Personally, I'm a filmmaker and this is what I love to do. I do love to think about our society and how we can further equality and help people

live peaceful lives in our country and enjoy our lives, that's what I like to do. I just don't like to have to go back 50 years, you know? I don't like to have to bring the conversation back to the level that it was at 50 years ago, that's what's frustrating. Because I enjoy debating *today's* issues.

EZRA: Well, I'm thankful that you do take that burden on and that you do it passionately and thoughtfully. I have a lot of respect and appreciation for that role that you play outside of your role as an artist. So thank you for that.

ALETHEA: I think it's really cool what you're doing, not just within Cinema Politica—that's one thing to do that ethically, the way that Cinema Politica is doing things—but to further the discussion in the whole industry and seeing what we can do there. I was trying to figure a way to ensure this discussion happens, that this discussion is bigger than just this one film, and I didn't know how to do that or who to talk to, so I'm thankful that you're doing this.

EZRA: I'm a film programmer but I'm also now working as an educator and I think so much comes together around that space. It's very telling that my students have identified that education around Indigenous issues and culture (including cinema) must happen in high school.

ALETHEA: Yes.

EZRA: So they know, everyone knows. It's how to affect policy change and I think the way it starts is from talking to amazing people like you and Tanya Tagaq and others who are really pushing the discussion so that eventually policymakers can't ignore it. That's my hopeful bit in all this. Anything else you'd like to add?

ALETHEA: I was just going to say that last night when I was on some article about the Edmonton Eskimos, one of the comments about Inuit being drunks was from a 12-year-old boy. And I thought, okay, this is why that film was such bullshit. It's perpetuating that view, and presenting Inuit as drunks doesn't say anything new because there's a 12-year-old child in Alberta who thinks all Inuit are drunks. That says a lot I think, it says a lot about how Inuit are viewed by the rest of our country and for Gagnon to just perpetuate that is so frustrating.

EZRA: I think the very depressing and quite devastating fact that CBC has to turn off its comments section on Indigenous articles speaks volumes about the kind of "debate" that this film is contributing to. It seems rather that it's serving in one way as a vehicle to coalesce racist and stereotypical articulations in a bolder fashion because these days there are multiple platforms—including CBC.ca. There's a long way to go, basically.

ALETHEA: Yes, I used to think that overt racism toward Indigenous people in Canada was the last socially acceptable form of racism, you know? Where we were the last ethnic group that you can be so openly racist against. And then the whole Niqab debate came around and I thought, okay, we're not the only ones, there's the Muslims, too— you're allowed to bash them as well publicly without losing your job or whatever.

EZRA: I thought that was changing, and things like this remind me that I live in a bubble within progressive communities, with activists, with documentary filmmakers who are doing good work. And then this RIDM/*of the North* thing happens and I realize, okay, no, this is apparently still acceptable and reinforced.

ALETHEA: That's exactly how I felt, like it opened my eyes to how much of a bubble I live in as well. Because I live up here so it's its own little bubble. But I travel a lot, almost always for documentary film–related reasons, and therefore I'm usually encountering very socially conscious people. And I didn't realize how insulated I am from all that stuff. And this film, dealing with this film and discussion around the film, really snatched the blanket off me. I felt suddenly very exposed and raw. It feels like I've always been in a cage or zoo and I didn't realize it until now. It was like pulling off a sheet and then suddenly realizing, oh my god, I've been in a zoo this whole time, I had no idea. I was actually thinking we were beyond that, and well, we aren't.

EZRA: If we can say anything good comes out of this, I hope it's that that awareness is transformed into action with Indigenous and non-Indigenous artists and activists who are working against the root causes of what makes you feel this way.

ALETHEA: Yes. For me it felt like we went back in time, but really of course we're moving forward because that person [Gagnon] has always existed and the state of race relations in Canada is what it is. I may have perceived it to be better than it was, but that's how it was. And this conversation is moving things forward, and integrating Indigenous issues into our education system will move things forward. And asking curators to consider Indigenous issues is moving things forward. So, yes, things are moving forward, I just thought we were further along than we actually are. That's all.

EZRA: Alethea, thank you so much for spending time talking about this.

ALETHEA: Thank you.

NOTES

1 This interview has been edited for clarity and length.
2 Cinema Politica is a Montréal-based non-profit film screening and distribution organization co-founded by Winton and Svetla Turnin in 2003.

Sights of Homecoming: Locating Restorative Sites of Passage in Zacharias Kunuk's Festival Performance of *Angirattut*

Claudia Sicondolfo

"For the colonizer, to be human is to speak *his* language."
—Ella Shohat and Robert Stam (2006, 129, original italics)

"It galls us that Western researchers and intellectuals can assume to know all that it is possible to know of us, on the basis of their brief encounters with some of us."
—Linda Tuhiwai Smith (2012, 1)

A FILM FESTIVAL PROPOSAL; AN ESSAY PROPOSITION

In the spring of 2015, Zacharias Kunuk, Inuk director, producer, and co-founder of Igloolik Isuma Productions, Canada's first Inuit-owned production company,[1] wrote to the imagineNATIVE Film + Media Arts Festival, the world's largest international Indigenous film festival.[2] Kunuk had a proposal for imagineNATIVE: he wanted the opportunity to screen his newest film, *Angirattut (Coming Home)*, in its original Inuktitut and without English subtitles.[3] Daniel Northway-Frank, imagineNATIVE's former manager, Festival Initiatives, explains that Kunuk's proposal wanted *Angirattut* to reach its first public audience without reinterpretation, "as truthfully as possible."[4] Prior to going ahead with Kunuk's proposal, some of imagineNATIVE's non-Inuktitut-speaking staff watched *Angirattut* both with and without

subtitles. Northway-Frank—who is non-Indigenous—tells me he was compelled by the regulatory knowledge process he experienced as he switched between versions. He describes the weight of his viewing process, noting the always present tension of unfamiliarity and his constant negotiation of both wanting to know what was being said and "feeling okay" with not knowing. Understanding that *Angirattut* was the right film and Kunuk was the "right" filmmaker, imagineNATIVE programmed *Angirattut* according to Kunuk's proposal.

Kunuk's prioritization of the Inuktitut language, oral tradition, and Inuit culture is well-documented,[5] cementing his long-standing career as a storytelling sovereigntist. While, Isuma, for one, translates to "thought" in Inuktitut, Kunuk maintains it refers to far more than cognitive activity: "to the currents of the personal soul, and it carries intonations of wisdom, insight, and history" (2008, 20). Kunuk's most well-known film, *Atanarjuat: The Fast Runner* (2001)—the first written, directed, and produced Inuktitut-language film—was lauded with international praise, and was notably awarded the Caméra d'Or in 2001 for Best First Feature Film at Cannes. Kunuk famously delivered his Cannes acceptance speech entirely in Inuktitut.[6] Northway-Frank's trust in Isuma to deliver a film experience that engages with Inuit narrative sovereignty—with wisdom, insight, and history—through cinematic languaging[7] and orality excited imagineNATIVE, particularly for encouraging future exploratory and non-traditional festival programming.

Northway-Frank and I are both "Qallunaat" (pronounced KHAD-loon-at), non-Inuit people.[8] More specifically, I am a Qallunaak settler scholar and film festival–goer. As I am committed to applying decolonizing methodologies in my writing and teaching, I acknowledge the responsibilities of my role to be both thinker and listener; teacher and learner. In this chapter I commit to re-engaging with my attendance of this collaborative programming intervention between imagineNATIVE and Isuma[9] in order to situate *Angirattut*'s film festival programming as performance.[10] I argue that in this festival screening of *Angirattut*, long-standing and familiar film festival sites, sights, and cites—what film festival scholar Marijke de Valck calls "sites of passage" (2007, 13)—are challenged. I explore how film festival "sites of passage" have come to commonly define the film festival–going experience, and how they are confronted through the relational-spectatorial experience of witnessing. The ephemera of this unique film festival performance

expose the often-concealed mediations of film festival going by de-centring ritualized and colonial sites of cultural legitimization, language, and translation for non-Inuktitut-speaking and settler festival audiences, in which I include myself.

As I situate Kunuk's performance within film festival scholarship, translation, and performance theory and engage with, what I term, his decolonizing act of film festival monolingualism, I subsequently facilitate an act of scholarly translation. In turn, I position this chapter as a methodological challenge to myself, the "outsider" settler film festival scholar, and to subsequent cinema and media film festival and translation settler-researchers. I turn to teachers and scholars Dylan Robinson and Keavy Martin, who have argued for the need to create scholarship that thinks about research differently than the pursuit of "interesting data" (2016, 4), calling for all settler scholars of Indigenous media aesthetics to keep decolonization at the forefront through reciprocity and critical thinking (2016, 5). Thus, I confront the knowledge presented within this academic text through my own positionality as researcher, as teacher, as learner, and as an audience member.

A note on methodology before proceeding, as it is undeniable that engaging with autoethnography in scholarship can quickly turn solipsistic. With an acknowledged emphasis on self, autoethnography can function "as a way of controlling self-interests through their exposure" (Freeman 2015, 30). Jones, Adams, and Ellis (2013) have distinguished specific characteristics of critical autoethnography from other types of personal writing, including the attempt to create a reciprocal relationship with audiences to compel a response,[11] a task I take seriously as a settler scholar residing on the ongoing colonized territories of what is now known as "Canada."

When I engage with autoethnography, I aim not to re-centre my individual "enlightened" knowing-self—the otherwise differentiating worldview of the ongoing Euro-American knowledge creation project.[12] Rather, as Linda Tuhiwai Smith has importantly taught us, there are specific factors that must be built into decolonizing work: "to be thought about reflexively, to be declared openly as part of the research design, to be discussed as part of the final results of a study and to be disseminated back to [communities] in culturally appropriate ways and in a language that can be understood" (2012, 16). This chapter acknowledges my responsibility in decolonizing knowledge transfers by accounting for my own act of reception[13] as a witnessing subject of an event and work of

Indigenous—and more specifically, Inuit—art. I cannot discuss the act of performative film festival reception without accounting for my own positionality, as Qallunaak and as a southern, non-Inuktitut-speaking person. In thinking about the relationship between Kunuk's refusal of translation and this, my own scholarly re-translation, I invoke a provocation by theorist Rey Chow, who recasts translation as language differentiation. Rather than thinking about translation through the lens of an overarching, authentic colonial original (2014, 33),[14] Chow positions translation not in origin, but as passages between sovereign bodies.[15] I consider this festival performance as historically and geographically relational—a political commentary on the colonizing interactions common in cinematic translations, language politicking, film festival programming, and audience encounters.

SITES: ARCHITECTURES OF THE FILM FESTIVAL ENCOUNTER

In an iconic article, Bill Nichols attributes the lure of the film festival circuit to the viewer's encounter with "foreign cinema," "like the anthropological fieldworker, or, more casually, the tourist" (1994, 17). It is worth quoting Nichols's film festival spectatorial account at length:

> We are also invited to submerge ourselves in an experience of difference, entering strange worlds, hearing unfamiliar languages, witnessing unusual styles. The emphasis, in a climate of festivity, is not solely on edification but also on the experience of the new and unexpected itself. An encounter with the unfamiliar, the experience of something strange, the discovery of new voices and visions serve as a major incitement for the festival-goer. Cinema, with its distinctly dream-like state of reception, induces a vivid but imaginary mode of participatory observation. The possibility of losing oneself, of temporarily "going native" in the confines of a movie theater, offers its own compelling fascination. (17)

Written in 1994, prior to the formation of the field of film festival studies, Nichols's tourist festival-goer finds pleasure in the brief unknowable encounter with the so-called "foreign."

"Going native" aside, Nichols's embarrassingly colonial statements call for a fetishistic spectatorial affect of wonderment. His account also glosses over important historical contexts that previously took

place in transnational film festivals prior to the 1990s. Historian Elena Razlogova (2015) rightfully claims that film festival scholarship rarely accounts for the multiple occurrences of live or simultaneous translation that occurred in non-Western film festivals and that complicate colonial encounters of translation. While Razlogova's scholarship predominantly focuses on Soviet film festivals during the Cold War, her historical salvaging of live and simultaneous film festival translation shifts the "entire global festival network without placing major West European festivals at the center" (Razlogova 2015, 71). Her research demonstrates, for example, how the absence of a subtitle requirement at some Soviet film festivals provided opportunities for Majority World filmmakers to participate in international film festivals. While these films may have been rejected by Cannes or Venice because they could not afford subtitles, transnational exchanges with international cinematic audiences outside of the global hegemonic circuit still remained possible due to alternative exhibition models.

Razlogova's research also points toward decolonizing possibilities in thinking about film festival spectatorship through audience engagement interventions such as liveness. One of the many ways imagineNATIVE engages its audiences, for example, is through programming that exposes the performative actions of film festival spectatorship, exhibition, and curation. This is an active—or live—spectatorial process between festival and audience that Davinia Thornley (2017) calls "collaborative curatorship." Thinking through live performance, mediation processes of cultural knowledge transfers within the colonized Americas become apparent. "Part of what performance and performance studies allow us to do," as Diana Taylor's work teaches us, "is take seriously the repertoire of embodied practices as an important system of knowing and transmitting knowledge" (2003, 26). As performance-based "acts of transfer" canonize themselves as repertoire (Taylor 2003, 2), embodied knowledge transfers resist anthropological documentations of pastness, positioning themselves as vibrant, ongoing lived experiences.

On October 16 at 10:30 a.m., imagineNATIVE and Isuma co-curated a performance-based act of transfer for a film festival audience in Toronto, filled mostly with non-Inuktitut speakers, by programming *Angirattut*, a 90-minute documentary about a group of Elders who return to their home site, Siugarjuk,[16] after being relocated to southern

settlements some five decades ago. The press release of the film (2015) states that "through this homecoming journey, [the Elders] remember their past and the pain of relocation."[17] In one of the longest sequences of the film, beginning around the 28:30 mark,[18] the Elders take turns sharing testimony in an oral exchange lasting for over 30 minutes. A later sequence shows some of these Elders performing ceremony at a gravesite. Kunuk tells me this is his grandfather's gravesite, finally located following a 50-year familial search.

For these 30 minutes, without subtitles, dubbing, or any form of oral translation, viewers are asked to listen, to watch mindfully, and to bear witness along with Elders, their children, and grandchildren. The testimony shared by the Inuit Elders is heard exclusively by Inuktitut-speaking kin both on- and off-screen, permitting the sanctity of private ceremony despite its exhibition on a large screen, in a packed Toronto cinema. In our Truth and Reconciliation era of public testimony, this sequence resists the all-too-facile reduction of Indigenous trauma as spectacle.[19] As rejection of a theatrical state-sanctioned reconciliation narrative, this sequence calls for spectatorial self-reflection regarding the responsibility of bearing witness. It also acts as a form of settler exclusion. Settler scholar David Gaertner (quoting Paulette Regan) would call this act a profound disruption to the colonial status quo. Gaertner asserts that settlers who are committed to ethical witnessing and to good academic practice must acknowledge that

> some knowledge is off-limits ... no one is welcome everywhere. Recognizing one's boundaries is in itself an academic gesture: it facilitates the growth and rigour of knowledge and opens up stronger lines of communication *across* communities. ... In naming ourselves, and thus our status as guests, we also acknowledge the existence of borders and the hosts' rights to open or close them. (Gaertner 2016, 152, original italics)

As Kunuk invites those of us who are settler audience members to become guests for this intimate historical exchange, we are simultaneously asked to respectfully hold our positions as guests. He subsequently creates a film festival encounter that immediately confronts the Euro-American-centric and commodifiable possession of differentiation.

Surprisingly, while much scholarship has theorized the ephemera of film festival experiences,[20] few perspectives have engaged with the potential act of transfer located within the spectatorial encounter of the film festival performance.[21] Perhaps even more surprisingly—as a discipline that often thinks phenomenologically—film studies owns a glaring absence for thinking through audience co-presence in public screenings. This is an argument recently made in Julian Hanich's 2018 book, *The Audience Effect*, which historicizes reception from the "viewer to *viewer*" collective cinematic experience instead of the more commonly used spectatorial framework of viewer to film (7, original italics).[22] Ezra Winton and Svetla Turnin (2017) have also emphasized the political potentials of the coming together of communities and bodies within film festival spaces in what they describe as "affective architectures" (88). For Winton and Turnin, screening a political documentary is not necessarily a political act in and of itself. These screenings must be built as "affective architectures"—spaces that encourage embodied and active responses to festival programming through tactics such as elongated Q&A periods and co-curation with community panelists and organizers, and thus are staged as social events with direct connections to the (nearby) "outside" world. Affective (architectural) programming encourages festival-goers to encounter themselves, each other, and ultimately larger socio-political circumstances outside of the film festival space. Winton and Turnin encourage us to think about film festival architectures beyond static infrastructure. Through the design of affective film festival encounters, festival-goers become contributing members of body politics with "the potential to translate personal experiential impact to social impact" (Winton and Turnin 2017, 88).

Prior to attending this screening of *Angirattut*, I can confidently say I was not prepared for the emotive challenge that would present itself to me through the affective architecture of this program. I consider myself a seasoned film festival–goer (my body is now intimately familiar with the lack of sleep, bad food, piles of laundry and dishes as well as neglected family members during festival time). I am also a determined admirer of Kunuk's work (I will openly acknowledge the sheer joy and honour I felt in sharing multiple conversations with him over the years of working through the ideas that have manifested as this chapter). So, upon seeing Kunuk's name attached to a world premiere screening of

his newest film, I didn't feel the need to read any program notes. I simply committed to arriving on time for a 10:30 a.m. screening on a Friday morning. I had no prior awareness of the contextualizing notes in the festival's catalogue stating, "This film, in Inuktitut, is presented intentionally without English subtitles and creates a remarkable cinematic experience where non-Inuktitut speakers become beautifully embedded in the Inuit language and landscape" (imagineNATIVE 2015, 69). Thus, when one of the festival's programmers issued an introductory caveat, I was surprised. This opening statement was not issued as a typical "trigger warning," as we have come to understand them in our classrooms, but rather as an invitation for anyone not comfortable with watching the film without subtitles to leave.

The programmer also encouraged everyone to stay for a post-screening discussion to discuss their experience of the screening, but surprisingly not with Kunuk or any other Isuma representatives. The post-screening session would be facilitated by Northway-Frank. There would be no specialists or filmmakers on stage. No one left following this announcement (had others been more prepared than I was?), but a handful of bodies trickled out throughout the film (a common sight at film festivals, subtitling, or lack of, aside).

It was not until this introductory caveat that I became aware of my unconscious film festival–going habits. My choices to not read the program notes, for moving in brief and quick strides from event to screening to panel and late-night sleep to social gathering had helped embolden a form of shallow festival-going, made visible through the architectural transfer of this programming encounter. imagineNATIVE and Kunuk had successfully caught me by surprise by calling out my festival-going knowledge bluff. This programming act had interrupted my own unconscious festival "site of passage" (de Valck 2007, 13). A substantial focus of de Valck's canonical festival studies book *Film Festivals: From European Geopolitics to Global Cinephelia* is dedicated to theorizing the industrial network that names and sustains the blurry barrage of "unknown and incomprehensible" phenomenological festival encounters. A consensual process of repetition, "a site of passage" produces festival knowledge, unified by sights (performances, presence of stars, events) and citations (mandates, agendas, references to events). For de Valck, these practised rites function as "gateways to cultural legitimization" (de Valck 2007, 38) within the film festival circuit—a network in

which global cinematic production, exhibition, and distribution industries have now come to depend upon.

De Valck's theory remains useful in this chapter, not necessarily in thinking about how circuits or networks of film festivals form, but rather, in thinking about how festival engagements are canonized by transnational cinema-going audiences. De Valck documents, for example, how the filmic encounter with the non-(Western-)European "Other" has become institutionalized as "the foreign" across European transnational film festivals from the 1960s and onwards. A large part of this legitimization process occurs on the level of performative programming, as "films could be (and were) claimed as 'discoveries' and 'national cinemas' by the festival programmers (competing with other festivals on the circuit)" (de Valck 2007, 71). In other words, Majority World–produced films were forced to compete within Eurocentric film festivals, far away from their regional festivals and audiences. De Valck calls this legitimization process a form of cinematic colonialism "replaced by new forms of domination that, instead, operated globally and under the guise of open (fair) competition" (2007, 71). This is a process that has not only colonized the habituation of film festival programming and exhibition, but also sights of spectatorial engagement, and more importantly, the storytelling, exhibition, and performance choices for stories and films by Majority World and all filmmakers from colonized territories.

My initial "refusal," thus, to skim over the program notes is predicated upon my own habituated legitimization—of *not* feeling the need to engage further with the program book beyond its citation of Kunuk's name, a now canonized transnational film festival insider. While de Valck helps us understand "the festival circuit as a series of related events ... as a network" (2007, 17), this act of co-programming by Kunuk and imagineNATIVE resituates knowledge through reference points that exist within this singular film festival event—not "out there" in an abstracted global festival circuit. This programming is a call to action, an "affective architectural" (Winton and Turnin 2017, 88) programming design that confronts decades of institutionalized "foreign film" festival exhibition. The encounters with these historical lineages and geographical specificities entangle our bodies, our cognitive impulses, and the social positions we hold outside of the cinema in direct relation with the event of *Angirattut*'s world premiere screening.

CITES: SUBTITLING AND THE FOREIGN

Unquestionably, *Angirattut*'s imagineNATIVE screening engages directly with the colonial legacies of the "foreign" in cinematic exhibition. This section underscores the additional potentials for translating this personal encounter into social impact, demonstrating how both the citational and filmic architectures of the screening politicize the act of non-subtitling. These architectures create what I call a performance of cinematic monolinguality. Debates addressing the effectiveness or "abusiveness"[23] of translation through subtitling and/or dubbing have raged passionately (albeit intermittently) since the late 1990s within cinema studies scholarship.[24] John Mowitt has notably argued "foreignness" and "bilingualism" in cinematic exhibition and distribution is "far from simply relative" (2005, 45). His work demonstrates how Western cinema has constructed foreignness through "bilingual" standardization, primarily through instituted nationalistic subtitling requirements from organizations like the Academy of Motion Picture Arts and Sciences (more colloquially known as the Oscars) for the award for "Best Foreign Language Film" in the 1940s.[25] This instituted cinematic "bilingualism," often communicated through the subtitle, has come to construct colonial spectatorial differentiation, whereby "*audible* foreignness [is] fetishistic and objectifying" (Dwyer 2017, 74). As Tessa Dwyer has explained through Mowitt, "cultural difference" is turned into an "exotic sound effect" (2005, 74), an aesthetic object defined through language.

The subtitle, it is argued, acts as a central semiotic segue for the settler-colonial narrative of inclusivity, multiculturalism, and diversity. This is a process by which Abé Markus Nornes vehemently argues is a form of textual violence—manifesting through either corrupt or abusive tactics that smooth over and "domesticate all otherness while [pretending] to bring the audience to an experience of the foreign" (1999, 18). Following Nornes, Mark Betz has more recently argued that the subtitle has historically come to claim a seamless ability to provide an uninterrupted viewing experience of international cinema. Its semiotic domestication has subsequently reinforced superiority claims for the international export of European art cinema as a pure and authentic national cultural resource (Betz 2009, 50).

While these interventions have been imperative for opening up new research avenues within cinema and media studies[26] related to the erasure of cultures, identities, and languages within translative

encounters, they rarely account for the scholar's responsibilities within the act of translation.[27] Arguably, my act of scholarly re-translation operates within the same colonial structures of knowledge circulation that Kunuk and imagineNATIVE confront in their programming choices. As a settler scholar and Qallunaak film festival audience member, this screening challenges me to engage in what Masha Salazkina calls a translative contact zone (2016, 29). Operating as a "contact zone" between regional forms of knowledge and the political economy of global cinematic exhibition, the translative encounter between myself, Kunuk, other audience members, and readers of this chapter has the potential to operate as a moment of insubordination instead of as a policing mechanism.

Throughout our conversations from 2016 to 2018, Kunuk recounts many stories of his childhood encounters with cinema. He sees cinema as a form of artmaking closely aligned with Inuit oral tradition where "nothing is written down." He speaks of his youth, recalling how excited his Elders would become when movie reels came to Igloolik: "they would sometimes leave a hunt early just to catch them." However, the reels always arrived without Inuktitut subtitles and the community "did not understand a word of English. They would just talk over the films in Inuktitut to each other." Kunuk tells me he wanted to reciprocate this communal experience for his Elders and his community members and did not want his Inuit audience to be faced with written language. His intervention originates in his shared encounters with cinematic exhibition. Kunuk's memories gesture toward the performance of screen translation, underscoring the always ongoing performative mediation with language encounters Inuit audiences have faced across histories and geographies. The lived enactment of this memory stages possibilities for exhibiting cinematic languaging through ongoing meditative exchanges between peoples and communities, rather than as stark linear transfers between objectifiable and originating difference points.

Kunuk's act of Inuit narrative sovereignty, entrenched in traditional Inuit storytelling as knowledge transfer (Igloliorte 2016), is a political action that imbues written theory with lived oral history. It stridently announces the vital connections between Inuktitut language preservation and Inuit narrative, cultural, and geopolitical sovereignty. In one of our conversations, Kunuk states he wanted the opportunity for the Elders to tell their own "good old stories." He continues: "We've been

FIGURE 3.1 A rare wide-angle shot of the knowledge transfers, through oral storytelling circles featured prominently in *Angirattut*. Video grabs from *Angirattut* (2014), courtesy Isuma.

putting subtitles on films for 30 years. We wanted the audience to look at the pictures, to realize what's really happening. So there are some Elders looking here and there, some kids fishing at the shore, Elders preparing food, mainly joking around and talking about when they lived there and how it looked in the winter." As the Elders return to Siugarjurk, spectatorial emphasis is placed on acts of witnessing. Elders take turns sharing stories. At times we are shown some of the Elders crying. We are shown the newer generations—the youth—listening, and waiting for—as Kunuk tells me—"all of the good food" to be doled out. The camera is almost always positioned tightly within the various sharing circles, resting closely alongside bodies and faces. This intimate camera work reveals the boom recorder, hovering momentarily over the orators, steadily working to transmit this aural ceremonial transfer of witnessing to Inuit storytelling circles outside of Siugarjuk.

Kunuk's orality, then, cites not from a position of difference toward settler or Qallunaat audiences, but rather insists on the direct experience of Inuit knowledge transfers, as embodied and lived across temporalities of experiences. These Inuit bodies gather to share space and living memory. Peter Morin, Tahltan Nation professor, artist, and curator, might call these healing acts of transfer performances of the

FIGURE 3.2 The resonant chamber of oral storytelling in *Angirattut*, unbashfully featuring the boom mic. Video grabs from *Angirattut* (2014), courtesy Isuma.

memory of the land. For Morin, the Indigenous body holds knowledge. It is "a resonant chamber, a place for the articulation and amplification of many experiences. Colonization has interrupted this resonance. It has interrupted indigenous knowledge production and history" (Morin 2016, 71). Kunuk's refusal to translate re-accords bodily knowledge transfer with Inuit orality, a knowledge transfer process otherwise violently denied to his family and community due to forced colonial languaging, assimilation, and relocation. Moreover, with *Angirattut*'s minimal post-production editing—its narrative is made up of a total of five sequences—the film remains situated (in as much as a film can be) within the live, communal act of storytelling.

What is enacted at this southern Indigenous film and media arts festival, composed of a range of nations among Indigenous and settler audience members, then, is the performative act of languaging the film. This is an act of *conciliation*: a "production of moments of empathy and agreement beyond Native/settler binaries ... the goal is to resist and transform colonial ideology" (Garneau 2016, 24). David Garneau, Métis professor and artist, explains that conciliation, unlike reconciliation, "is not the erasure of difference or sovereignty. Conciliation is not assimilation" (2016, 32). In this act of collaborative programming, Kunuk and imagineNATIVE choose against the "smoothing over" (Brady and Kelly 2017; Thornley 2017) of Indigenous narrative and aesthetic sovereignty,

opting for citational exhibition that resists claim to an authentic origin-
ation of cinematic languaging. Their political intervention, thus, asks
each member of this mixed-identity, southern audience to persist with
the ongoing performative process of translation. Knowledge transfer is
emphasized through listening—an otherwise meditative negotiation
that often comes to pass as an invisible originate. In this cinematic
encounter, the exchange between spectators and documentary subjects
becomes hyper site-specific, rather than citational.

SIGHTS: THE BODY IN LAND

"To speak of indigeneity," Mohawk cultural anthropologist Audra
Simpson tells us, "is to speak of colonialism and anthropology, as these
are means through which Indigenous people have been known and
sometimes are still known" (2014, 95). Simpson's work on Indigenous
acts of refusal has been integral in demonstrating how ongoing col-
onial structures manifest beyond military and nationalistic violence,
but also through "methods and modalities of knowing—in particular,
categorization, ethnological comparison, linguistic translation, and eth-
nography" (Simpson 2014, 95). Kunuk's performative mediations of film
festival site and citational encounters challenge colonized ways of know-
ing and of hearing. To think of Kunuk's act of refusal is to also think of it
as a refusal of colonizing sights.

This refusal is primarily land-based. In documenting homecoming,
Angirattut's camera is often framed by limited landscape sightlines,
holding long takes on the faces of the Elders rather than on the land-
scapes they emotionally resituate themselves upon. Throughout the
film, there is little knowledge transferred to spectators about the land
and its location. The boat travel is marked by a few early shots of sup-
plies being loaded up in trucks and boats. We do not know the duration
of the trip and from where it starts. Any orientating inter-titles are
used sporadically throughout the film and are in Inuktitut syllables.
The name of the home-sight is only known because it is published in
the imagineNATIVE program notes (and now on the IsumaTV web-
site). It does not appear in the film. While *Angirattut* also acts as an
ethnography of a locative passage, colonial markers of travel, such as
orientating cartographies, are not included. The names of inlets, bays,
and camps, as well as travel duration between sites, are already known
by the Elders in the film and by many residents of Igloolik, where many

of these relocated families later settled. Interestingly, if you google the travel distance points between Siugarjuk and Igloolik, Google—the otherwise algorithmic "OZ" of cartography—does not recognize Siugarjuk as a "location." It remains an intimate place that belongs specifically and only to its former inhabitants. All other visitors are not granted possession to this land in their temporary cinematic sight-visit.

Northway-Frank and I discuss the film's visual structure at length: the tight close-ups, how the bodies of the speaking Elders are framed, the ambiguity of the children fishing, the intimacy of the food prepared in the camps. Northway-Frank tells me he wishes the film was more visual, wanting "to get more of a feeling of the land and the place." He feels the physicality of these bodies in the land is missing. I propose an alternative reading, seeing these limited sightlines as part of the film's interventional refusals.

When I ask Kunuk about the limited sightlines of the land in the film, he tells me, "The land always stays the same, but the people change." The woman we see in the wheelchair throughout the film, Kunuk, tells me, is his mother. She is carried across the tundra with help and care. At another point, she must make her way across a homemade ramp placed between the shore and a small boat. Kunuk and I speak about the difficulties involved in helping his mother and another mobility-restricted Elder move on this land. These women are faced with new, unknown challenges in the tundra of their youth, of their former home, from five decades earlier. The camera's choice to focus on the bodies of these women rather than on the sweeping wide angles of the landscape privileges the shifting rapport with this land, by the people who must (re)navigate it.

Rather importantly, any and all locative sight markers are found in the densely researched film's companion website, *Amitturmiut* (http://www .isuma.tv/amitturmiut). Maps of Nunavut's Ammituq region visually illustrate the widespread colonial dislocation throughout the 1960s.[28] The website acts as a resource hub for Inuit families who have been historically displaced. Inuit familial histories are re-mapped as lineages of camps are retraced. *Amitturmiut* also features genealogical records gathered and presented in family trees through the Kinship Scrolls. Visitors are invited to explore additional audio and visual materials documenting families from the region and to contribute their own historical data. The website is conceived as a space where families can reconnect with each

FIGURES 3.3, 3.4 AND 3.5 Elders face unique visceral and physical challenges in returning to their home-sight. *Angirattut* documents their difficulties as important markers of the healing passages along their journey. Video grabs from *Angirattut* (2014), courtesy Isuma.

other and with their homes. As a (web)site managed and sustained by its own regional participatory knowledges, Siugarjuk's architectural mapping is built through representational sovereignty.

Linda Tuhiwai Smith has made important associations between colonization and stories of travel. Travel encounters are brief but often spectacular, appealing "to the voyeur, the soldier, the romantic, the missionary, the crusader, the adventurer, the entrepreneur, the imperial public servant and the Enlightenment scholar" (2012, 9). This screening of *Angirattut* resists such a colonizing spectacular gaze. Instead, it contains intimate specificity, holding relationships between land and body in accordance with homecoming. As Elders give testimony, all Qallunaat are refused colonial (visual) possession of these Inuit bodies and their homecoming land. Qallunaat are asked, rather, to reflect upon the possessive act of seeing, which has come to colonize the process of knowing in ethnographic cinema. Kunuk's mediated sights act as alternatives to canonized settler-colonial anthropological politics of recognition. His provocative ethnography refuses to tell [this community's] internal story of struggle but consents to telling the story of their constraint (Simpson 2016a, 328). Qallunaat are not permitted research "data" nor are these our stories to claim. We are, however, asked to bear witness to the constraining and painful intergenerational effects of decades of colonial relocation. All Qallunaat are asked to see, instead, that reconciliation with this land—a homeland that has been violently dispossessed from its Elders— does not end with this film. As I watch, I confront my positionality as visitor at this site, and if I wish to sustain the privileges in sight I have been granted beyond a colonizing encounter of affective wonderment, I know I must stay for the post-screening discussion and continue to listen and share with the community of spectators that surround me.

TOWARD LOCALIZED SITES OF PASSAGE: SOME CONCLUSIONS

Coupled with the *citational* absences of subtitles and the refusal to position *sightational* colonial identifiers of land, testimony, and body, Kunuk does not attend the screening, nor does he attend the post-screening discussion through video conference. Initially, in our discussion, Northway-Frank laments Kunuk's absence.[29] Once again, we proceed to discuss an alternate reading and come to understand

Kunuk's absence as an integral factor within the performative realm of this festival encounter. Without a visible primary industry representative on stage, questions that are often asked at film festivals— questions related to production, reception, and distribution—cannot be answered by Northway-Frank, who acts as a representative of the festival and not the film. The traditional linear, top-down industry knowledge-legitimatizing process is replaced by one of the most vibrant post-screening discussions I have come to experience.

Northway-Frank opens the discussion from the perspective of imagineNATIVE, explaining they were nervous to present *Angirattut* this way (particularly without Kunuk present), but both Isuma and the festival were interested in testing the limits of their audience. He invites honest feedback from both Inuktitut- and non-Inuktitut-speaking members of the audience.[30] The first audience response does not perceive this screening as targeted for a Toronto-based audience, seeing the film as a representation of a dying culture that Toronto residents could not understand nor respect accordingly. This comment is very quickly challenged by an audience member who asserts that this film is made *exactly* for a Toronto audience—an audience who otherwise assumes the position that the North is made up of a dying culture. This second speaker is emotional and thanks the festival for bringing *Angirattut* to them in this way and for "showing active language and culture." A third audience member also responds to the first speaker's comments, stating, "Now, *you* are the outsider. This is not a film about a dying culture. This is a film about a living culture." A fourth respondent states that it was "really hard for my heart and my mind to watch and listen to this, but it was very healing." A little later in the discussion, which continues for almost 30 minutes, an Inuktitut-speaking audience member confirms that while they did not understand all of the dialogue due to the dialect spoken, they "cried so much during this screening." They explain that they chose to sit in the back of the theatre to take in everyone's reactions.

I have written this chapter from the perspective of a settler audience member and scholar, to demonstrate how *Angirattut* and its film festival screening perform absences in site, cite, and sight. These audience responses, however, illustrate the state of active presence that came to unravel through this truly unique film festival encounter. While both Kunuk and imagineNATIVE refuse to "translate" according to hegemonic cinematic exhibition codes, they do facilitate translative

exchanges and collaborations between audience members both in the cinema and subsequently, with readers of this essay. These ongoing acts of re-translation challenge overarching fallacious and finite binaries of "foreignness" categorized in finite Western scholarship models and interrupt dualistic spectatorial positions often invoked in traditional Euro-American film festival encounters.

These decisive absences enact the testimonies of the Elders, from "written to embodied culture" (Taylor 2003,16), thus expanding the knowledge transfer beyond written archive. As the Elders confront geographical and temporal passages in their own words, imagineNATIVE's audience bears witness to oral repertoire. The multiple Qallunaat spectators at this imagineNATIVE screening in downtown Toronto at the TIFF Bell Lightbox—many passages away from Siugarjuk—are asked multiple times over to confront their own conflictingly (un)knowing bodies. Linda Tuhiwai Smith reminds us that Indigenous narrative orality means more than simply "an account or a genealogical naming of the land and the events which raged over it," but also refers to "a very powerful need to give testimony to and restore a spirit, to bring back into existence a world fragmented" (2012, 29–30).

The imagineNATIVE screening of *Angirattut* recounted here performs the ongoing perseverance of Inuit bodies, dialects, and landscapes that have been historically displaced and mistranslated. While this performance proclaims itself for and by Inuit audiences, it asks the Qallunaak, and more specifically, the southern settler film festivalgoer to sit in an ongoing negotiation with this witnessing encounter. It is an act many more film festivals who consider themselves alternatives to the global festival circuit should acknowledge and enable in their own programming, if they wish to challenge and disrupt acts of transfer that continue to circulate through colonial passages of programming encounters.

NOTES

1 Co-founded in 1990 by Kunuk, Paul Apaq Angilirq, Pauloosie Qulitalik, and Norman Cohn. Isuma consider themselves 75 percent Inuit-owned. In 2007, Isuma launched IsumaTV, an ambitious online broadcasting site featuring global Indigenous content from over 41 languages and a two-way communication stream to service low-broadband communities in the

North. For more information about IsumaTV see their "About Us" page: http://www.isuma.tv/isuma-productions/about.

2 For more information about imagineNATIVE's mandate and origination see http://www.imagineNATIVE.org/profile/.

3 As told to the author in an unpublished conversation with Daniel Northway-Frank (February 2016), who at the time held the position of manager, Festival Initiatives. In our conversation, Northway-Frank confirms the festival is always open to proposals for new and innovative programming. Kunuk and I also had a number of (unpublished) email exchanges and phone conversations leading up to the writing of this chapter. Kunuk tells me the Inuktitut dialect in *Angirattut* is Aujuittuq.

4 As told to the author in February 2016.

5 See Banning 1991, McCall 2011, Evans 2008, and Brady and Kelly 2017.

6 I have tried searching for the speech online but it seems to be unavailable. Instead, see this article covered by *Nunatsiaq*, a Nunavut newspaper following Kunuk's win: http://nunatsiaq.com/stories/article/kunuk_captures _golden_camera_at_cannes/.

7 I am using this term as a way of understanding language as a verb and in an active tense as a process of exchange, transition, and engagement.

8 In his glossary, Michael Robert Evans (2008) explains that the singular for Qallunaat is Qallunaak—a non-Inuk person. Moreover, the term is usually reserved for white people, of which I am as a first-generation Canadian settler scholar.

9 At times, in this essay, I alternate between listing imagineNATIVE's coprogrammer of this performance as Kunuk and other times as Isuma. This oscillation distributes *Angirattut*'s authorship to both Norm Cohn, the film's producer, and Zacharias Kunuk, the film's director, but also to the Elders in the film and the larger Isuma crew who worked on the film. In addition, Northway-Frank attributes both Cohn and Kunuk as the initial proposal's authors.

10 In situating this screening of *Angirattut* as performance I emphasize direct spectatorial engagement with the lived and ongoing experiences of Indigenous bodies with colonization, relocation, and displacement. I reference Peter Morin, Tahltan Nation artist, curator, and assistant professor, who describes the performance-as-research methodology as a space where "the brown body becomes a matrix, a system of filters that encounters, organizes, and acquires information" (2016, 67). Understanding this screening of *Angirattut* as performance does not lessen it to an act as/of "show." Rather,

performance theories highlight productive engagements between filmic representations, curatorial choices, and audience members that continue to propel live encounters with mediated recordings of lived experience.

11 The three additional distinguishing factors they identify are "(1) purposefully commenting on/critiquing of culture and cultural practices, (2) making contributions to existing research, and (3) embracing vulnerability with purpose (Jones et al. 2013, 12).

12 As Linda Tuhiwai Smith explains, "The Enlightenment project involved new conceptions of society and of the individual based around the precepts of rationalism, individualism and capitalism" (2012, 33–34). The Enlightenment project confirmed the rational "self" was known and recognized in contrast to the "savage" pre-"historical" Other, the "Indian," the "Negro," the "Jew," and the woman—bodies explicitly outside of the regimes of the modernized classification of industrialized society (Tuhiwai Smith 2012, 33).

13 In their special dossier on "Decolonizing Autoethnography," Chawla and Atay highlight the relational process of decolonization between multiple peoples (2018, 5–6). Chawla and Atay rupture false safety for settler scholars to view decolonization as a one-sided endeavour, calling all bodies into awareness, participation, and action.

14 In *Not Like a Native Speaker* (2014), Chow expands upon her previous scholarship (1995, 2012), which challenges origination as authenticity in translation. Chapter 1 of the book challenges readers to treat the "condition of coloniality as a prosthetic add-on, rather than, … as the authentic origin." Chow poses a provocative question, which I embrace in this chapter, asking, "What would coloniality look like if and when it is recast as prosthetic rather than assumed as essentially originary—especially in terms of language politics and practices" (33). I position the language politics of coloniality as prosthetic in this paper. I do not ignore the material violence of language politicking, but I seek to rupture the authenticity of film festival programming claims to origination.

15 In pushing against both the "one-way street" built within the ethnographic practice of non-Western art, and the binary that develops between "East" versus "West" in ethnographic knowledge representations, Chow (1995), vis-à-vis Walter Benjamin, sees translation as a passageway, "an activity, a transportation between two 'media,' two kinds of already-mediated data" (193). Chow refutes origination terms such as "the Other," emphasizing, instead, the need to acknowledge the transparent transmission process of

translation within cinema. This process encourages the potential for the "foreign" to destabilize the hierarchical conception of the original in Western ethnographic cinema: "the 'fables' that cast light on the 'original' that is our world's violence" (Chow, 1995, 201–2).

16 A note about spelling. On IsumaTV, the homeland site is spelled *Siugarjuk*. In an unpublished email communication I had with Kunuk (May 2018), it is spelled as *Siurajuk*. I am choosing to use the published spelling of the homeland for consistency with Isuma's press text.

17 Isuma Distribution International, "Zacharias Kunuk Screens His Latest Film *Angirattut* in Original Inuktitut Version," news release, October 7, 2015, http://www.isuma.tv/ComingHome/zacharias-kunuk-screens-his-latest-film-angirattut.

18 *Angirattut* is available on IsumaTV (without subtitles): http://www.isuma.tv/ComingHome/Movie.

19 For a more thorough analysis on naming and claiming Indigenous trauma in Canadian cinema, see Longfellow's contribution in this collection on residential school films.

20 See, for example, de Valk 2007, Loist and Zielinski 2012, Harbord 2016, and Zielinksi 2016. De Valck (2007) works through a Bourdieusian value-adding process of mediation of the festival event as performance, but from the perspective of the spectacle and popular attention generated by festival journalism. See Chapter 3 (de Valck, 2007).

21 In an interview with Carlos A. Gutiérrez, co-founder and executive director of Cinema Tropical Film Festival, Gutiérrez states, "We need to rethink cinema as a performance, and place it within performance studies instead of within literary studies. The performance is the communion between the film and a particular audience at a particular time, and film festivals are arenas for performance" (Patti 2016, 358).

22 More precisely, Hanich proposes a theory of phenomenological transfer as a triadic collective constellation, one between viewer, film, and the rest of the audience, shifting traditional dyadic relationships between film and viewer that are common in our discipline (2018, 7).

23 See Nornes (1999, 2007).

24 See for example, Shohat and Stam (2003), Egoyan and Balfour (2004), Mowitt (2005), Nornes (1999, 2007), Betz (2009), Eleftheriotis (2010), Mamula and Patti (2016), and Dwyer (2017).

25 For a more comprehensive analysis of Mowitt's chapter on "Foreignness and Language in Western Cinema," see Dwyer 2017, 74–76.

26 Including a powerful and important re-reading of the absent subtitle by
 Tessa Dwyer (2017), who argues for the problematic differentiation role of
 the "vanishing subtitle." While the disruptive translation strategies between
 Dwyer's main case study, Anthology Film Archives, and imagineNATIVE
 may appear similar, the variations in interpretative understanding between
 these two case studies are located precisely in Kunuk and imagineNA-
 TIVE's insistence toward Indigenous narrative and exhibition sovereignty.
 Moreover, imagineNATIVE's audience is invited to collaborate and discuss
 their experience, a community-inspired strategy architecturally foreign
 from Anthology's infamous individually separated seating pods. Neverthe-
 less, Dwyer's chapter is notable. It helps us understand nuanced outcomes
 of various attempts to program alternative forms of translation.

27 This argument is indebted to Masha Salazkina (2016), who calls on cinema
 and media scholars who both translate and theorize translation to account
 for the Eurocentric "uneven power structures" (21) inherent in the circula-
 tory geopolitical hierarchies of cinema migration.

28 Siugarjuk Peninsula is not marked in this map. I ask Kunuk why and he
 tells me: "these people have moved to Kapuivik and Iglujuarq and some
 to Pond Inlet after my father's parents' death. So, if you can find Siugarjuk
 Peninsula on Igloolik side there may be camp marked." As of the publi-
 cation of this chapter, I have still not located Siugarjuk in cartographic
 representation, but I understand I am not meant to.

29 Northway-Frank also tells me Kunuk is not able to attend the screening
 because he is hunting. There is no discussion as to whether or not this
 absence is planned, nor do I ask Kunuk if he intended to be present or not.
 I do not believe it matters either way as I am discussing the performative
 knowledge transfer that occurs through Kunuk's absence. It is felt by the
 spectators in the cinema and by Northway-Frank in different ways, and
 it must be accounted for as an integral aspect of the knowledge transfer
 process of this screening.

30 In quoting the post-screening discussion comments, I try to remain
 observational. Audience members remain anonymous. Participants
 were not asked to identity whether or not they identified as Indigenous
 or settler, although commentators sometimes voluntarily identified
 their positionality.

Protecting Culture

Introduction to Part II

Dana Claxton and Ezra Winton

In the four chapters that make up the second part of this book, authors probe questions and concerns around cultural protection, including efforts, actions, and processes around cultural creation, reclamation, and reparation. Readers may ask at the outset questions like: What is cultural protection? Which cultures are in need of protection? And why? We hope you find the responses herein to be enlightening, inspiring, and engaging.

Culture, which of course includes the creative expression of humans, begins with a relationship to the land and is also closely linked to the imagination. In her must-read book *Indigenous Writes: A Guide to First Nations, Métis and Inuit Issues in Canada*, Chelsea Vowel (Métis) connects issues of Indigenous representation in Canadian media to the colonial imaginary: "Canada has created an image of itself, based not so much on historical fact as on ideological interpretation. In doing so, Canada has necessarily had to rely on upon an image of Indigenous peoples, which ... portrays us as pretty much useless" (2016, 119). The creation of images (on screens, on canvases, on pages, in our minds) has been central to the colonial process of interpellation and enculturation, whether that involves the eradication or assimilation of "the colonized" or the incorporation of the dominant culture to support and propagate the colonial agenda. Along the way, as is the case with Canada, Indigenous languages, knowledges, practices, lands, and lives have

been lost. A direct consequence of what Sto:lo author, poet, and intellect Lee Maracle[1] (2017) calls the pillaging by colonial capitalism is the loss of or radical transformation of culture. Part of the struggle against cultural erasure and/or subsumation is the staging of a radically diverse, often maintained traditionally in communities and on reserves, bold fight to remember, create, share, recognize, and caretake culture. Holding culture, through Elders and practitioners in home communities or with urban practices and protocols—a kind of cultural protection— is paramount.

When the United Nations Declaration on the Rights of Indigenous Peoples,[2] or UNDRIP, was presented for vote at the General Assembly in 2007, Canada was among a small out-of-step group of anglo-colonial states that voted against (along with the USA, New Zealand, and Australia), while an overwhelming majority (144) voted to ratify. After shameful news of Canada's backroom lobbying to pressure other states to vote against, as well as Indigenous-led public pressure globally, the government eventually reversed its position. Among other things, at stake in the Declaration was the need and directives for signatories to protect Indigenous cultures the world over. In the years since the Declaration, the United Nations has commissioned several reports, convened working groups, and consulted and collaborated with Indigenous groups internationally. In 2015 the Human Rights Council requested the Expert Mechanism on the Rights of Indigenous Peoples to "prepare a study on the promotion and protection of the rights of indigenous peoples with respect to their cultural heritage to present it to the Council at its thirtieth session" (UN Human Rights Council 2015). Among the declarations and directives, the report states that signatories like Canada should

> ... recognize the value and livelihood aspects of the cultural heritage of indigenous peoples, which is not limited to the protection of specific manifestations, symbols or objects, but also includes tangible and intangible manifestations of their ways of life, achievements and creativity, and of their spiritual and physical relationships with their lands, territories and resources. ... Indigenous peoples should be consulted and enabled to actively participate in the whole process of identification, evaluation, classification, interpretation, preservation, safeguarding, monitoring, stewardship and development of their cultural and natural heritage.

While we recognize the limitations of the UN as an inter-governmental body commandeered by colonial and imperial states, we do find the language in this report complementary to any discussion of Indigenous cultural protection. For its part, the state of Canada continues to either ignore or move at a glacial speed to respond to, adopt, and/or enact the resolutions laid out in the UNDRIP, including Article 11, which states:

> Indigenous peoples have the right to practise and revitalize their cultural traditions and customs. This includes the right to maintain, protect and develop the past, present and future manifestations of their cultures, such as archaeological and historical sites, artefacts, designs, ceremonies, technologies and visual and performing arts and literature. (UN General Assembly 2007, 11)

As a universal right long understood to be such by Indigenous peoples globally, cultural practices and customs must be safeguarded.

When a culture or cultural practices of a group (or language of a group) is outlawed and criminalized, it goes underground and into urgent caretaking and safeguarding mode. Even once the colonizing powers lift bans, discontinue disciplinary measures, and invite practices back into the mainstream manifold to be part of a newly constituted "multicultural state," culture must be protected anew. NDN culture is very precious and holds deep cultural ways of being (and knowing) that sustain Indianness. NDNs are able to thrive against all colonial odds because of culture. We don't have the space to enter into a longer discussion about the historical pitting of "civilization" against "culture," which is discussed at length in the writings of cultural theorist Raymond Williams, and of course has obvious implications for any discussion about colonialization and Indigeneity, but the basic notion that culture is the cultivation of a way of life is indelibly linked to sustenance, survival, and sovereignty. Culture can be constituted by a social contract governing relations between people and communities; it can be the "works and practices of intellectual and especially artistic activity" (Williams 1976, 90); it can be the ways in which a group of people express themselves orally, visually, performatively, or otherwise. It is certain that culture is vital to human existence; it is certain that Indigenous cultures have been under continuous threat since outsiders arrived on the continent

over 500 years ago; and it is certain the denial or misunderstanding of Indigenous cultural authority from newcomers continues to this day.

In her politically expansive and refreshingly frank book *My Conversations with Canadians*, Lee Maracle discusses at length the idea and act of appropriation, outlining the ways in which knowledge and cultural reclamation includes, but is not limited to protection:

> Today we struggle to reclaim knowledge, to articulate and create literary and scholarly works from it, and to end the theft through writing that characterized 120 years of prohibition, theft, and abrogation of our ancestors' authority and ownership of knowledge. For us to reclaim knowledge, we must have access to it, we must re-aggregate it and we must build institutions to accomplish this. Protection before aggregation of our intellectual property will only lead to an atrophied or crippled and limited rebirthing of our original knowledge base. No one grandmother knows what all the grandmothers once knew. (2017, 106)

We are in full agreement with Maracle and hope that this section (and this book as a whole) does its part in the work of re-aggregation toward safeguarding the cultivation of ways of life, and the expression and representation of Indigenous cultures for the past, present, and future. In order for culture to be protected and thrive in an open, liberatory, and just manner, it must be recognized, reclaimed, and made accessible in non-essentialist (save perhaps for strategic essentialism), non-controlling ways.

Together the chapters of Part II not only directly or consequentially address the thematic of Indigenous cultural protection, they share understandings of cultural expression and reclamation, and not only safeguard Indigenous culture's sacred place, but contribute to the growing, unstoppable Indigenous cultural surgence *and* resurgence led by traditional knowledges that were never surrendered in the first place.

NOTES

1 With heavy hearts we acknowledge that the brilliant and beautiful Lee Maracle passed away on November 11, 2021. Her contribution to liberation texts by Indigenous women is enormous as she led the West Coast literary charge. Forever in our hearts.

2 Download the PDF version of the Declaration here: https://www.un.org /development/desa/indigenouspeoples/wp-content/uploads/sites/19/2018 /11/UNDRIP_E_web.pdf.

Addressing Colonial Trauma through Mi'kmaw Film[1]

Margaret Robinson and Bretten Hannam

INTRODUCTION

Indigenous people have been involved in filmmaking as directors, writers, producers, actors, and designers since the industry emerged in the late 19th century (Rosenthal 2005), yet are repeatedly misrepresented in filmed works intended for settler audiences. Professor of philosophy Blaire Topash-Caldwell (Potawatomi) describes film as "the primary way dominant society has consumed inaccurate and problematic symbols, images, and stereotypes of Native peoples for over one hundred years" (2020, 29). Settler movies created "Red Indians" as stock villains and designed their look to meet their need for an exotic Other. As Cree filmmaker Neil Diamond and his colleagues argue in their documentary *Reel Injun* (2009), such characterizations erase cultural differences between Indigenous nations, and reinforce tropes of either (1) the noble savage, a gentle soul who befriends woodland creatures, or (2) the ignoble savage, an animalistic threat who attacks without motive or honour (Diamond, Bainbridge, and Hayes 2009). Stereotypes do not occur in a vacuum, and images on the silver screen reflect, reinforce, and re-invent colonial power structures as well as the petty prejudices of daily life. In her book *Killing the Indian Maiden: Images of Native American Women in Film*, M. Elise Marubbio notes the recurrence of a character she terms "The Celluloid Maiden ... a young Native American woman who enables, helps, loves, or aligns herself with a

white European American colonizer and dies as a result of that choice" (2006, p. ix). Marubbio argues that the death of the Maiden—often by suicide or murder framed as resulting from her own poor judgement— represents the death of all Indigenous peoples either literally or by assimilation into colonial society (2006, 57–58, 70). Indigenous people are portrayed onscreen in ways that shape how settlers view us, and how we who are Indigenous view ourselves. So when Mi'kmaw people make films, we have an opportunity to challenge media stereotypes and represent the Mi'kmaq as we know ourselves to be.

The Mi'kmaq have resisted settler colonialism since the French established Port Royal in 1605 (Jefferys 1939), but the impact of colonialism is still evident. A study by the Mi'kmaq Health Research Group, of Mi'kmaw people living on reserve in Nova Scotia, found that 31 percent of women and 16 percent of men had considered taking their own life (Loppie & Wien 2007, 82). The problem of suicidality is not exclusive to the Mi'kmaq. Intergenerational trauma, including loss of territory, culture, and language, has led to a suicide rate for youth in Indigenous nations across Canada that is the highest in the world (Chandler et al. 2003).

Individual and communal engagements with Mi'kmaw culture can help us heal from colonial trauma, including being subjected to the colonial gaze, which reduces us to objects for settler scrutiny. The degree to which Indigenous communities connect with their past and secure control over their future has been termed "cultural continuity," and it significantly reduces Indigenous youth suicide (Chandler & Lalonde 2008) by enabling communities "to create a cultural life that young people judge worth living" (Hallett, Chadler, and Lalonde 2007, 393). Indigenous filmmaking is integral to cultural continuity because it asserts visual sovereignty by representing us in ways that assert Indigenous self-worth.

This chapter explores how films by three Mi'kmaw directors decolonize and L'nu-ize (make fully Mi'kmaw, fully human) Indigenous characters, showing recognizably Mi'kmaw lives as worth living. Decolonizing images of us is important for the Mi'kmaq since, due to our territory's location on the eastern coast of the continent, our nation has been resisting colonialism longer than many others.

This work occurs in a context of revitalization. The films we examine—Catherine (Cathy) Martin's *The Spirit of Annie Mae* (2002), Jeff

Barnaby's *Rhymes for Young Ghouls* (2013), and Bretten Hannam's *North Mountain* (2015)—fall solidly within the Indigenous New Wave, an international cinematic movement of Indigenous self-representation with roots in independent filmmaking of the 1970s (Bergstrom 2015; Davis 2014; Urban 2011). The Indigenous New Wave in film is tied to a similar Next Wave (CBC 2017) in music, which incorporates traditional musical elements into contemporary styles, as exemplified by Tanya Tagaq and by The Halluci Nation (previously known as A Tribe Called Red). Also connected is the explosion of Indigenous media commentary such as *Métis in Space* (Swain & Vowel 2016) or *The Candy Show* (Palmater 2010). Empowering all these works is an Indigenous resurgence in politics and culture that centres Indigenous knowledge, including self-knowledge (Battiste & Youngblood Henderson 2009, 9). The cinematic works of Martin, Barnaby, and Hannam have Indigenous protagonists, which shifts focus to characters usually rendered marginal in settler films. This re-centring offers viewers "unsettling" experiences that reject the portrayal of colonialism as benevolent (Regan 2010, 13).

In this chapter we examine Mi'kmaw films in relation to four themes: (1) land and territory as indivisible from Mi'kmaw identity and culture; (2) normalization of Mi'kmaw language; (3) denunciation of colonial violence; and (4) troubling of colonial gender. Taken together, these themes undermine the colonial gaze in ways that empower Mi'kmaw people, especially youth, and address intergenerational trauma by connecting us with our communities and cultures during times of personal crisis.

FOUR THEMES IN THREE FILMS

The films examined here, *The Spirit of Annie Mae*, *Rhymes for Young Ghouls* and *North Mountain*, were selected because they feature Mi'kmaw characters or people, the directors self-identify as Mi'kmaq, and the directors had additional roles that suggest broader control over the final product. In addition to directing, Barnaby wrote, edited, and composed music for *Rhymes for Young Ghouls*. Hannam directed, wrote, and produced *North Mountain*. In addition to directing, Martin conducted research for *The Spirit of Annie Mae* and narrated the work. Our intent is not to survey all Mi'kmaw film, but to note common themes in specific works. *North Mountain* is a 78-minute action film, produced by Mazeking Pictures, with an estimated budget of $250,000 CDN (IMDb

n.d.a), released on-demand by Northern Banner. *Rhymes for Young Ghouls* is an 88-minute drama with a budget of 1.5 million CDN (IMDb, n.d.b). *The Spirit of Annie Mae* is a 73-minute documentary with an estimated budget of $500,000 CDN (IMDb, n.d.c).

Our analysis of these films draws on interviews conducted with Hannam, Martin, and Barnaby by Robinson in 2017.[2] It is a happy accident that each director was at a different stage in their career at the time of the interview: Hannam was an emerging director whose film did not yet have distribution; Barnaby's feature film debut was critically acclaimed with international distribution; and Martin is a lauded documentarian whose work is distributed by the National Film Board of Canada.

Our analysis of the interviews and films was emergent, cyclical, intuitive, and abductive, using logical inference to generate tentative knowledge (Reichertz 2007; Thagard & Shelley 1997). Robinson approached directors by email to request an interview, and all agreed.[3] Interviews focused on three questions: (1) What challenges do contemporary Mi'kmaw directors face in representing Indigeneity? (2) What resources empower Mi'kmaw directors to decolonize and Indigenize Canadian film media? and (3) What techniques of decolonization do Mi'kmaw directors favour in their work? While many subjects emerged from the analysis and interviews, four themes stood out: the representations of land, language, violence, and gender or sexuality.

LAND

In Bretten Hannam's action thriller *North Mountain*, the protagonist, Wolf (played by Justin Rain, a member of Sakimay Cree Nation), finds an older Mi'kmaw man, Crane (Glen Gould, a Mi'kmaw actor from Membertou First Nation), in the woods, injured and clutching a briefcase containing two million in American currency. Wolf takes the injured man home, to the cabin shared with his Nan/Nukumi (played by Mi'kmaw actor Katherine Sorbey of Eskasoni First Nation), and the two shelter Crane during his recovery. Wolf and Crane develop a sexual relationship, but their bond is tested by the arrival of New York crime lord Sylas (played by Gary Levert) and his team of henchmen and corrupt cops, determined to kill Crane and recover the money.

In terms of the visual representation of land, Hannam's film portrays a decolonized landscape as the opening three minutes of the film feature a slow pan across North Mountain, showing trees stretching to the

FIGURE 4.1 Wolf, played by Justin Rain (left) and Crane, played by Glen Gould, repose by a comforting campfire in *North Mountain* (2015). Production still courtesy Bretten Hannam.

horizon as a crow flies overhead. The shot is almost devoid of marks of colonial occupation, visually manifesting it as Mi'kma'ki, the unceded territory of the Mi'kmaq. To achieve the decolonized effect, the bulk of Hannam's film was shot near Kejimkujik, an area of old-growth forest that has stood for nearly half a millennium, the last two hundred and seventy-odd years on land identified as the province of Nova Scotia. In 1969 Kejimkujik became a national park.

Wolf and Crane's familiarity with the land, and techniques to survive on it, provides the advantage they need to defeat Sylas and his men. In their interview with Robinson, Hannam describes *North Mountain* as a "reverse western" in which the "Indians" are fighting the "cowboys." "They're protecting their land," Hannam explains, "they're protecting their family, they're protecting each other, and repelling these invading forces." The erasure of colonialism in the opening of *North Mountain* heightens the image of Silas and his team as invaders whose defeat restores hope for peace and happiness. Yet beyond an idyllic setting against which to contrast settler violence, the land is a being with whom Wolf and the others have pre-existing relationships. As Hannam

explains, "The land is as much a character and is a vital part of the characters as is the story. You can't really divorce the people from the land." Early in the film, Wolf demonstrates proficiency with snares and bow, and a conversation with Wolf's aunt Mona (played by Meredith MacNeill) reveals hunting is a primary food source for Wolf and Nan. Despite the autonomy his skills provide, Wolf lacks the independent self-interest of a western film hero (Adzani 2017). Instead, Wolf performs a nurturing role in relation to Nan and Crane and shows little interest in Crane's cache of money.

In addition to setting Mi'kmaw characters in a mostly unmarked landscape, Hannam also uses a non-specific setting in time. *North Mountain*'s interior sets mix contemporary and vintage props. In Mona's store, the Black Rabbit Trading Post, contemporary products sit alongside vintage toys and dishes, yet the police officer who menaces Wolf outside the store wears a contemporary pistol. Wolf and Nan light their cabin with candles and oil lamps and spend their evenings playing cards, yet Wolf hunts deer with a compound bow and rides a snowmobile. The mix of past and present makes *North Mountain* feel both current and nostalgic.

The uncertain time is supported by the film's engagement with spirituality. A large tree that Nan has decorated with glass bottles serves as a focal point. "I never really liked this place," (32:43–32:44) Wolf explains to Crane. "My father killed himself here. She [Nan] used to bring me out here all the time to talk to him" (32:53–33:02). This tree is also where Wolf first discovered Crane lying injured. Later at that same tree, Wolf prays in Mi'kmaq to Gisu'lgw (Creator) for protection and Crane offers the familiar phrase "Msit No'kmaq" (all my relations), which affirms the interrelatedness of all life. While Mi'kmaw spirituality is important to Wolf, Christianity is associated with the past. Aunt Mona tells Wolf that his mother used to sing in church and met his father there, but the only church we see lies abandoned in the woods, serving as a site of violence or sex, and a place to hide the money. This reverses settler narratives that portray Christianity as triumphing over Indigenous traditions.

At the end of the film, Silas attempts to murder Crane by forcing him to hang himself from the big tree, perhaps as Wolf's father did. Wolf defeats Silas and rescues Crane, cradling the injured man as the gently clinking bottles on the big tree are heard.

"Everybody's dead," (1:12:59) Wolf informs him, fighting tears.

"Look at me," Crane says, touching Wolf's face. "You're alive. That's all that matters. You're still alive" (1:13:06–1:13:30).

Many works for cinema or television end same-sex relationships in death, a trope referred to as "bury your gays," that draws on morality codes framing same-sex attraction as deserving punishment (Bridges 2018). Hannam's reverse western ends with a focus on life instead of death.

Cathy Martin's documentary *The Spirit of Annie Mae* examines the life, activism, and 1975 murder of Annie Mae Pictou Aquash, a Mi'kmaw woman who was a leader in the American Indian Movement, which *The New York Times Magazine* describes as the "most visible, and radical, advocacy group for native American civil rights" (Konigsberg 2014, para. 2). Annie Mae Pictou (later, Pictou Aquash) helped form the Boston Indian Council, was an educator in the Teaching and Education in Bicultural Research (TRIBE) learning centre, demonstrated at the site of the *Mayflower II*, and was at the forefront of American Indian Movement (AIM) protests such as the occupation of the Bureau of Indian Affairs in Washington, DC, and the 71-day occupation of Wounded Knee in 1973 (Poliandri 2011). Dr. Simone Poliandri, a settler anthropologist who conducted fieldwork in Mi'kma'ki, notes that while Annie Mae's contemporaries held mixed views about her work with AIM, many now consider "her determination and resilience as markers of the Mi'kmaw people's strength and courage in surviving centuries of colonial aggression and injustice" (Poliandri 2011, 251). If Annie Mae Pictou Aquash is viewed as a positive model of Mi'kmaq personhood, then the way her life is represented cinematically may impact how Mi'kmaw viewers feel about ourselves and each other.

Released in 2002, *The Spirit of Annie Mae* also opens on a landscape devoid of colonial occupation and unsettled in time. The documentary begins with an extreme close-up of Deborah Maloney-Pictou (then credited as Pictou Maloney), one of Annie Mae's daughters, now an adult. We hear birds chirp, as she raises a rifle and takes a shot against a backdrop of fall foliage. The camera cuts to a full shot of Maloney-Pictou, back to the viewer, and as the opening credits begin, she walks across a field ringed in trees that extend to the horizon without any signs of settlement. Maloney-Pictou's camouflage hunting vest and rifle mark her as contemporary, but the colourful fall landscape devoid of occupation suggests a timeless cycle of seasons.

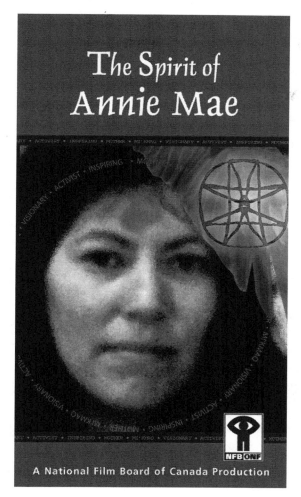

FIGURE 4.2 Official poster for *The Spirit of Annie Mae*. Digital image courtesy the National Film Board of Canada.

Although different in genre, both Martin's and Hannam's opening credits counter the classic Canadian narrative that pits the individual against the environment (Smith & O'Connor 2005). In both instances the effect created is one of comfort; Wolf and Maloney-Pictou are not individuals lost in the wilderness; they are at home in it, as demonstrated by their relaxed body language and ease of movement through the space. By interviewing people outdoors Martin frames the land as a source of power that helps the Mi'kmaq resist cultural and religious assimilation. "If we peel away those layers of colonization," Martin suggests to Robinson, "we can really look at who we are." By portraying Mi'kmaw people

as comfortable and competent in our territory's natural spaces, these visual works make visible our claims to land and sovereignty.

The erasure of settler markings from the landscape may cause a sense of unease for some, approaching what Austrian psychoanalyst Sigmund Freud ([1919] 1955) describes as *unheimlich*, a fear one feels when the familiar becoming unfamiliar—often through repetition—or when the strange is revealed to be hidden in the familiar. This phenomenon of *unheimlichkeit* is sometimes translated as "the uncanny." The cinematic manifestation of Mi'kma'ki may reframe land that is settled into literally uncharted territory. Freud proposes that encountering the uncanny elicits a "feeling of helplessness" he compared to being lost in the mist or in a mountain forest (Freud [1919] 1955, 237). If the decolonial aesthetics, such as those in the opening of *The Spirit of Annie Mae* (2002), unsettle the land in ways that elicit fear and helplessness in settler viewers, these same aesthetics may ease the fear and helplessness that Mi'kmaw people experience in seeing our territory alienated from us by settler colonialism.

As Martin traces the life and experiences of Annie Mae, she mixes contemporary and period shots of real locations, creating a feeling of familiarity and intimacy, as if the viewer has walked the same streets, driven the same roads, and sat in the same kitchens as Annie Mae. If Freud's ideas about the uncanny are correct, then Martin's documentary style may aesthetically decolonize the "settled" spaces she portrays. The sense of place Martin achieves helps root Annie Mae's life in specific cultural and geographic locations such as the "Shubenacadie reserve" (now Sipekne'katik First Nation); Lithgow Street in Boston, Massachusetts; the Bureau of Indian Affairs in Washington, DC; or the Pine Ridge Reservation in South Dakota. The specificity Martin brings to her documentary helps to centre Annie Mae as a woman with agency, which combined with words from family, friends, and Annie Mae's own voice and letters, avoids reducing her to a symbol of vulnerable Indigenous womanhood.

Jeff Barnaby's *Rhymes for Young Ghouls* is a drama set in 1976. The film centres on Aila, a Mi'kmaw teen (played by Devery Jacobs) who leads a group of youth in a revenge plot against Popper (played by Mark Antony Krupa), the brutal Indian agent who controls St. Dymphna's Residential School, the police, and the fictional Red Crow reserve. Barnaby also uses the illusion of endless forest, but does so to achieve a sense of isolation and confinement. Michel St-Martin's cinematography

fills the screen with vertical new-growth trees, mimicking the effect of prison bars (St-Martin in Director's Commentary, 48:07). This is one of many elements in *Rhymes for Young Ghouls* that frame the landscape as marred by colonial violence.

Residential schools were usually located hundreds of kilometres away from Indigenous communities, but Barnaby uses computer-generated imagery to show St. Dymphna's "looming over the community ... like a gothic castle" (Barnaby, Director's Commentary, 4:49). The school has tainted the territory and made it sick, and this is mirrored in an animated story within the live-action film. Narrated by Aila's adopted grandmother, Ceres (played by Katherine Sorbey), the story tells of a ravenous wolf (the residential school system or colonialism itself) that consumes children and eventually itself as well (Pewenofkit 2016).

While the wooded landscape could be read as decolonized, by permeating it with violence and the ghosts of its victims Barnaby makes the forest an internment camp. Despite having a tree fort labelled The Fortress of Solitude, Aila is rarely alone in the woods, and when she is her dead brother or mother appear to her, covered in leaves and dirt. In one of the few comments Aila makes about her own aspirations, she tells the viewer: "For seven years I've dreamt of nothing but getting out of this place. That my world ends at the borders of the reserve, where dirt roads open up to dreams of things you can never be here" (12:12–12:22). Aila's reference to "seven years" would make the death of her mother the point at which she began dreaming of escape, suggesting that until the loss of that relationship, the land held a future for her.

The use of land in these three cinematic works reflects what professor of film studies Mary Jane Miller (2008) has identified as a feature of Indigenous cinema: a strong yet unromanticized sense of place. The territories in *North Mountain* and *The Spirit of Annie Mae* are fully recognizable to those of us who have grown up in the woods and kitchens of Mi'kma'ki. By contrast, Barnaby's use of land is symbolic and metaphorical; the territory is home to zombies, ghosts, and mass unmarked graves. Despite this, there is a hint at what the territory was before, present in the fixation of Aila's father, Joseph (played by Glen Gould), to "get down on the water" (37:26). While boating at that time of year (late fall) is forbidden by Popper, Joseph is driven to do so. Joseph associates the water with family (it was his wife, Anna's, favourite place), and also with culture, courage, and survival in the form of a local Elder

referred to as Gisigu, or The Old Man (played by Stewart Myiow). Joseph's memories of the water offer a glimpse of a territory that could heal colonial trauma—if only we could get rid of Popper and his ilk.

Rhymes for Young Ghouls also has elements of circular or repeating time. Aila's brother, Tyler, who dies early in the film, bears resemblance to Jujij, the boy who works for Aila and calls her "boss." Other characters often ignore Jujij, just as they ignore the ghost of Tyler, and Aila's scenes with Jujij mimic the dynamic with her brother. Toward the end of the film, after Aila has led the revenge against Popper, she enters the woods and witnesses a scene from her own past, when she and her mother painted a chief within a Mi'kmaw star on an old wooden door. As her mother teaches her how to do lines and brushwork, she explains.

"Why are we doing all the detail work in the dark anyway?"

"Well, drawing of an Indian on some piece of wood isn't a big deal," her mother explains. "Two Indians drawing an Indian is. To some people that's scary. And we could get in trouble for it" (1:12:11–1:12:37). Earlier, the painting on the door was shown completed, visible in a place of pride at the garage run by Aila's family. Scenes such as this suggest that past events are remembered by the land, especially if those events were painful.

Michelle Raheja (Seneca), a scholar of film and visual culture, defines visual sovereignty as "a way of reimagining Native-centered articulations of self-representation and autonomy" that enables film-makers to frame "imaginative renderings" of Indigenous "intellectual and cultural paradigms," among which she includes spiritual or dream worlds (Raheja 2007, 1161–63). Raheja's words apply to Barnaby's film, as *Rhymes for Young Ghouls* used animation and computer-generated effects to create a supernaturally imbued landscape in which colonialism taints all it touches. Sigmund Freud's ideas about the *unheimlich*/the uncanny may also apply, as the repetition of cycles of violence evokes potentially disturbing feelings that the past is overlapping the present.

LANGUAGE

Colonial governments in Canada and the United States invested heavily in the eradication of Indigenous languages and positioned English as the dominating language in education, business, entertainment, and government. As a result, we see a significant reduction in knowledge of the Mi'kmaw language. "In 1970," *The Canadian Encyclopedia* notes,

"there were approximately 6,000 Mi'kmaq speakers, compared to the nearly 9,000 reported in 2016. However, these numbers may be misleading" (McGee, 2021). Indeed, if the increase in the Mi'kmaq population is considered, there has been a 21 percent decrease in knowledge of Mi'kmaq between 1972 (61 percent) and 2016 (40 percent).[4] Further, this decrease does not include Mi'kmaw people not registered with a First Nation, for whom language fluency would be significantly lower. Given this ongoing language crisis, the ways in which Mi'kmaq is represented in film becomes increasingly important. *North Mountain* and *Rhymes for Young Ghouls* both use Mi'kmaw language in ways that normalize the language.

In *The Spirit of Annie Mae*, Mi'kmaw language shapes how Annie Mae Pictou Aquash is represented. "Annie Mae's first language was Mi'kmaq," Martin says, "but with each passing generation it was becoming harder and harder for the culture to survive" (12:56–13:03). Equating culture and language recurs when Linda Cookie Maloney notes that her friend Annie Mae "retained a lot more of her culture than I ever did, when she used to speak Mi'kmaq, you know, some people would have to throw an English word in there. But she was fluent" (48:26–48:34). Aquash's sister, Mary Hubba Lafford, shares that "one of the things that she [Annie Mae] wrote to me about was the language, and it's the women that are going to revive the Mi'kmaq language" (26:50–26:54). Although Mi'kmaq is a minor subject in the documentary as a whole, it is used to show Annie Mae as embedded in her culture and to connect language revitalization to womanhood.

Martin balances her desire to include Mi'kmaq with concerns about accessibility. "I believe in preserving the language," she affirms to Robinson, "but I also want my films to speak to everybody, including our own people, and the language proficiency of Mi'kmaw people in this nation, you know, it's under fifty-one percent." Most Mi'kmaq words in *The Spirit of Annie Mae* are subtitled or explained in English, serving as a placeholder for a time when Mi'kmaw people can reclaim language fluency.

Similar issues of language as a signal of culture are engaged in *North Mountain*. When it came time to recruit actors Hannam explains, "I was talking to Glen [Gould], who asked, 'So are we going to be speaking Sioux?' I'm like, 'Sioux? Why would we be speaking Sioux?' He [Gould] says, 'Because that's in all the old movies,' right?" For Hannam, the use of Mi'kmaq "was a large signifier" that *North Mountain* was not offering

a mainstream representation of Indigeneity but one rooted in language, and through language to land. The first lines in *North Mountain* occur when Wolf, having slain a deer with a contemporary bow and arrow, performs ceremony over the dying animal and offers the words "Msit No'kmaq," meaning "all my relations." Hannam notes that Wolf and Crane are "speaking the language of the land. They're surrounded by the land."

The central relationship in *North Mountain* begins violently as Crane, suffering stab wounds, mistakenly thinks he is being attacked by Wolf and responds in kind. It is only after Wolf and Nukumi speak Mi'kmaq that Crane relaxes and accepts their help. The Mi'kmaq call themselves the L'nu'k, meaning "the people," and Crane's first lines are in Mi'kmaq when he says, "Lnui'sit" (10:47) (you speak the language of the people). Mi'kmaq also shapes the relationship as Crane introduces himself as "Tmgwatignej" (10:53) (Crane or Heron), and Wolf responds with "Paqt'sm" (11:10) (Wolf). The names are significant: Crane evokes images of construction and reinforces the character's connection to New York's skyscrapers, but as Mi'kmaw scholar Raymond Sewell (2014) notes, Tmgwatignej also means "the one with the broken neck" (p. 71), which may pre-figure the scene in which Crane is hanged and nearly dies. Settler symbolism associates the wolf with aggression and loneliness, but the Mi'kmaw emphasize the wolf's bond to pack members and prowess as a hunter.

Hannam considered filming all of *North Mountain* in Mi'kmaq, because as they tell Robinson, "the language comes from the land, and the characters are part of the land, and I was like, 'Oh, it's all this perfect circle.'" By having characters speak Mi'kmaq, directors affirm the language as counter to colonial violence and as fostering peaceful relations with the land and with one another.

Language also shapes *Rhymes for Young Ghouls*, marking Barnaby's characterizations as more accurate than those of mainstream cinema. When students in Robinson's Indigenous Representation in Film course at Dalhousie University first screened the film, one Mi'kmaw woman indicated that she knew it was "the real thing" when she heard Joseph shout, "Don't look, *tu's* [daughter]!" (6:27) in an effort to shield Aila from seeing her mother's body hanging from a rafter of the porch. For Barnaby, using Mi'kmaq is about grounding the film in reality. "I grew up on a reserve," he explains, "surrounded by my language and culture." A

commitment to supporting language runs throughout Barnaby's work. "Every film that I've done has Mi'kmaq in it," he explains. "I think the language has a chance of surviving, and the language, to put it bluntly, is the culture." This view echoes that found in Martin's documentary.

Rhymes for Young Ghouls intentionally positions speaking in Mi'kmaq as a form of resistance to inspire youth to engage with the language. As Barnaby explains, "A lot of the things that you have to battle from Western culture come in the form of entertainment. So, if you ingrain your language into that entertainment, you're kind of Miyagi-ing the youth into thinking it's cool."[5]

As Aila pays Popper the bribe that keeps her out of residential school with cash she hides in an outhouse, she jokes in Mi'kmaq to her friend Maytag, "This is the closest we'll ever come to having our asses kissed by an Indian Agent" (11:02–11:06). Popper is incensed to hear a joke in a language he cannot understand, and his drive to control others demands he punish the use of Mi'kmaq. In his speech to boys interned at St. Dymphna's, Popper explains that speaking in Mi'kmaq will result in being beaten, followed by confinement to an isolation cell. "From here on in," he announces, "it's the Queen's fucking English. Relish it" (23:15–23:17). Aila describes Popper's own language differently, telling the viewer, "Indian agents don't speak Indian. They speak money. They speak it with their boots. They speak it with their fists. They speak it with their blood and bats" (10:29–10:38). Popper's violent repression of Mi'kmaq suggests he is aware of the power of the language to enable alternative understandings and foster rebellion against colonial authorities.

Mi'kmaq is also spoken when Aila has to say something that carries too much emotional weight for her to express in English. When her uncle Burner speculates that prison has broken her father, Joseph, Aila disagrees. Contextualizing her father's actions in the context of loss—of his son, Tyer, to a drunk driving accident; of his wife, Anna, to suicide; and of himself to alcohol, guilt, and self-recrimination—Aila explains, "The joint didn't break him," then switching to Mi'kmaq adds, "we did." As Joseph stumbles in the forest searching for his wife's unmarked grave, he shouts in Mi'kmaq that he dreams she walks the beach as a zombie, unable to rest (44:28–45:07). At the end of the film, as Joseph is arrested, having again claimed responsibility for a crime he didn't commit, Aila puts her hand to the window of the police car and says "Wela'lin," thanking him for the sacrifice that leaves her free. It is possible that English,

as a language of colonial violence, is inadequate for expressing the emotions that result from that violence, but it may also be that the bond that speaking in Mi'kmaq affirms is an integral part of what Aila needs to communicate.

Barnaby believes that seeing Mi'kmaq used as a form of resistance is powerful in itself. "Here's this kick ass character in *Rhymes* speaking Mi'kmaq," he explains, "insulting her oppressors in the language, and it's empowering. That's why I put the language in, because it's still there after centuries of oppression." The longevity of the language, despite settler efforts to eradicate it, serves as a point of "survivance," a combination of resistance and survival that Indigenous scholar Gerald Vizenor (Anishinaabe) calls "an active sense of presence" (1994, vii). For Barnaby, survivance may include realistic representations of Mi'kmaw people in popular cinema. "In my fantasy world," he tells Robinson, "I get to the point where I'm directing, you know, *Iron Man* movies and they're speaking to each other in Mi'kmaq."

VIOLENCE

A third theme emerging in the films examined here is unflinching representation of colonial violence. The violence in *North Mountain* begins offscreen: an altercation has left Crane stabbed and bleeding and Wolf has to knock Crane out with his fists before taking him to safety. The conflict escalates as one of Sylas's men shoots Crane and is killed by Wolf. Discovering the body of their associate in the trunk of his abandoned vehicle, Sylas's men burn Wolf's cabin, killing his grandmother, Nan/Nukumi. They later kill Wolf's aunt Mona, who attempted to protect Wolf by agreeing to lead Silas to Crane.

After an attempted revenge at a motel where Silas and his men are staying leaves Wolf injured, he and Crane retreat to the woods. Anticipating Silas's next attack, they use their hunting skills and knowledge of the territory to their advantage, picking off their enemies with a bear trap, bow and arrow, axe, and rabbit wire. Hannam finds the scenes cathartic, telling Robinson, "I was like, 'Yeah! Have a taste of your own medicine!'" They admit, however, that such catharsis isn't for everyone:

> It's too violent for a lot of people that I meet. They're like, "I would like to watch it but it's too dark, it's too violent, it's too heavy," which I understand. And even I watch it and I'm like, "That's kind of dark

and violent and heavy." And I was a younger, angrier person when I wrote this initially. It was supposed to be more violent, actually. A lot of it got cut out. So, I can only imagine what would have happened if it got filmed.

Hannam's settler antagonists barely have names, and they lack back-stories or motives apart from a taste for money and brutality. In this, they mimic the trope of the "ignoble savage" menacing settlers in films such as *Stagecoach* (1939) and *The Searchers* (1956) or in the portrayals of the Pawnee in films such as *Little Big Man* (1970) and *Dances with Wolves* (1990). Marubbio notes that the western genre created a parallel between Indigenous women and land, suggesting both are deadly unless brought under settler male control (2006, 127). This pattern is avoided in *North Mountain*; the land is not equated with Indigenous women, is not framed as requiring domination, and is portrayed as sustaining and protective rather than malevolent.

Colonial violence is rife in *Rhymes for Young Ghouls.* In the opening credits, Popper's agents pull Mi'kmaw men from a strip club and beat them in the parking lot with fists and baseball bats. Popper frames Aila's uncle Burner as an informant (a move known as "snitch-jacketing"), and the scene cuts to the victims of Popper's men in the previous scene, now attacking Burner with boots, fists, and a two-by-four, unwittingly acting as conduits for colonial violence. Popper later reveals this beating to be a "gift" (recipient unspecified) to celebrate the release of Aila's father from prison (10:57).

Barnaby's villains are cartoonish; Popper and his subordinate, Milch, are the only settler characters with names, and neither has any redeeming features. They are sadists and rapists, corrupt even at the jobs they perform for the colonial authorities. Their attacks are unprovoked, and their victims span all ages and sexes. "I deliberately treated them the way white people have treated Natives in the 100 years of cinema," Barnaby tells Robinson. "They're lucky I didn't give them handlebar mustaches." Barnaby's approach to representing settlers is similar to that of Hannam, although drawing on the action genre more than the western.

The colonial violence in *Rhymes for Young Ghouls* is often impersonal, with Popper and his men viewing Indigenous people as interchangeable. This dynamic is evident in the scene where Aila rides her bicycle along a dirt road where she encounters her friend Sholo

(played by Cody Bird) in his underwear, fleeing Popper's enforcer, Milch (played by Kent McQuaid). Unable to catch Sholo, Milch beats Aila instead. The camera takes Aila's viewpoint as Milch looms over her. "You see Sholo," Milch says, "you tell him somethin' for me?" (12:49). At this, Milch strikes—and the shot goes black. By putting the camera—and thus, the viewer—in Aila's position (on the ground, looking up at her attacker), Barnaby forces settler viewers to experience colonial violence from the victim's perspective. This framing prevents settler viewers from distancing themselves from colonial violence, forcing them to view the world through a Mi'kmaw lens.

The colonial threat to children in *Rhymes for Young Ghouls* begins with the death of Aila's brother, Tyler, and the death of children at St. Dymphna's is a recurring theme, yet it is also children who exact revenge against the colonial powers. Aila is a child in that her attendance at residential school is mandated by the state, but she also an Elder, as indicated by her leadership role as "boss," by her "old lady" Halloween mask, and by her claim to have "aged by a thousand years" (6:46) the day her mother died. This remark echoes her description of The Old Man (played by Stewart Myiow), a veteran of World War II who "left as a teenager and came back a thousand years old" (48:48–48:51). When Joseph finds Aila contemplating suicide due to the guilt she feels over the suffering of her friends and family, he tries to comfort her by saying, "I don't know if you know this, but you're just a little girl" (1:13:57–1:14:03). Aila replies, "I was never a little girl, Dad" (1:14:04–1:14:06). Colonial violence has separated Aila from childhood but resisting it has made her an Elder.

Barnaby speculates that one of the reasons *Rhymes for Young Ghouls* has been so well-received by Indigenous viewers is that it encapsulates their experience. "What I do," Barnaby says, "is capture the anger, grief, and emotion of the moment. Not the reality of factual events." Barnaby connects these feelings to intergenerational trauma, explaining that the "grief and ugliness" he shows "stem from something that happened to your parents, or your grandparents, 200 years ago." While much of the violence Indigenous people have endured has been physical, Barnaby's film also addresses ideological, cultural, and spiritual struggles that occur when colonists try to stamp out Indigenous ways of knowing and being. Barnaby describes epistemological violence viscerally, as a need "to fight that colonist or settler culture, just to have room to breathe."

For Mi'kmaw and other Indigenous viewers, this representation is a breath of fresh air.

In all three films examined here, colonial violence has deadly results for Mi'kmaw women: In *North Mountain* both female characters in the film, Nan and Aunt Mona, are murdered; in *Rhymes for Young Ghouls*, Aila's mother, Anna, commits suicide and Aila's adopted grandmother, Ceres, is murdered; and Martin's documentary centres on the murder of AIM activist Annie Mae Pictou Aquash, but also recounts her experience of male violence in her relationship with Nogeeshik Aquash, at the hands of American authorities, and from men in the American Indian Movement. Through her use of camera placement, Cathy Martin focuses on the personhood of Annie Mae Pictou Aquash and on her relationship to her daughters.

As noted earlier, Martin's documentary begins with an extreme close-up of Deborah Maloney-Pictou, one of Annie Mae's daughters, now an adult. We see her right ear, brow, cheek, and jaw in profile, her dark hair drawn back. Rather than looking *at* her, the camera is peering over her shoulder, looking *with* her. This shot creates a sense of intimacy and that feeling is reinforced as Maloney-Pictou's voice begins describing her experience as a police officer, interviewing suspects that have looked her in the eye and lied to her. Combined with the tight camera focus, Maloney-Pictou's soft, calm words sound like a secret. Two-thirds of this shot has the background out of focus—blue over green—then that space is filled as Maloney-Pictou raises a rifle to her shoulder and takes aim through the scope, in which we briefly see her face reflected. As she mentions looking people in the eye the camera cuts to a front shot, tight on Maloney-Pictou's dark brown eye, then pans lower as her finger curls around the trigger of the rifle. We hear birds chirp, and an eerie sound (possibly an EBow) warns us something is about to happen. The next cut is to the rifle barrel as the shot fires, the recoil pulling it almost out of shot. Having been shown the gun, Maloney-Pictou taking aim, and finally the barrel, the shot is not alarming when it comes.

The camera shifts to a medium close-up in which we see Maloney-Pictou's face in full for the first time. She looks pleased, as if she has hit her target, and the image of her as a hunter is reinforced by her camouflage and orange vest against a background of red and yellow leaves. Before Maloney-Pictou walks out of frame we hear her voice, "I'd like to look in the eyes of the people who murdered my mother"

(0:29–0:33). At this point, the ominous music swells, and the EBow is joined by a haunting flute, shaker, and hand drum, as the camera cuts to a full image of Maloney-Pictou, back to the viewer now, walking across a field ringed in trees that extend to the horizon as the opening credits roll. The music gives way to the sound of helicopters, and the image cuts to black-and-white shots from South Dakota in September of 1975, helicopters flying behind an American flag as armed men move around armoured personnel carriers and other vehicles. We hear gunshots and bullet ricochets behind the thin voice of Annie Mae Pictou Aquash as she describes the injustices that drew her and other AIM activists to the reservation in South Dakota. The violence represented by the helicopters and armoured vehicles intervenes in the mother-daughter bond, but cannot sever it, as Martin features Deborah Maloney-Pictou and her older sister, Denise Maloney-Pictou (credited as Pictou Maloney) throughout the documentary, reaffirming Anna Mae's belonging to family.

Although *The Spirit of Annie Mae* highlights Annie Mae Pictou Aquash's experiences of violence and details her murder, she does not fall into the Celluloid Maiden trope described by Marubbio (2006). Annie Mae's death is presented as resulting from choices made by the American government and the American Indian Movement, and lacks the personal culpability associated with the Celluloid Maiden, and her unwavering allegiance to Indigenous people further distinguishes her from the trope. She more closely resembles a figure Marubbio calls the Indian Queen, "the warrior woman and the mother-goddess" (2006, 10) who "embodies the qualities of the feminized and premodern New World, including the danger awaiting the colonial forces there" (2006, 203). Marubbio's analysis of the character Maggie Eagle Bear in the film *Thunderheart* (1992) summarizes the Indian Queen trope: "she fights against the power structures that abuse the federal-Indian treaty relationship and for the rights of [I]ndigenous people" (2006, 203). This similarity is unsurprising, as Marubbio notes that Annie Mae's life inspired the Eagle Bear character.

GENDER AND SEXUALITY

All three films we examined reject the hierarchical and binary gender system imposed by residential schools in favour of Indigenous gender roles that support two-spirit identity and women's leadership. In *The Spirit of Annie Mae*, Martin rejects stereotypes of subordinate and silent Indigenous women, adding balance to the history of AIM by bringing

women's testimony to the foreground. "The story of AIM has only been told by men, about men," Martin tells Robinson, when in reality, "the Clan Mothers, the women, did much of the work and the promotion and raising the money to help people go to court, and doing all the grassroots stuff." This approach to activism is one that Martin sees as innate to Mi'kmaw culture. "There's always a head of the family," she explains, "always the woman. Somewhere. Either it's a Grandmother, or a Great Auntie, or a Mother, that unless she says something, it doesn't happen." Martin's work affirms Annie Mae Pictou (later, Pictou Aquash) as a matriarch by making her relationship with her daughters a central thread. "I truly believe that we [the Mi'kmaq] are a matriarchal and matricultural society," Martin tells Robinson, "yet the five hundred years of oppression and colonization ... people have forgotten who they are." In Martin's documentary she reminds us of who we are as women by showing us who specific Mi'kmaw women have been in specific times, places, and events. This isn't hagiography; Martin gives interviewees space to critique Annie Mae and others, and what results feels more critical and honest than an idealistic portrayal of a cultural hero.

Martin's approach centres and humanizes the women in her documentary, countering settler patterns of dehumanization. In a 2010 article for *Feminist Media Studies*, Kristen Gilchrist notes that Indigenous women who are missing or murdered receive three and a half times less press coverage than settler women, and that articles about Indigenous women are shorter, detached in tone, and give fewer intimate details of the woman's life. Martin's documentary avoids this pattern by close shots of women's faces, aligning camera angles with their eyelines, and authorizing them as the narrators and reporters of history.

Leadership by Mi'kmaw women is also present in *Rhymes for Young Ghouls*, where Aila directs youth and adults around her to run the bootlegging empire that provides the money to keep her and her friends out of St. Dymphna's. Her uncle Burner and her father, Joseph, both take direction from her, even if reluctantly. Settler media tends to stereotype Indigenous women as maidens whose attraction for settler men leads them to support conquest, as found in Terrence Malick's film *The New World* (2005) (Marubbio 2006, 229–30), or, as a "squaw" whose sexuality and reproduction are excessive and make her the victim of violence, as seen in settler news coverage of Missing and Murdered Indigenous Women (Bird 1999; Marubbio 2006; Kopacz and Lawton 2011). *Rhymes for Young Ghouls* forms a counter-narrative, making Aila an action

hero akin to Ripley (played by Sigourney Weaver) in the *Alien* franchise (Carroll et al. 1979).

A number of elements in *Rhymes for Young Ghouls* shift Aila's gender toward masculinity on a settler spectrum. Her treehouse, "The Fortress of Solitude," frames her as Superman. She rides a boy's lowrider Stingray bike to which an animal skull has been attached. The film also makes a parallel to *Hamlet*, with Aila being urged to vengeance by the ghost of a dead parent. The wardrobe de-genders Aila, especially the gasmask she wears to protect herself from the fumes of paint or drugs. The scene in which Aila is stripped by nuns reveals a grey Henley, white tank top, grey men's underwear, and no bra. For Barnaby this reflects his commitment to represent Indigenous women accurately, and "that's the way women dressed from my res in the 70s," he explains. The choice makes sense for the character, whose practicality and lack of money leads her to wear whatever was left by Joseph when he went to prison.

Aila's characterization counters the Celluloid Maiden trope (Marubbio 2006, 57–58, 70) by not aligning herself to a settler figure and by surviving. Aila evades the trope so successfully that freelance writer Ali Nahdee (Anishinaabe/Ojibwe) crafted The Aila Test,[6] which assesses characters on three criteria: "1. Is she an Indigenous /Aboriginal woman who is a main character ... 2. Who DOES NOT fall in love with a white man ... 3. And DOES NOT end up raped or murdered at any point in the story" (Nahdee 2017, emphasis in original). Anthropologist Dr. Blair Topash-Caldwell (Potawatomi) notes that the "simplicity" of the criteria of the Aila Test "gestures to the horrifying fact that Indigenous women are stock figures whose sole purpose is to be victims of White male aggression and sexual desires in cinematic stories" (2020, 32). By avoiding this sexual submission Aila has become a standard against which to assess other characterizations of Indigenous women.

Barnaby relates that Aila's character emerged when he challenged himself to write from a perspective different from his own. What results is a character that breaks stereotypes that hypersexualize Indigenous women. Aila's peers do not treat her as a sexual object; she is sexualized only in her interactions with Popper and Milch. Although settler funders questioned why sexual aggression didn't figure more prominently in his film, Barnaby tells Robinson:

> I didn't want to directly address it in the sense that like she was
> the survivor of a rape, or anything like that. It was more about her

being autonomous as a woman, and her being strong as a person.
... I don't think it [sexual violence] needed to be the defining qual-
ity of where this person got her strength from.

Instead we see Aila's strength as necessitated by the death of her mother,
which ages her beyond her years, and by the arrest of her father, which
makes her the head of the family. As Burner explains when Joseph com-
plains about Aila's involvement in the bootlegging business, "D'you even
know your girl, Man? Huh Jo? She's a coupling of Anna, Ceres, and your
fucking hard head. She's gonna be eating people after the apocalypse.
What makes you think any of this was my idea?" (29:13–29:29). Aila's
leadership is challenged by Joseph's return, but Burner prefers Aila's dir-
ection over that of his brother and backs her when they disagree.

Barnaby's directorial choices open space for Aila to be perceived
as a sexual subject rather than an object, and to be read as two-spirit.
Barnaby shared with Robinson that he thought of Aila's character as
"totally gay." He laughs. "I think everybody thinks that, too, because Aila
has such a huge gay following." Barnaby supposes Aila's independence
speaks to people "because she's not letting anything, or anybody define
her, or how she's going to live her life." Yet even as the film creates space
for Aila's difference, it distances her from categories like gay, lesbian, or
bisexual through her use of homophobia. In one of the first scenes we
see of Aila, she paints an image of Gunner, a female warrior who kills
zombies and protects children, on the side of her friend Maytag's van.
"I still don't see why it has to be a girl," Maytag complains. Aila smirks.
"Cause if it ain't," she says, "people'll think you're a fag" (9:25–9:33). As
Barnaby explains, when a "male that has the nerve to question her, she
directly challenges his sexuality with homoeroticism." A similar scene
occurs later, when Aila goes to visit her friend Sholo and is kept waiting
as he rouses himself from a hangover. "What the fuck were you doin'?"
she demands, "shavin' yer legs?" (38:59). Homophobia recurs when
Joseph fails to show interest in Tammy, a settler woman with whom
Burner attempts to set him up. "Still like women, right?" Burner asks
(28:53). When Joseph snubs him Burner shrugs. "Well I don't know. You
just got outta prison" (28:59). Later, Popper taunts Joseph, "That's your
ass, back in jail. You must enjoy the company of men" (52:17). Milch
immediately reiterates the taunt in more graphic terms.

A Mi'kmaw context in which Indigenous women are equals to men
makes Aila's homophobia differ slightly from that of Popper and Milch,

for whom White masculinity signals superiority. In that context, each homophobic joke evokes the sexual violence being visited upon the boys at St. Dymphna's by their male dominators.

While statements about sexuality are used as a weapon, gender is more flexible, with Sholo using the phrase "Jam out wit' yer clam out" (1:00:55) despite describing an activity involving three males and Aila. Although Barnaby does not shy from representing colonial masculinity, Rhymes breaks expected patterns by refusing to objectify or hypersexualize Indigenous female characters.

North Mountain also draws on Mi'kmaw understandings of gender and sexuality. As a film about two-spirit people (Wolf and Crane), by a two-spirit filmmaker (Hannam), for an audience that includes two-spirit people, *North Mountain* is by, about, and for an insider audience. This is clear in the way the film unapologetically represents the relationship between Crane and Wolf as sexual, yet never uses the term "two-spirit." Rather, *North Mountain* relies on the ways their relationship challenges colonial notions of gender and sexuality to distinguish Crane and Wolf as two-spirit.

North Mountain subverts masculine gender performance. As Hannam explains, "It's not intended to be two very macho, 'masc. for masc.'[7] fellows in the woods that have, you know, soft feelings for one another." Hannam presents Wolf and Crane as independent people whose personalities, experiences, and skillsets make them compatible. "They are stronger with each other," Hannam says, "and they're stronger with the community, and they each have strengths and weaknesses." Crane and Wolf move fluidly between gendered roles. At the beginning of the film, Wolf takes a nurturing role, preparing food for his grandmother and nursing Crane back to health. Wolf is also a hunter, killing deer to feed Nan and himself, and easily killing one of Silas's men to protect Crane. When Silas's men burn Nan to death in her cabin, Wolf attacks them at their motel, but is outmatched and barely escapes with his life. Crane tends to Wolf's wounds and draws on his broader life experience to provide insight and guidance. Hannam's film allows roles of protector/protected to manifest in a circular way, as opposed to a linear shift in a hierarchical colonial binary.

Wolf performs traditionally masculine activities, such as hunting, and traditionally feminine activities, such as preparing food. That Wolf doesn't agonize about what such actions mean for his identity makes the

film feel culturally Mi'kmaw. The strength Crane and Wolf use to overcome the odds against them stems from connection to the land, culture, and each other, not from identity labels. These are not gay tough guys who find love in the wilds of Nova Scotia. As Hannam explains:

> The way that I wrote the character [Wolf], he has a more fluid gender and sexual identity. Wouldn't bat an eyelash tomorrow if he fell in love with a woman, or a transgender person. That's fine. At this point in life he's attracted to this particular thing, but that doesn't mean that that's what it's always going to be. Because, again, we are always changing, the world is changing, and the [Mi'kmaw] language is mostly verbs, right?

Hannam's explanation highlights a Mi'kmaw/L'nuey focus on change that challenges identity politics and notions of "happily ever after." L'nu scholar John R. Sylliboy (2019) describes human beings as constantly in flux within the L'nuey worldview, and as interconnected to all other life, which is also constantly changing. Rather than being born into a category such as "gay" and expressing that category more fully over time, Sylliboy describes the L'nuey perspective as one in which individuals are "constantly evolving, developing, transforming, to reach their optimal level of balance" (2019, 105). In *North Mountain*, Wolf and Crane are drawn to one another, and express their connection sexually, but that doesn't come with a mandatory identity. Any sex that occurs in *North Mountain* takes place off camera, leaving settler viewers unclear what their encounters entail, or what they mean in a settler framework.

Hannam's engagement with two-spirit identity frees *North Mountain* from conventional depictions of same-sex love. For decades, LGBTQ cinema was marred with forlorn characters and tragic endings, a trope that, as mentioned earlier, has been named "Bury Your Gays" (Deshler 2017; Waggoner 2017). *North Mountain* challenges this trope by having both Wolf and Crane survive even while everyone around them dies. Hannam puts it bluntly: "I wouldn't call it a wonderfully happy ending but it's not a devastatingly tragic gay ending, or like all Native people have to die at the end." By the time the final credits roll, both two-spirit characters have triumphed over the representations of a corrupt, flawed system, although they've paid a heavy price.

CONCLUSIONS

All three films analyzed here have represented the Mi'kmaq as contemporary people, countering frameworks that associate Indigenous authenticity with the pre-colonial past. Yet all three are also slightly out of sync with the present. *Rhymes for Young Ghouls* and *North Mountain* are both vaguely period pieces, and *The Spirit of Annie Mae* documents the life of a woman who lived from 1945 to 1975. *North Mountain* and *The Spirit of Annie Mae* prefigure an Indigenous future by visually and symbolically erasing elements of colonial occupation from the land while using contemporary weapons such as the rifle and the compound bow to identify the period as post- rather than pre-colonial.

In their use of land, language, violence, gender, and sexuality, these films reveal such categories to be fluid and interrelated rather than discrete boxes. Each director interviewed for this project presents a distinct vision of Mi'kmaw life, but L'nuizes film in ways that resonate with Mi'kmaw viewers, and in capturing this specificity, finds the universality that appeals more broadly to people who relate to the experience of being an outsider to the dominating culture. The Mi'kmaw characters and people in these films do not fit familiar tropes. Aila is neither a maiden nor a squaw, Crane and Wolf are not heroes of emerging "gaystream" film, and Annie Mae is not a case study of "Missing and Murdered Indigenous Women." The Mi'kmaq in these works are individuals, rooted in territory, language, and culture in ways that enable them to resist assimilation, and teach others how they might resist too.

The self-empowerment of Indigenous artists through movements like the "New Wave," or "Next Wave," opens space in which cultural specificity can speak back to stereotypes that are ubiquitous in mainstream film and other artworks. By embodying an Indigenous gaze, and making that gaze specifically Mi'kmaw, directors Martin, Barnaby, and Hannam support the kind of cultural continuity that empowers Mi'kmaw youth and enables them to envision a future that is both worth living and is innately Mi'kmaw.

Note: Dr. Robinson wishes to acknowledge Dr. Rachel Freedman Stapleton for her contributions to editing and developing this chapter.

NOTES

1 With heavy hearts and enduring admiration the editors of this book and authors of this chapter acknowledge the inimitable talent and creatively expansive work of Jeff Barnaby, who left this plane too early when he passed on October 13, 2022. His boundless artistic spirit and political grit lives on in the cinematic gifts he has left for all of us to experience, return to and reflect upon.

2 This research was reviewed and approved by the Research Ethics Board of Dalhousie University and by Mi'kmaw Ethics Watch.

3 Robinson interviewed Martin and Hannam in person and Barnaby by phone. Interviews were recorded and participants provided with transcripts to confirm or correct the text. Following recommendations of Simonds and Christopher (2013), films and interviews were not broken into units but examined as wholes. We watched the films multiple times, and reflected on points of similarity through notetaking, reflection, dreams, and discussion. Film analysis was triangulated with interview transcripts for resonance or conflict.

4 Robinson calculated these figures using data from Statistics Canada, *The Canadian Encyclopedia*, and encyclopedia.com. Figures from Newfoundland and Labrador were removed from 2016 because those regions had not been included in the 1972 data.

5 Barnaby is referring to the character of Mr. Miyagi (played by Pat Morita), a karate sensei in *The Karate Kid* (1984).

6 This evaluation is modeled from the Bechdel–Wallace test (Jusino 2015), which appeared in Alison Bechdel's comic series *Dykes to Watch Out For*. To pass that test a film (or other media work) must have at least two women in it, who must speak to one another, and their discussion topic must be something other than a man.

7 Shorthand for "masculine for masculine," indicating a masculine man seeking a masculine male partner.

Not Reconciled: The Complex Legacy of Films on Canadian "Indian" Residential Schools

Brenda Longfellow

A MEDIATIZED EVENT

From the launch of Canada's Truth and Reconciliation Commission on Indian Residential Schools (TRC) in 2008 to the closing three-day ceremony in 2015 in Ottawa, the TRC was an intensely mediatized event. National events were broadcast on major networks; many of the public hearings, panels, and circles went live on the web; and the work of the Commission—as it hosted massive gatherings in major cities and remote Northern communities—was covered intensely in print, radio, and television press. Media items included a Canadian Broadcast Corporation (CBC) series of extended news items;[1] a Canadian Heritage moment;[2] Gord Downie's *The Secret Path*[3] (which was broadcast and livestreamed in October 2016 and followed by a live panel discussing reconciliation); an episode of Viceland and APTN's documentary series *Rise*, written and directed by Michelle Latimer, called "Indigenous Peoples in Residential Schools"; and the Al Jazeera Canada feature documentary *Canada's Dark Secret*,[4] to name only a few of the many productions released throughout the course of the Commission.

In 1990 when Phil Fontaine (then the head of the Assembly of Manitoba Chiefs) disclosed that he had been sexually abused in residential school on CBC's *The Journal*[5] that unprecedented media event shocked audiences and became one of the many factors sparking a powerful cross-nation movement demanding redress that culminated in the

Indian Residential School Settlement Agreement (IRSSA) in 2007—the largest class action settlement in Canadian history.[6] Twenty-eight years later, Fontaine's disclosure has been amplified by dozens of interviews with residential school survivors on national broadcasts, both leading up to and during the course of the TRC. The ongoing mediatization of these stories has played a crucial role in the articulation of new kinds of claims, both political and legal, and in the formulation of new public understandings of the legacy of residential schools.

The work of the TRC, however, also overlapped with an unprecedented grassroots explosion of Idle No More, whose organizers' media tactics, representational strategies, and political emphasis stood in stark contrast with those of the TRC. Explicitly tied to environmental struggles over pipelines and water protection, the Idle No More movement combined a trenchant critique of colonialism with an understanding of the ways in which neo-liberalism and unfettered corporate expansion are implicated in ongoing Indigenous dispossession. The prime modus operandi of the movement was the tactical, dispersed, and aggregating affordances of social media, and within a few short months, organizers were drawing millions of people to Idle No More websites, hashtags, and Facebook pages. Chief Theresa Spence's hunger strike on Victoria Island in 2013 built additional momentum and focused national attention on the appalling conditions in remote reserves such as Attawapiskat.

I reference Idle No More because it helps situate and contextualize the particularity of the IRSSA and the TRC as one mode—and one mode only—of historical redress and reconfiguration of the relation between the settler-colonial state and Indigenous peoples. Indeed, the question posed by the most trenchant Indigenous critics of the TRC, such as Audra Simpson, Dian Million, Glen Sean Coulthard, and Leanne Betasamosake Simpson (among others) is: Why the focus on residential schools now? How did the horrifying legacy of residential schools come to function as what Jennifer Henderson (2013, 67) calls "a synecdoche of colonialism," displacing other considerations around land claims, treaties, and dispossession? How, as Dian Million asks in *Therapeutic Nations: Healing in an Age of Indigenous Human Rights*, did the colonized subject became a trauma victim?

The answer is obviously deeply complex, and Million explores her question through a detailed historical investigation of the evolution of the UN Declaration on the Rights of Indigenous Peoples,[7] documenting

how varied political regimes in Australia, New Zealand, Canada, and the United States have taken up the issue of colonial restitution in response to Indigenous political and legal struggles. While this chapter can only sketch out the broad contours of Million's argument, what I would like to call attention to and will be exploring in the pages that follow is how her question implicates issues of framing and how meaning is interpreted, processed, and most importantly, becomes "sayable" and comprehensible. As Million states, "The discourse around the residential schools is a *conceptual* site where Canada's historical narratives about 'Indians' are organized to be articulated into the present" (2013, 74, my emphasis). Million interrogates the inevitability of this conceptual site by pointing to the 1996 *Report of the Royal Commission on Aboriginal Peoples* (RCAP),[8] written in the wake of Oka[9] and involving extensive consultation and collaboration with Indigenous leaders and communities. The RCAP's long list of final recommendations were driven by an explicit and clear advocacy of Indigenous political self-determination and called for "substantive Indigenous political empowerment" (Million 2013, 6). As with many Royal Commissions, these recommendations were largely ignored or tabled. While there was little movement at the political level during this time period, there was a massive intervention within the court system via the consolidation of thousands of individual and class action suits against perpetrators of abuse in the residential school system. The resulting IRSSA in 2007 foregrounded residential schools as a prime embodiment of colonial injustice and, as part of the settlement, mandated the 60-million-dollar budgeted Truth and Reconciliation Commission "to inform all Canadians about what happened in the 150 year history of the residential schools, and guide and inspire a process of reconciliation and renewed relationships based on mutual understanding and respect."[10] With the inauguration of the TRC, the hegemonic public framing of the issue of a reconstituted settler/Indigenous relation switched from a consideration of collective self-determination in the political sphere to a focus on individual compensation in the legal arena, to a pedagogical mandate in the cultural sphere. In this process, as Dale Turner points out, "renewal," understood in the RCAP report as the attempt "to implement the nation-to-nation political relationship," is both eclipsed and marginalized (though, obviously, never entirely repressed) as a new political currency of reconciliation is foregrounded, with a focus on "healing" and therapeutic reparation (Turner 2013, 100). Within the discursive frame of the TRC, "truth," as Million and Turner

argue, is largely confined to testimonials of traumatizing abuse and individual violence whose spectacular affective charge is key to suturing attention and to the constitution of specific spectatorial spaces and subjectivities. For Audra Simpson, the excavation and appropriation of affect, in fact, represents a core operation in new forms of settler governance, as the public face of the state is transformed from its disciplinary iteration to a reconstituted liberal posture where contrition, apology, and an avowed investment in symbolic reconciliation animate new policies, while material issues of land and territory remain deeply confrontational and unresolved (2016b).

The critique of the TRC by Indigenous scholars and allies provides an essential frame for considering the moving image legacy of residential schools in Canada, and points to a complex discursive field with competing and historically mediated framings of the structure and history of colonialism. Interrogating the inevitability and singular focus on trauma allows us to question the primacy, political efficacy, and ethical implications whereby the testimonial is continuously privileged as the primary mode of narrating history, as a memory artefact, legal claim, and mode of affective intensity that proffers very particular subject positions. As a settler woman who grew up on the Robinson-Huron Treaty territory and who works in the ancestral traditional territories of the Ojibwe, the Anishinaabe, and the Mississaugas of the Credit First Nation, I'm aware of my status as an uninvited visitor, not only in relation to occupied territory, but also epistemologically. I could never presume to know how Indigenous audiences, particularly audiences with an embodied, experiential memory of residential schools, respond to and make meaning from the vast store of media on residential schools. Clearly the distinction of experience mediates and shapes reception in ways that are radically different from the reception of media on residential schools by settler audiences, who are positioned and addressed, for the most part, as potentially empathetic yet deeply ignorant of the extent of human rights abuses and state-sanctioned violence. Throughout this chapter, I try to highlight and am sensitive to the fact that reception is irreducibly dependent on which side of the colonial divide one is situated on, a divide mediated by the asymmetrical impacts of colonial benefits and harms.

This chapter is in no way comprehensive. The body of moving image films, broadcasts, and archives produced on the topic of residential schools in Canada is large and growing and there are many fascinating

examples[11] that I've had to ignore in the interest of space and for the sake of cogency of argument. My research is thus confined to a key question: How have different institutional sites and public discursive shifts shaped the moving image representation of residential schools? Both the CBC and the National Film Board of Canada (NFB) have had a very long and sustained engagement with the representation of residential schools, beginning in the 1960s and culminating with recent television broadcasts and films produced in response to the new era of reconciliation catalyzed by the IRSSA and the TRC. Both agencies, but particularly the CBC as a national public broadcaster, saw themselves as playing a key, if not foundational role in realizing the public education mandate of the TRC and in facilitating public interest and investment in a new, reformulated relationship between the settler state and Indigenous peoples.[12] But this new relationship, as many of the critics of the TRC have pointed out, is almost certainly constrained, shaped, and interpreted in relation to the overarching mandate of these agencies to represent the national interest of Canada, a settler state whose own sovereignty and, indeed, whose legitimacy has been dependent on the intentional extinction of Indigenous sovereignty. I'm interested in how this contradiction plays out over time and becomes manifest in key films and media productions produced over the past 60 years.

PROPAGANDIZING COLONIAL PORTRAITS

The audio-visual legacy of residential schools begins with the collection of still photographs—approximately 35,000 in total—taken between 1885 and 1996 and housed in multiple church and school archives, at Library and Archives Canada in Ottawa, and in digital form at the National Centre for Truth and Reconciliation in Winnipeg. This voluminous collection, encompassing photographs from dozens of distinct institutions, reveals in its iterative banality the calculating, disciplinary operations of settler governmentality that regulated every aspect of Indigenous children's lives. Hair cut in bobs for girls and military buzz cuts for boys, dressed in school uniforms and frozen in postures of obeisance, the children are figured as objects of a clinical gaze, exhaustive bureaucratic proof of the success of the schools' colonizing mission: to Christianize and assimilate. However, as Naomi Angel and Pauline Wakeham (2016) argue in "Witnessing *In Camera*: Photographic Reflections on Truth and Reconciliation," these photographs represent

a semiotically confounding legacy. While providing evidentiary proof of the particular regimes of instruction and work, the photographs for the most part are completely staged, and as such, deliver a highly sanitized version of daily operations. Intended to bolster a public narrative and, most importantly, an institutional rationalization of the school's alleged benevolent mission, the photographs, without significant contemporary remediation and reframing, repeat a colonial version of history with endless redundancy.

Not surprisingly, the first moving image representations of residential schools were produced by Canada's major cultural agencies, the NFB and the CBC, and are framed in relation to both agencies' founding mandates to produce and disseminate media in the national interest.[13] The first mention occurs in *People of the Potlach*,[14] produced in 1944 as part of a "Peoples of Canada" NFB series initiated by John Grierson, who contracted Laura Boulton, a US amateur music ethnologist, dilettante,[15] and travel writer to direct. While the film credits Marius Barbeau (then museum anthropologist at the National Museum in Ottawa) as a consultant, Robert McMillan points out the narration is "riddled with contradictions" as Haida and Tsimshian cultures "are intermixed carelessly" (1991, 75). The significance of the potlach (then still outlawed) is never discussed in any detail as continuous narration and the ethnographic gaze of the film appropriate a salvage anthropological perspective,[16] noting the positive adaptation of "potlach people" to new conditions of Christianity and modernity. A key component of this adaptation, according to the film, includes attendance at "Canadian Government schools," and as we see images of happy children doing jumping jacks and performing calisthenics, the narrator informs us that while nomadic for part of the year, these children "get the benefit of learning to work and play together" in such schools.

Two short films produced at the CBC and NFB at the end of the 1950s and beginning of the 1960s evince a less explicit ethnographic obsession with an exotic, "vanishing" culture and are more focused on the ways in which assimilation and the acculturation of children into mainstream Canadian values represent an unimpeachable positive outcome. Both *Off to School* (1958), an NFB news reportage on unusual schools for children in Canada, and *The Eyes of Children—Life at Residential School* (1962), produced out of the Vancouver office of the CBC, are highly choreographed and intended to bolster a public narrative around

the normativity of the schools' Christianizing mission. In *Off to School*, the residential school at Moose Factory is presented as one of a series of unique educational experiences administered by a government intent on ensuring equal access of opportunity to all children. Referenced in the narration as a "flourishing, modern school for young Indians," run by the Anglican church, the school is never explicitly named but it could well be the Bishop Horden Residential School, named in the IRSSA on behalf of nine survivors who pursued claims of abuse. Abuse, of course, is a galaxy away from the cheery, happy world of laughing children portrayed in the film, which is narrated by a voice of god baritone who, in the paternalistic racism of the day, points out the "flair for decoration" that the "Indian" students have, adding that "pupils with names like Jimmy Otter, Norman Icebound, and Able Trapper soon learn that getting an education doesn't have to be sheer drudgery." As an educational short, the film conforms precisely with Zoë Druick's thesis in *Projecting Canada* (2007) that NFB documentaries have frequently functioned as a technology of liberal governance as they project the image of Canada as a unified, cohesive, and benevolent nation. The closing narration, in fact, explicitly references the avowed biopolitical aim of the state in running residential schools: "to make the country's 150,000 Indian population increasingly independent and self-supporting," an intent that was obviously bound to the assimilatory project of Indigenous elimination.

The CBC 1962 Christmas special, *The Eyes of Children*, also represents Indigenous children as singularly joyful and advantaged by the school's tender and nurturing care. The school featured here, however, is the notorious Kamloops Residential School for Indian Children (whose genocidal legacy was confirmed by the horrifying discovery in May 2021 of an unmarked burial site of 215 Indigenous children on its grounds).[17] Built on the territory of the Tk'emlúps te Secwépemc First Nation, the Kamloops Indian Residential School was one of the largest of Canada's institutions designed to violently segregate Indigenous youth from their communities and cultures. It operated from 1890 to 1969, mostly under a Catholic order, but the federal government ran it as a day school for nine more years before it closed in 1978.

The Eyes of Children follows the school's Christmas festivities: hymn and poem recitations led by a kindly nun, a school pageant with children dressed as angels and Wise Men, and a bizarre lecture on the history of Saint Nicholas, which involves the miraculous resurrection of children

doomed to be eaten in a Polish famine.[18] Broadcast on December 25, 1962, the film evokes seasonal sentimentality as it observes the participation of Indigenous subjects in typical Christian activities. At a time when the Canadian census listed 70 percent of the population as affiliated to a Christian denomination,[19] the program was clearly aimed at addressing a settler audience, for whom the danger or threat of difference is contained by the overt choreographing of Indigenous children as devout Christian subjects. The violent and coercive aspects of such Christianization processes are hidden off-screen away from the camera's view.

The coercive aspects of residential schools were not, obviously, unknown in Indigenous communities, as Tricia Logan (2017) observes in her unpublished dissertation *Indian Residential Schools, Settler Colonialism and Their Narratives in Canadian History*: "Oral histories of the schools circulated throughout Aboriginal communities and as silences between family members who were affected by the legacy of the schools" (38). The discipline of shame enforced by schools and churches and the well-founded belief that no authorities would believe any claim obviously made public disclosure of abuse intensely difficult, if not impossible. This did not mean there wasn't resistance to the violent regimes of the schools. From the inauguration of the schools in the 1880s, many Indigenous families expressed their outrage by hiding children or moving on to the land to prevent their children from being taken. Children also ran away, and through the course of the TRC hearings, multiple survivors recounted micro acts of resistance in stealing food, caring for each other, and even "drinking sacramental wine" (Niezen, 26).[20]

DOCUMENTING INDIGENOUS RESISTANCE AND THE EVOLUTION OF A HUMAN RIGHTS DISCOURSE

The first film to explicitly document Indigenous resistance to residential schools is *PowWow at Duck Lake* (prod. David Hughes, 1967), a short produced at the National Film Board under the aegis of the newly constituted Challenge for Change Program.[21] The bland title disguises what is extraordinary about the film as it documents and makes public a confrontation between Indigenous members of the Duck Lake community and an arrogant Catholic priest who is principal of a local residential school. Although directed by non-Indigenous filmmakers (*PowWow at Duck Lake* precedes the formation of the Indian Film Crew by one

year), the film represents a radical departure from other documentaries produced at the NFB on the "Indian problem" by the unadorned space it gives to Indigenous voices. The paternalistic and ethnographic voice-over narration evident in *People of the Potlach* or in *Off to School* has vanished, replaced by the documentation of passionate synch speech acts and by an energetic and observational style of camera work that embodies spontaneity, visual commentary (as in the low-angle unflattering shots of the priest), and receptivity to group dynamics. From the inclusion of the opening song and jokes about Indian agents to the fiery speeches by activists Harold Cardinal and Howard Adams on the ongoing discrimination and second-class status of Indigenous people in Canada, the film is unequivocally allied with an Indigenous perspective.

Ronald Niezen, in his provocative book on the TRC, *Truth and Indignation* (2017), also views the confrontation in *PowWow at Duck Lake* as an unprecedented discursive intervention, one marking a crucial shift as shame and secrecy give way to a sense of solidarity and awareness of "a shared condition of injustice," a key prerequisite, Niezen argues, on the way to a "judicially mobilized sense of indignation" and the articulation of collective harm (26). *PowWow at Duck Lake* provides ample evidence of how this sense of solidarity and collective articulation of harm are developing both in the repeated references by speakers to the inalienable rights of all peoples ("We are human beings, just like everyone else," says Harold Cardinal); in the song lyrics which avow that [the "Indian"] "only wants to live as other men in a land created for all"; and in the more inchoate formation of the crowd, which murmurs its approval and laughs uproariously when a speaker jokes that "freedom has no colour … it's pure white." As Niezen points out, what had been unthinkable only a few decades prior (standing up to the authority of the Catholic Church) was now actionable, a phenomenon obviously linked, I would argue, to other human rights struggles of the sixties, including post-colonial movements in Africa and Latin America, a resurgent American Indian Movement, and the civil rights movement in the United States. Of course, equal rights for all is a cornerstone of national myths concerning the settler state of Canada, and the discourse of human rights runs the risk, as Dian Million and others have pointed out, of accommodating difference rather than redistributing property and land (Million 2013). But in 1967, during a year of boosterish Canadian pride in the centennial celebration of Confederation, *PowWow at*

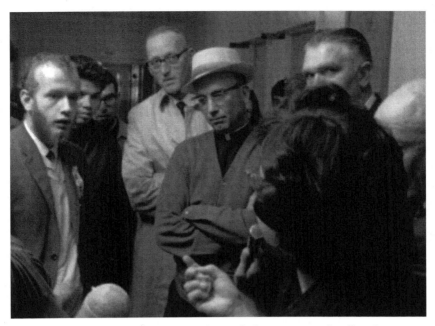

FIGURE 5.1 A public confrontation with a Catholic priest over the alleged
beneficence of residential schools in *Pow Wow at Duck Lake*. Frame grab courtesy
National Film Board of Canada.

Duck Lake provides a sharp prod to the unravelling of the settler myth
of Canada as a beacon of equality. It was perhaps for that reason that
the NFB insisted on the disclaimer embedded in the final credits that
films produced for Challenge for Change are "experimental in nature,
offer[ing] platforms for strong and often purely personal viewpoints."

The next film to interrogate the alleged beneficence of the residen-
tial school mission, although from a distinctly more accommodationist
perspective, was the NFB's *Cold Journey*, directed by a non-Indigenous
director, Martin Defalco, and released in 1975. *Cold Journey* grew dir-
ectly out of the work done by the Indian Film Crew, which had provided
training to key Indigenous participants including Mike Kanentakeron
Mitchell and Noel Starblanket. Both were survivors of residential
schools and, according to an interview in *Cinema Canada* with Defalco,
it was Starblanket who had suggested the topic of residential schools
as a fitting one for a film treatment.[22] There were other key cross-
over personnel from the Indian Film Crew: Defalco had co-directed
the documentary *The Other Side of the Ledger: An Indian View of the*

Hudson Bay Company with Willie Dunn (1972, 42 minutes), who went on to compose the music for *Cold Journey*, and Mitchell is listed in the film's credits as community liaison. Narrated from the point of view of Buckley (played by Buckley Petawabano), a deeply disaffected teenager forced to attend residential school who is alienated from his Indigenous culture as much as he is alienated from the white disciplinary culture of the school, the film follows his (usually misguided) attempts to find a place where he belongs. Although counselled by Uncle John, who is played with presence and reserve by Chief Dan George, Buckley ends up stealing a skidoo to join his older friend who is trapping in the north but gets caught and faces reform school when he decides to run away. The opening and final scenes of the film, elevated by Dunn's haunting score, anticipate with uncanny precision the visual iconography used in contemporary renditions of the Chanie Wenjack story[23]—a young boy, scantily clad against the severe cold and storm, walks along a train track in the dead of winter, abandoned and alone, facing certain death. These scenes, perhaps the most effective in the entire film, condense a number of tropes around the Canadian landscape, the image of the railway as an ironic embodiment of progress and nationhood, and the affective intensity of the abandoned child.

Cold Journey holds little aesthetic interest: the performances, apart from Chief Dan George, are wooden, the pacing is awkward, and the dialogue is corny and obvious. As a recent NFB blog post indicates, the film came very close to being shelved when producers at the NFB felt the acting was flat, the plot aimless, and the story "too bleak."[24] The film, however, represents a fascinating historic artefact and is a telling symptom of the fundamental ambivalence by which the NFB addressed Indigenous issues at the time. While the Indian Film Crew provided a crucial and radical alternative to the longstanding tradition at the Board, where non-Indigenous directors directed and produced films about Indigenous subjects, it was clear that by 1975 support for the Indian Film Crew and the notion of empowering Indigenous directors was diminishing. As Michelle Stewart notes, "During the late seventies 'access/process' type projects took a backseat to 'product' type projects. … Numerous projects were done with the intention of giving a voice to the people, yet few people besides Challenge for Change directors picked up cameras" (2007, 187). Rick Moore's PhD thesis on Challenge for Change argues that this trend signalled "a retreat from the VTR

FIGURE 5.2 Marshalling the image of the railway as an ironic embodiment of progress and the affective intensity of the abandoned child in *Cold Journey*, 1975. Frame grab courtesy National Film Board of Canada.

inspired strategy of using film/video to afford access and catalyze action to a strategy of producing films that generated and displayed *sympathy*" (1987, 166, my emphasis).

Moore's insights provide a critical view into how *Cold Journey* is distinguished from the more radical documentaries such as *PowWow at Duck Lake, You Are on Indian Land* (dir. Mike Kanentakeron Mitchell, 1969),[25] and *The Other Side of the Ledger*, which explicitly critique colonial processes leading to Indigenous dispossession. While *Cold Journey* incorporates many documentary elements including location shooting at Pelican Narrows reserve in La Pas, Saskatchewan—at the time the biggest reserve in Canada—and at the Piopot reserve north of Regina where a powwow takes place (these are among the more captivating scenes), the film's critique of residential schools focuses exclusively on the harm caused by alienating Indigenous students from their culture and its message is one of tolerance and cultural appreciation of diversity.

The advocacy of cultural pluralism, of course, is very much in line with the discourse of multiculturalism promulgated by the Liberal government under Pierre Trudeau (1968–79 and 1980–84) and eventually consolidated in the Canadian Multicultural Act of 1988. The accommodation of cultural and religious difference is at the core of liberal multiculturalism, but this regime, as Glen Sean Coulthard and Audra

Simpson have argued so brilliantly, is constitutionally incapable of addressing structural issues of Indigenous dispossession, treaty rights, and land claims. Within the framework of multiculturalism, Indigenous "difference" is simply one form of alterity among many others, and the structural dissymmetry of colonialism is ignored by the assumption, as Coulthard (2014) points out, that settler colonization can be reconciled through a process of cultural recognition. While the discourse of *Cold Journey* might well be read as aligned with new modes of liberal governance, it would be presumptuous to assume how Indigenous audiences received and made meaning from the film. According to George Pearson, one of the two NFB producers involved in *Cold Journey*'s distribution: "The native audience loves it every time. They see much humor in the film." By contrast, he points out: "A white audience by itself sees none of that humor and sometimes can feel quite threatened. They take the film as an inditement [sic] of themselves. ..."[26]

At the urging of Alanis Obomsawin, *Cold Journey* was screened at the annual meeting of the Indian Brotherhood of Canada, where two resolutions were passed: one commending the film for its sensitive and accurate portrait, and one urging the NFB to give the film the widest possible distribution. The NFB launched the film in Regina and Edmonton in collaboration with the Department of Indian Affairs and local First Nations organizations. It had a short commercial run before it was broadcast on the CBC and extensively distributed to unions, church groups, residential schools, council houses, and as producer Anthony Kent claimed, anywhere "that you could put up a projector."[27] As a non-Indigenous person, I can only speculate, but I might suggest that the enthusiastic reception of the film in Indigenous communities points to the importance of audio-visual texts as mediators of history, provocations to memory, and catalysts in the symbolic transformation of individual experience into the collective articulation of injustice. With all its limitations, *Cold Journey* was one of the first films to articulate a critique of residential schools and to do so from the putative perspective of Indigenous people. As such, it prefigures the discursive shift that Dian Million argues begins in mid-1980s when the trauma of residential schools becomes publicly sayable and discursively comprehensible.

According to Million, the disciplinary regime of shame and secrecy that facilitated the silence of residential school survivors began to break down in the mid-1980s in the wake of the second wave feminist

movement, which radically reoriented public understanding of the primal distinction between the personal and the political as it reframed sexual violence and abuse as political issues. Million insists that this massive public shift was made culturally relevant to Indigenous communities during this period by way of the groundbreaking memoirs and novels of writers such as Maria Campbell and Jeanette Armstrong, whose truth-telling and courage in narrating intimate secrets denoted "the affectively charged experiential that became available to individuals, families, and sometimes communities" (2013, 67). While their work did not, as Million writes, "always "translate into any direct political statement ... it is exactly this felt knowledge that fuel[ed] the real discursive shift around the histories and stories of residential schooling"[28] (2013, 67).

By the late 1980s and early 1990s, a floodgate had opened, and an accumulating mass of testimony was translated into the first legal suits organized and filed in communities across the country. As Ronald Niezen narrates:

> Long before the TRC began its work, the courts became the most important venue by which an alternative narrative about IRS [Indian Residential Schools] began to gain traction. Starting in 1989–90, prosecutions of former residential school staff took place in BC and the Yukon, initiating an ever-widening circle of investigations, indictments, and prosecutions across the country. ... Local organizations of former students, using the word "survivor" to designate their common criterion of belonging, were also central to this awareness-raising momentum. (2017, 36)

One of the first dramatic films made in this period was the CBC-produced feature television special *Where the Spirit Lives* (1989), directed by veteran television director Bruce Pittman with a script by Keith Leckie. Leckie had been a writer for the CBC television series *Spirit Bay* (1982–87), which focused on the lives of townsfolk on an Ojibwe *reserve* near MacDiarmid, Ontario, and, in the course of his research, had heard stories about residential school experiences. The film has some commendable features including an astonishing performance by Michelle St. John as Ashtohkomi (Komi), a young girl kidnapped with her brother by an Indian agent and taken to a residential school by bush

plane. But, as a very influential and public version of history,[29] the film is shaped by a familiar dynamic whereby the coming to consciousness of the limitations of residential schools is focalized through a sympathetic non-Indigenous outsider, a young Anne-Marie MacDonald who plays Kathleen, a feisty novice teacher. In this vision of residential school, the kind teacher nurtures and mentors and learns to appreciate Indigenous culture as she is increasingly disturbed by the school's harsh and arbitrary disciplinary regimes. The Indian agent also, inexplicably (and unrealistically), suffers a crisis of conscience and willingly quits his job kidnapping and chasing runaway Indigenous children. While some of the harsh realities of the schools are depicted—such as sexual abuse between a female teacher and a girl (alluded to but tastefully kept offscreen), boys strapped and beaten, and the children fed slop while the teachers are served rare roast beef—the film suddenly veers in a new direction a third of the way in, from indictment of brutality to a sentimental drama of Komi's adaptation to the school under the warm tutelage of Kathleen, the kind young teacher. In the end, the film supports a liberal version of reconciliation where a reconstituted relation between Indigenous peoples and settlers is possible through a humbling request for forgiveness in order that the harshness and missteps of the past can be set aside. In the final scene in the film, Komi and her brother escape the school and ride into the vastness of the prairie landscape, but not before Kathleen garnishees a horse and gallops after them, catching up to explicitly asks Komi for forgiveness. When *Where the Spirit Lives* was broadcast—and this was a testament to the radically transformed conditions of reception—it was met with immediate contention. Lenore Keeshig-Tobias, an Ojibwe poet and story-teller, wrote a devastating critique in *The Globe and Mail* accusing the filmmakers of cultural appropriation and challenged the right of anyone but a member of the First Nations to tell such stories: "The Canadian cultural industry is stealing—unconsciously, perhaps, but with the same devastating results—native stories as surely as the missionaries" (1990).

By the end of the 1990s, the issue of residential schools had moved increasingly into public view, as the Royal Commission on Aboriginal People released "A Statement of Reconciliation" in 1998 in which the federal government included a written apology to those who had experienced physical and sexual abuse. In 2001, the federal Office of Indian Residential Schools Resolution Canada was created to manage

and resolve the large number of claims filed against the federal govern-ment. In 2004, *the Assembly of First Nations Report on Canada's Dispute Resolution Plan* advocated for a more comprehensive approach, and in November 2005 the Canadian government announced the IRSSA compensation package. Ten years after the Statement of Reconciliation and, as a condition of the IRSSA settlement agreement, Prime Minister Harper made a long overdue public apology in the House of Commons on June 11, 2008. In 2009 the TRC began its cross-country process, con-solidating and amplifying a new era of reconciliation.

FILMMAKING AS REPARATIVE JUSTICE

The new era also marks the emergence of films on residential schools directed and initiated by Indigenous filmmakers. These films are pro-duced in a number of different institutional contexts, at varying levels of budget and professionalism, but all, I would argue, develop a perspec-tive that is dramatically distinct from mainstream television dramas such as *Where the Spirit Lives* with its outsider's view and liberal concep-tion of reconciliation. While the latter is primarily addressed to a settler audience, imbued with a pedagogical mission of advocating tolerance and motivated by the aspirational hope that forgiveness will usher in a new era of enlightened co-existence, films produced by Indigenous directors are directly mediated through intimate connections with com-munities, families, and loved ones who have lived through and been marked by the experience of residential schools. While the rest of this chapter addresses the more prominent among the films I am looking at, what I would like to do in the next section is to consider a smaller sub-set that are community driven and collaborative in execution and that embody what I'm calling processes of reparative justice.

REPARATIVE DOCUMENTARY

The first and groundbreaking entry into a series of reparative documen-taries was Métis director Loretta Todd's *The Learning Path*, produced by Tamarack Productions in 1991 and introduced by a luminous Tan-too Cardinal. *The Learning Path* introduces innovative formal elements including dramatic re-enactment, remediated archival footage of chil-dren at residential schools interwoven with black-and-white stylized sequences featuring a disembodied camera moving through the hall-ways and classrooms of an abandoned school, elements that come to

constitute a kind of iconic cluster in films of this genre. *The Learning Path*, however, is less preoccupied with documenting the horrors of residential schools than with focusing on the contemporary work of three extraordinary Edmonton Elders (Ann Anderson, Eva Cardinal, and Olive Dickason) who are involved in a passionate mission to reclaim education for young Indigenous students through teaching Indigenous culture and language. As Todd's narration puts it, "It is a new morning, education is serving to empower and not oppress our children." Apart from the film's hybrid formal aesthetic, what marks its distinctiveness is the way in which the narration embodies a collective enunciation. While the narration is voiced by the director, Loretta Todd, she speaks for her people and as a part of her people. Far from the disembodied "impartial" voice-over of the Griersonian documentary or the colonial detached observer in settler documentaries, Todd's narration functions as a conduit implicating a collective Indigenous subject: "our women are our guides," "our children" "our people."

The evolution of a collective Indigenous enunciation as part of a reparative documentary practice also animates the following three documentaries: Christine Welsh and Peter C. Campbell's *Kuper Island: Return to the Healing Circle* (1998); Trudy Stewart and Janine Windolph's *RIIS from Amnesia: Uncovering the Forgotten Legacy on the Regina Indian Industrial School (1891–1910)*, completed in 2015; and Barbara Cranmer's *Our Voices, Our Stories* (2016). All of these films are collaboratively produced in partnership with distinct Indigenous communities, and all document processes of collective mobilization, where the community assembles to conduct symbolic acts of historical accounting. In *Kuper Island* this involves a school reunion where the assembled crowd hoists a large stone marker bearing the name of the Kuper Island Residential School into the sea. *RIIS* documents a community memorial walk, as members of the community holding flowers and tokens walk to the site of an overgrown cemetery where dozens of children who had died at the Regina Industrial School were buried in unmarked graves. The central event in *Our Voices, Our Stories* is a demolition ceremony held on the grounds of the St. Michael's Indian Residential School in Alert Bay as the ancient school is torn down by bulldozers. In addition to the focus on corporeal and collective mobilization, one of the crucial distinctions of these films is their profound understanding of the importance of land as medicine and as modality

of healing. The land speaks in RISS: the large, overgrown cemetery is alive as a sacred site, and the film's subjects attest to the presence of the spirits of the children who "cannot rest" and "who want to go home." In *Our Voices, Our Stories* and *Return to Kuper Island*, interviews take place outside in a verdant landscape of West Coast forest and the delicately composed shots of plants and flowers, dew dripping from a branch, or a misty river at dawn and a sweat lodge in a dense old-growth forest are integrated elements in a healing journey. The foregrounding of the land in both films aligns very powerfully with Leanne Betasamosake Simpson's (2017) call for a reclamation of "land as pedagogy," and for the ways in which learning and healing from the land represents the ultimate retort to residential schools, especially as an alternative epistemology rooted in Indigenous cultural traditions.

While the testimony of survivors documented in these films carries a powerful affective charge, none of the films adheres to the dominant therapeutic model of individual disclosure and emotional catharsis that has characterized much of the media produced during and in the wake of the Truth and Reconciliation Commission. In *Our Voices, Our Stories*, individuals who offer testimony are also clearly visually and aurally situated in the context of their community as participants in the healing ceremonies, both on the grounds of the former school and inside the communal space of a longhouse. In *Kuper Island*, each subject is also situated in community, holding an eagle feather, revealing their history and memories within the comfort and bond of a talking circle, beside a beloved brother or reflecting directly to the camera itself where the relation between subject, camera, and spectator forms a kind of virtual circle. The storytelling is intensely emotional, the tears and pain of the speakers is palpable, but the camera is never voyeuristic. Implicated into the circle of healing, the camera acts as a patient empath, witnessing the hard work of healing, the necessity of speaking, and the wisdom that each speaker earns in the process of self-reflection.

RIIS is more of an example of imperfect media. The sound is frequently marred by wind noise, transitions are abrupt, and the camera is shaky, but RIIS is a profoundly moving piece and an important example of community-based reconciliation. Posted online[30] and screened in sequences or "story bundles," as one of the directors explained to me, the project was funded and initiated by the United Church who, together with the Presbyterian Church, had hosted a gathering for descendants

of relatives who had attended the site of the former school (which burned down in 1948). The prime focus of the film is the revelation that a large plot on a local farmer's land houses the cemetery of the industrial school where dozens of children had been buried in unmarked graves. The film opens with a long hold on the grassy and overgrown patch of cemetery while the voice-over of a woman interprets the desires of the dead: "They want to be heard. They want to be recognized, they want to go home." The film documents the process of community mobilization as church archivists, members of a local historic advisory board, and local Indigenous community members visit the site, take sonar measurements, and eventually lobby to have the site protected and properly memorialized. The community's memorial walk closes the film as a lively hip hop song plays, thus refusing mourning or melancholia as the only affective responses to loss. Driving, urgent, and utterly contemporary, the song reminds viewers that anger and resentment can also be productive motivators of change.

MODELLING PERSONAL TESTIMONY AND THE AFFECTIVE AND AESTHETIC POLITICS OF ENACTMENT

One of the enduring strategies employed by filmmakers working within the CBC and NFB on films related to residential schools has been docudrama. While the term itself is notoriously vague and encompasses a broad spectrum of practices, I'm interested in how each film orchestrates a distinct and unique relation between documentary and fiction. The semi-improvisational *Cold Journey* incorporated non-actors and actual events, such as a community dance and powwow, into a fictional diegesis, while *Where the Spirit Lives* mediated the social issue of residential schools into full period drama. As I consider the most recent film in this tradition, *We Were Children*, produced in 2012 as a co-production with the Manitoba office of the NFB, it might be appropriate to ask how enactment and fictional mediations of documentary elements shape and alter the nature of a film's address. In contrast to the films discussed in the last section, which are community driven and presume an Indigenous audience as the primary constituency, the docudramas seem far more dedicated to addressing a mainstream settler audience deploying fiction as a mechanism whereby painful stories might be made emotionally accessible through character focalization

and through the appropriation of familiar tropes such as the abandoned child or the residential school represented through Gothic architecture.

We Were Children (dir. Tim Wolochatiuk, 2012) was executive produced by Lisa Meeches (Ojibwe from Long Plain First Nation), a well-known, Winnipeg-based television and film producer with Eagle Vision Productions, a company specializing in Indigenous stories. The film features personal testimony from Lyna Hart, a member of the Nisichawayasihk Cree Nation near Nelson House, Manitoba, and Glen Anaquod, a member of the Muscowpetung First Nation near Fort Qu'Appelle, Saskatchewan, which is supplemented by dramatic enactments.

We Were Children is distinguished from the full fictional mediation of Where the Spirit Lives, given the way in which the testimonial voice is imbricated as the origin and authenticating source of the fictional enactments. Hart and Anaquod are filmed in what appears to be a studio where the high-key dramatic lighting and shallow depth of field render space as abstract, a discursive space of memory and recollection. Their individual speech acts trigger the movement into 1950s period enactment as voice is transformed from synchronized dialogue into voice-over narration. In this shuttle between present testimony and past fiction, the enactments tend to be more illustrative than "fantasmatic," the quality Bill Nichols (2008) observed in documentaries that use enactment reflexively to highlight the definitive gap between representation and history. By contrast, the art direction and costuming in We Were Children, the dolly and crane shots, and the use of actors to portray the documentary subjects as children all contribute to a fictional diegesis that conforms to the realist conventions of period drama, set to a sweeping orchestral score. These conventions, however, tend to represent memory as entirely fulsome, linear, and absent the aporias, lapses, and forgetting that shape memory in the wake of trauma. Moreover, the past, as rendered by the dramatic enactments, is portrayed as segregated from the present, a "foreign country" where costume, period cars, and colonial violence are rendered as anachronisms of a bygone era.

What mode of reconciliation is on view here? Jennifer Henderson and Pauline Wakeham have argued that the hegemonic model of reconciliation deployed in post-war cultures of redress is based on a "normative teleology of overcoming differences" focused on acts of

narrative closure, "turning the page" or "closing a dark chapter" (2013, 15) in a way that prematurely forecloses a more substantive reconfiguration of Indigenous/settler relations. In its marshalling of conventional dramatic structures and tropes, We Were Children could certainly be seen to be moving toward such a "teleology of overcoming differences." The final coda of the film, in fact, includes television footage of Prime Minister Stephen Harper's 2008 Statement of Apology to former students of Indian Residential Schools as if this moment represented a triumphalist beginning of substantially (and not only symbolically) reconstituted relations between the settler state and Indigenous people.

We Were Children opened at the imagineNATIVE Film + Media Arts Festival and was broadcast on APTN in 2013, followed by a panel discussion with Meeches, Lyna Hart, and other survivors. The film was invited to various festivals but, most importantly, it was screened extensively during the Truth and Reconciliation Commission Hearings. I had argued above that the film's appropriation of conventional dramatic tropes situated it within mainstream and normative conceptualizations of reconciliation. Miranda J. Brady and John M.H. Kelly (2017) point out in We Interrupt This Program/Indigenous Media Tactics in Canadian Culture that the film also provided a crucial template and public modelling of how to perform testimony. As the authors note, several of the survivors they witnessed who spoke in Montréal compared their own experiences to those depicted in We Were Children (46). As with other efforts the TRC made to constrain and elicit testimony and to encourage, as the authors note, potentially idiosyncratic stories to "fit particular speech typologies, media forms, and discourses," (40) We Were Children played a key role in triggering memories and in actively demonstrating particular modes of performing public testimony.

As argued in the introduction to this chapter, personal testimony, particularly that which relates to egregious sexual violence, provides a powerful testament to the horror of residential schools and a deeply compelling retort to national myths around the benevolence of Canadian colonialism. But as Audra Simpson (2016b) and many critics of the TRC have noted, the solicitation of extreme emotional vulnerability and of singular modes of affective display can also have deleterious impacts that include the perpetuation of the myths of Indigenous peoples as victims and the occlusion of considerations of the harms of colonialism beyond the "synechoche" of residential schools.

BEYOND THE TESTIMONIAL

While much of the audio-visual legacy on residential schools is oriented around the reliance on the testimonial or, in the case of the docudrama, on a pedantic fictional supplement that illustrates testimony, I want to conclude by looking briefly at three films by independent artists that take up the history of residential schools from a completely different formal, aesthetic, and political approach. All three films eschew testimonial accounting and the focalization of the history of residential schools on personal experience narrated by survivors with, as I have argued above, its particular affective resonance. Indeed, the traditional solicitation of pathos or even of unsettled empathy is replaced in these films by an affective register that is more akin to a controlled rage mediated through a brilliant pulsation of montage, provocative soundscapes of contemporary music, and highly cinematic and reflexive orchestrations of bodies and spaces in a deliberately non-realist idiom. While so many of the films and video testimonies discussed above are elaborated and circulated within a discursive frame of reconciliation, with its emphasis on the education of a settler public in the interest of moving on, these films provide no such reassuring prospect and, in so doing, embody what Audra Simpson has identified as an Indigenous "politics of refusal" (2016a).

The first of these films, the short *Savage,* by Anishinaabe filmmaker Lisa Jackson, was commissioned in 2009 by imagineNATIVE as part of the Embargo Collective Initiative.[31] Jackson was given certain obstructionist instructions she had to follow in the elaboration of the film: it had to be a musical; include heavy metal, period set decoration, actors, and non-actors; and have no English. The result is an ingenious hybrid of hip hop, zombie flick, and performance, a residential school musical that opens with an extraordinary soulful rendition of a Cree lullaby by performance artist Skeena Reece, who plays the bereft mother of a small daughter taken into custody by Indian agents. Jackson appropriates many of the tropes used in fictional versions of residential school history, including scenes where a young girl gazes out the window of a period car and enters an imposing gothic building where she is bathed, her braids are cut, and she is dressed in the ruthless efficiency of a school uniform. But the film quickly veers away from any adherence to realist traditions as the dutiful, seemingly disciplined young students[32] (all done up in zombie white-face) break into an inspired *Thriller* dance

FIGURE 5.3 A choreography of refusal in *Savage*, 2009. Production still courtesy Kris Krüg / Lisa Jackson.

routine once the teacher leaves the school room. The dance is delightfully anachronistic, thrilling in its verve of execution, and a powerful and defiant gesture against unquestioned obeisance to colonizing discipline.

A second short, Kent Monkman's *Sisters and Brothers* (2015), was produced as part of *Souvenir*, a series of four films by Indigenous directors which remediate footage from the NFB archive. Opening with a quote by Leonard Peltier that calls for "hope" and "resilience," the film appropriates and recontextualizes images from the colonial archive to read history against the grain, set to a propulsive drumming and chanting score by A Tribe Called Red.[33] Montage works like a sharp blow, intercutting images of children in residential schools with footage of settler cowboys corralling bison into pens on the prairie. The metaphor is explicit: the bison, as much as the children, were marked with colonial violence and a will to annihilate. But the film does not narrate this history in the key of victimization or melancholy. The visceral urgency of the film, the children's direct gaze at the camera, slowed down and repeated, their sense of freedom and corporeal joy in running alongside the tracking camera, mark spaces and bodily expressions of resistance.

Finally, Mi'kmaw filmmaker Jeff Barnaby's 2013 feature debut, *Rhymes for Young Ghouls*, also constitutes a surprising genre twist in

the representation of residential school experience. Set in 1976 on the fictional Red Crow reserve in New Brunswick, the film is narrated from the perspective of Aila (played by Kawennáhere Devery Jacobs), a whip-smart and infinitely resourceful teenager who runs the family's drug business after her mother's suicide and dad's incarceration. Part heist film and full-blown revenge fantasy, the film tracks an unremitting relay of colonial violence, self-inflicted violence, and intra-community violence as, in the first five minutes, a child is run over in a drunken car accident, Aila's mother hangs herself, and the Indian agent and his goons savagely beat Indigenous patrons of the town's strip bar. But the violence the film depicts is not only visceral and physical (the sound of blows landing on human flesh is indelible), it inheres in the regime of arbitrary rules, fishing restrictions, and control written into the Indian Act and enforced by Popper, the town's brutal Indian agent. When drug money is stolen by Popper, Aila launches a scheme to steal the money back but is caught, committed to the dubious care of St. Dymphna's Residential School, and made to suffer the indignity of having her braids shorn and being forced to wear the school's uniform. Locked into a basement cell for her defiant behaviour, she is promptly rescued by her gang and the revenge plot begins in earnest. While the Indian agent in *Where the Spirit Lives* belatedly (if unrealistically) recovers his conscience and is allowed some redemption, there is no hope for Popper, an unrepentant and corrupt tyrant whose comeuppance is all the more spectacular for it. Doused in shit, foiled in his endeavour to exert his authority over Aila, he is finally shot in the head by the youngest member of Aila's gang when he attempts to rape the young rebel. Revenge is sweet and this violent retort to colonial violence can only be apprehended with grim satisfaction.

Audra Simpson defines refusal as both a political stance and a political theory embodied in an enduring resistance to accommodate oneself and one's people to the colonial condition, to apparatuses of the state, and to papering over territorial theft and injustice. "Refusal holds on to a truth," she writes, "structures this truth as a stance through time … and operates as the revenge of consent—the consent to these conditions, to the interpretation that this was fair, and [to] the ongoing sense that this is all over with" (2016a, 330). All three of these films gesture toward this notion of refusal through their indictment of history not as a wound to be healed, but as an urgent and contemporary claim. The trauma of residential schools is clearly and explicitly acknowledged but in representing

its after-effects, all three filmmakers refuse the kind of therapeutic discourse that can only, as Dian Million points out, imagine the Indigenous subject as a suffering subject. Positioning a resilient female Indigenous subject as the key locus of resistance, all three films can be seen to catalyze and prefigure a resurgent and unreconciled future.

CONCLUSIONS

This chapter has argued that the audio-visual archive of films and media on residential schools has played a foundational role as a public mediator and conceptual site of specific understandings of settler/Indigenous relations in Canada. Beginning with the still photographic archive and documentaries produced on residential schools at the CBC and NFB up to 1967 that were clearly aligned with a genocidal colonial policy, this chapter has traced key discursive shifts in media representation of residential schools that responded to Indigenous political mobilization and a growing public consciousness of the colonial implications of these schools. While *PowWow at Duck Lake* (1967) marked the first public representation of Indigenous resistance to the myth of residential school benevolence, films produced within national film institutions such as *Cold Journey* (NFB, 1975) and *Where the Spirit Lives* (CBC, 1987) began to reflect an acknowledgement of the deep harm produced by these schools. As I've argued, this harm, however, was exclusively represented within the context of a liberal multiculturalism that advocated for a tolerant acceptance of Indigenous culture while disavowing the necessity of refiguring material relations of land and sovereignty. The IRSSA class action settlement in 2005 and the launch of the TRC in 2008 sparked a contemporary wave of media on residential schools, much of which tended to be modelled on personal testimonials of traumatizing abuse and individual violence. As critics of the TRC such as Audra Simpson (2016a, 2016b) and Dian Million (2014) have argued, this discursive ploy also tended to reproduce narratives of Indigenous victimhood while eclipsing collective concerns with sovereignty. Finally, I argued that the most substantial discursive shift occurs in work by contemporary Indigenous directors, either through a mode of reparative documentary that is embedded within collective and land-based healing or in the hybrid work of Jackson, Monkman, and Barnaby, which moves beyond liberal notions of reconciliation to insist on the momentum of resurgence as an ongoing retort to colonialism.

NOTES

1 Many of these titles are available on the internet, including "Stolen Children" (2015), an extended item broadcast on *The National*. See https://www.youtube.com/watch?v=vdR9HcmiXLA.

2 https://www.youtube.com/watch?v=v_tcCpKtoUo

3 *Secret Path* was livestreamed on CBC October 23, 2016. The film includes illustrations and storyboards from the graphic novel by Jeff Lemire with music by the Tragically Hip and tells the story of 12-year-old Chanie Wenjack, who ran away from the Cecilia Jeffrey Indian Residential School in Kenora and tried to walk home to Ogoki Post, 600 kilometres away, in the dead of winter.

4 *Canada's Dark Secret* is available here: https://www.youtube.com/watch?v=peLd_jtMdrc.

5 Fontaine's disclosure may be viewed here: http://www.cbc.ca/player/play/1776926760.

6 The Indian Residential Schools Settlement consolidated multiple claims that had been ongoing since the 1980s and represented an agreement between the government of Canada and the approximately 86,000 former students of residential schools. It recognized the damage inflicted by residential schools and established a multi-billion-dollar fund adjudicated through individual payouts. Every former student received $10,000 for the first year of schooling and $3,000 for each subsequent year. Additional funds were allocated for out-of-court suits to resolve claims of sexual and serious physical and emotional abuse. The IRSSA also allocated $60 million for a five-year Truth and Reconciliation Commission.

7 The United Nations Declaration on the Rights of Indigenous Peoples (UNDRIP) was adopted on September 13, 2007, and formalized the rights of all Indigenous people, the culmination of decades of struggle. The four countries who originally voted against the resolution included Australia, Canada, New Zealand, and the United States, all settler-colonial states.

8 The RCAP is available here: https://www.bac-lac.gc.ca/eng/discover/aboriginal-heritage/royal-commission-aboriginal-peoples/Pages/final-report.aspx.

9 The Oka crisis involved a 789-day, highly mediatized standoff between Mohawk protesters, police, and the army. The crisis was provoked by the proposed extension of a golf course on Mohawk sacred territory and brought Indigenous claims and resistance to public attention. The crisis was dramatically captured by Alanis Obomsawin's master work

Kanehsatake: 270 Years of Resistance (1993), a National Film Board
documentary.

10 This is how the TRC publicized its mandate to communities. See http://
www.trc.ca/websites/trcinstitution/index.php?p=201.

11 Recent work includes the earnest, if clumsy, adaptation of the novel *Indian
Horse* by Richard Wagamese and directed by Clint Eastwood's cinema-
tographer, Stephen Campanelli. The film follows the life of Saul Indian
Horse, as he survives Indian residential school in the 1970s by becoming a
star hockey player. The persistent racism of fellow players, hockey coaches,
and crowds, however, finally defeats him; he abandons the sport and ends up
on skid row only to be redeemed by a visit home. The eight-million-dollar
production represents the most ambitious cinematic treatment of
IRS, but the effort to meld the Canadian romance with hockey with a
didactic revelation of racism frequently feels flat-footed and caricatured,
particularly the scenes of addiction and street life. When the film was
released in 2018, it was met with the question posed to *Where the Spirit Lives*
in 1989—namely, why is this film directed by a non-Indigenous director?

12 In 2017 the NFB launched a three-year plan around Indigenous equity
which includes representational parity in the workforce; a commitment to
ensuring Indigenous-led production represents a minimum of 15 percent
of overall production spending; and a commitment to working with Indig-
enous partners to develop protocols around the use of their archives. For
more details see: https://blog.nfb.ca/blog/2017/06/20/nfb-commits
-indigenous-equity/.

13 The NFB mandate as set forth in the National Film Act, 1950 is "to produce
and distribute and to promote the production and distribution of films
designed to interpret Canada to Canadians and to other nations" (onf-nfb.
gc.ca/en/about-the-nfb/organization/mandate/). The 1991 Broadcasting
Act sets a similar mandate for the CBC to "contribute to shared national
consciousness and identity." See www.cbc.radio-canada.ca/en/explore
/mandate/.

14 *People of the Potlach* may be viewed at: https://www.nfb.ca/film/people_of
_the_potlatch/.

15 For a fascinating look at the career of Laura Boulton, see: Robert McMil-
lan, "Ethnology and the N.F.B.: The Laura Boulton Mysteries," *Canadian
Journal of Film Studies* 1, no. 2 (1991): 67–82.

16 Salvage anthropology references a subset of early twentieth-century
anthropology inspired by the belief that Indigenous cultures were on the
brink of inevitable extinction.

17 Previously, the TRC's registry could confirm only 51 deaths at Kamloops from 1914 to 1963. The TRC's Missing Children Project has so far documented more than 4,100 deaths in the schools, but the full tally could be as high as 6,000. See http://www.trc.ca/events-and-projects/missing-children-project.html.

18 According to a Wikipedia entry, the story around Saint Nicholas does include the account of Polish cannibalism. See https://en.wikipedia.org/wiki/Saint_Nicholas.

19 http://publications.gc.ca/collections/collection_2017/statcan/CS92-522-1961.pdf

20 The deplorable condition of the schools was hardly a state or public secret. As early as 1907, Dr. Peter Henderson Bryce, the chief medical officer for the federal government, released a damning report pointing to the unprecedented incidence of tuberculosis that was killing residential school children. In the face of obdurate institutional inaction, Bryce also published a book in 1922, *The Story of a National Crime: An Appeal for Justice to the Indians of Canada*. The book was widely commented upon in the public press and provided unimpeachable evidence of the complicity of the government in maintaining conditions that continued to lead to criminal levels of death by neglect. The Bryce interventions were also supported by numerous reports in the years that followed from school superintendents and church officials, which also fell on deaf ears.

21 Challenge for Change. *Pow Wow at Duck Lake* was produced by David Hughes; no single director is credited.

22 Joan Irving, "An Interview with Martin Delfalco," *Cinema Canada*, no. 43 (1977).

23 Chanie "Charlie" Wenjack was an Ojibwe boy who ran away from Cecilia Jeffrey Indian Residential School, where he boarded for three years while attending public school in Kenora, Ontario.

24 Albert Ohayon, "Cold Journey: A Feature on Residential Schools," *NFB blog*, June 9, 2017, https://blog.nfb.ca/blog/2017/06/09/cold-journey/.

25 When *You Are on Indian Land* was released in 1969, the director credit was shared between Mort Ransen and Mike Mitchell. In 2017, the NFB formerly assigned the director credit to Mitchell exclusively, using his full Indigenous name: Michael Kanentakeron Mitchell.

26 George Pearson, "Grass Roots Distribution," *Cinema Canada*, no. 43 (December 1977/January 1978).

27 Anthony Kent, "Grass Roots Distribution," *Cinema Canada*, no. 43 (December 1977/January 1978).

28 Tricia Logan also argues that the first public disclosures emerged primarily in the form of Aboriginal literature in Canada and points to key texts such as Basil Johnston's (1988) *Indian School Days*; Celia Haig-Brown's (1988) *Resistance and Renewal: Surviving the Indian Residential School*; and Isabelle Knockwood's (1992) *Out of the Depths: The Experiences of Mi'kmaw Children at the Indian Residential School*.

29 According to Canadian television historian Mary Jane Miller, writing in 2001, "*Where the Spirit Lives* has been and remains the most watched fictional representation of residential schools." Mary Jane Miller, "*Where the Spirit Lives*: An Influential and Contentious Television Drama about Residential Schools," *American Review of Canadian Studies* 31, no. 1–2 (2009): 71–84.

30 https://www.youtube.com/watch?v=l8yfSM87Ces&feature=youtu.be

31 The Embargo Collective was initiated by imagineNATIVE in 2008 as one of its tenth anniversary special programs. The Embargo Collective is a group of seven international Indigenous filmmakers who were given individual restrictions that forced them to deviate from their usual style. In its first iteration, the guiding rule for the group was that the films needed to use a language other than English and had to incorporate the theme of patience.

32 In conversation with director Lisa Jackson, Jackson explained that *Savage* involved a challenging casting process, which, despite exhaustive efforts, resulted in the fact that half the children cast were non-Indigenous. The other half were Indigenous.

33 Featured releases and news of the band A Tribe Called Red (now renamed The Hallluci Nation) can be accessed here: http://atribecalledred.com/.

The Resurgence of Indigenous Women in Contemporary Québec Cinema

Karine Bertrand

In her book *Reservation Reelism* (2010) Michelle Raheja uses the term ideologies of (in) visibility to describe the absence of Indigenous women in classic Hollywood cinema, where Indigenous women characters were either portrayed by famous non-Indigenous actors (for example, Natálie Wood or Audrey Hepburn) or cast as objects of desire (the sexualized maiden) or helpless maidens. In more recent years, films such as *Night at the Museum II* (Levy 2009), *The New World* (Malick 2005), and of course Disney's *Pocahontas* (Goldberg and Gabriel 1995) contributed to the fictionalization of the Indigenous woman, by serving the audience with erroneous depictions of the historical figure of Matoaka.

In Québec, both documentary and fiction films have followed in the footsteps of the American western and fiction genres, presenting Indigenous cultures and histories through the male gaze, with a majority of films being made by male directors and about male characters. Moreover, most of the articles and film reviews about these works pay little to no attention to the female characters that loom in the background or serve other purposes in the narrative. Indeed, although Indigenous women have always been actively involved in the social, political, cultural, and economic aspects of their communities, they remain obvious victims of colonization, for example being "seven times more likely than non-Indigenous women to be victims of murder, and they are also much more likely to experience sexual violence" (Native Women's Association of Canada 2021, 5).

Indeed, according to a report prepared by Brad Morse for the Native Council of Canada, even if Québec contains "the lowest social distance of any province" between Indigenous and non-Indigenous populations, it still needs to face up to a long history of colonialism, and of persisting systemic racism, a reality that the Québec government still has a hard time admitting to in 2021 (Marshall 2001, 239). Nevertheless, the long history of close encounters between Indigenous people and Québécois can perhaps partially explain the ways in which First Nations and Inuit women are portrayed today, in a context where collaborations between Indigenous and non-Indigenous women filmmakers are becoming more frequent.

In this light, I seek to put representations of Indigenous women in Québec cinema in dialogue with contemporary films that are made collaboratively by female Québécois and Indigenous filmmakers, to demonstrate how relationality (Wilson 2008; Kovach 2010) plays a key role in the success of these films. More importantly, I will also describe the ways in which Indigenous women filmmakers respond to these representations, and to the ideology of "invisibility," by "shooting back" and Indigenizing these images (Raheja 2010, 200).

Finally, in her monograph *Dancing on Our Turtle's Back* (2011), Nishnaabeg scholar, writer, and artist Leanne Betasamosake Simpson asserts reconciliation must be grounded in political resurgence and must support the regeneration of Indigenous languages, oral cultures, and traditions of governance. Whether through Alanis Obomsawin's important role in giving Indigenous women a voice they had partly lost, through the empowering short films of the Wapikoni Mobile female filmmakers, or through APTN's series *Princesses,* this chapter will demonstrate how Indigenous women are linked to resurgence, defined "as a socio-cultural movement and theoretical framework that concentrates on regeneration within Indigenous communities and validates Indigenous knowledges, cultures, histories, ingenuity, and continuity" (Hanson 2016, 274).

RESPONDING TO REPRESENTATIONS: ALANIS OBOMSAWIN AND THE VOICE OF INDIGENOUS WOMEN

When looking at the history of Québec cinema, it is safe to say that up until recently, First Nations, Inuit, and Métis peoples have remained absent from the landscape of French-Canadian films, making their first appearance in the 1965 feature-length fiction film *Le festin des morts*

(Fernand Dansereau). One does not have to search very far to understand the reasons why the "Indigenous Other" suddenly shows up in both documentary and fiction films made by Québécois filmmakers. After living in a period of "Grande Noirceur"[1] (Great Darkness) under the reign of Premier Maurice Duplessis, the French-Canadian man became politically and socially involved in the province's modern quest to define itself as a sovereign entity, with Indigenous peoples serving, as Marshall states, "as cultural symbols that also challenge the grand narratives of modernity and technological progress" (Marshall 2001, 214). Furthermore, the Québécois people, regarding themselves as the colonized, and thus refusing to recognize their role as colonizers, viewed the Indigenous male figure as a mirror reflecting the image of the oppressed French-Canadian man who wants to integrate himself into dominant society, "without being fully aware of what it will cost him to do so" (Therrien 1995, 28). The films of this period, similarly to the literature that was created, are centred on male Québécois identity, reflecting a political climate in which women remain excluded from the nationalist project. Looking at the corpus of documentary and fiction films made between 1960 and 1990 in Québec, Indigenous women are nowhere to be seen. Whether in Dansereau's *Le festin des morts* (1965), Gilles Carle's *Red* (1970), or Claude Gagnon's *Visage pâle* (1985), the question of the construction of Québécois identity is always dealt with in regards to racial alterity and sexual identities, and where Indigenous women—or rather what they symbolize—are vaguely, metaphorically present through stereotypical images of "pure" and "untouched" lands or landscapes.

At the same time French-Canadian audiences were watching cinema direct filmmakers and their plight to "build a country," another filmmaker—an Indigenous woman—was releasing a documentary entirely devoted to the beauty, strength, talent, and entrepreneurship of First Nations women living on Turtle Island. Abénaki singer, storyteller, and filmmaker Alanis Obomsawin's prolific and widely recognized documentary practice (52 films in 52 years at the National Film Board of Canada) has allowed First Nations people to finally voice their concerns, tell their stories, and rewrite history from an insider's perspective. Her contribution to Indigenous cinema cannot be understated, as she has influenced subsequent generations of Indigenous filmmakers, including some creators from Québec, including Tracey Deer (Mohawk), Sonia Bonspille Boileau (Mohawk), Caroline Monnet (Anishinaabe), and Kim

O'bomsawin (Abénaki), to name but a few. Working relentlessly decade after decade to make Indigenous people's voices heard, the singer, storyteller, and filmmaker makes use of a very simple and effective aesthetic style by separating image from sound, and by making sure the images are there to support the voices that carry the stories and testimonies of her people. Furthermore, engaging in what Leanne Betasamosake Simpson calls an act of resurgence, the filmmaker's emphasis on testimonies (oral stories, personal stories) reframes the act of storytelling as "an important process for visioning, imagining, critiquing the social space [and] challenging the social norms" (Simpson 2011, 34).

Often described as a feminist filmmaker, Obomsawin hesitates to acknowledge or adopt this term, because of a concern "for the whole family" (Lewis 2006, 72). Nonetheless, Indigenous women are at the centre of the majority of her documentaries, becoming the voices of their people, for example in political situations such as the Québec Oka crisis (*Kanehsatake: 270 Years of Resistance*, 1993; *My Name Is Kahentiiosta*, 1995) and the Attawapiskat housing crisis (*The People of the Kattawapiskak River*, 2011). They are also knowledge transmitters in *Waban-aki: People from Where the Sun Rises* (2006) and social activists in *Hi-Ho Mistahey!* (2013). More recently, *We Can't Make the Same Mistake Twice* (2016) showed the tenacity and great willpower of Professor Cindy Blackstock (Gitksan First Nation), also director of the Caring Society, seen in the film fighting for Indigenous children to be given the same rights and levels of care as all other Canadian children. In all these works, the filmmaker makes Indigenous women's presence more than visible—she makes them indispensable and essential in understanding decolonization, activism, and notions of *survivance*, which is "more than survival, more than endurance or mere response; the stories of survivance are an active presence" (Vizenor 2008, 39). In *Mother of Many Children* (1977), the following statement appears in text at the beginning of the documentary: "From earth—from water our people grow to love each other in this manner. For in all our languages there is no he or she. We are the children of the earth and of the sea." The statement indicates that even if the main subject matter of the film remains Indigenous women, there is an intent to abolish binaries that separate people into gender roles, something that does not exist in her language. Putting once again women's voices at the forefront of the narrative, Obomsawin weaves a rich and colourful quilt made up of testimonies from

First Nations and Inuit women from all ages and social status, living in Canada and studying law, creating co-ops, helping prisoners, communicating knowledge, and being mothers, wives, sisters, and teachers. In the same way, her constant use of testimonial narrative possesses "a political and aesthetic function that draws on the tradition of Native storytelling and other modes of oral history, [becoming] a vehicle whereby Native history can be validated," which creates a communicational network enlarging the quilt as to make the protagonists and audience feel a part of the same world "through constant, ongoing discussion between filmmakers, audiences and film subjects" (Pick 1999a, 78).

Very far from the typical depictions of the Celluloid Maidens, the filmmaker's protagonists are shown to possess layers of depth; they are firmly grounded on lands that they seek to respect and protect in the name of all populations. They have a voice of their own that need not be mediated or filtered and that is being used to create change and alleviate turmoil. Therefore, they are actively engaged in multiple acts of resurgence, telling stories and inserting themselves into these stories, remembering and revitalizing language, and "recreating the cultural and political flourishment of the past to support the well-being of our contemporary citizens" (Simpson 2011, 41, 51).

Alanis Obomsawin does just this in *Kahnesatake: 270 Years of Resistance* (1993) using women's voices and testimonies to defuse the tension surrounding the Oka conflict and to respond to the negative media coverage trying to turn the conflict into a mythic "Cowboys versus Indians" saga. In this regard, settler scholar Bruno Cornellier reveals the double function the filmmaker seems to be playing in the Canadian film landscape, insisting that she is useful to her people and to the Canadian nation who advocates through her an "indianity" (*indianité*) that offers the settlers a "non-threatening feminized image (through the figure of the beautiful, soft spoken *Indigenous Princess* singing the glory of her people) of the Other," a position that will reveal itself as indispensable to the post-Oka intercultural reconciliation—at a moment where the image of the Mohawk warrior reminiscent of the "Bloodthirsty Savage" is invading television screens (Cornellier 2011 158–59). Through carefully chosen (and often still) images and above all through feminine voices that seek to engage the audience with a narration that puts into light contemporary realities; by deconstructing ancient myths and repositioning First Nations and Inuit women at the centre of Indigenous

culture, knowledge, and community, Alanis Obomsawin engages in an ideology of *visibility*, which is in itself an act of visual sovereignty allowing us "to rethink collective subjectivity and communal memory in North American film histories" (Raheja 2010, 101).

INDIGENOUS WOMEN FILMMAKERS IN CONTEMPORARY QUÉBEC CINEMA

In the last decade or so, First Nations and Inuit presence has considerably increased in both documentary and fiction films made by Québécois filmmakers, and there are many reasons that explain this sudden shift. The emergence of a First Nations and Inuit cinema in 2001 with the release of Zacharias Kunuk's award-winning feature, *Atanarjuat: The Fast Runner*, and the creation of the Wapikoni Mobile, a mobile audio-visual unit that provides First Nations youth with training and equipment to make their own short films, contributed to putting Indigenous people on the Québec cinema map. In this vein, popular filmmakers and artists such as Denys Arcand and Richard Desjardins have screened Indigenous shorts before their films, and eclectic video artist Robert Morin sought the collaboration of Wapikoni participants in the making of his docu-fiction *3 Histoires d'Indiens* (2014). Centring on the lives of five Indigenous youth, the concept of the film explores the questions of identity and colonialism through three different narratives that are put into dialogue with each other: protagonist Erik's mission of reconnecting his community through the use of technology; Shayne's wandering between mine fields and his hometown while listening to classical music; and the three young women's (Alicia, Shandy-Ève, and Marie-Claude) religious cult to Mohawk Saint Kateri Tékakwitha, a historical figure who represented "the Christian value of restorative suffering and the Iroquois value of self-sacrifice, as well as a naïve faith that led First Nations to adopt catholic faith, with its theatric settings and rituals" (Faucher 2012). Using vibrant aesthetics—for example, filming the three young women covered in a red shawl, walking in a deserted landscape of white snow—the filmmaker brings us back to the figure of the Celluloid Maiden who betrays her people by adopting the colonizer's religion and culture, as is the case with Pocahontas. In a manner similar to Pierre Perrault's denunciation of imperialism and the colonized state, Robert Morin is first and foremost preoccupied with injustice and the possibilities of fighting back. He therefore continues to depict oppressed

subjects who are facing racism (*Le Nèg*, 2002), sexual abuse (*Journal d'un coopérant*, 2010), and corruption (*Papa à la chasse au lagopède*, 2008), as well as characters with identity issues (*Yes Sir! Madame*, 1994) who are confronted with the "Other" (i.e., anyone but French Canadians) (*Windigo*, 1994; *Les quatre soldats*, 2013). In this sense, First Nations People are just another object of representation able to exemplify the corruption, paradoxes, and internal pollution of the system we live in.

When compared to the short films made by the female Wapikoni women filmmakers of the same community (Lac Simon) represented in Morin's *3 histoires d'Indiens*, it is clear their vision of the community clashes with that of the filmmaker, not so much where themes are concerned (isolation, the consequences of religion, and the fragmentation of the community are still present), but how those themes are approached. Rather than positioning themselves as the victims of a world that has very little to offer them, they celebrate their survivance: they reconnect with the Elders and the traditional knowledge they possess (*Kikenidamowin*, June Anichinapéo, 2009); they use decolonization strategies such as humour to speak of their past and present struggles (*Setbacks*, Délia Gunn, 2010 and *Deux Pocahontas en ville*, Jemmy Echaquan Dubé, 2015); and they use oral tradition and music to speak of Anishinaabe women and their connection to the land and community (*Anishnabekwe*, Yasmina Jérôme, 2010). For further example, in Tammy Maranda's *Dance with Pride* (2013) the impact of religion and of residential schools are presented only as background themes, to explain how traditional dancing and the knowledge associated with the dance can become healing tools, allowing the community to strive and the individuals to feel good about themselves, even if they are living with the traumas of the past. The short documentary features the testimony of a young dancer, sitting beside a lake and talking about the importance of standing up for the next generation's rights, with traditional background music adding more weight to her words. We are shown multiple shots of her dancing at a traditional powwow and making her own regalia clothing. While she does admit that she is "praying" for the generations to come and that the initiation that comes with powwow dancing is like a "baptism," she also reminds us that we are on Turtle Island (North America) and standing on a land called Mother Earth, thus empowering Indigenous women who, despite religion, are able to reconnect to themselves and their culture. In this respect, they are reclaiming what

Simpson calls "the very best practices of our traditional cultures and knowledge systems" by integrating them in a medium that allows for a "dynamic and respectful context" to express these practices of resurgence (2011, 18).

Secondly, at the beginning of the millennium (2000), the shaping of a more diverse multicultural landscape brought on by steady immigration—the likes of which was not seen before in the province—provoked even more uncertainty in regards to Québécois identity questions. Confronted once again with the ongoing impossibility of separating from the rest of Canada (after the 1995 referendum) and/or finding out exactly what it means to be Québécois in a 21st-century setting, Québécois people turned to Indigenous identity once again, this time to fill the gaps in their own identity. The emergence of neo-traditional music and the refashioning of traditional storytelling from the likes of Fred Pellerin allowed the population to dig into history, reconnecting with narratives of the land and with figures such as the infamous (male) *coureur des bois*, to revive the *pure-laine* Québécois pride. Moreover, as stated by Marshall, the *Indigenous Other* is a vehicle for more specific interrogations related to "the construction of the modern nation, pre- and non-capitalist cultures and structures of belief that are marked by racial and ethnic difference and the consequences of European conquests" (Marshall 2001, 242).

These interrogations can be found in Michelle Poulette's *Maïna* (2013), where the Innu and Inuit of Québec are meant to represent this encounter with the Other, at a time when the land was still pure and untamed, right before the arrival of European settlers. In fact, the very last seconds of the film let us see the boats arriving in the distance, thus threatening the idyllic life the characters have forged for themselves. Despite the filmmaker's effort to bring together a cast of "authentic" First Nations and Inuit actors (for instance, Graham Greene and Tantoo Cardinal, both of whom acted in the Hollywood epic *Dances with Wolves*, 1990) who all speak either the Innu Aimun or Inuktitut language within the narrative, the presence of a voice-over narration by an Indigenous character (Maïna) describing her story in English removes much credibility from a story buried under the music of an overwhelming soundtrack. *Maïna* is an adaptation of a young adult novel written by Dominique Demers, and tells the romanticized tale of a revamped version of Pocahontas. Like the original "Indian Princess," Maïna is the

daughter of a chief, courted by a strong and virile man from her nation, but who eventually falls in love with the enemy. However, the enemy here is revealed to be an Inuk man from the North (Maïna is Innu, from Eastern Québec) whose relationship with Maïna and her people is meant to speak of the encounter of cultures and the fear of the Other, two themes that are contemporary to Québécois realities. Indeed, when Maïna, searching for a young boy of her community kidnapped by Inuit—who apparently came all the way to Innu territory for a rock—is introduced to her Inuk lover's family and friends, the young woman has a hard time fitting in.

The audience is shown how little things such as dissimilar ways of kissing, wearing clothes made from different animals, and expressing conflicting opinions on topics such as sleeping with your mate's best friend or hunting with the men can eventually be resolved, with a dash of compromise and a hint of open-mindedness. Furthermore, because of the Disney-like conclusion to the love story, which contradicts the novel's not-so-happy ending, we are led to believe that love conquers all differences and that at an emotional level, we are all the same. The child born of Maïna and Nataq's union, at the end of the movie, is the ultimate symbol of how intercultural unions are actually a good thing. As for Maïna's character, she is meant to represent a contemporary version of the "Indian Princess": she is shown to be the daughter of a chief and of a "medicine" woman, having inherited both her father's self-confidence and her mother's gift for healing. She is not inhibited by her womanhood, showing her abilities at hunting and standing up to her mate when she does not agree with him. However, these qualities seem to be directly tied to the connection she shares with her "totem animal" (as told in the narrative), which is a male wolf. Strangely enough, Québécois critics barely address the somewhat troublesome representation of Maïna, with the exception of Denis Desjardin's brief comment on the "retro feminist" conception of an Indigenous heroine that does not convince us of her timelessness (2014, 57). Instead, the majority of reviewers recognize the originality of a film that shows "the founding peoples of America" before the settlers came and teaches us "the hardships of surviving day to day, as it was lived 600 years ago" (Ramond 2014, 1), a task that Indigenous filmmaker Zacharias Kunuk had achieved successfully with *Atanarjuat* (2001) and *The Journals of Knud Rasmussen* (2006) a decade before *Maïna* was shot.

REHABILITATING POCAHONTAS: *RHYMES FOR YOUNG GHOULS*'S AILA AND APTN'S *PRINCESSES*

Perhaps the most relevant film to put into conversation with Michel Poulette's *Maïna,* where representations of Indigenous women are concerned, is Mi'kmaw filmmaker Jeff Barnaby's *Rhymes for Young Ghouls* (2013), which came out the same year as *Maïna.* However, Barnaby's main character, Aila (played by Kawennáhere Devery Jacobs), answers in no ways to the stereotypes associated with the Celluloid Maiden. This is probably because the filmmaker, with the character of Aila, intended to represent the real heroes in his life, the women he grew up with in his community:

> All the cinematic native heroes that I've encountered in my life up to this point have worn buckskin, have been men, and were more often than not, not actually native. The real heroes I've encountered in my life, growing up on the reserve, have been women and every inch of them Indian. (Leal 2015, 385)

The feature film *Rhymes for Young Ghouls* thus revolves around the story of young Aila, whose life in the fictional community of Red Crow in the 1970s is marked by the effects of colonization and residential schools, a phenomenon that was still going on at the time the story is told. Because her mother takes her own life and her father is sent to jail for a crime her mother committed, the young Aila takes it on herself to disrupt the colonial order by avenging the hundreds of children who have fallen prey to the Church and their politics of assimilation. Inspired by the women in Barnaby's family and community, Aila is given a strength of character that manifests through a dry wit, a silent determination, a natural leadership, a vivacious intelligence, and a quick mind that situates her far from the stereotypes associated with the Celluloid Maiden. If anything, Aila represents the antithesis of Pocahontas, with her gender-neutral clothes, her lack of interest in romance, her complete and total devotion to her community and family, and her no-nonsense attitude. She navigates fluidly and lucidly through a community where the masculine figures are shown to be weak and broken, dealing with drug and alcohol abuse, corruption, violence, and a general sense of loss and disconnections.

Ultimately, it is Aila who takes care of her dad and uncle, who protects a little boy, keeping him from residential school, and who imagines

and puts into action a plan to avenge her people and gain back control of her life. It is also through her character that we are shown how colonial powers have tried time and time again to assimilate, destroy, and take possession of the lands and the spirit of Indigenous people, through acts of racism and subordination, with Indigenous women facing "more extreme effects as sexism and racism are combined to oppress and marginalize them" (Kubik, Bourassa, and Hampton 2009, 21). This is something we are shown quite abruptly in the scene where Aila is a victim of abuse at the hands of the evil Indian agent. Aila, depicted as a modern-day Indigenous superheroine, as well as her marijuana-growing-storyteller "grandmother" Ceres, reminds the audience of the importance of First Nations women in the "unsettling" process, where each of the characters brings forth the healing and awareness that is necessary in order to deal with colonial trauma. In *Rhymes for Young Ghouls*, the scene where Ceres tells the story of an insatiable wolf (the residential school) that devours Mi'kmaw children highlights the essential role storytelling still plays in knowledge transmission. Moreover, by using an aesthetic where the story is illustrated through a contemporary animation style, the filmmaker makes a statement about the adaptability and mobility of oral tradition. In a similar way, the scene where Ayla gets taken to a Catholic school, has her hair cut, and is put in solitary confinement rewrites history by showing the young woman's resilience despite the violence she is living through. Finally, while some might see the dream sequences showing Aila's dead mother and brother or the dismembered bones of hundreds of children as "popular tales of the undead blending with native totem stories," they could also be envisioned as one of Aila's rules of *survivance*, one that remains unspoken but that holds the key to remembering and connecting, which are two of Māori scholar Linda Tuhiwai Smith's plans for decolonizing (Lacey 2014, 1). For these reasons, *Rhymes for Young Ghouls* is a breakthrough film, directed by a male Mi'kmaw filmmaker who consciously chose to bring everyday Indigenous heroines back to life through the character of Aila, something non-Indigenous filmmakers have yet to do.

Indigenous women filmmakers have also responded to these representations of the weak Indigenous woman and the sexualized maiden through innovative media works such as APTN's (Aboriginal Peoples Television Network) television series *Princesses*, conceptualized and developed by Mohawk filmmaker Sonia Bonspille Boileau and

Abénaki filmmaker Angie-Pepper O'bomsawin. According to Bonspille Boileau, the objective of the series is to "reclaim our beauty as Indigenous women, to redefine what the word beauty signifies for Indigenous women, and to get away from all those stereotypes attributed to us for so many years" (Bertrand 2018). The series, which dismantles the myth of Pocahontas and educates viewers by retelling history from an insider's point of view, is available in English with kanien'kéha (Mohawk) dubbing. Through interviews with Indigenous women stemming from numerous nations and horizons, the different episodes focus on themes such as the world of fashion, the definition of beauty, the importance of being a nurturing soul, the role of activism, the re-appropriation of language and culture, and the importance of reconnecting to the land. In episode 3, for example, an Indigenous studies specialist, Jessica Meltcalfe, tells the story of a young Indigenous fashion model frustrated by her work because the non-Indigenous, Western world focuses on her physical body, which makes them incapable of recognizing the spiritual beauty of her heart and soul. In response, the model decides to take action and to pierce her nose with a small bone, which becomes the symbol of her affirmation as an Indigenous woman. Thus, with each episode of the series, the audience is invited to join a space where presence, oral speech, and the actions of Indigenous women stating their own individual beauty become essential to our understanding of what decolonization, activism, and Indigenous feminism mean. Beyond the physical body, beauty stems from this active and continuous involvement in acts of decolonization and resurgence:

> Transforming ourselves, our communities and our nations is ultimately the first step in transforming our relationship with the state. Building diverse, nation-culture-based resurgences means significantly re-investing in our own ways of being; regenerating our political and intellectual traditions; articulating and living our legal systems; language learning; ceremonial and spiritual pursuits; creating and using our artistic and performance-based tradition. (Simpson 2011,17–18)

In doing so, all the women who are part of this endeavour participate in acts of visual sovereignty, as defined as "a way of reimagining Native-centered articulations of self-representation and autonomy that engage the powerful ideologies of mass media" (Raheja 2007, 1163).

INTERCULTURAL COLLABORATIONS: ENVISIONING INDIGENOUS CINEMA THROUGH A SHARED LENS

The third reason explaining the sudden (but still very partial) visibility of First Nations cultures and identity on Québec screens has to do with the partnerships developing between Québécois and Indigenous filmmakers. In the conclusion of his chapter on the *Indigenous Other*, Bill Marshall states that "no Québec film has yet articulated the full symbolic and narrative potential that lies within the relationship between Native peoples and Canadiens/Québécois" (2001, 262). However, since Marshall's monography came out nearly 20 years ago, new and fruitful collaborations between Indigenous and female Québécois filmmakers have emerged, thus creating in-between spaces where two cultures are able to (finally) meet and learn about/from each other. Indeed, looking at the collaborations that actually are successful, it is interesting to see that they are the product of relationships and partnerships between Québécois women filmmakers and First Nations/Inuit communities or individuals. Is this just a coincidence, or do the work ethic, subject treatment, and ways of interacting of these women influence the end results?

After carefully analyzing a feature film (*Before Tomorrow*, Marie-Hélène Cousineau and Madeline Ivalu, 2008) and a documentary film (*Martha of the North*, Marquise Lepage, 2008), and discussing the subject with the filmmakers, I conclude that these women share a common vision, where they are eclipsing themselves and their own culture to create a space where Indigenous protagonists and their languages, cultures, and values are not overshadowed by third-party interests. In Lepage's *Martha of the North*, for example, the story of Martha Flaherty, granddaughter of the famous filmmaker Robert Flaherty, is told through Martha's testimony, through interviews with members of her family, and by inserting clips and archive photos from Robert Flaherty's *Nanook of the North*. Rather than expressing the filmmaker's personal agenda, the documentary chooses to focus on Martha's journey reconnecting with a grandfather she has never known, all the while telling the story of the forced relocation of the people of Inukjuak (which included Martha's family), who in 1953 were displaced from their communities and moved 1,200 kilometres to Canada's most northerly settlements. By putting Martha at the heart of the narrative, Marquise Lepage gives a face and identity to all these families who suffered the consequences of being de-territorialized. By centring on Robert Flaherty's granddaughter, she allows the Inuk woman to re-appropriate her ancestor's images

to fill in the voids in her family history. This re-appropriation, by an individual who is also a strong advocate for Inuit women's rights, thus becomes an act of visual sovereignty. This once again shows the important role Indigenous women play in the decolonization process of their communities. Finally, according to Lepage, the intimate partnership between the two women and the publicity that the film generated lead to a formal apology by the Canadian government for these displacements.

In a similar manner, *Before Tomorrow* is the result of a close collaboration between Québécois filmmaker Marie-Hélène Cousineau and Inuit women Madeline Ivalu (co-director) and Susan Avingaq (scriptwriter). Since 1991, Cousineau has invited Inuit women of all ages to participate in Arnait Video Productions, whose objectives are "to promote and value the unique culture and voices of Inuit women, and to create dialogue with Canadians of all origins [thus representing] Inuit women's perspectives and values within larger national and international discussions" (Arnait website). Following the *Inuk point of view* model promoted by Zacharias Kunuk and Igloolik Isuma Productions (closely associated with Arnait), the collective's approach to filmmaking favours horizontal relationships, community work, and narratives that focus on Inuit culture and history, past and present. As the first feature film produced by Arnait, and inspired by a novel written by Bjorn Riel, *Before Tomorrow* tells the story of a grandmother and her grandson, who have to find ways of surviving alone after their entire community is decimated by infected needles. Beyond the narrative and its meaning (the importance of community and of transmitting knowledge for survival), the treatment of the female characters and overall aesthetics of the film seem to be enveloped in gentleness, fluidity, and grace.

In a first instance, the female characters in the film are mostly women over the age of 50, who are presented as quick-witted, funny, and with a strength of character that lets us believe that they hold an important status in their community. The relationship between Ninioq (the grandmother) and her elderly friend Kuutujuq is particularly interesting, as it shows the vitality of the women, giggling, for example, at how they would sleep with white men in exchange for needles. Their conversations are shot in close quarters, in a tent diffusing a soft glow, thus reproducing the inside of the female matrix and its comforting warmth. The scene where Kuutujuq is dying is particularly touching, as it shows the two women sharing dreams and saying their last goodbyes. The frail and

naked body of the old woman reminds us of that of a baby returning to the womb. In this way, the bodies of these women are beautifully shot, showing the aging skin as something fragile, all the while making us feel the majesty and grandeur of the soul that lies beneath or beyond the bodies. Accompanying these scenes are shots of calming waters and gently rocking waves, which make us feel as though the landscape is an extension of those bodies and not something to be conquered or possessed—but rather a safe, reassuring place of mystery and grace. To this end, the use of a very simple and stripped aesthetic to represent the nature of Inuit women contributes to the dismantling of centuries of stereotypical screen representations. And although we are shown some elements of non-Inuit culture through a soundtrack that includes music from the McGarrigle sisters, its discreet insertion in the narrative and the presence of lyrics that express Inuit culture (*We are meat, we are spirit, we have blood and we have grease, we have a will and we have muscle, a soul and a face. Why must we die?*) make us forget the temporary absence of the Inuktitut language, otherwise found throughout the movie.

Finally, there are more recent examples of successful collaborations between Indigenous writers and Québécois filmmakers, which I will briefly mention. Chloé Leriche's *Avant les rues* (2016) is the first feature-length fiction film made in the Attikamekw language. The filmmaker, who worked with the Wapikoni Mobile for many years before, already had a relationship with the Attikamekw people and nation before she started shooting her film. Although she wrote the screenplay and story herself, the Attikamekw cast (all non-professional actors) were the ones translating the dialogues and story from French to Attikamekw, thus taking charge of the narrative in a way, and transforming part of its meaning through the structure and connotation of the language. To explain this phenomenon, Leriche, in an interview with Karina Chagnon (2016), describes how the title of the film (*Avant les rues, Before the Streets*) in Attikamekw reads as *Tewehikan epwamoci meskanawa*, which means "the drum that existed before the streets." In the word *drum* (*tewehikan*), *hikan* refers to the word *heart*: "for them, the drum is the first heartbeat of life. It is a musical instrument but it's much more than just that" (Chagnon 2016, 4). Thus, in the simple act of translation, new meaning is created, relationality is recovered through those words that are related to a way of being, a way of seeing the world through those connections to people, places, stories, and where "the

concepts and ideas are not as important as the relationships that went into forming them" (Chagnon 2016, 4).

In the same way, Myriam Verrault's remediation of Innu writer Naomi Fontaine's *Kuessipan* (2020) demonstrates the importance of relationality when working with Indigenous creators. Very much concerned with the act of taking control of the story, Verreault sought out Fontaine and developed a relationship with her based on trust; she was invited into her community of Uashat (Côte-Nord, Québec) and she enlisted Fontaine as a co-writer for the film (Smith 2019). Her ultimate goal was telling the story of the people of this community, as they live in contemporary times. In an interview conducted by TIFF (Toronto International Film Festival), Fontaine explains why the encounter between herself, Verrault, and the *Kuessipan* story was fruitful: "Myriam is the type of person we like, as Innu people, because she's humble, and she's an open person. She likes to create real relations with us. I never thought that she just took our story or drama or tragedy. She is a true person, which is really important for us Innu people" (Smith 2019, 1). Relying on a cast of non-professional Innu actors, Verrault portrays the clashes between tradition and modernity, and the struggle that the youth face, having to carry tradition and fully integrate the contemporary world in order to be able to carry the culture and language. It is this reality that comes shining through in a film that brushes an intimate portrait of a community through the lives of two teenaged girls, one becoming a mother at age 15, and the other wandering outside the reserve, looking for more opportunities to accomplish herself, eventually building bridges between two cultures.

Although our corpus is limited, these examples demonstrate how recent works of close collaborations based on trust between Indigenous and Québécois women filmmakers are able to convene representations of First Nations and Inuit communities and cultures that are more representative of their histories and cultures.

CONCLUSIONS

In the preface to the book *Jeunesse autochtone*, the young Inuk political activist Mona Belleau writes about the new generation's struggles: living with the pressures of fighting to keep their culture alive and at the same time learning to open up to a world that can sometimes seem hostile or just plain strange (Belleau 2009, 9). Dealing on a daily basis with the

consequences of colonialism, the destruction of the land, the missing and murdered sisters, residential school syndrome, and ongoing stereotypical and racist depictions of themselves, Indigenous women are developing strategies and using tools such as visual art, video, writing, music, and political activism to give their people a voice.

Looking at the growing Indigenous cinematic landscape in Canada, I believe that it is not a coincidence that about 90 percent or more movies and video works (for the most part short films) are being made by Indigenous women, those *superheroines* who are shooting back and repositioning themselves—and their First Nations sisters onscreen and off—as active agents of change and transmission. When I asked them a few years ago why so many Indigenous filmmakers are women, Sonia Bonspille Boileau (Mohawk), Kim O'bomsawin (Abénaki), and Jemmy Echaquan Dubé (Atikamekw) all responded in the same way. They indicated that these women artists are simply doing what they have always done in their community, in other words, teaching, healing, sharing, gendering, and celebrating survival. This resurgence of Indigenous women emphasizes the need for Indigenous nations to "reclaim the very best practices of our traditional cultures, knowledge system and lifeways in the dynamic, fluid, compassionate, respectful context within which they were originally generated" (Simpson 2011, 18).

In Québec, the young Wapikoni filmmakers like Natasha Kanapé Fontaine, Délia Gunn, Meky Ottawa, Katherine Nequado, Évelyne Papatie, as well as filmmakers such as Tracey Deer (*Mohawk Girls*, 2005), Caroline Monnet (*Bootlegger*, 2021), and Sonia Bonspille Boileau (*Rustic Oracle*, 2019), are now making films about their cultures and their experiences living in a province that literally ignored First Nations presence if it did not serve political or social (including identity questions) goals, rendering them invisible until, as Innu political activist, filmmaker, and actor Natasha Kanapé Fontaine declares in her short film *Nous Nous soulèverons*: "we ALL rise up"—to bring these women into the realms of visibility.

NOTES

1 The term *Grande Noirceur* in Québec refers to the period of educational and industrial stagnation (1944–59) in which Québec lay under the reign of Québec premier Maurice Duplessis, whose right-wing politics and conservative values (farm, faith, and family) are said to have kept the province from properly entering modernity.

"Our Circle Is Always Open": Indigenous Voices, Children's Rights, and Spaces of Inclusion in the Films of Alanis Obomsawin

Joanna Hearne

> "It's the set of values that are different. ... The respect for any living things. Children, for instance. Children are very respected ... what a child feels or says is very important. It's not pushed away on the side."
> —Alanis Obomsawin, *Alanis Obomsawin the Activist, 1966*

> "Children [are] very important to us and no matter how many there are they should always be present, with everything we do."
> —Alanis Obomsawin, *Our Dear Sisters, 1975*

In the two quotations above, spoken at the height of the Sixties Scoop, Abenaki filmmaker Alanis Obomsawin describes First Nations attitudes toward children—first while being interviewed in 1966 about her own childhood and learning from Abenaki Elders in her extended family, and then in 1975, holding her daughter in her lap as an interviewer asked her how being a single mother affected her work as an activist. Her clear, direct communication of children's centrality within First Nations community life—that children are "respected," that "what a child feels or says is very important," that "children should always be present, with everything we do"—has lent consistent energy to her five decades of activist filmmaking. A Companion of the Order of Canada

and with more than 50 films to her credit, Obomsawin is internation-
ally recognized and has attracted considerable scholarly attention,
including the first book-length study of an Indigenous director. She
is widely known for her documentaries about tense confrontations
between First Nations communities and the Canadian state, espe-
cially her four powerful films documenting the Mohawk resistance to
land expropriations at Oka in 1990.[1] But Obomsawin's larger oeuvre
criss-crosses categories from stage to multimedia to film, from short
form to long form, and from documentary to drama. Since the very
beginning of her career, she has made short narrative, animated, docu-
mentary, and experimental films for and about First Nations children,
their rights, and their experiences. She provided the music for Duke
Redbird's short satirical animation *Charlie Squash Goes to Town* (1969),
and a few years later made her first short film based on Cree children's
drawings, *Christmas at Moose Factory* (1971). Her earliest documen-
tary film work—multimedia kits for classrooms—was directed to youth
audiences in educational settings. Over her career she also made short
dramatic films for children: *Walker* (1991), *Sigwan* (2005), and *When
All the Leaves Are Gone* (2010). Her documentary films about Indigen-
ous children's welfare and educational rights include *Richard Cardinal:
Cry from the Diary of a Métis Child* (1984), *Hi-Ho Mistahey!* (2013), *We
Can't Make the Same Mistake Twice* (2016), and *Jordan River Anderson,
The Messenger* (2019), among many others. For Obomsawin, children's
rights to Indigenous care represent an anchoring through-line across
her many films. This chapter explores these youth-oriented films within
several larger contexts: the history of state interventions in Indigenous
families and education as well as Indigenous strategies of resistance
and healing; critical questions and frameworks from documentary film
studies and Indigenous media studies around social change as well as
the politics and aesthetics of speaking and listening; and scholarship
on Obomsawin as an Indigenous film auteur. Across these intersecting
concerns, I focus especially on Obomsawin's methodological and aes-
thetic attention to ethics of inclusivity, and her assertion that children
are at the centre of the relationship between film and social action.
Media that impacts Indigenous children's learning—and all children's
education—represents a direct conduit connecting media with social
change, and Obomsawin takes up this work not only through films for
general audiences about Indigenous children's rights and education,

but also, simultaneously, through short films made for young people themselves. This point of articulation between film and activism is most evident in her emphasis on intergenerational Indigenous voices— Indigenous ways of instructive speaking and listening, sound-first modes of production, and direct address to children. I argue that her emphasis on sound in both production practice and aesthetics positions audiences as listeners within scenes of Indigenous teaching, while her return to footage from earlier films creates resonances between her documentary and dramatic works in ways that extend the instructional dimensions of archival images in service of Indigenous resurgence.

While most of Obomsawin's short films, which span the arc of her career, are addressed directly to youth audiences, they also tell stories about Indigenous communities for the widest possible audience. These films illustrate the aesthetic strategies by which Obomsawin has sought to intervene in the legacies of residential schools and state education, foster care, and imposed forms of governance. Her production practice foregrounds Indigenous voices, recording extensive interviews and sound before commencing any camera work, and her children's films engage Abenaki representational systems alongside re-enactment, voice-over, and historical narrative. Linking the sovereignty of the camera to decolonizing Indigenous education, these productions answer the de-culturating project of residential schools with an expanded reach of traditional stories and values through audio-visual storytelling. Obomsawin identifies Indigenous children as bearers of Indigenous political, cultural, and linguistic futures by strategically reimagining youth as both storytellers themselves and as listening audiences. Attention to these films yields new ways of understanding Obomsawin's own film practice and also documentary and Indigenous filmmaking more broadly in relation to Indigenous systems of teaching that are based on storytelling and listening, generational interaction, and ways of addressing multiple audiences at once. She also follows Indigenous children into the spaces of institutionalized education, from residential schools to public day-school classrooms. Her earliest films were state-funded educational materials that represent what Charles Acland calls "useful cinema," designed for such utilitarian audience spaces as classrooms and public libraries (Acland and Wasson 2011). Along with this early-career work as a storyteller and educational consultant preparing multimedia educational kits about First Nations cultures and histories, her later children's

films combine documentary film tools and aesthetics with elements of dramatic film storytelling in service of a larger ethos of care for Indigenous children. Modelling inclusivity without ceding to mainstream aesthetics, Obomsawin embeds Indigenous teaching and learning models across the wide range of her work for and about children.

This expanded view of a major documentary filmmaker through the lens of her work with, for, and about children has implications for how we understand the moment in which she began her career—that is, the history of Indigenous women's media from the mid-1960s forward, and the relationship of that history to broader activism around Indigenous children's and family rights. Unlike studies of Indigenous media oriented toward feature films, this history tracks short-form, televised, grant- and state-funded, largely non-feature production, forms that involve far greater gender parity than feature productions. Obomsawin has been a transformative force in the history of the late 20th-century surge in Indigenous screen presence and media production—and she remains a transformative force in the 21st century. Her early films share qualities with those of other North American Indigenous women multimedia activist-artists and early adopters of electronic and digital forms working concurrently starting in the 1970s, such as Makah filmmaker Sandra Sunrising Osawa, Laguna Pueblo author (and sometime scriptwriter) Leslie Marmon Silko, and Cree musician and digital artist Buffy Sainte-Marie.

Their representations of Indigenous communities supported Indigenous education of children as a political right, in contexts of historical and ongoing practices of state-organized removal of Indigenous children and institutional intervention in Indigenous families through residential schools, foster care, and adoption systems. Obomsawin began making films at a time when many residential schools were closing, but child welfare workers were conducting mass removals of Indigenous children from their families and communities, with many of those children placed for adoption inside and outside of Canada. It is a well-documented history. In the Indigenous child welfare report commissioned by the Canadian Council on Social Development in 1983, researcher Patrick Johnson called Canada's adoption policy from 1965 onward the "Sixties Scoop," which Justice Edwin Kimelman (in his 1985 review "No Safe Place: Review Committee on Indian and Metis Adoptions and Placements") described as "cultural genocide ... taking place

in a systematic, routine manner." In the 1980s, the Canadian government formed First Nations child welfare agencies to curb this practice, but these agencies receive about 22 percent less federal funding than non-Indigenous child welfare agencies.[2]

In the context of this erasure and recovered history, imagining Indigenous childrearing and pedagogy in media is a political act. The rise of contemporary Indigenous media production in the 1960s and 1970s began simultaneously with new waves of Indigenous pushback against assimilationist policies of child removal and institutionalization. Images of Indigenous children are central to Indigenous media activism, including projects that recover and reveal suppressed histories, make structures of settler-colonial power visible, and activate viewer sentiments toward policy change, as well as productions that imagine Indigenous futures and transmit intergenerational Indigenous knowledge. Images of children move audiences, and this visibility and elicitation of feeling through screen media counters the bureaucratization of care and the disappearance of children perpetrated by the settler state and the churches, as well as public apathy and skepticism in the face of community stories of loss. Films about Indigenous residential schools and child welfare policies visualize institutional intervention in Indigenous families through scenes of separation, showing children being taken away or looking through the windows of a departing car. These images recur in both feature films and documentary re-enactments by Indigenous and non-Indigenous filmmakers, such as the re-enactments in Obomsawin's *Richard Cardinal: Cry from the Diary of a Métis Child* (1987), Loretta Todd's *The Learning Path* (1991), feature dramas such as *Map of the Human Heart* (Vincent Ward, 1994) and *Rabbit-Proof Fence* (Philip Noyce, 2002), the short film *Savage* (Lisa Jackson, 2009), Tim Wolochatiuk's *We Were Children: The Traumatic Legacy of Residential Schools* (2012), and others. While acknowledging the generic power of interlocking dramatic and documentary modes in screen representations of Indigenous children (and the affective work these images are doing), I want to focus here on the instructional registers that Obomsawin engages as a form of ethical guidance in her children's films. Contextualizing the staging of these representations in the long political fight for Indigenous children's and family rights can help us to understand Indigenous media and communications, both historically and now, more broadly as a less generically determined and more directly

didactic mode of address, and to take a more expansive view of Obomsawin's filmmaking as a multi-genre activist and educational project.

"TELL US STORIES LIKE YOU DO IN SCHOOL": TALKING IN AND SONIC SOVEREIGNTY IN *CHRISTMAS AT MOOSE FACTORY* AND *MANAWAN*

Obomsawin's biography is well known, recounted by Obomsawin herself in interviews, and detailed in scholarship such as Randolph Lewis's 2006 book, *Alanis Obomsawin: Vision of a Native Filmmaker*. Issues of inclusion and exclusion central to her filmmaking originate in defining early experiences and emergent activism, especially in relation to education, and she began her career working with children in part because of events that occurred in her own childhood. While her early years were spent with family, extended family, and Elders on the Odanak reserve—where Abenaki was spoken in her home, along with some French—she left the reserve when her family moved to the nearby town of Trois Rivières, where she began school (probably around age six). Hers was the only Indigenous family in town; she had to expand her French vocabulary quickly, and she was targeted at school—bullied physically and psychologically by classmates. Looking back on this experience, and "thinking that I had to work to make some changes," she says, "I thought, the only way I could do my part would be to address the children directly" (Hearne 2006). She did this by visiting schools—both residential schools and public day schools—where she sang and told stories to children. Although she was in demand as a singer, she eventually moved from a professional career on the stage to focus on working in the schools with children.

This educational activism became her bridge into early multimedia work. While consulting on an NFB film, she remembers being invited into a room of National Film Board of Canada (NFB) staff producers and filmmakers who asked her to "tell us stories like you do in school" (Robertson 2014). This moment reveals not only an effort to integrate narrative with documentary and extend the NFB's educational mission, but also the process of transformation in the organization itself—the development of Indigenous filmmaking within the NFB. With the early success of the Challenge for Change Program's 1968 Indian Film Crew project and then the NFB's 1971 Indian Training Program, the 1991 Studio One all-Indigenous film studio, and 1996 Aboriginal Filmmaking

Program, Indigenous filmmakers were able to use the structures of state-funded media as a platform from which to speak out against the depredations of the state, and Obomsawin further shaped the NFB from within over the course of her career.[3]

Obomsawin leveraged her work as a storyteller and consultant, using media to scale up her intervention in schools with audio-visual curricular materials. Hired on to work with the NFB, she began collaborating with Indigenous communities to produce filmstrips and kits for classroom use—small vignettes from First Nations communities. Experimenting with electronic media as a way to translate an Indigenous teaching system based in storytelling to institutional educational spaces, Obomsawin developed a low-budget, slow-paced, minimalist aesthetic using still photographs and recorded sound. This multimedia form foregrounded the sounds of Indigenous voices and soundscapes and was adaptable to both field recording on remote reserves and the limited, non-theatrical exhibition conditions in classrooms. Obomsawin describes the kits as a composite of film image and sound:

> A filmstrip is like a 35-mm film which passes through a small projector. To "create" the story, you would refer to numbers on a slide, which corresponded to a track on an LP. Later, we used cassettes. Every class had one of these special projectors, with a turntable and slides. It was really the first time that we had a project "made by us" [Indigenous people] for classrooms. (Elawani 2018)

These multimedia kits often included reproductions of primary documents supporting land claims and other rights, juxtaposing evidence for ongoing contestations with the Canadian government alongside oral histories and images—and sounds—of daily life in the community. Archived at the NFB, the filmstrips and kits for the Cree community at Manawan Lake are now widely available on DVD and through digital streaming from the NFB website.

Already attuned to sound as a singer and storyteller before becoming a filmmaker, Obomsawin has described her early documentary work in terms of sound recording: "I was fascinated with sound, and I ran around recording everything" (Robertson 2014). This was an especially unusual strategy at that moment, in the wake of the pivotal, mid-1960s development of lightweight synch-sound field cameras (such as the Sony

FIGURE 7.1 A children's drawing from *Christmas at Moose Factory*. Production still courtesy the National Film Board of Canada.

Portapak) that led to the camera-first dictates of following unfolding action in direct cinema, cinema verité, and observational documentary. Obomsawin's sound-first philosophy and practice of documentary making was critical to her earliest works, which were not moving images but instead matched sound with drawings and still photographs to emphasize listening rather than action.[4] Her first two productions, *Christmas at Moose Factory* in 1971 and *Manawan* in 1972, were part of this NFB of Canada initiative to produce media for school settings. In *Manawan*, Obomsawin completely abandons the longstanding practice at the NFB of using settler experts to introduce Indigenous subject matter and instead partners directly with the Cree community to facilitate the telling of their own story, spending time with Elder César Néwashish at Manawan. In *Christmas at Moose Factory*, the children's drawings and voices that make up the 13-minute film are the result of Obomsawin's extended visits, living in the dormitory with the students in the residential school at Moose Factory. Obomsawin told the children stories and played games with them—and then asked them for stories and drawings. Even now, in her lectures and master classes Obomsawin recommends recording interviews and sound extensively before commencing any camera work, requiring filmmakers to listen first, while keeping the intrusiveness of cameras in check.

In addition to these children's stories (in *Christmas at Moose Factory*) foregrounding the voices of children themselves, and oral histories told by Elders (in *Manawan*) intended for youth audiences in schools, Obomsawin's kits feature recordings of different kinds of silence as well as environmental conditions and the sounds of daily life—including children's play, sledding, skidoos, and barking dogs; ambient sounds like wind; outdoor sounds of hunting and travelling like walking with snowshoes and paddling canoes; indoor sounds of woodcarving; quiet conversation with the Cree language, left untranslated; and more attention-grabbing sounds like moose calls. Through these soundscapes Obomsawin redirects our attention to the overlooked sounds of community life. In *Christmas at Moose Factory*, these place-based sounds, along with the children's voices telling stories about their communities, infuse the images with their sonic presence and authenticate their imaginative drawings with the sounds of the real world, underscoring the veracity of their expressive art. In *Manawan*, bringing listeners into the soundscape or "sound territory" (Robinson 2020, 53) of the reserve and its community connects the audience imaginatively to *Manawan* as audio-visual visitors, including through oral stories that manifest Indigenous occupation of the land before and after Manawan had reserve status, as well as documenting changes in the law afterwards. Initially produced for school curricula, Obomsawin also used this early material in her later documentaries, for example embedding whole vignettes from *Manawan* on childbirth and childrearing in her 1977 documentary, *Mother of Many Children*.

Obomsawin recalls of the filmstrips and media kits that "it was the first time we actually had some tools for the teacher, and it was the voice of a Nation, it was the people talking directly to the children. ... It was like winning a war to start to get them to teach the real history" (Robertson 2014). In numerous interviews she has repeated this characterization of her work—that changing how Indigenous and Canadian history is taught is "like winning a war." Her simile describes both the violence of institutional suppression of Indigenous stories and also the intensity of the struggle to have accurate history—and Indigenous perspectives—aired and heard by young people in educational spaces. And war isn't only a metaphor for the re-centring of Indigenous voices— years later, in 1990 while filming *Kanehsatake: 270 Years of Resistance*, in the midst of extraordinarily tense unfolding action in which the Canadian Armed Forces had begun to close in on the Mohawk warriors,

Obomsawin turns her camera to a moment of Indigenous instruction as Loran Thompson teaches the resident children how to identify trees and find food in the woods, while also modelling the sovereignty of not listening to the auditory violence of the Canadian state. Thompson teaches the children strategies of Indigenous refusal, blocking out the sonic havoc around them by plugging his ears when military helicopters hover overhead: "Do this! War is really annoying!"[5] He shows students not only how to hear and speak Mohawk, but also when to listen and when not to, and how to navigate the soundscapes of invasion, or what Dylan Robinson terms "sonic encounter" (2020, 11). The representation of Indigenous armed resistance to settler-colonial land expropriation in *Kanehsatake: 270 Years of Resistance* is entwined, in these images, with what Chad Allen calls "scenes of Indigenous instruction," which sometimes feature an "an idealized grandparent-grandchild bond" or indicate a broader community responsibility for the cultural educa-tion of Indigenous youth, through which they may "lay claim to their cultural inheritance and Indigeneity" (Allen 2002, 132, 161). Making education her "main concern," Obomsawin organized her documentary sound recording around Indigenous instructional imperatives for story-telling and oral histories (Hearne 2006).

Seneca scholar Michelle Raheja refers to Indigenous control of the camera and its storytelling processes as "visual sovereignty," work-ing from models of aesthetic sovereignty and intellectual sovereignty first articulated by Jolene Rickard and Robert Warrior (Raheja 2010). In Obomsawin's films, sovereigntist Indigenous creative control is sig-nalled not only by visual materials but also—even primarily—through sound and voice. Conversations in Indigenous sound studies around sonic sovereignty and sensate sovereignty—especially the work of sound scholars such as Dylan Robinson, curators such as Candice Hop-kins, literary scholars such as Beth Piatote, and others—have expanded critical attention to settler-colonial listening positionalities, decolonial listening, and sonic registers of Indigenous legal discourse, among other dynamics. In his work on sound in Indigenous media, Coman-che scholar Dustin Tahmahkera (2017) reminds us to "listen for aural affirmations and disavowals of Indigeneity" and "reflect on the role of sound in becoming and being Indigenous." He argues that sonic sover-eignties encompass both emitted sounds, "the formations of sonic vibrations in the air," and also "restoring good health through cultural

ways of listening," even as borderlands become spaces of dissonance with "sonic clashes" and "cacophonies of colonialism," from the sounds of artillery and military helicopters to the booms of noise cannons (long-range acoustic devices, or LRADs) used to drown out the prayers and honour songs at Standing Rock in 2016 (Tahmahkera 2017).

Following Tahmahkera's interest in "cultural ways of listening," I am interested in how sound positions viewers in a relationship to Indigenous speakers, as Obomsawin's NFB films speak both to an Indigenous audience and (given their intended classroom presentation and NFB distribution) a broader public. For example, in the instance described above, Loran Thompson's instructions are just for the children, but when shown on the screen in *Kanehsatake* they become available for everyone to see—and hear. If Obomsawin's sonic sovereignties involve attention to materialities of sound, they also involve reframing Indigenous voices, ways of listening, and ways of addressing an audience, within and beyond Indigenous communities, as these patterns intersect with the infrastructures and audiences (classroom, theatrical, and televised) of the NFB as a public, state-sponsored national film organization.

Thus Obomsawin's NFB work involves twin forms of address—to an Indigenous audience and a public one, suggesting also the way Indigenous filmmakers are positioned more generally as listeners and speakers in relation to multiple communities. In his 1990 book *Our Own Image*, Māori filmmaker Barry Barclay describes the way Indigenous films "talk in" to their own communities or "talk out" from them. He characterizes "talking in" as the "right and responsibility for any culture to present itself to its own people in its own way," while, on the other hand, "talking out" involves presenting aspects of a community to the world beyond it (75). "Talking out" benefits from "an awesome communications structure already established by the majority culture, which either shrieks ratings and returns, or seductively pleads to find out more" about Indigenous cultures. Barclay argues, however, that Indigenous people "need to be talking to our own people first, to be 'talking in,'" and goes on to offer the model of the marae—the Māori tribal or family meeting grounds that function as their turangawaewae or "place to stand and belong"—as a paradigm for Indigenous communications. While invited guests are welcome at a marae—which is a space for hosting outsiders as well as for ceremonies and meetings—there are rules of conduct that are particular to this bounded Māori space (75–76). Like the physical

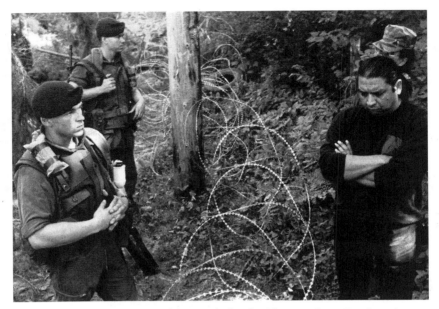

FIGURE 7.2 An iconic image of the standoff at the Oka siege from *Kanehsatake: 270 Years of Resistance*, NFB. Production still courtesy Shani Koumulainen.

marae, Barclay's "communications marae" is "looking inward but open to all," a system that asserts "cultural confidence" "in such a way that people are kept in the fold" (76–79).

Sonic sovereignty as a form that structures healthy listening, and "talking in" as a form of healthy speech, provide two frameworks for understanding Obomsawin's educational multimedia as an Indigenous instructional mode of address, with the NFB as a platform for both. Her short films for and about children "talk in" to Indigenous community members and young people, while also positioning a broader viewing public as listeners with less cultural access but still subject to Indigenous instructional authority. As I discuss below, the circle provides an Abenaki version of a "talking in" Indigenous communications model: an enclosure that is both a place of instruction and a synecdoche for Indigenous territory, meant to welcome others into an Abenaki space where listening and talking are heightened, performative, and identitarian.

"HUMANS AND ANIMALS TOGETHER": RE-IMAGING ELDERS AND ANIMALS IN *SIGWAN* AND *WHEN ALL THE LEAVES ARE GONE*

While almost all of Obomsawin's films for the NFB are documentaries, her short, dramatic films for children—including *Sigwan* (NFB, 2005) and *When All the Leaves Are Gone* (NFB, 2010)—depart from that anchor genre yet take up its signature tools, such as voice-over, re-enactment, and archival images of wildlife footage. These films also maintain the continuity of an instructional mode of address. *Sigwan* tells the story of a young girl, Sigwanis, who has been rejected by her peers in an Abenaki community and is taken in by a wise and instructive clan of bears (dramatized by masked human performers and voice actors). The film's focus on division within a First Nations community alludes to the repercussions of the imposed blood quantum rules in the revised Indian Act (Bill C-31), while the film's larger thematics of insider and outsider are also made available for generalized uptake in the way it narrates the pain of exclusion and provides models of inclusivity. The bear and other animal masks used in the film create different levels of access for insiders—those with knowledge of Abenaki bear stories and beliefs—and outsiders, even as Obomsawin provides some brief explanation in voice-over. Thus, the film itself models and strongly advocates for inclusiveness and welcome across different communities in and beyond Abenaki territory, yet this moment also delimits settler entry to the space of signification. The film dramatizes Barclay's "talking in" and "talking out" at the same time; aligning with what Cheryl L'Hirondelle calls "radical inclusion" (qtd. in Robinson 2020, 237), *Sigwan* "extends participation to all," including nonhuman relations, but does so within Indigenous protocols rather than structures of settler expectation.

Sigwanis is among a contemporary group of children at the film's opening, listening to a masked storyteller who describes the setting of the story—the village in a time of plenty, just before the summer ceremonies. From this "scene of the story"—a modern storytelling scenario that emphasizes through reduplication the importance of storytelling for transmitting knowledge—the film turns to the storyline. Awassos, the black bear (played by Guillaume Wawanolet, voiced in English by Cayuga actor Gary Farmer), visits his friend Tolba, the Turtle (played by Sophy Wawanolet, voiced in English by Michelle St. John) in the marshlands, who warns of "trouble among the clans. We must think of our

future generations." Awassos then encounters Sigwanis, who is alone and neglected. She says, "I'm sad, because I'm not allowed to go to the celebration and the dance. They said, 'You're not part of the Nation.'" Spurned by her community ("I don't have any moccasins and I'm bare-footed"), Sigwanis becomes emotionally vulnerable to self-loathing, saying, "I'm six years old and I'm ugly." This brief exchange implicates the divisive and gender-discriminatory regime of colonial governance at the heart of the Indian Act (and its 1985 revision, Bill C-31) under which Indigenous women—but not Indigenous men—lose Indian status by "outmarriage." Obomsawin explains the effects of the revised Act on her community:

> When I got home ... and I was working on a documentary—I could hear the little children: "You're 6-3, you're not allowed to come here, you're not allowed to get on the bus, you're not allowed to do this or do that." And it's just, it's so heartbreaking, you know, to see that ... I wanted to do something to guide the children, like in the old days. In the old days, we told stories or we heard stor-ies from our elders, and these stories gave you a choice. They didn't say don't do this, or don't do that, don't go there, but most of the time they had to do with relations with animals and the choice was left for the child, and that's a respect that you must give the child. (Obomsawin 2006)

The bears offer this respect to Sigwanis, preparing a healing ceremony for her that reaffirms an ethic of inclusion. Awassos and Sigwanis walk through the woods together, eating berries and playing, and Sig-wanis joins a circle of bears around the fire. In voice-over, Obomsawin explains the significance of the circle: "The circle is the sacred symbol of life—everyone who takes part in the circle is filled with a feeling of love and peace." The Medicine Bear burns sweetgrass, and "Sigwanis felt happy, because she was welcome." When Sigwanis's parents find her missing, they search for her and her father brings her new moccasins and a new dress. The Bear Chief delivers his lesson to the community: "You see, our circle is always open, so that all will feel welcome." The bears and humans join together: "everyone from the village joined the circle, which grew larger and larger" and Sigwanis dreams that "now she

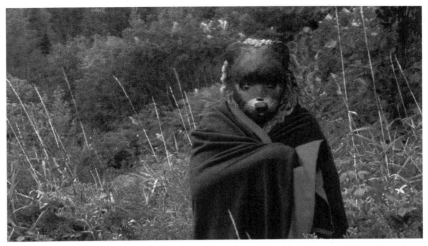

FIGURE 7.3 A bear in *Sigwan*. Production still courtesy the National Film Board of Canada.

truly belonged." Faced with the exclusions and divisions embedded in Canada's imposed determinations of Indigenous identity, which operate along what Glen Sean Coulthard calls "eliminatory logics" to maintain settler-colonial control over territory, Obomsawin teaches inclusion. *Sigwan* counters settler-colonial law with an older, pre-colonial sovereignty—a nation whose circle is both "ours" and "open." Accessing what Leanne Betasamosake Simpson calls "the fluidity of our traditions" (2011, 51) and what Coulthard calls "resurgent practices" (2014, 23), Obomsawin crafts a discursive address to children that privileges the Indigenous territory of the reserve over settler legal structures, and that offers access to more capacious ways of thinking about Indigenous nationhood and Indigenous education that are emergent from relationships with the land and all its inhabitants.

The film's rendering of its characters is complex in ways that invite viewers to reflect on the dynamics of listening and performance. Almost every figure is doubled: Sigwanis is both a listener in the audience and a character in the story, and the performers in animal masks and blankets are silent, their dialogue conveyed by voice actors (viewers can select either French or English versions). Layering each character through sonic "doubling" (by voice-over) separates on-screen performance from sound; the reduplication of each performance widens the circle of

impact to include not only professional voice actors but also children and nonprofessional performers, who can benefit from Obomsawin's community intervention by participating in the event of the production itself.

In addition to using sound (voice-over) and actors in costume to convey the creatures of the forest, Obomsawin also draws on wildlife footage—some of which may have come from NFB archives. Her use (or re-use) of this footage is different from wildlife documentaries that frequently narrate relationships of predator to prey in either evolutionary or melodramatic terms, emphasizing competition. In *Sigwan*, wildlife footage conveys interspecies reciprocity and shared pleasure in summer abundance, linking this Odanak reserve environment to symbolic animals and the values they convey around generosity, healing, and care for future generations. The wildlife footage also indexes the costumed performers to their wild counterparts by interspersing them (turtle is juxtaposed with Turtle, bear with Bear), as does the image of "humans and animals together" in the human figures who perform animal roles. The narrative emphasis on the setting of the Odanak reserve, like the sonic attention to place in *Manawan* and *Christmas at Moose Factory*, represents Indigenous territory in terms of plenitude, an opportunity for teaching not only ethical relationships but also how to engage with the land through sensory connection. Many narrated exclamations underscore this message: "Oh, it's a beautiful day! There's magic in the air"; "All the bears of my clan are reveling in the warmth of the sun"; "We stopped ... to eat raspberries and blueberries. I love raspberries!" "I love raspberries too!" The way the Medicine Bear plays with Sigwanis and introduces her to harvesting and foraging (they pull up garden vegetables to eat, and he promises that "I'll take you to meet my friends the bees—you'll see how generous they are") models healthy connection with seasonal sustenance and subsistence in her territory.

The style of the masked figures, the narrative strategy of finding lessons in the natural world, and offering children choices through stories with an instructional mode of address all suggest the way *Sigwan* is "talking in" to the community while still inviting outsiders to listen, as Barclay describes a "communications marae" should do. The Abenaki version of this communicative space is the circle. At the centre of the story and the story's message, the circle works according to Abenaki authority, but is always open to others. The space of the circle conveys acceptance and belonging that is crucial for well-being, yet is

also strongly connected to instruction, with teaching and learning at the centre of human-animal interactions. By taking in Sigwanis, spending time connecting with her, caring for her, teaching her about the forest, and reminding her of her value, the bears teach Sigwanis—and her parents and community, when they arrive—to value one another in relationship to the tapestry of Abenaki land and animals. It is a lesson in belonging.

Obomsawin's most recent dramatic short, *When All the Leaves Are Gone*, is more overtly autobiographical than any of her earlier work, telling the story of her own childhood through the character of Wato (played by Rosalie Dumas), a young girl who moves from the Odanak reserve to the city, as Obomsawin did at around age six. She experiences not only homesickness and sadness over her father's illness, but also trauma from her encounters at school with callous teachers, racist textbooks, and bullying students. Issues of inclusion and exclusion, which are central to Obomsawin's filmmaking, originate in these defining early experiences of discrimination, and she recalls this time as formative, the source of her clarity about the way "the educational system was really excluding us ... teaching things about us that were making us invisible" (Hearne 2006).

The film is set in the early 1940s and combines documentary techniques such as voice-over, intercut archival footage and re-enactments, and panning and zooming on still images with lyrical dream sequences in which actors in horse costumes comfort and heal Wato. Most of the film is in black and white, with the final dream sequence in colour, and Obomsawin situates viewers in time and space by attending to animal life and the environment in what might otherwise be termed "b-roll" footage, measuring time by seasonal cues such as leaves falling, and orienting viewers to changes of place by showing geese migrating. Wato's story moves not only place to place seasonally but also between the external world and the world of her dreams.

At the centre of the film is a beating. Wato is attacked by her classmates while walking home from school, but the film shows how this violence is actually born in the classroom, where the word and category of "savage" is introduced to the students, and the bullies among them carry it to the streets as an epithet. The key staging of this settler-colonial construction of "Indians" as "savages" is seeded with a history textbook from the period (1940) as an iconic prop. The

textbook's divisive, incriminating story, which defines Wato as "savage", and separates her from the other children, is the source of the violence that blossoms on the street—the film establishes a direct link between misrepresentation in educational materials and physical harm. This understanding of the immediate damage from institutions, documents, policies, and curricular materials makes their human consequences visible in stylized portrayals of social relations in Wato's life, especially the model adults offer of teaching and learning.[6]

Obomsawin addresses this trauma in the film by answering colonial texts with oral history, just as she did in her early career multimedia kits like *Manawan*. While the 1940s Canadian history textbook describes Abenaki as "savage" torturers, Wato's voice-over later counters with her own family's historical memory: "Papa says the cruelest torture is that our country was stolen and our languages were silenced. He says, someday our people will have a voice again. No one can take away what is in our hearts, our spirits, and our dreams." If the central violence of the film is Wato's beating, its counterweight is her healing in the final dream sequence, which turns to animals for models of recognition, inclusion, care, and nurturing. In her dream, Wato is curled up face down in a fetal position on a blanket (a graphic match to her position on the sidewalk when she was beaten), but the dream is set on the Odanak reserve, where an old woman tends to a fire. Two actors in horse costumes emerge from the woods, gently nuzzling and caressing Wato until she uncurls and begins to respond, then to play (riding one horse while the other rolls on the ground), and finally dances with them. She shows them her scraped knees and they tend to her.

The two horses that care for Wato in the dream sequence manifest compassion just as Obomsawin's beloved relatives at Odanak, her mother's sister Helen and her mother's cousin, Theophile, once did. Wato says at the beginning of the film that she knew she was loved by these two Elders, who fulfilled her need as a child to be seen, heard, and cared for by the people around her. While the schoolteacher, a nun, is represented by a statue reminiscent of museum dioramas, the footage of Theophile is actual archival footage of Obomsawin's relative, who taught her many songs and stories. The footage is from a 1966 Canadian Broadcast Corporation profile of Obomsawin, in which she credits Theo for teaching her most of what she knows and calls him "a tree of this tribe" ("Alanis Obomsawin the Activist" 1966). Also from the 1966 broadcast is footage

of a white horse running in a field, which in the original CBC segment was accompanied by Obomsawin's voice-over description of her aunt Helen, who encouraged her to sing, and who Obomsawin took as a model of a "great old woman." A clip of this footage of the white horse appears at the beginning of *When All the Leaves Are Gone* just before we see Wato's aunt. By integrating these segments of older footage, the film honours Obomsawin's relatives and teachers who have passed away but remain with us onscreen. In addition to these two Elders, Helen and Theophile, we see other Elders in the film, namely an old woman by the fire and the man playing the violin. The two spirit horses seem to represent the strength that an extended family and cultural community can provide, and that is so violently suppressed in Wato's institutional school settings.

While part of the film relies on nonfiction footage—of Theophile from 1966, and of 1940s Québec from the NFB archives—and the re-enactments include precise historical props such as the Canadian history textbook and period automobiles, the dream sequences are joyously, flamboyantly stylized. As with *Sigwan*, Obomsawin turns to Abenaki representational strategies involving masks, regalia, and theatrical costumes, with which people evoke and embody spiritual animals who visit children in order to help them overcome loss, homesickness, or exclusion. In his essay "Indigenous Experimentalism," Hopi filmmaker Victor Masayesva describes the "tribal person's trans-cultural performances" as "most profound when inherited skills and ancestral knowledge dominate the stage" (2001, 238). He continues: "The Indigenous aesthetic—like each unique tribal language, is not a profane practice, a basic human protocol, or merely a polite form of etiquette and transaction, but rather it is the language of intercession, through which we are heard by and commune with the Ancients" (Masayesva 2001, 232). Wato's dreams serve as a resource for healing, restoration, and accessing other worlds to communicate with loved ones. She tries to reach out to another father figure earlier in the film, St. Joseph, but the shot/reverse shot sequence emphasizes her distance from the immobile church statue. In the dream sequence, however, she is able to address her father directly ("Papa, I am dancing, can you see me?"). Her dance with the costumed horses performs the "language of intercession" and communication with family, ancestors, and ancients, helping her return in her mind to Odanak, where she can "stand and belong."

"THE STATE MAKES A LOUSY PARENT": *HI HO MISTAHEY!* AND *WE CAN'T MAKE THE SAME MISTAKE TWICE*

Obomsawin began her film career using multimedia kits to move Indigenous voices (history, perspectives, stories, and culture) into curricular materials, and as she returns to making short films for children she has also continued making long-form documentaries that advocate for Indigenous rights with regard to educational institutions. The first two of a planned cycle of five films about the rights of Indigenous children point to criminal underfunding of Indigenous education and foster care, as well as illegal land expropriations, among other issues. These films trace legal challenges to the Canadian government's discriminatory funding models for Indigenous education and child welfare systems. Court battles for Indigenous survival and Indigenous futures— the rights of Indigenous peoples to raise, nurture, and educate their own children—show what is at stake when Obomsawin chooses to centre children as subjects, speakers, and audiences in her film work.

Hi Ho Mistahey!, released in 2013, documents educational inequalities in Attawapiskat (which operates schools at half the funding level for non-Indigenous school systems).[7] While educational funding is protected in provincial budgets, in Indian Affairs these funds are often redirected to meet other needs. The film follows students who seek to bypass the Canadian government's discriminatory legal systems to appeal directly to children across Canada and to international human rights forums such as the United Nations in Geneva; ultimately, they successfully pressure the Canadian Parliament to pass legislation and Indian Affairs to build the school that was first promised in 2002. The students' "Shannen's Dream" campaign is one thread in the groundswell of Indigenous activist movements across Canada, immediately preceding the Idle No More movement.[8] In fact, the two were so entwined that Obomsawin temporarily halted filming of *Hi Ho Mistahey!* in order to make *The People of the Kattawapiskak River* about Chief Theresa Spence's hunger strike over housing and infrastructure crises at Attawapiskat.

Obomsawin spends considerable time building a larger picture of the Attawapiskat community, visiting with men in goose hunting camps, the local priest, and participants in an emotional anti-suicide campaign event. At unexpected moments, she turns abruptly to brief, voice-over-narrated journeys into the historical background of the

reserve's current problems (such as the 1979 diesel spill that made the community's school uninhabitable in the first place), which are characteristic of her insistence on telling a whole story, beginning to end. These moments resemble the much-remarked pivot in her signature film, *Kanehsatake: 270 Years of Resistance*, when Obomsawin pulls back unexpectedly from the standoff between the Canadian army and the protesters to delve deeply into the Indigenous history of early contact and land settlements in and around Montréal. The sequence reveals the original colonial incursions into Mohawk lands, the Church's further theft of lands, and the ongoing land expropriations leading up to the Oka crisis. Michelle Raheja has described similarly deliberate and slower pacing strategies in the film *Atanarjuat*; there is an insistence on Indigenous temporality and close attention to material that "if skipped over would mean missing the ways in which the film constructs an Inuit [or Indigenous] epistemology" (Raheja 2010, 216).

Demands are also made of the viewer in Obomsawin's 2016 film, *We Can't Make the Same Mistake Twice*, which follows the discrimination complaint filed by the Child and Family Caring Society of Canada and the Assembly of First Nations against Indian Affairs and Northern Development Canada over inadequate and inequitable funding for First Nations child welfare services. Like Obomsawin's short films and early multimedia kits, this film prioritizes Indigenous time and Indigenous voices of testimony. Its extended length structures audience listening for as long as that testimony might take and without conforming to standard television documentary story arcs or time limits. The film features many scenes of courtroom testimony, as the case was argued before the Canadian Human Rights Tribunal over nine years. The setting is a space far removed from reserves, a space where colonizers must be met on their terms and in their language (although smudging is allowed at the outset of the hearings). Proceeding in fits and starts and beset by procedural obstructions, the case hinges on highly technical legal and evidentiary requirements, uncovering discrimination hidden deep within administrative systems, in the line items of budgets and how funds are accessed, and embedded in legal language where small nuances deny care to thousands of children, resulting in a system that requires Indigenous children to be removed from their homes and separated from their families in order to receive basic social and medical services. Obomsawin's camera reveals the fight for children's rights to be

a test of endurance and the system of child welfare itself to be excruciatingly bureaucratic—far removed from the sensory pleasures of Abenaki territory that enriched the dreams of child characters in her short dramatic films. Speakers—residential school survivors, social workers, and fiscal officers—testify against a background of white binders filled with case documents and labelled with inscrutable codes. To help viewers understand the content of these records, Obomsawin shows documents and legal text onscreen with highlighted passages, but at times the distinctions are so confusing that Obomsawin deploys an animated infographic with polar bear characters who guide the viewer to help clarify the labyrinthine funding formulas for child welfare.

The courtroom structures this struggle in adversarial terms, and despite 72 days of wrenching testimony, the Government of Canada argued a "lack of evidence" and that the tribunal was "not the right place for this type of claim to be addressed." The state particularly did not want testimonials about the legacies of residential schools to be admitted (and further delayed and withheld documents from the plaintiffs, extending the court battle by many months); Obomsawin's inclusion of long sequences of Indigenous testimony extend the work of the Indigenous plaintiffs, amplifying their defiance of the state.[9] While Obomsawin's early-career documentaries such as *Richard Cardinal: Cry from the Diary of a Métis Child* (1986) grip viewers through re-enactment and were circulated to professionals in training in the social work system in Alberta for years, *We Can't Make the Same Mistake Twice* delivers straightforward courtroom testimony, summed up by child welfare advocate Cindy Blackstock's blunt assessment that "the state makes a lousy parent."

Obomsawin's camera captures again—for adult audiences—the struggle against silencing Indigenous voices, since what is at stake in this case is also the right of Indigenous peoples to tell their story in full, linking the history of residential schools to the subsequent and similarly devastating child welfare system. To insist on these things as elements of an overall system of cultural genocide, to insist on centring Indigenous voices within the decision-making and institutional spaces where they had been excluded, widening the circle of the tribunal to hear counter-histories, and making the courts into a didactic space for Indigenous concerns, is to engage the ethos of the Abenaki circle (or Barclay's "communications marae") even within the restrictive tenets of colonial courts.

FIGURE 7.4 *We Can't Make the Same Mistake Twice*. Production still courtesy the National Film Board of Canada.

CONCLUSIONS

Children are not usually centred in documentary and film studies scholarship, although occasionally they are subjects of documentary films. The genre's preoccupations with difficult subject matter and large-scale social problems, along with what documentary film scholar Bill Nichols has called its "discourse of sobriety" (an "instrumental power" to represent and intervene in the real world, which makes documentaries "seldom receptive to whim or fantasy"), sometimes preclude engagement with the imaginative play that so often marks children's storytelling and ways of being. Yet Obomsawin's emphasis on children's rights and education in her work gives particular shape to documentary filmmakers' long-standing desire to track an explicit origin point in the instrumentality of film for social change. I saw this ethic unfold when Obomsawin screened her signature film, *Kanehsatake: 270 Years of Resistance*, at the 2006 True/False Film Festival—a documentary film festival in Columbia, Missouri—where she also gave a master class on documentary sound and showed her recently completed short film *Sigwan*. In addition to her screening and master class, Obomsawin asked if she could offer a storytelling session with children. For three hours at an evening youth workshop she told stories from her community to children aged four through twelve, and since the space had a kitchen, she taught them how to make bannock. The True/False festival had committed to educational outreach for many years, yet Obomsawin's explicit

request to visit with children was singular in the festival's history to that point.[10] The multiplicity of her teaching at the festival—across long-form documentary, short narrative film, live storytelling, and the masterclass for filmmakers—exemplifies an ecosystem of Indigenous media instruction that consistently includes children at the centre of its circle.

During her True/False masterclass, a filmmaker asked the big question for documentarians: "You said a little bit earlier that films could change the world. ... I was wondering if you could elaborate a little bit about how this works?" The question provoked an impassioned response from Obomsawin:

> Changing the world starts in very much a simple way. It happens in a house. It happens in a family. It happens with your children, how you raise them. Are you raising them to be racist or are you raising them to have love for all? All those thing start right there ... so when you make films, you give examples of these things ... give examples to children. ... It is like a seed that you put somewhere to develop, you know, to be good persons. No matter what race, what color, your neighbor or whoever it is that you are with, they are human beings. To acknowledge that—that is how you change the world. Start with knowledge of each other, loving each other, and it's very easy. (Obomsawin 2006)

In her response to this fundamental, long-standing question in documentary film history and scholarship about the world-changing promise of documentary film, Obomsawin turns away from media altogether and instead prioritizes childrearing. Yet the exchange also underscores how recognizing the centrality of children to her filmmaking across narrative and documentary forms can expand how we understand film as social action, a particularly Indigenous way of making films that change the world (that simple yet confounding quest at the heart of so much documentary production).[11] My point here is not only that Obomsawin's children's films are extensions of her documentary practice, but also the reverse: that perhaps more fundamentally her documentaries are extensions of her world-changing work with children. Her children's films bring together documentary film tools and aesthetics with didactic and imaginative elements of dramatic film storytelling, while also inflecting long-established documentary aesthetics with formal innovations and experimentalism.

Attending to Obomsawin's early work—including the heritage of multimedia educational materials, sound-based modes of production, and lower-budget aesthetics from the NFB—alongside her recent short films and documentaries, links understanding of her long career to the larger context of North American Indigenous women's media since 1970. In the wake of residential school experiences and shifting child welfare policies in the United States and Canada, this work expands the history of Indigenous women artists and performers working in media technologies in the decades before the millennial turn to the digital. Their inventive experiments in short-form media took place in connection with activism for children's cultural and political rights, countering the calculated absence of Indigenous images in mainstream media screen cultures. Obomsawin connected these experiments with new kinds of publicly funded short-form media to children's worlds, setting her sights on the capacity of instructional media to unsettle— to decolonize—the kinds of settler pedagogy she had experienced in schools. She attends to children's articulation of their own experiences, shifting emphasis from the perspective of the state to the perspective of Indigenous children in order to centre children's rights and personhood. She did this by inventing a new kind of public address, using the resources of the state to create a media space for images of Indigenous teaching and learning. Obomsawin intervenes in First Nations school and foster care experiences, re-presenting pedagogical iconographies as scenes of storytelling rather than scenes of formal classroom education. She draws upon documentary conventions and footage for narrative purpose, asserting Indigenous control over visual and aural representations. Finally, she systematically targets the narratives that divide people, keeping everyone "in the fold" while consistently "talking in" to First Nations peoples. Using an instructional mode of address, archival footage, and sound-first documentary practice, Alanis Obomsawin uniquely privileges Indigenous voices in a public way, acknowledging Indigenous children as producers and receivers of knowledge for Indigenous futures.

NOTES

1 See, for example, White 1999 and Lewis 2006.

2 Kimelman's comments are from his 1985 review "No Safe Place: Review Committee on Indian and Métis Adoptions and Placements." In Obomsawin's 2016 documentary, *We Can't Make the Same Mistake Twice*, Cindy Blackstock testifies to child welfare conducting mass removals of Indigenous children during the Sixties Scoop, concluding "fundamentally what's at stake is the survival of our peoples." In the 1980s, the Canadian government formed First Nations child welfare agencies to curb this practice, but these agencies receive about 22 percent less federal funding than non-Indigenous child welfare agencies. Similarly, in the United States between 1958 and 1967, the Indian Adoption Project of the Bureau of Indian Affairs (BIA) and Child Welfare League of America (CWLA) sought to place Native American children with white homes, in order to combat racism in adoptions (a major exception to race-matching in adoption). As a result, according to a 1977 study by the Association on American Indian Affairs, in 1976 25 to 35 percent of all Native American children were being placed in out-of-home care; of these, 85 percent were placed in non-Indigenous homes or institutions. In 1978 Congress passed the Indian Child Welfare Act (ICWA) supporting tribes' fight to protect their member families, reaffirming children as vital to the integrity and existence of Indigenous peoples.

3 There is significant scholarship on this history, including Waugh, Baker, and Winton 2010, Stewart 2007, Dowell 2013, and Hassannia 2017.

4 This slide-show style anticipated the "digital storytelling" community media work promoted by the Center for Digital Storytelling in the 1990s, but before digital media tools lent wider access to filmmaking technology.

5 See *Kanehsatake: 270 Years of Resistance*, 1:08:30–1:09:06. In Joanne Robertson's *Making Movie History—Alanis Obomsawin*, Obomsawin talks about her obsession with documentary sound by describing a similar moment of sonic dissonance during her filming of *Kanehsatake*, in which a warrior's victory song is drowned out by the sound of a military helicopter. Indigenous soundways and sounds of militarized interruption are repeated phenomena across the protest camps at Oka in 1991 and at Standing Rock in 2016.

6 This classroom scene is part of a long tradition of such scenes, dating back at least to the Hollywood film *Redskin* in 1929, and including dramatic features such as Vincent Ward's *Map of the Human Heart* in 1994 and Lisa Jackson's *Savage* in 2009, all of which dramatize Indigenous children brutalized by their institutional education at residential schools.

7 At the time, as documented in the film, Attawapiskat received $8,000 per child per year, rather than the more typical $15,000 per child per year in southern schools.

8 Shannen Koostachin was a youth education activist from Attawapiskat First Nation; she advocated for the federal government to fairly fund First Nations education and to alleviate the disparities between First Nations and other provincial and territorial schools. She passed away in a car accident before graduating from high school, but others carried on her work through the "Shannen's Dream" campaign, resulting in the construction of a new school facility at Attawapiskat (completed in 2014).

9 For a nuanced analysis of Indigenous media testimony in the wake of the TRC, see Gaertner 2016.

10 True/False Film Festival founder David Wilson affirmed that "I can say definitively that no other filmmaker has ever asked to do a storytelling session with kids."

11 See Gaines 1999.

Methods/Knowledges/Interventions

Introduction to Part III

Dana Claxton and Ezra Winton

"Only recently have Aboriginal scholars been allowed the respect of conducting their own research." Shawn Wilson wrote those words in 2008, in his indispensable book *Research Is Ceremony: Indigenous Research Methods.* That's nearly 220 years since the first university was founded in Canada in 1789, not to mention the founding of the academic institutions from colonial motherlands that provided the research papers and conceptual footing for *terra nullius* and other colonial conquest myths. Indigenous research predates these collected colonial halls by thousands of years, but the formalized inclusion of Indigenous thought, arguments, theories, and methods has only very recently—as Wilson points out—found foothold in Canadian academia. We cited some of the foundational Indigenous research texts in our introduction, and since their publication we are inspired by the sheer breadth, depth, and capacity of Indigenous scholarship inside and outside of officiated academic spaces.

Methods. Knowledges. Interventions. What do these words mean in the context of Indigenous media arts representation in Canada? What do they mean to making, caring, and sharing? What is our relationship, whether we identify as settler or Indigenous, to these terms? The chapters in this section present a dynamic fusion of embodied practices and thought in Indigenous media arts. From history to advocacy, from self-expression to community-building, the four chapters that follow explore Indigenous media and research methods, Indigenous knowledge building and sharing, and Indigenous interventions in the status

quo functioning of settler Canada. Part III's plucky works position and argue for Indigenous storytelling as the embodiment of a never-ending, fluid, and fervent epistemological gathering. We gather these authors—these researchers—together in the spirit of claiming Indigenous knowledge space, Indigenous ways of doing and knowing. In Chapter 8, Jules Arita Koostachin says it best: "Our stories embody collective and personal meanings, hence, a comprehension of Indigenous epistemological approach to story is fundamental in understanding how Indigenous documentary methods intersect with Indigenous research methodologies." While Jules is writing about nonfiction media arts, we see these pulsing lines of knowing and doing intersecting across all Indigenous media arts.

We are also aware of the troubling potential for Indigenous methods and knowledges to be read or consumed in an extractive manner commiserate with the larger settler-colonial project. Eve Tuck writes about this in the introduction to the premiere book in the series "Indigenous and Decolonizing Studies in Education," that which she co-edits with Linda Tuhiwai Smith and K. Wayne Yang. She talks of an ongoing frustration with the manner in which settlers have read Indigenous theory, a cautionary comment we are aligned with and would extend to Indigenous media arts productions and the ways in which they may also be *read* extractively.

> I spent almost all my career, up until recently, believing that if white settlers would just read Indigenous authors, this would move projects of Indigenous sovereignty and land rematriation in meaningful ways. I underestimated how people would read Indigenous works extractively, for discovery. I underestimated how challenging it would be for settlers to read Indigenous work, after all these years of colonial relations. (Smith, Tuck, and Yang 2019, 15)

Following Tuck, we also call for non-Indigenous readers of Indigenous theories, research, and media artwork to do the heavy lifting involved in manifesting ideas into action, of seeing decolonization through such work as a process toward equality, justice, and liberation, not an end point where, as Tuck points out, settlers continue to belabour Indigenous thinkers to outline what comes next.

Through the production of knowledge (research) and the manifestation of culture (media arts), Indigenous thinkers and makers continue to provide upending and needed interventions in Canada's academic and arts fields. The seeds may have not been given much time, nor space in the garden to grow, but they are fierce and they are resplendent.

Indigenous Documentary Methodologies— ChiPaChiMoWin: Telling Stories

Jules Arita Koostachin

Our stories embody collective and personal meanings, hence, a comprehension of Indigenous epistemological approach to story is fundamental in understanding how Indigenous documentary methods intersect with Indigenous research methodologies. In respect to the diversity that exists within our Indigenous storytelling practices, this chapter reflects upon the storytelling approaches that inform our knowledge systems and ways of being. It considers approaches to story that are deeply embedded in our orality, as well as the narratives informed by our diverse lived experiences as Indigenous people. An Indigenous documentary approach to story creates space for individual and collective differences; for the most part, our methods prove to be holistic, all the while encompassing protocols and customary practices. Most aim to engage with audiences through the documentary platform by permitting time to reflect, contemplate, and most importantly, question the context of the story. There are many Indigenous storytellers who work in the industry who may not produce documentary from the same stance, nor share similar sentiments with regards to Indigenous epistemologies. Rightfully so, yet this only serves to demonstrate the diversity of social locations and realities that exist. With this in mind, in this chapter I am more concerned with Indigenous documentary practices that create opportunities for meaningful exchange from both within communities and beyond.

We—Indigenous storytellers—work to (re)inscribe the image of Indigenous people in the Western imagination through varied documentary platforms, strategically challenging colonial history and discourse with every story told. Indigenous documentarians address settler colonialism by generating self-representations that impede colonial constructs; what is more, storytellers are invariably restoring cultural knowledge. The stories we tell offer entirely new responses, doing away with discriminatory colonial ideals and practices marked in the Western form of documentary. The Western form of documentary can otherwise be understood as the principle ethnographic/observational tool entrenched in Anglo-European tradition (Wood 2013, 54). That being said, by practising Indigenous documentary methodologies, we can deepen our relationships by assuring accountability and responsibility to our stories.

Over the years, I have observed that documentary is especially enticing to Indigenous storytellers because the fluidity of documentary platforms allows for more creative approaches, ones that better express our varied cultural locations. Also, Indigenous documentary practices attend to ontological characteristics, including place and temporality. Documentary as a storytelling platform manifests time and space—and most importantly archives our experiences collectively and individually.

ORALITY

Similar to orality, documentary too is recognized as an effective mode of transmission, a means of passing honoured and relevant knowledge from one generation to the next. Documentarians are likely more inclined to employ documentary as a form of storytelling practice because of the creative freedom it offers. Balance, cultural sustainability, and permanence are realized through orality, which can easily translate into documentary. Scholars Eigenbrod and Hulan stress that our connection to our oral traditions informs how we approach our cultural narratives. They propose that the stories we share derive from a distinct way of being rooted in our cultural origins:

> To understand oral tradition as a form of knowledge shaping the work of Aboriginal artists and authors, for example, one listens to the oral narratives in order to know their voices might be heard

within the communities they come from as well as the communities in which they are received. (2008, 7)

In this belief, the temporality of orality transcends time and space, advising and influencing the way we think of stories today. Orality, like documentary, is an immediate intervention reviving Indigenous stories, all the while, (re)connecting audiences to their culture, community, and in some cases their *ancestral* lands. Its formation is never conclusive, and like the art of filmic expression, no two experiences/responses are ever the same. Our narratives bear the capacity to alter perspectives, and of course reactions will always differ. Stories are the passageway for change and transformation. The ideologies are intertwined, and documentary as a storytelling practice has proven to be an effective form of knowledge exchange.

Renowned documentarian Alanis Obomsawin, who is most known for *Kanehsatake: 270 Years of Resistance* (1993), cited in Randolph Lewis's book *Alanis Obomsawin: The Vision of a Native Filmmaker*, regards documentary as a method parallel to the art of orality because Indigenous people come from a place of listening. She states, "I am very fussy about sound. ... I come from a place where hearing and listening to people is important" (2006, 64). This is evident in Obomsawin's array of documentary film work, over fifty films to date, where the sound quality is notably impeccable and the narration is compelling—her voice-over inviting viewers into engage with each story. As part of Obomsawin's methodology, she has replaced the overshadowing didactic settler voice-over with her own voice, that of an Indigenous woman—the subjective raconteur. Lewis highlights that Obomsawin utilizes persuasion as an artifice: employing her own voice is a strategic move, where she rouses compassion and receptivity from her audiences. Essentially, her documentaries humanize us as Indigenous people, which has created opportunity for meaningful dialogue, and has even resulted in legislation changes.

Additionally, in manipulating rote Western documentary practices fixed in Eurocentric thought, documentarians may shift ways of thinking by initiating innovative approaches to Indigenous storytelling through the documentary form. As alternative advances soar, such as Tasha Hubbard's award-winning National Film Board of Canada (NFB) feature documentary *nîpawistamâsowin: We Will Stand Up* (2019); Neil

Diamond's documentary *Reel Injun* (2010); and I would also add my CBC Short Docs *NiiSoTeWak: Two Bodies One Heart* (2017) and *Osh-KiKiShiKaw: A New Day* (2019); as well as countless others, our stories continue to counter mainstream notions of Indigeneity as easily knowable, simplistic, and superficial. Indigenous documentarians inevitably dislodge settler representations with profoundly complex meanings. Indigenous knowledge is rooted in our *ancestral* lands and to our relationships to story; therefore, our narratives are not fixed, and they are always adapting and changing just as we do. Our documentaries, in turn, are deep-rooted in community and our cultural identities. Scholar Beverly Singer echoes similar sentiments regarding orality as fundamental to understanding Indigenous film when she writes, "The oral tradition is a continually evolving process and is apparent in Aboriginal and native films and video, which are extensions of the past in our current lives" (2001, 3). Indigenous documentarians are strategically using story, both *ancestral* and from the current day, as a method to unite and inform and as a means to acknowledge our various knowledge systems. Historian Donald Fixico suggests, "For American Indians, oral tradition is imperative to holding communities together. A story unites us with a common understanding of kinship, giving us a common experience, and creates a group ethos" (2003, 29). Documentarians thus provide an imperative perspective, such as the works by story matriarchs Loretta Todd, Alanis Obomsawin, Tasha Hubbard, and many others, unremittingly bestowing new meaning to communities surviving at the margins of settler colonialism. Usurping the colonial gaze, documentarians have appropriated the camera for the sake of our families and communities. Stakes are high because we are held accountable by the community in which the stories derive, and to the story itself. Scholar Margaret Kovach claims, "In oral tradition, stories can never be decontextualized from the teller" (2010, 94). I concur; the *storyteller/listeners* have a moral obligation to the story because they have entered into a verbal agreement. Hence, we too have a moral responsibility not only to the story, but to the community from which it originates. In this way our exchanges are cultivated by the demands of our relationships, and without such social allegiance, we chance damaging trust.

Also, our storytelling methodologies offer a route to social determination, and an opportunity to self-represent. In such acts of self-agency we have opened the door to (re)define our own ways of

innovating documentary. Māori scholar Linda T. Smith claims that Indigenous methodologies—and I would also argue Indigenous documentary methodologies—employ our values, protocols, and philosophies, which are deeply rooted in Indigenous research practices (2012, 15). These ideologies and values employed by Indigenous documentarians, such as respect, responsibility, and accountability, are intertwined, and furthermore, documentary as a storytelling platform has proven to be an effective form of knowledge exchange. Indigenous methodologies and documentary practices allow for a distinctive voice to advance meaningful engagement with community and employ methods of reciprocity. When paying attention to our own challenges as Indigenous documentarians, we are responsible for articulating our processes and methods. Documentary provides a window into our worlds; for the most part we are sharing intimate and meaningful stories with the public, such as my short documentary *PLACEnta* (2014) regarding Indigenous birthing ceremonies. *PLACEnta* encompasses my lived experience as a mother, which is made up of moments that lead me to present time.

Documentary has the capacity to inform on lived experiences and change minds with respect to Indigenous realities. Indigenous documentary practices uphold the shared core values, ideologies, philosophies, and principles prominent in Indigenous research methodologies; they are rooted in the same place—both are deeply embedded in Indigenous knowledge systems. Indigenous research methodologies are central to the documentary process. In recognizing the importance of using a visual tool to observe, intervene, and question, I have learned the ways in which we engage with story as the documentarian, and in most cases, how we are also engaged as *storyteller/listener*. As theorist Houston Wood writes, "Indigenous filmmakers frequently adapt film technologies to reflect their own culture's pre-existing visual and storytelling traditions" (2013, 55). This is true, and although early ethnographic documentary and Indigenous people have a long-standing and strained relationship, especially with regards to representation, we are now using documentary as a mode of storytelling where we are finally representing ourselves and on our own terms. Certainly, there has been a shift in documentary methodologies and moving away from the traditional documentary approach, which was intended to record facets of *real life* for the purposes of institutional

education, obtaining information, and collecting historical evidence of the *vanishing Other.*

OTHERING

For over a hundred years, films in general have contributed to *Othering* and dehumanizing Indigenous people. The images of early films propagate the imagination of the Eurocentric world, and these depictions of us as wild, simple, and other misrepresentations unfortunately remain engrained in the minds of settlers today. These *misrepresenting* films are culpable in (re)producing colonial discourses and shaping public perception, and of course, responsible for constructing problematic and racist depictions, such as the noble savage, the Indian princess, and the stoic warrior. Eurocentric films such as *An Indian Love Story* (1911), *War Bonnet* (1914), and the *Daughter of Dawn* (1920), to name a few, have not only depicted Indigenous people as hyper-sexualized, violent, submissive, and primitive, they have portrayed us as the vanishing Other (Columpar 2010, 3). Regarding these early productions, Pearson and Knabe assert, "The truth produced by these early cameras and the filmmakers behind them was, by and large, a visual exploration and commemoration of what were assumed, at the start of the twentieth century, to be rapidly vanishing Indigenous lives and cultures" (2014, 3). *Nanook of the North* (1922), for instance, became known as one of the first commercially successful documentary feature films; it was produced and directed by Robert Flaherty, now widely considered the father of documentary and ethnographic film. Interestingly enough, later he was exposed as fraudulent with regards to his claims of capturing an authentic glimpse of Inuit life and was heavily criticized for staging filmic events as reality. According to anthropologist Faye Ginsburg, *Nanook of the North* is saturated in performativity. Flaherty's filmic choices, in terms of how he chose to represent the character of Nanook, escalated a cultural difference. The process of dehumanizing Allakariallak, who was renamed *Nanook* for the film, was a means to position *the Native* within a historical colonial discourse. Appropriation of identity continues to be a common practice of colonization. Scholar Ginsburg writes,

> The Nanook case reminds us that the current impact of media's rapidly increasing presence and circulation in people's lives and

the globalization of media that is part of whether one excoriates or embraces it are not simply phenomena of the past two decades. The sense of its contemporary novelty is in part the product of the deliberate erasure of indigenous ethnographic subjects as actual or potential participants in their own screen representations in the past century. (Ginsburg, Abu-Lughod, and Larkin 2002, 39–40)

Flaherty's film has come to represent a *constructed authenticity* clouded by a Western lens where the filmmaker projected his own colonial fantasy onto the Eurocentric world. Flaherty reduced Allakariallak to a racial category, a non-white body fixed as a sign of *the primitive*, made clearly distinct from the white observer. Unfortunately, *Nanook of the North* was widely regarded by audiences as a glimpse into Inuit culture, but in fact Flaherty's ethnographic approach to storytelling presented unethical re-enactments as truth.

Soon after the first camera was invented, Indigenous people found themselves and their culture in front of the new invention as subjects. Based on what was observed in *Nanook of the North*, ethnographic documentary as a practice fostered an explicit social agenda of erasure, and on the heels of *Nanook*'s huge success, soon became an influential instrument of persuasion for white audiences (Alia 2010, 150). The *hunt for authenticity* at a time when it was presumed we were a dying race became an act of deculturation. Anthropologist Renato Rosaldo argues, "The peculiarity of their yearning, of course, is that agents of colonialism long for the very forms of life they intentionally altered or destroyed" (1989, 69). Colonization as a project was fuelled by the prediction—and expectation—that we would eventually die out.

As documentary became increasingly common as a means to observe the Other, it also became progressively problematic in deciphering truth from fiction. Early filmic representations endorsed further productions embedded in Eurocentric ideologies, which Indigenous documentarians continue to deconstruct to this day (Leuthold 1998, 61). Harald Prins argues that the *vanishing Indian* image fostered the hypothesis of a *pre-contact* Indigenous culture, and in turn, the collective intent of settler researchers was to eliminate the appearance of white society's influence. Early filmic representations of Indigeneity embodied a collective desire to romanticize and portray Indigenous culture as primitive. Prins argues that "although it is true that indigenous

peoples have long been portrayed along the lines of a dominant soci-
ety's primitivist's ideology, evidence suggests that tribes-people who
willingly posed or performed for strangers had their own perceptions
about the politics of visual representation" (2002, 62). An interesting
point, but while Indigenous people found themselves shrouded by the
ever-present colonial gaze, I am not convinced they failed to intervene.

DECOLONIZING DOCUMENTARY

The 1960s were a transformational period in Canadian film, a time
when Indigenous storytellers found themselves working in the
film industry where the production of Indigenous film flourished
and storytellers had access to documentary film. Indigenous docu-
mentarians situated themselves not only in front of the camera, but
behind the camera in key creative roles, such as writers, producers,
and directors. The National Film Board of Canada launched train-
ing programs that equipped Indigenous people with what was once
understood to be *colonial tools*, such as the camera, and sound equip-
ment to take the lead and tell their own stories, and to some degree
without too much interruption per se (Foster and Evans, 226–28). An
example of early Indigenous documentary with a strong message, and
what is regarded as the very first Canadian music video,[1] is a short by
acclaimed filmmaker and musician Willie Dunn, titled *The Ballad of
Crowfoot* (1968), followed years later by acclaimed filmmakers such as
Alanis Obomsawin, Gil Cardinal, Loretta Todd, and countless others.
Indigenous political movements were on the rise at this time, includ-
ing the Red Power Movement, which played an important role (Ball
2010, 1). What is relevant here is that political activism coincided with
the new understanding that research methods, technology, and vari-
ous modes of artistic expression could be utilized, not only as a means
of reclamation, but as mobility and transformation. Scholar Darlene
Clover writes, "Critical to community-based research is knowledge
dissemination, or what is sometimes called mobilization" (2014, 144).
Documentary became a necessary platform for sharing knowledge
globally, and despite our challenges, we offered (and continue to offer)
stories of resilience that not only educate, but advance Indigenous rights
and culture. We have in fact seized control of the camera and reclaimed
our narratives. Media scholars Wilson and Stewart argue, "Indigenous
peoples have appropriated the technologies of the dominant society and

transformed them to their own uses in order to meet their own cultural and political need" (2008, 19). Indigenous documentarians are part of an effort to decolonize documentary by examining the relationship with the camera, and by positioning themselves (Indigenous makers) as storytellers. Scholar Julia Emberley claims,

> Indigenizing epistemologies, then, is about critiquing Western epistemologies for their blindness and absences regarding how the histories of imperialism and colonization have shaped their structures of power, truth and knowledge. It is also about recognizing how indigenizing epistemologies entered European knowledge and knowledge systems, especially in the nineteenth century through ethnographic and anthropological discourse. (2014, 295)

Therefore, it is not surprising that in response to generations of invasive and racist ethnographic documentary, Indigenous peoples have responded by overhauling the traditional Western filmic process to better suit their own community needs, all with an Indigenized lens (Columpar 2010, 116; Leuthold 1998, 79; Wilson and Stewart 2008, 19).

Indigenous documentarians have pierced through the limitations of the Western didactic form, replacing the Eurocentric documentary methodology with an invigorating fusion of blurred genres, such as found in the works of Dorothy Christian, Gregory Coyes, Dana Claxton, and others. Subsequently, we have come to realize an inventive and flexible approach to documentary as a whole, evident with a fast-growing and diverse body of Indigenous-made work. From media scholar Steven Leuthold's point of view, in this light new documentary approaches have materialized. He writes, "Visual arts documentaries, then, have been created in an era of active discussion about the relationship between Indian art and identity" (1998, 132). Leuthold supports the notion that documentaries are a significant tool in preserving knowledge and in communicating Indigenous identity on an international scale; therefore, documentaries by Indigenous makers around the world have cultivated a space for narrative sovereignty. Documentary has proven to be a necessary storytelling tool and a crucial form of visual and cultural expression for Indigenous people.

The growing body of Indigenous documentaries are recognized for exposing national histories and highlighting our experiences through

an intimate style that strategically sustains the personal *and* the community voice. We are the authorities in decolonizing documentary and other media platforms; the works of Alanis Obomsawin, Loretta Todd, Shelley Niro, Gil Cardinal, Christine Welsh, Dana Claxton, Lisa Jackson, and countless others are creating real change in the industry (Pick 1999b, 76–93; Ball 2010; Kalafatic 1999, 109–19; Dowell 2013, 134–40). Furthermore, Indigenous documentarians are actively producing alternative platforms for first-hand accounts, while establishing new approaches to documentary. Documentaries range in approach, from installation, such as Claxton's *Buffalo Bone China* (2013) and my interactive media installation *Alive with Breath* (2013), to virtual reality work by Lisa Jackson, such as *Biidaaban: First Light* (2018), and even interactive websites. These varied forms of documentary expression represent our diverse truths, all uniquely conveying our own realities. As Indigenous documentary scholarship flourishes, studies have proven that regardless of the form they take, documentary plays a key role in offering innovative modes of storytelling (Columpar 2010, 155; Bredin 2010, 74; Alia 2010, 173).

Indigenous documentary is fundamental to understanding the ways in which we have braided together the principles, strategies, and values of Indigenous research methodologies such as cultural integrity, accountability, responsibility, and respect. As scholars Wanda McCaslin and Denise Breton assert, "Indigenous perspectives must be listened to and heard outside the assumption of colonial rule, and Indigenous autonomy and competence in handling our own affairs through our own ways must be unconditionally respected" (2008, 529). We have been exerting our voices since the settlers arrived to our lands, and it is through our documentaries and scholarship that we are finally being heard. The act of incorporating Indigenous documentary methods when approaching story exemplifies the significance of establishing our authority, as well as our efforts in building equitable partnerships within community. We understand that sustaining and nurturing these relationships is vital for values of reciprocity. By following protocols, and adhering to principles and values offered by the community we are working with, we can ensure the safeguarding and protection of the *subject/s* and their knowledge. We are obliged to weigh the benefits and risks of research, in all its forms; this must be part of the methodology when approaching Indigenous community (Hacker 2013, 31).

Entering any Indigenous community with a camera in hand can be challenging; both non-Indigenous and Indigenous makers are often faced with skepticism, and rightfully so. Naturally, community members will question the intent of the research/documentary proposed. Community members should be encouraged to ask questions, and based on a multitude of past experiences with the industry, there are several reasons to be wary. For example, filmmaker and anthropologist Charles Menzies, who is a member of Gitxaala Nation, has strategically used the camera to respectfully turn the gaze inward. His research focus involves working with and on behalf of Indigenous people in the Pacific Northwest. His documentary methods reveal a comprehensive understanding regarding the impact of previous unethical research practices, and in turn, he works to assure relationships, protocols, stories, and Indigenous knowledge are respected. Menzies asserts, "I begin with observational research directly, no camera. I participate, talk, engage, and watch as things unfold through the normal course of life. Then, once I have developed an understanding of what is taking place, I start working with the camera" (2016, 111). Inspired by collaborative research practices, he has produced personal research guidelines embedded in defending and advancing the rights and titles of Indigenous peoples. Additionally, his approach to documentary is an extension of his research methodology and practice, evident in his films as he integrates his guidelines by promoting the importance of initiating dialogue according to the needs and protocols of the community:

> As social researchers affiliated with mainstream institutions—and irrespective of our personal commitments and intentions—we are located at the nexus of power in the dominant society. Thus our methodological approach should not expand the power and knowledge of the dominant society at the expense of the colonized and the excluded. (2001, 22)

As Indigenous documentarians and researchers, oftentimes, the stories we tell derive from our communities; therefore, we are expected to follow protocol specific to the community visited and/or being researched/represented. It is important to be attentive, and to honour the transmission of the story according to community protocol. The stakes are high for us—these are our relationships and at times, our personal narratives.

Moreover, stories are constituted through a collaborative process, wherein we are not always telling the story of one person—the story may belong to the whole community. Documentarians must guarantee that the individual who is sharing the story not only knows the story well, but carries the authority. For instance, Cree scholar Shawn Wilson argues, "It is clear that the nature of the research that we do as Indigenous people must carry over into the rest of our lives. It is not possible for us to compartmentalize the relationship that we are building apart from the other relationships that make us who we are" (2008, 91). Wilson supports the idea that there is an obligation to protect our relationships and the knowledge bestowed upon us.

During the production of my documentary film *Remembering Inninimowin* (2010), I travelled to my home community of Attawapiskat First Nation with the intent to explore the language gap between generations. As an emerging documentarian at the time, as well as a graduate student in the Documentary Media program at Ryerson University,[2] I acknowledge that I was not fully prepared to bear witness to my community stories. My documentary uncovered more than a language gap—it revealed horrifying stories seeped in intergenerational trauma from the residential school system. I felt a deep sense of concern, so I had to tread carefully. As the daughter of a residential school warrior who is a fluent speaker of InNiNiMoWin (Cree),[3] I understood the sensitivity regarding trauma. In an early article of mine, I reflect upon my filmic journey home: "The film presents an alternative perspective crucial to comprehending the history of Canada's shameful treatment of its Indigenous population and the horrendous consequences that communities have been left to deal with" (2012, 75). Since its release in 2010, *Remembering Inninimowin* has travelled internationally, igniting dialogue regarding Indigenous languages, and more specifically, intergenerational resiliency. I felt obliged to *walk the talk*, so to speak, just as Kovach asserts, "The privileging of story in knowledge-seeking systems means honouring 'the talk'" (2010, 99). While I was an emerging documentarian at the time, I was guided by my customary practices of the MoshKeKoWok InNiNiNeWak. I followed protocol specific to my community, and ensured I was respectful, accountable, and responsible. I honoured the customary practices by ensuring Elders and Knowledge Keepers approved my documentary and my written thesis (submitted in Cree syllabics) before it was disseminated. Once approved, I then

submitted my work to the university, and released my documentary to the world. This is and continues to be my methodology—work guided by my InNiNeWak values.

INDIGENOUS PARADIGMS

Indigenous paradigms are entrenched in experiential knowledge, and it is the exploration of our Indigenous stories (through the art of documentary) that has stimulated our continued cultural resiliency. Based on my years of experience in the industry, I believe that Indigenous knowledge does indeed play a critical role in the articulation of our research methods as documentarians: it has allowed for an open space to negotiate, collaborate, protect, and disseminate knowledge. Post-colonial scholar Bagele Chilisa claims, "Stories provide the literature that bears testimony to postcolonial and indigenous peoples relational ontology with its emphasis on connectedness with the living and the nonliving" (2012, 140). Indigenous knowledge carries agency, and story embodies our values, ethics, and practices; I would also argue that our knowledge carries the power to protect itself, just as it has in the past. It is critical for storytellers to approach community with an understanding of ethical standards and the approaches used for thousands of years to honour our stories. These epistemologies transpire during the filming process as relationships develop, just as in the case with my film *Remembering Inninimowin*.

Our methodologies in relation to Indigenous story allow for a distinctive kind of voice to be heard, inspiring purposeful engagement, a necessary means to communicate and apply methods of reciprocity. When paying attention to our own challenges as Indigenous documentarians, we are responsible for articulating our processes/methods—we are also obligated to make certain the stories imparted to us are not exploited. Once gifted with a story from an individual, or the community at large, we, in turn, are expected to nurture the story with paramount respect. We need to understand the stories we carry hold the *spirit* of the people before us—our stories represent the lives lived. Our stories are alive through us, and if we do not share them with honour they will lie dormant, and eventually fade, until they are awakened again. Documentary has now become a way to achieve cultural and *visual sovereignty*, and a means to attain autonomy. Furthermore, documentary is as a necessary tool to retrieve story in a meaningful and responsible way. According to scholar Kristin Dowell,

> Sovereignty references a variety of domains in Aboriginal life
> from cultural to political to spiritual, and also ... to the domain of
> media production. I define visual sovereignty as the articulation of
> Aboriginal peoples' distinctive cultural traditions, political status,
> and collective identities through aesthetic and cinematic means.
> (2013, 2)

Furthermore, in order to achieve sovereignty, we must acknowledge that at times we experience a shared anxiety and distress in our communities due to our experience with settler colonialism. In expressing our concerns as a community, we conjure an awakening—motivating the first phase of restoring balance, and most importantly awakening *spirit*. There is renewal, (re)connection, and awareness in the act of raising consciousness, and what follows closely behind is a collective movement toward shared goals. We are then striving for sovereignty together. In this paradigm shift, the very method of (re)storying Indigenous lives through our own lens (re)awakens our communities. Just as our *ancestors* prepared animal hide, we too are in a way slowly purging ourselves by scraping away at the colonial residue left over by centuries of dehumanization. We are utilizing the camera for our own sovereign purposes, and clearing a path for the next generation.

As documentary is more accessible, affordable, and manageable, there are few limitations, and therefore the space remains very much available to rediscover and venture into new dimensions of exploration. We have come to be quite accustomed to using documentary as a means to share our shared interests, and with the growing body of films by Indigenous documentarians, we are also offering an alternative representation vis-à-vis our experiences. As scholar Jennifer Gauthier suggests, "Indigenous documentaries also transfer authority to Indigenous people, redefining the 'voiceless victim' as a proactive political participant, calling attention to unequal power relationships" (2013, 14). The singular narrative of Indigenous peoples has been sustained by the colonial imaginary. We were never *voiceless*: we have been asserting our voice since contact. Our voices come through our stories, as they always have. Indigenous documentary has been a voice platform, and through it we have demonstrated our authority and our responsibility as caretakers of story.

Merely capturing images and/or words will fall short of fully embracing the entire context of story, but it is still a notable attempt in

rectifying the void left by decades of colonialism. Indigenous documentaries are informed by an Indigenous consciousness, and an expression of our experiences, languages, and knowledge. Through our storytelling methodologies, we resume our rightful place in relation to story. What is more, scholar Robina Anne Thomas reminds us that story has the capacity to guide us: "All stories have something to teach us. What is important is to learn to listen, not simply hear, the words that storytellers have to share" (2015, 183). I would add that Indigenous documentarians carry the right to highlight what is relevant to the individual and/or the community they are representing. For example, in an interview with Sherene Razack, Cree documentary filmmaker Tasha Hubbard recounts her experience of filming *Two Worlds Colliding* (2004), in which she exposes harrowing stories of police brutality in Saskatchewan. Hubbard recounts her experience: "As I started looking more closely at the context of these events, I realized that those involved, specifically the survivors and the families of the deceased, experienced pain at the hands of a racist, colonial state" (2011, 319). It is apparent that intervening as documentarians is essential in efforts to expose colonial assaults on our bodies; our *talking back* is necessary for social justice, and thus, our cultural resurgence. As in the case with Hubbard, there are risks involved with these types of stories, and as mentioned previously the stakes are high—the documentarian is held accountable by the community, and obliged to ensure subjects are not re-victimized, especially those who broke silence by speaking out against injustice.

Inevitably, our stories draw attention to how structural forms of violence are frequently lived, and how our *(in)visibility* is another part of their oppressive strategy. Scholar Graham Hingangaroa Smith emphasizes the importance of taking control of our lives by speaking our truths, as he claims, "We must reclaim our own lives in order to put our destinies in our hands" (2000, 211). During the process of *speaking out* or *talking back*, the documentarian must abide by protocols and dutifully employ the direction of the community. With this responsibility of upholding story, even if it is uncomfortable, we are raising our social, political, and spiritual consciousness by shedding light on issues that continue to impact our lives. The raising of consciousness does not come without risk; protocols and practice in respect to orality, culture, and adherence to our stories come into play because documentary reveals not only our complexities as human beings, but also our vulnerabilities that are produced through years of survivance.

Recording the transformational is imperative, along with the abstract and reimagined, and in this, the pervasive re-engendering interpretation of documentary has boundless possibilities. The process of digitally capturing story, although at times disrupted, entails ethical considerations, approaches, and methodologies with regards to (re)storying Indigenous knowledge systems and ways of being. Margaret Kovach warns that as researchers (and I would add as documentarians), we need to link Indigenous epistemologies to story as an Indigenous research method, otherwise there may be contradictions:

> Concurrently, the use of story as method without an understanding of cultural epistemology, defined broadly, can create problems with understanding the totality of Indigenous narrative. Cultural specificity of Indigenous story is manifest in teaching and personal narratives and can have profound implications for the interpretation of story within research. (2015, 97)

Indigenous research methodologies are central to the documentary process; we are using a visual tool to observe, intervene, and question—we are actively engaged in the story, and in most cases, we are engaged as *storyteller/listener*. By continuously examining our own their/her/histories and cultural/social location, we assert and articulate our stories, ourselves, thus providing an alternative perspective. According to Dian Million, "The struggle in our generation has been to honour our own paradigms, concepts that arise from our lives, our histories, and our cultures while knowing that these are often mixed with concepts growing from our subjugation" (2014, 34). In honouring our own paradigms, we reject the notion of *Other*; we continue to speak for ourselves. Just as Indigenous documentarians in the 1960s and later, we today continue to produce an extensive alternative scheme that includes transformative · Indigenous storytelling practices. For instance, documentary can shift ways of thinking, especially when the documentary articulates a social condition, or an injustice from a differing (other than mainstream) perspective; the audience gradually begins to question what they have come to know as *normal*—this profound shift in thinking is irreversible. Understanding the difference between what is constructed by the mainstream, and realizing there is another *truth* is fundamental in social transformation. Indigenous stories are reflective, restorative, and pragmatic; they are always seeking inclusion, and vigorously re-establishing

cohesion by asserting our way through colonial boundaries. There is significance in imagining one's potential through story; this can lead to governing our own destiny. Our united actions afford an opportunity for not only growth, but also a space for gathering and coalition, where communities can regenerate through their collective forces, and of course, through our stories.

As outlined throughout this chapter, there are varied approaches in addressing our stories through the wide-ranging forms of documentary, and as such we have come to address the past and present, and also utilize documentary to (re)imagine our futures—this is our duty as storytellers. We must first acknowledge the impacts of colonialism, and furthermore, our past relationships with research and ethnographic documentary. According to Linda T. Smith, "The history of research from any indigenous perspectives is so deeply embedded in colonization that it has been regarded as a tool only of colonization and not as potential tool for self-determination and development" (2008, 116). With this realization in mind, we can work toward creating a more inclusive platform where a diversity of Indigenous voices can thrive.

Since the invention of the camera, we have been active in resuming our authority as storyteller both individually and collectively; our documentaries strive for self-determination, self-representation, and empowerment through the acknowledgement of our sources, and most importantly through our connection to those sources—our relationships. As Indigenous documentarians we have become ambassadors, wherein we understand the complexities of living in the *hyphen*—recognized as Indigenous people ourselves, and as someone going into the community to document/research—it is a fine line. Declaring our positionality as Indigenous documentarians in relation to our cultural stories is also a significant protocol; out of respect we must be clear of the reasons why we are collecting stories and how we will protect them. Scholar Alison Jones contends that the "struggles at the hyphen also characterize some collaborations between indigenous researchers and their own people. These collaborations become a rather different exercise in translating, as indigenous researchers find themselves outsiders in their own communities" (2008, 474). Communication is key to ensuring we continue to nurture established relationships. For decades there has been an extensive shift in documentary, although, based on my experience thus far, I believe that there needs to be further

discussion in regards to how to exist in the hyphen of decolonized documentary and mainstream. Researcher Michelle Fine states, "Working in the hyphen in cross cultural inquiry means creating occasions for researchers and informants to discuss what is, and is not, 'happening between,' within negotiated relations of whose story is being told ... and whose story is being shadowed" (cited in Jones 2008, 475). Fine speaks to the *self-other* as being in the hyphen, and this is a time of methodological self-consciousness. Respectful exchange builds opportunity for meaningful engagement, growth, and insight on both sides, as demonstrated with documentaries by Menzies and Hubbard, and I would also include myself in this equation. Documentarians entering and/or returning to community must acknowledge the *power* they hold when representing an institution. Jessica Ball asserts that as Indigenous researchers (and again, I would also add documentarians), there is a need to be flexible in approaches:

> Researchers who work successfully with communities tend to have an open-ended, flexible program of research that can shift in focus to accommodate community requests and emerging needs and take advantage of emerging opportunities to pursue a question through knowledge sources and methods that reside in communities. (2014, 39)

As a researcher and a documentarian, there have been many unforeseen events while conducting work, and I soon understood that it was my responsibility to shift my focus to ensure cultural safety. For example, when returning to my community, I acknowledged that trust was already established because I was related to many of the subjects in my documentary. I found that members of my community were more open to share personal stories, and so I was left to make pertinent choices in terms of their safety. Despite the colonial *his*tory of documentary, works by Indigenous documentarians have highlighted a way to achieve cultural sovereignty and autonomy. Including Indigenous documentarians in the filmic process works toward ensuring a pedagogical model where Indigenous perspective is centrally situated. Indigenous documentarians think relationally because these are our relationships.

CONCLUSIONS

In closing, Indigenous documentary practices do indeed uphold the same core values, ideologies, philosophies, and principles prominent in Indigenous research methodologies; they are rooted in the same place—both deeply embedded in Indigenous knowledge systems and ways of being. When working with story, we often find ourselves in a critical position, and we ourselves need to be aware of the power we hold, and not further exploit the stories that are in our care. Following Smith, as researchers and documentarians, we must be mindful in our approach. We are not only obligated to acknowledge the roots of our stories, but also the power our stories hold:

> Research exists within a system of power. What this means for indigenous researchers as well as indigenous activists and their community is that indigenous work has to 'talk back to' or 'talk up to' power. There are no neutral spaces for the kind of work required to ensure that traditional indigenous knowledge flourishes; that it remains connected intimately to indigenous people as a way of thinking, knowing and being; that it is sustained and actually grows over future generation. (Smith 2012, 357)

There is power in documentary as a research methodology; in the age of globalization, technology has allowed for greater mobilization, reaffirming the rights and recognition of Indigeneity. Leroy Little Bear, Blackfoot researcher, asserts, "It is through stories that customs and values are taught and shared. In most Aboriginal societies, there are hundreds of stories of real-life experiences, spirits, creation, customs, and values" (2000, 82).

Documentary embodies the gestures, syntax, and nuances of its recorded subjects within a landscape of a specific time and place. When audiences witness our documentaries, they will always bring forth new responses, analysis, and understanding. Their responses are deeply rooted in their own social location. The fluidity of this form of expression has allowed me to negotiate space within an ecosystem of seemingly disparate ways of being. As with any story, whether narrative film, documentary, or an oral story, the beauty as a *storyteller/listener* is that the meaning and our responses will continuously change.

Prior to embarking on a new project, I acknowledge that I am accountable to the subject, and also to the Elders, Knowledge Keepers,

to our *ancestors*, to all of our relations, and to our respective community members. I understand that our stories are rooted in our experiences, in our lands, communities, and with the people. Jo-ann Archibald, Sto:lo scholar, supports this:

> I believe that understandings and insights also result from lived experiences and critical reflections on those experiences. Many Aboriginal people have said that to understand ourselves and our situation today, we must know where we come from and know what has influenced us. (2008, 42)

Our documentaries carry the knowledge and the diversity of Indigenous voices; they hold the power to reconcile, restore, and heal. Cultural ways of being are sustained through knowledge reciprocity of the *storyteller/listener*, and this exchange of story is entrenched in the principles of orality. The stories as they are told weave a fabric of continuity, thus holding the community together. They give a sense of place, time, people, feeling, and identity (Fixico 2003, 29).

Of course, Indigenous documentarians have *ourselves* engaged with technology; we were never fixed in the past. We have successfully utilized technology to assist not only in our own cultural, social, and political action of resistance, but as a means of reclamation and self-representation. There is a significant effect when *reversing the shots* (Pearson and Knabe, 2014) while also appreciating the complexity of Indigenous stories; documentary modifies the relationship between camera and subject. We have not only moved to the space behind the camera, but have also remained in front of the lens asserting ourselves as authority. By responding to *Otherness* we have dismantled colonial tropes; we provide a counter-narrative to Western history, inviting settler audiences to re-evaluate their preconceived assumptions time and time again, and to reconsider the colonial superiority of speaking for us. More than that, over the last century, we have *ourselves* transformed Western media to assist in our own cultural understandings. And documentary has acted as an avenue to advance our personal and collective stories to a global forum. Our Indigenous lens has revolutionized documentary, and we have commenced the necessary journey of (re)positioning ourselves.

For me, the most significant aspect of Indigenous stories is that they are about us as a people; they speak to our struggles, their/her/histories

and our resilience. Mi'kmaw scholar Marie Battiste argues that "Indigenous knowledge represents the protection and preservation of Indigenous humanity" (2000, 507). Not only do our stories humanize the Indigenous experience, but they also represent thousands of years of *ancestral* teachings. Stories bind us together, creating space and the time to grieve, provoke, and/or celebrate—the story itself becomes a catalyst to sustain our cohesiveness. Hence, orality is vital to understanding Indigenous methodologies and documentary practice, and how we experience *truth*, convey experience, communicate, and laugh (Singer 2001). I have come to an understanding that our stories have the power to awaken the *spirit*, whereby creating personal and collective meaning, in turn, rousing us into action—our stories evoke hope, potential, (re)affirmation, and possibility. In exploring the intersection of Indigenous research methodologies and Indigenous documentary methods, studies prove our values and principles embody reciprocity, accountability, protocol, respect, and responsibility. Our methodologies as Indigenous storytellers are instrumental and required in the documentary practice. Particularly so, if we are successful and competent in sharing our stories with cultural integrity, and telling the story as our *ancestors* did before us.

NOTES

1 https://www.nfb.ca/film/ballad_of_crowfoot/

2 I submitted my thesis (written in both Cree syllabics and English) to my home community prior to submitting to graduate school.

3 I am an InNiNew IsKwew (Swampy) Cree woman and a band member of Attawapiskat First Nation, MoshKeKo AsKi Territory in Treaty 9. My community is located in what is now called northern Ontario.

Marking and Mapping Out Embodied Practices through Media Art

Julie Nagam and Carla Taunton

In this chapter we analyze Ursula Johnson's *Lnuwelti'k (We Are Indian)* (2012–) and Lisa Jackson's SNARE (2013). We have selected these works because of the embodied knowledges they present of the gendered, colonized Indigenous body. Which is further unpacked by Nagam in her essay "(Re)mapping the Colonized Body," on Rebecca Belmore, where she argues,

> The absent Native body is tied to gendered understandings of land. Land is connected to the female body because, during the mapping and surveying, Canada was constructed through ideas of transparent space, which is the existing spatial relationships among gendered, masculine, and colonial relations. Blunt and Rose argue that feminist thinking of space is situated in the public and private debate. They argue that the relationship between gendered identity and space should not be framed as patriarchal structures but should be looked at as a "social process of symbolic encoding and decoding." These authors understand space to be a series of patterns among spatial, symbolic, and social orders. If we stick to space as male or female then it reaffirms gendered power differences and locks these identities into the public and private debates. (Nagam 2011, 149)

Throughout this chapter and across our scholarly research, we argue there are links between the Indigenous living archive and performance- and media-based arts practices that foreground connections among performance, media technologies, and embodied practices. "Embod- ied practices" refer to elements of a person's actual being, including but not limited to everyday practices demonstrated through relationships to land, cultural knowledge, family, and community, as well as bodily experiences. "Media technologies" involve the ongoing and adaptive use of media by Indigenous people and artists since time immemorial—the ways that basketmaking and video production, for example, are both distinctive Indigenous technologies connected to land, story, and mem- ory. As Dana Claxton argues,

> Aboriginal media is connected in context and cultural practice as a result of shared socio-cultural experiences. Together these works bring forth significant accounts that are embodied in our ancient homelands. Our creative expression sustains a connection to ancient ways, places our identities and concerns in the immediate, while linking us to the future. To a broader audience, this expres- sion conveys an Aboriginal worldview, revealing the Aboriginal experience in all of its complexities. Such expression is an articu- lation of our cultures and presents an Aboriginal perspective for all those who will listen. (2005, 40)

As performative acts of embodied practice, Jackson's and Johnson's works provide another way of bringing forward into public space dif- ficult knowledge about historic and contemporary colonial gendered violence. Each artist mobilizes a site to memorialize murdered and missing women, loss of identity, and colonial-imposed regulations of identities while at the same time enacting a decolonial strategy of chal- lenging ongoing apathy toward social justice issues in Canadian settler society. We focus on their embodied practices to explore performativity in contemporary Indigenous performance and video art. Jackson's video work has been shown both in performance-based installations and at festivals. Johnson's work is situated in typical performance practices; however, the finished media product—the basket bodice—has appeared in the gallery as a sculptural work. We have chosen to focus on these art- ists because they are invested in Indigenizing spaces through their own

memories, histories, and stories by way of their embodied practices. What ties these artists together is their ability to mobilize the performed gendered, colonized body as a tool for confronting the legacies and continued projects of colonialism and their arts-based decolonizing strategies. In the following pages we highlight the ways in which contemporary Indigenous art participates in decolonial aesthetics to activate the urgent project of Indigenous sovereignty and resurgence.

EMBODIED RESURGENCE: *SNARE* AND *L'NUWELTI'K (WE ARE INDIAN)*

Anishinaabe artist and filmmaker Lisa Jackson was inspired and aimed to honour missing and murdered Indigenous women by creating a short film entitled *SNARE* about the discrimination and racism Indigenous women face in Canada.[1] Her work has been shown nationally and internationally as both a film and a performance-based art installation. This artwork articulates the struggle Indigenous women face in both the Canadian and global Indigenous contexts, vividly describing how Indigenous female bodies are regulated and bound through colonialism and racism.

SNARE begins with a bare foot pressing into the black earth as the blurred form of the bottom half of a body comes into focus. A person can be seen from the waist down in a white dress. The camera lens moves to another set of feet walking, their imprints traced in the earth. More bodies and more feet become visible as several women in identical white dresses walk toward a rope noose lying on the ground. As each foot gently falls within the noose, the camera quickly pans to a black screen. Suddenly we hear and see each body flip into the air, suspended from a single rope. All the women appear lifeless. A snowfall of white eagle feathers falls from the sky, covering each of the frozen, floating, and swinging bodies. The screen then shifts to the women standing in a circle with emotionless expressions on their faces. The camera pans to each woman, framed from the waist up. They vary in age and appearance, but face the viewer head on, all standing in the same stance. This work was produced while Jackson was living in Vancouver, BC. She references and situates *SNARE*'s site of production through the inclusion of featherdown, which has a particular customary/cultural significance for First Nations on the Northwest Coast. The inclusion of featherdown references the survival and resurgence of Indigenous cultural knowledges

grounded in intergenerational transmissions of cultural knowledges and memory in dance and performance.

In September 2012, the Prismatic Festival in collaboration with the Dalhousie University Art Gallery and the Schulich School of Law at Dalhousie University in Halifax, Nova Scotia, hosted Mi'kmaw artist Ursula Johnson's durational performance *L'nuwelti'k (We Are Indian)*. Via an open call on Facebook, the Prismatic Festival website, and a widely distributed press release, Johnson invited Indigenous volunteers to participate in this multifaceted performance about Indian registration and membership codes. The first volunteers were all Indigenous women. Johnson's performance call read:

Performance Artist Looking for Volunteers for a public performance from the following 4 categories:

1. A status Indian
2. A non-status Indian
3. An indian whose status has been revoked (or voluntarily enfranchised)
4. An indian who has been granted status

*Please note—volunteer will have to sit for a portrait for a maximum of 4 hours (minimum of 2). Participant can be either "on" or "off" reserve.[2]

L'nuwelti'k (We Are Indian) is an ongoing series; it has also been exhibited as a part of *Memory Keepers* at Urban Shaman Gallery in Winnipeg (2014) and in *Fourth World* (2015). It is a collaborative performance between Johnson and her Indigenous participants. After a conversation with the participants, Johnson invites each of her collaborators to sit down on a stool, where strips of white ash are laid out on a table to the left of the sitter. Johnson's performance tools—normally used for traditional Mi'kmaw basketmaking—are ready to take a new form. The individual works take several hours for the artist to produce, because the process of basketmaking takes time, in this case, wrapping and weaving natural fibres of black ash around the head and chest of Johnson's collaborators. Following the contours of the body, and inverting the form

of the basket and thus subverting the purpose of the object, Johnson's multi-hour and laborious performance concludes when a bust of the sitter is complete. The basket-based bust works as a portrait, and the busts are subsequently displayed around the gallery space on plinths.

Johnson's performance and Jackson's performative video/media work relate to Indigenous resistance against the ongoing violence endured by Indigenous women and Indigenous bodies in settler nations such as Canada. Jackson's video work records a choreographed performance of Indigenous bodies, while Johnson's performance records/maps Indigenous bodies using basketmaking technologies. These are both collaborative works led by Indigenous women that bring forward notions of collective memory, experience, and responsibilities as well as methods of collective resistance and actions. At the same time, we consider how these distinct works create a space for the remembrance and commemoration of victims, or rather *survivors*, of settler colonialism. Indigenous bodies have long historical ties to colonialism and the violence of conquest in the Americas. In Canada, Indigenous women face colonial violence on a daily basis. In 2016 there were over 1,180 open and unsolved RCMP cases pertaining to missing and murdered Indigenous women. This staggering statistic, plus a further 3,000 cases documented by Indigenous social justice and community organizations, is the result of colonial policies exemplified by forced disenfranchisement, residential schools (1830s–1996), the Indian Act (1876–present), the Sixties Scoop, and forced relocation (apartheid reserve system).[3] The two recent cases of Colten Boushie and Tina Fontaine remind us of the hopelessness and violence that is perpetrated on Indigenous bodies, where women, girls, and two-spirited people are particularly vulnerable. These cases gained media attention with the publication of the Amnesty International report *Stolen Sisters* (2004) and its follow-up *No More Stolen Sisters* (2009), which documented 500 cases of missing and murdered Indigenous women across Canada. Among these happenings was the release of the Truth and Reconciliation Commission of Canada's (TRC) final report and calls to action (June 2015). The calls to action put forward 94 urgent initiatives/projects as the responsibility of all Canadians, and specifically, federal, provincial, and municipal governments, to act on and to implement in order to increase equity for Indigenous peoples. In direct relation to this chapter, call number 41 stipulates the following:

> We call upon the federal government, in consultation with Aboriginal organizations, to appoint a public inquiry into the causes of, and remedies for, the disproportionate victimization of Aboriginal women and girls. The inquiry's mandate would include:
>
> i. Investigation into missing and murdered Aboriginal women and girls.
> ii. Links to the intergenerational legacy of residential schools.
> (TRC 2015)

In September 2016, in response to the TRC's (2008–2015) calls to action, the federal government of Canada finally convened The National Inquiry into Missing and Murdered Indigenous Women and Girls (NIMMIWG), which followed a similar structure of "truth gathering" events held in urban and rural communities across Canada developed by the TRC, where "2,380 family members, survivors of violence, experts and Knowledge Keepers shared over two years of cross-country public hearings and evidence gathering."[4] In June 2019 the National Inquiry's final report, *Reclaiming Power and Place*, released a national call to justice outlining 231 actions that "are legal imperatives—they are not optional"[5] directed at governments, institutions, social service providers, industries, and all Canadians. The National Inquiry into Missing and Murdered Indigenous Women and Girls also addressed ongoing violence against 2SLGBTQQIA people. Fundamentally the inquiry argues,

> As the evidence demonstrates, human rights and Indigenous rights abuses and violations committed and condoned by the Canadian state represent genocide against Indigenous women, girls, and 2SLGBTQQIA people. These abuses and violations have resulted in the denial of safety, security, and human dignity. They are the root causes of the violence against Indigenous women, girls, and 2SLGBTQQIA people that generate and maintain a world within which Indigenous women, girls, and 2SLGBTQQIA people are forced to confront violence on a daily basis, and where perpetrators act with impunity.[6]

Together, Jackson's and Johnson's work suggests a critical investigation into the ways in which the body both performs and records cultural

memories, stressing *how* performative practices in art, video, film, and photography can reveal and mobilize particular histories of colonialism and their ongoing impact on Indigenous and non-Indigenous people in Canada. We investigate the politics of forgetting and the resistance of remembrance articulated, evoked, and represented by these artists. We situate our arguments within the history of intentional regulation of the gendered Indigenous body, addressing how these artists' works dismantle the colonial and gendered noose in order to demonstrate the decolonizing potential of performance- and media-based art. We tease out this thread through the scholarship of Indigenous women scholars Mishuana Goeman (2008) and Aileen Moreton-Robinson (2011), paying particular attention to concepts of performativity in settler colonialism, the white male body, and the power of self-representations. Furthermore, our analysis draws on Bonita Lawrence's (2003, 2004) concepts of the politics of Indigenous identities. We assert throughout our discussions of these works and elsewhere that Indigenous performative arts (mediated or otherwise) practices that articulate personal and communal stories and memories are vehicles for the disruption of erasures, exposing the complexities of Indigenous lived experience and the contradictions of so-called official colonial history (Mutua and Swadener 2004, 16). In other words, contemporary Indigenous art practices such as Johnson's and Jackson's are examples of Indigenous resurgence.

REFLECTIONS ON INDIGENOUS RESURGENCE AND SOVEREIGNTY

As we write this essay, as noted above, we are reflecting on all that has happened over the past few years since Johnson and Jackson produced these two profound works in order to engage with (among other things) historic and contemporary representational, systemic, gendered, and colonial violence toward the Indigenous body.

As a result, many significant shifts have occurred in the political landscape spearheaded by Indigenous leaders, educators, Elders, artists, and cultural thinkers such as TRC Chief Commissioner Senator Murray Sinclair and those involved in the Idle No More movement (2012–), the Indigenous land and social justice project that has captured significant media and public attention across Canada and the world. Indigenous women across what is now known as Canada founded and facilitate

this movement, which is characterized by the iconic repetitive act of flash mob round-dances held in malls and city squares. In addition, we have witnessed many Indigenous self-determined political and cultural initiatives such as countless water protection actions exemplified by Standing Rock, and the multisite (over 25 hosts) art installation *Walking With Our Sisters* (wwos) (2012–19) started by Métis artist Christi Belcourt to honour thousands of missing and murdered Indigenous women and girls.[7] wwos, a commemorative arts-based project, draws upon local Indigenous spiritual practices, epistemologies, and methodologies to facilitate and organize installations at each venue/host. These resurgence-based projects are not mere protests in the Western sense of political action and theorizations, but rather, as Michi Saagiig Nishnaabeg scholar Leanne Betasamosake Simpson states, mobilizations of collective acts of resurgence, decolonization, and resistance, and reminders of Indigenous cultural practices such as songs, stories, dances, and performances. She argues:

> When resistance is defined solely as large-scale political mobilization, we miss much of what has kept our languages, cultures, and systems of governance alive. We have those things today because our Ancestors often acted within the family unit to physically survive, to pass on what they could to their children, to occupy and use our lands as we always had. … Defining and analyzing Indigenous resurgence from a social movement perspective erroneously concludes that there has not yet been an Indigenous social movement in Canada, a conclusion that flies in the face of 400 years of Indigenous resistance. We have been resisting colonial imposition for four centuries. I think our communities know something about organizing, mobilizing, and strategizing. I think our communities know quite a lot about living through the most grievous circumstances. (2011, 11–12)

Drawing on critical Indigenous methodology that foregrounds multiple Indigenous systems of knowledge and ways of knowing, we argue that contemporary Indigenous performance- and media-based work participates in the project of decolonization by remembering the past through the present.[8] This project is evident in early media works by Indigenous women artists such as Mohawk filmmaker Shelley Niro's *It*

Starts With a Whisper (1993), as well as *Honey Moccasin* (1998), among the earliest Indigenous-produced feature-length films. In both of these experimental works, film provides a tool for transmitting intergenerational and embodied knowledges based in a Haudenosaunee worldview, including beadwork patterns and stories, and the sharing of contemporary lived experiences. These works, along with Niro's video- and photo-based work *The Shirt* (2003) and Dana Claxton's video installation and performance *Buffalo Bone China* (1997), overtly showcase outrage and absolute resistance to past and contemporary colonial processes. These are powerful examples of media technologies as decolonial tools from Indigenous artists working in these mediums.

It is imperative that we clearly define the project of decolonization as a shared responsibility of Indigenous people, newcomers, refugees, and settlers, one that necessitates simultaneous action around Indigenous sovereignty (the centralization of Indigenous epistemologies, stories, and lived experiences) and settler responsibility (the recognition of colonial processes, systemic colonial violence, and settler privilege). By reframing Indigenous stories, memories, and histories, and by participating in the displacement of national/ist and colonialist narratives, Indigenous women artists articulate and embody a politics of self-determination and cultural sovereignty. As Tuscarora art historian Jolene Rickard argues, "The work of Indigenous artists needs to be understood through the clarifying lens of sovereignty and self-determination, not just in terms of assimilation, colonization, and identity politics. Sovereignty is the border that shifts Indigenous experience from a victimized stance to a strategic one" (1995, 57). Ultimately, this chapter is grappling with representations of the Indigenous body, memory, and colonialism, and in doing so we explore the intersections between media art production by Indigenous artists such as Johnson and Jackson as well as current global projects of Indigenous resurgence politics. In this, we agree with Simpson:

> Building diverse, nation-culture based resurgences means significantly investing in our ways of being; regenerating our political and intellectual traditions; articulating and living our legal systems; language learning; ceremonial and spiritual pursuits, creating and using our artistic and performance-based traditions. All of these require us—as individuals and collectives—to diagnose,

interrogate and eviscerate the insidious nature of conquest, empire, and imperial thought in every aspect of our lives. It requires us to reclaim the very dynamic, fluid, compassionate, respectful context within which they originally generated. A critical level of anti-colonial interrogation is required in order for us to see the extraordinary political nature of Nishnaabeg thought. (2011, 17–18)

Indigenous resurgence and embodied knowledges are intricately connected with the practices of Indigenous cultures and Indigenous cultural productions. The critical moment that Canada is currently experiencing is rife with examples of resurgence. Indigenous knowledge is growing, expanding, and permeating all aspects of Canadian culture.

THE INDIGENOUS LIVING ARCHIVE

As scholars invested in decolonial scholarly, curatorial, and artistic practices, we are interested in/committed to documenting the *Indigenous living archive*, which stems from the embodied knowledges that both the artists who conceive and make the work and the participants who contribute to its creation produce. The traditional/conventional Western archive exists primarily in the form of documents, maps, literary texts, letters, archaeological remains, bones, videos, films, and CDs—permanent entities that cannot be transformed. As Thomas Richards argues, 19th- and 20th-century British geographers, archivists, and curators played a part in building this body of material and the institutions that hold it. He states,

> The operational field of projected total knowledge was the archive[;] the archive was not a building, or a collection of texts, but the collectively imagined junction of all that was known or knowable, a fantastic representation of an epistemological master pattern, a virtual focal point for the heterogeneous local knowledge of metropolis and empire. (1993, 11)

Performance studies scholar Diana Taylor argues the archive is already situated in power, and reminds us of several foundational myths that perpetuate the notion that the information collected in the archive is unmediated and resistant to change (2003, 19). Canadian history holds numerous examples of what Taylor describes, such as

treaty negotiations, the creation of the Indian Act, forced enfranchise-ment, lack of support to address open cases of missing and murdered women, and residential schools, to name but a few. In the context of settler nation-states, the national archive (what is included and what is omitted) is a colonial institution insomuch as it serves the ideology of colonialism, erasing and white-washing Indigenous experiences of col-onial violence.

An Indigenous living archive,[9] on the other hand, which is grounded in embodied knowledge and includes contemporary artists, activates and honours the lived experiences of Indigenous people, and the stor-ies, histories, and memories of culture and nationhood. Recognizing and prioritizing the embodied and lived knowledge of Indigenous people in such a way opens up possibilities for artists to translate and transform memory and present-day relations in colonized space. In SNARE, Jackson makes visible the gendered, colonized body, demanding that the viewer look at Indigenous bodies and become aware of their suffering. Each woman in this film faces the viewer, star-ing directly and powerfully at the audience/participant. The colonial gaze has shifted: each woman transforms herself from a passive object of possession into a strong vital/visible Indigenous body/subject. Thus, Jackson shifts the power of patriarchal colonial sovereignty—in this case, of Canadian white settler society—re-inscribing a powerful, self-reflective representation of Indigenous women who are not pos-sessed by the settler colony. Each body represents the strength and resistance of Indigenous women, because even after the bodies are sus-pended in the air they all land on their feet, facing the viewer head on.

Indigenous scholar Aileen Moreton-Robinson argues that in colonial states "performativity functions as a disciplinary technique imbuing the white male subject with a sense of belonging and ownership produced by a possessive logic that presupposes cultural familiarity and commonality applied to social action" (2011, 59). This possessive logic provides justifi-cation for all the missing and murdered Indigenous women in Canada, and has been reaffirmed through the colonial performance of the white male body and its relationship to existing environments in former Brit-ish colonies (2011, 59). Both the artworks discussed here demand that Indigenous bodies be seen and not objectified or possessed. Jackson disputes the possession of the gendered, colonized body by dressing everyone in the same timeless flowing white dress, which references

FIGURE 9.1 *SNARE* production still courtesy of Lisa Jackson.

purity and an angelic nature. The bodies are snapped up by the snare and suspended, floating without motion until small white eagle feathers fall from the sky. They are then set free and find their feet back on the earth where they confront the colonial state that has tried to catch them in a trap of colonization and possession. Their strong contemporary presence, staring directly into the lens, shifts the colonial gaze.

Indigenous scholar Mishuana Goeman argues that "these are contemporary Native peoples who look back at us—they are acutely aware of colonial gazing and its history of temporalizing and yielding a national affection that keeps Indians in the permanent position of speaking solely from a victimized past" (2011, 5). The presence of the women in Jackson's film, and their ability to free themselves from the colonial noose, demonstrates to the viewer that the "fetish of Indians from the past, or that discursive site of the Native body which produces settler anxiety, is complicated by the presence of the living Native body on screen and in the scene" (5). Healthy, strong, contemporary Native bodies dispel myths of possession and control. Just as the female body is marked by the ownership of the settler state, Jackson's placement of the gendered Native body into both captured/lifeless and free/strong tropes complicates the subjugation of their bodies. In this film, she calls attention to the historical colonial dispossession Indigenous women have experienced, their bodies hanging lifeless in the noose, while at the

same time demonstrating women's resilience and strength in confronting the colonial gaze.

DECOLONIZING THE COLONIAL ARCHIVE

> Barre Toelken … at the University of Oregon, tells a story about a northern California Indian basket-maker, Mrs. Matt, who was hired to teach basket making at his university. After three weeks, her students complained that all they had done was to sing songs. When, they asked, were they going to learn to make baskets? Mrs. Matt, somewhat startled, replied that they were learning to make baskets, that the process starts with songs that are sung so as not to insult the plants when the materials for the baskets are picked. So they learned the songs and went to pick the grasses and plants to make their baskets. Upon their return to the classroom, the students were dismayed when Mrs. Matt began to teach them new songs, those that must be sung as you soften the materials in your mouth before you start to weave. The students protested again, but Mrs. Matt patiently explained, "You're missing the point. A basket is a song made visible." (Trepanier and Creighton-Kelly 2012, 43)

The act of wrapping the bodies of Indigenous women is very intimate and at times unnerving, especially when the face of the sitter is covered by the basketmaking materials. The act of casting, or rather cocooning, the body ultimately serves to create a conversation between self-determined definitions of Indigenous women's identities and state-determined colonial regulation of those identities. *L'nuwelti'k* mobilizes critiques of historic settler representations of Indigenous peoples and activates resistance to colonial legislation that has regulated and thus attempted to occupy and control Indigenous bodies. Johnson's collaborative performance creates space for definitions of sovereignty that reflect the complexities of Indigenous self-representation encompassing the individual, the community, and the nation.

Historic attempts by the state and its colonial apparatus of power to control, regulate, define, undermine, and mediate Indigenous women's bodies and identities, as well as their cultural and political authority, give urgency to self-determined acts by Indigenous women, acts that have always been present throughout contact—and specifically in relation to this study of acts of performativity. Johnson's performance

specifically draws attention to the Indian Act and how categories of Indigenous or status are deployed. As Julia Emberley argues, "From early on, colonial policies were implemented to regulate the bodies of Indigenous women by controlling their sexual, reproductive, and kinship relations" (2007, 46). The institutionalization of identity defined, produced, and maintained by the Indian Act (1876) exemplifies the hegemonic regulation of Indigenous women's bodies and political power. In her book *Defamiliarizing the Aboriginal: Cultural Practices and Decolonization in Canada*, Emberley explores filmic, photographic, and popular culture representations of Indigenous women and families as modes of representational violence, arguing that they resulted in networks of images that have served the interests of colonial-settler culture and formed a significant part of Canada's national imaginary (2007, 3). It is key to highlight the crucial roles played by cultural expression and production in the construction and maintenance of the idea and imagery of empire and settler-colonial logics.

While not all Euro–North American cultural production (e.g., print, photography, and film) relates to colonial power and empire, settler cultural and popular culture production encouraged, legitimated, and maintained these systems of power. In this way, representations from colonial eras of both Indigenous peoples and settler society are linked to the history of legitimating colonial violence and colonial power over Indigenous peoples. Emberley's study of representation as "specific modes of colonial violence" is valuable when exploring the role and impact of anthropology and art history on processes of colonialism in Canada. She argues that film, photography, and popular culture offer "a sort of spectral violence ... because such images would come to haunt the desires of a civilizing colonial consciousness" (11–12). Emberley defines "spectral violence" as "a specific form of cultural hegemony that may intercept and work with the organized militaristic violence of the state, but is neither supplemental nor tangential to it" (12). She argues that representational violence, or rather spectral violence, "cannot be reduced to its merely symbolic component either as a reflection of 'real' violence or as textual instances of colonial ideology formalizing the actual violence that served to consolidate the state's social, economic, or political interests" (12). In other words, in the late 19th and early 20th centuries, eras of aggressive colonization, technologies of representation such as the photograph "were strategically deployed as part of a complex

web of colonial power which, in addition to political and economic violence, set out to constitute the colonial subject as *Aboriginal*, while simultaneously obliterating any trace of this 'originary' subject" (12).

Many Indigenous artists over the past four decades have confronted, resisted, and decolonized (made new meanings from) the history of representational violence, for example, photo-based artists Jeff Thomas (*Strong Hearts*), Shelley Niro (*Mohawks in Beehives* and *The Shirt*), Lori Blondeau (*CosmoSquaw*), KC Adams (*Cyborg Hybrids* and *Perception: A Photo Series*), and more recently, Ursula Johnson in her new photo series *between my body and their words* (2017), which was commissioned for the Winnipeg Art Gallery's exhibition *Insurgence/Resurgence* curated by Julie Nagam and Jaimie Isaac. All these media-based works evoke and embody the persistent presence of Indigenous agency and the resistance of Indigenous communities over the four decades of settler colonialism in Canada, meeting the colonial gaze and archive with wilful refusal.

In *between my body and their words*, Johnson places herself on display in order to interrogate the ways that "pop culture and mainstream fashion use Indigenous iconography to sexualize, objectify, and commodify the Indigenous female body" (Nagam and Isaac 2017, 92). In the four performative photographs that make up the work, Johnson wears clothing purchased from popular stores that highlights the ongoing issue of cultural appropriation, and overlays the portraits with quotations from four leading Indigenous women artists: Shelley Niro, Rebecca Belmore, Lori Blondeau, and Cheryl L'Hirondelle. This work thus directly resists the romanticized and exoticized stereotypes of Indigenous women perpetuated by settler representations and institutions such as Hollywood film, documentary (ethnographic) photography, and the fashion industry. The impacts, results, and legacies of ongoing representational violence that dehumanize and render people objects are devastating and propel colonial genocidal phenomena such as violence against Indigenous women.

In Canada (and elsewhere), Indigenous women must tread lightly for fear of becoming statistics in the violent colonial reality situated in discrimination. As the Native Women's Association of Canada and the Canadian Feminist Alliance for International Action reported in a brief presented to the Inter-American Commission on Human Rights in March 2013, Indigenous women in Canada experience a minimum

of 3.5 times higher rates of violence (including domestic and sexual assault) than non-Indigenous women. And, young Indigenous women are five times more likely than other Canadian women to die of violence. Between 1997 and 2000, the rate of homicide among Indigenous women was seven times higher than the rate for non-Indigenous women.[10] These statistics showcase the urgency in Jackson's film.

In SNARE each of the women represents different ages and Indigenous affiliations in order to demonstrate that violence against women impacts everyone. Jackson appeals to the general public to recognize the colonial violence that Indigenous women face daily. By having the women mimic the same actions, Jackson demonstrates the connection most Indigenous women feel when it comes to violence against them. The women in the film become self-representations of Indigenous people, because they have participated and have agency in their roles in the film.

Jackson creates contemporary images of Indigenous women through her own embodied knowledge as an Indigenous woman. She is part of an Indigenous community that aids her in acquiring the intergenerational knowledge that connects her to the land, stories, and relationships through objects and people. This connection is clearly demonstrated in SNARE; each of the women in the piece lends her own connections to the knowledge, experience, and relationship of violence against women. Building on what Taylor (2003) defines as the repertoire that Indigenous peoples have and continue to keep—their collective memories maintained through oral stories, rituals, dances, and events—which creates the living archive, both Johnson's and Jackson's performances have the potential to transport the viewer through space, place, and time, and to rupture static and lifeless renderings of colonial versions of Indigenous knowledge. The finished results of both Jackson's film and Johnson's performance/bodice sculptures transmit Indigenous knowledge as documents (a material thing) and as embodied practice— part of the Indigenous living archive.

The practices of the artists discussed here present an intervention into the regulation of Indigenous identities and bodies by federal status laws. Johnson's work speaks to historic and contemporary gender discrimination in the Indian Act and the ongoing delegitimization of Indigenous principles of nationhood through Canadian federal policies. The chosen performance venue, Dalhousie University's law building

in Halifax, adds another layer of meaning to the work. Johnson and her sitters' *presence*, or claiming of space as Indigenous bodies in the entrenched colonial space of the university, is deliberate, subverting prevailing Eurocentric cannons of knowledge. Johnson explains: "This conversation needed to be had with the various students who were studying to be the next generation of lawmakers in Canada's courts."[11] Her call for participants (reproduced above), which encompassed non-status, status granted, status revoked, or enfranchised individuals, blurs the colonial definitions of Indigenous people. *L'nuwelti'k (We Are Indian)* thus raises significant questions about who is Indian and what constitutes Indigenousness. In non-Indigenous Canadian society, codes of membership and status laws for Indigenous peoples are rarely understood. Furthermore, the complexities of the histories of nationhood and Indigenous identities are consistently erased or undermined by nationalist narratives. Over the course of Johnson's four-day performance she asked audience members and passersby: "Have you heard of the Indian Registry Membership Codes?" In response, as Johnson notes on her website, one settler student from the law department "placed her briefcase on the floor, crossed her arms and said, 'ok, you have 5 minutes!'"

Métis scholar Bonita Lawrence reveals such processes of colonization as fundamental to the regulation of Canadian Indigenous identity. She identifies systems of classification and control that have played a central role in enabling the colonizer to define who and what is "Indian." Lawrence references Foucault's understanding of regulatory regimes as a discourse in which "a way of seeing life is produced and reproduced by various rules, systems, and procedures—forming an entire conceptual territory on which knowledge is produced and shaped" (2003, 3). Johnson's performative intervention in the atrium of the Dalhousie law building expresses Lawrence's conclusion that "understanding how colonial governments have regulated Native identity is essential for Native people, in attempting to step away from the colonizing frameworks that have enmeshed our lives, and as we struggle to revive the identities and way of living that preceded colonization" (4).

Johnson's performance, therefore, embodies Lawrence's call to better understand colonial regulations such as the membership codes instituted by the Indian Act, and in doing so, advances the decolonial work of resisting state regulation of Indigeneity. Furthermore, drawing on decolonizing frameworks, which we argue necessitate the

unravelling and destabilizing of now seemingly invisible colonial processes, the regulation of Indigenous identities, endured and experienced by Indigenous peoples, is and should be clearly defined as an apparatus of settler colonialism. By regarding Indigenous women artists' contemporary performance as a strategy of resistance and cultural continuance within settler nations, we wish to underscore Indigenous women's experiences with imperialism, globalization, colonialism, and assimilation more broadly by highlighting intersections among racism, sexism, and colonialism. This is not to say that Indigenous women's histories and identities are framed, contextualized, and structured solely through colonial experience, but rather that understanding the complexities of the colonial project helps to elucidate the significance of Indigenous women's histories of cultural continuance, resistance, and agency. Fundamental to the project of decolonization is the revealing, unravelling, and recontextualizing of settler involvement, agendas, and gains in the colonial project.

Connecting to the work of Indigenous scholars such as Goeman, Morten-Robinson, and Rickard, these artists create new ways of seeing and knowing based on their lived experience as Indigenous women. Both Jackson and Johnson participate in the urgent project of advancing Indigenous political and cultural sovereignty, which Jolene Rickard argues frames and roots the decolonizing project: "The struggle for autonomous nationhood embedded in a political discourse of sovereignty is a critical factor for the ongoing presence of indigeneity in the Americas" (2006, 62). Ultimately, Johnson's performance produces histories that complicate, reveal, subvert, and expose the colonial regulation of Indigenous identities as well as their representations. She does so by creating a new archive of Indigenous self-determined portraits that intervene in and resist the global colonial archive of photographs, drawings, and paintings of Indigenous women. Alongside Jackson, she produces contemporary representations and creates space for articulating the lived experiences of Indigenous people and nations. *L'nuwelti'k (We Are Indian)*, performed on Mi'kmaw territory in the city of Halifax, speaks to the history of settler state and Indigenous nations relations, ongoing processes of colonial occupation of Indigenous lands, and Indigenous resistance to this occupation in Canada.

CREATING INDIGENOUS SPACES OF REMEMBRANCE

After Johnson concluded her performance "each bust was then out on display in the atrium where they all end up looking almost identical to the one woven before them."[12] Thus, the products of the performance end up further elucidating the complexities of Indigenous identity and the ongoing implications of federally sanctioned status laws and membership codes. That the busts are "almost identical" regardless of the sitter's "status" makes clear the title of the performance, *We Are Indian*— regardless of an individual's status under the Indian Act, current registration, or membership status, all of the women who participate are Indigenous. Pushing back against stereotypical portrayals of Indigenous peoples, as well as resisting the limitations of Indigenous identity connected to Indian status, *L'nuwelti'k (We Are Indian)* opens up space for individuals as well as collective representations and definitions of what it means to be Indigenous. This work also, then, poignantly addresses inadequate, narrow, and paternalistic expectations of Indigenous identity based in Canadian settler society's erroneous conceptions of Indigeneity as defined in the colonial imagination and archive.

Johnson's work, much like the photographs of Jeff Thomas, Shelley Niro, and KC Adams, subverts the colonial ideology of the salvage paradigm and the concept of the "Vanishing Indian" present in Western archives. The salvage paradigm defined a late 19th- and early 20th-century attempt to collect and preserve Indigenous material culture; to document cultural, social, and political practice; and to create a permanent record based on the Eurocentric belief that Indigenous peoples were vanishing. Although these attitudes have shifted in the academy and museum, Marcia Crosby argues that much of the Indigenous art produced today is an attempt to reclaim the image of the "Indian" from the ethnographic context of the salvage paradigm (1991, 174). The "Indian" was theoretically and physically collected; material and visual culture was "salvaged" and placed into museum collections— in other words, placed into the colonial archive.

Iroquois artist, curator, and scholar Jeff Thomas reflected on the representation of Indigenous women in his exhibition *Aboriginal Portraits from the National Archives of Canada* held at the National Archives of Canada in 1996. Thomas writes about the conversations he put forward in the exhibition, which has been incorporated into an online exhibition on the Library and Archives Canada website:

Throughout my research, one of the areas of concern that emerged was the representation of Aboriginal women. In general, photographers have shown Aboriginal women as subservient to a dominant male figure. The caption usually identifies the man and leaves the woman nameless, often referred to as a squaw or "wife of." Many times, women are pictured sitting on the ground and looking away from the camera or in a pose of domestic activity. While this would not be an uncommon scene in the Aboriginal world, once the photographs were taken out of the community and displayed for a non-native audience, the voiceless domestic servant suffered the indignity of becoming a negative stereotype. This series of portraits reflects the strength of Aboriginal women.[13]

He makes a similar insightful argument in his online catalogue for the exhibition, *Luminance: Aboriginal Photographic Portraits*. The same power of confronting the colonial gaze is seen in both Johnson's and Jackson's work discussed here.

Further, these historic visual and textual references reflect and work alongside and within the colonial projects of conquest, domination, marginalization, and assimilation as representational tools of colonialism. In most cases, they are decontextualized from Indigenous worldviews, knowledge, and lived experience. Without simultaneously acknowledging the attitudes and paradigms of their producers, who for the most part were white settler men, and contextualizing Indigenous cultural knowledge, such imagery participates in the epistemic and representational violence of colonialism. Johnson and Jackson interrogate Indigenous resistance to colonization through their artworks and in doing so claim space as *Indigenous*. In "After Essay: Indigenous Is the Local," Jolene Rickard (2006) makes a distinction between work produced in the 1990s by artists like James Luna and the work of artists today, arguing that the former deconstructed colonial space while the latter imagine an Indigenous space. Johnson's and Jackson's works create sites that simultaneously imagine and create Indigenous spaces through contemporary art practice and with the Indigenous arts community more broadly. Rickard declares, "We need to make art for each other. We need to write for each other, and we need to do it on a global scale" (2006, 64). Indigenous performance-based art plays a key role in asserting cultural sovereignty and self-determination, and in continuing

embodied practices that mobilize resistance and the resurgence of Indigenous pathways/ways of being.

We want to reiterate and support Rickard when she argues for the continuing development of global Indigenous networks as a strategy to resist neocolonial occupations, dominations, and co-options by nation-states and global forces, as well as to assert Indigenous nationhood, worldviews, cultural sovereignty, and autonomy. Rickard highlights collaborations between Canadian and Australian Indigenous people, stating, "I am not suggesting that we operate in a hermeneutic bubble; rather, I think we need to articulate local knowledge globally" (2006, 64). As transnational and global conversations become more prominent in scholarly and curatorial practice, how can we most productively represent both the cultural heterogeneity of Indigenous peoples and connections between artists' practices and local histories? We see the local in the geopolitics of space as a powerful vantage point from which to engage in global conversations about Indigenous cultural production and histories of survivance and resistance. In other words, we hope to further explore the concept of "the local" within Indigenous histories as a potential site for the development of global Indigenous networks—connecting Indigenous communities' struggles for self-determination and sovereignty. This can be done through mobilizing the sharing of stories, experiences, and strategies in the global academic, activist, and artistic communities. For example, we (the two authors and including Dr. Heather Igloliorte) have been involved in some recent projects as a collective of curators-artists-scholars who present innovative projects in public spaces by working through Indigenous, feminist, and anti-oppressive methodologies grounded in practices of research creation. We formalized our collaborative work by forming the GLAM Collective, a name that refers to the broader international movement of Galleries Libraries Archives Museums, as well as to our collective work in activating these spaces in and with the public. Since that time, we have brought forward several exhibitions and public art projects that hold space for critical discussions about long-standing Indigenous relationships to technologies as creative materialities, sites for exchange, dialogical interactions, and for the expression of continuities. Our work includes the research-creation incubator—alongside the series of public art and night festivals in which we have exhibited the outcomes of these

incubators, and which work in tandem with each other. These include the *Memory Keepers* series parts I, II, and III that took place throughout 2019; *gathering across maona* (2019–2020); and most recently *ebb and flow* (2020, and touring in 2021), engaging and activating Indigenous methodologies of visiting, mentorship, and intergenerational exchange.

GLAM Collective incubators are arts-based research-creation labs that take a collaborative co-creation and knowledge-sharing format. We bring together artists of diverse practices, media, knowledges, backgrounds, nations, and generations for intensive, short-term, and site-specific exchanges where they are encouraged to take risks and experiment outside their own practices, co-create and/or learn with and from one another, and share new knowledges for the creation of art that is shown to broad local publics, often immediately at the end of the incubator. This work aims to create and give rise to new methodologies that showcase the ideas, conceptualizations, and realizations of Indigenous futurisms, where Indigenous peoples are situated within a long continuum of past, present, and future on this land and waters. These arts-based critical engagements with public spaces assert Indigenous territorialities/sovereignties in terms of both land and belonging, sharing intergenerational knowledge to include land-based and technological materialities, resisting the erasure of Indigenous sovereignties/presence on land and in cities, and considering and redressing questions of who is included in conceptualizations of publics and public spaces.[14]

CONCLUDING THOUGHTS ON GENDERED REGULATION OF INDIGENOUS BODIES AND LANDS

The impact of colonial attempts to control, assimilate, and subjugate Indigenous women is manifested in contemporary Canadian Indigenous communities through the disproportionate numbers of Indigenous women who live in poverty, are incarcerated single parents, have health issues, suffer from drug and alcohol abuse, and are harmed or killed through violent crime. We include these bleak realities about contemporary Indigenous women to highlight how their issues are not considered and are not valued in Canadian society. Lisa Jackson's video work SNARE exemplifies this reality, along with other Indigenous women artists' performance-based works, such as Rebecca Belmore's *Vigil* (2002) and *The Named and the Unnamed* (2001). These works dialogue with Amnesty International's *Stolen Sisters* and *No More Stolen*

Sisters reports and with the National Inquiry into MMIWG final report and calls to justice (2019), which revealed to both national and international publics the appalling history of sexual and physical violence and murder experienced by Indigenous women in Canada since the 1970s. The contemporary legacies of colonization have real and everyday consequences for Indigenous peoples; the historic and legislative discrimination and marginalization of Indigenous women in Canada is overtly revealed in the systemic racism, sexism, and strategies of hegemonic paternalism and oppression they, as well as their communities, still endure and resist internally and externally.

Johnson's performance *L'nuwelti'k (We Are Indian)* and Jackson's film SNARE highlight the overarching need for Indigenous self-representation to resist and challenge the immense archive of Eurocentric and one-dimensional representations and stereotypes of Indigenous peoples, and specifically, Indigenous women by demonstrating differences in physical appearances, ages, and Indigenous nations. These powerful performative works embody the politics of Indigenous cultural continuance and autonomy through self-determined representations, contributing imagery of Indigenous women to an Indigenous living archive.

L'nuwelti'k (We Are Indian) and SNARE subvert the Indigenous representation of the Eurocentric archive. Johnson's and Jackson's works situate the Indigenous woman's body as the site of cultural intervention and resistance and create Indigenous spaces, such as living archives. Contemporary Indigenous artists often disrupt the colonial gaze by addressing agency and the cultural autonomy of Indigenous peoples' embodied knowledge. Johnson and Jackson not only mine the archive, so to speak, to produce new self-determined imagery, but also create an Indigenous living archive with their embodied knowledges. The historical and ongoing regulation of Indigenous women's status and bodies by the nation-state, as well as the extensive archive of Eurocentric representations of Indigenous women, makes the act of performing the body a powerful decolonizing strategy of resistance, reclamation, and sovereignty. These artists' performance-based works contribute to a living archive of Indigenous memories and experiences that disrupt the erasure and enact the remembrance of colonial violence against Indigenous communities carried out by the apparatus of settler-colonial nationalism. The installations discussed here can also be situated in a broader national and international context of performance- and

media-based interventions that challenge colonial amnesia. In the past decade many performance- and media-based works produced by Indigenous artists in Canada have interrogated the legacies of colonial trauma that mark the Indigenous woman's body and have explored the contemporary consequences of centuries of settler representation and regulation of Indigenous bodies, identities, and histories.

The works of Jackson and Johnson open up space for the performance of Indigenous experiences and stories that have been silenced and marginalized by dominant colonial history, which fosters a forgetting of Indigenous peoples in the cultural consciousness of settler society. Canada is a nation that fosters and perpetuates a politics of forgetting. The performative acts we have explored in this paper reference historical events, personal and familial stories and experiences, as well as cultural knowledge. All of these, through Indigenous performance strategies, contribute to the projects of decolonization and resurgence through acts of remembrance, self-representation, and cultural continuance, thus contributing to the Indigenous living archive. As we stated above, our research is contextualized and framed by decolonizing methodologies that aim to reveal and acknowledge the always already presence of Indigenous agency in both the past imperial and current global eras. Our critical analysis of SNARE and L'nuwelti'k (We Are Indian) highlights the ways in which Indigenous peoples remember and represent personal and collective memories and knowledges (in storytelling, dance, literature, and visual and performance art) despite colonial tactics of ethnocide and assimilation. By making these connections, we call attention to the significance and importance of performative memory; or, put another way, the Indigenous living archive, which makes Indigenous memory, trauma, and colonial experiences, *and their performers*, participants in the project of decolonization. As Goeman argues in her book *Mark My Words*, "Native feminisms can play a major role in our thinking about the connections between land, individuals, and constructions of nations. Bodies that are differently marked through the corporeal or through a performance—whether through gender, race, sexuality, or nationality—articulate differently in different spaces" (2013, 12). The works of Johnson and Jackson have created spaces that mark, map out, and validate Indigenous women and all the contributions and complexities of the gendered, colonized body. These works activate decolonized representation of Indigenous women and bodies while

showcasing how such bodies can and are decolonized living simultaneously within the contexts of settler colonialism and in Indigenous self-determined spaces of resurgence and resistance.

NOTES

1 The work was originally a silent one-minute film commissioned by the Stolen Sisters Digital Initiative and screened at the imagineNATIVE Film + Media Arts Festival 2012, as well as in the Toronto subway system and in malls across Canada.

2 This information is also archived on Johnson's website: https://ursulajohnson.wordpress.com/lnuweltik-we-are-indian/.

3 This list of colonial policies instituted in Canada by the Indian Act in 1876 are emblematic of the larger nation-building project of occupation, assimilation, and ultimately ethnocide.

4 The National Inquiry into Missing and Murdered Indigenous Women and Girls, *Reclaiming Power and Place: Final Report of the The National Inquiry into Missing and Murdered Indigenous Women and Girls*, June 2019, https://www.mmiwg-ffada.ca/wp-content/uploads/2019/06/Calls_for_Justice.pdf.

5 The National Inquiry into Missing and Murdered Indigenous Women and Girls, *Calls for Justice*, 2019, 168, https://www.mmiwg-ffada.ca/wp-content/uploads/2019/06/Calls_for_Justice.pdf.

6 The National Inquiry into Missing and Murdered Indigenous Women and Girls, *Calls for Justice*, 167.

7 See Walking With Our Sisters, "The Project," accessed May 6, 2018, http://walkingwithoursisters.ca/about/the-project/.

8 See the work of Margaret Kovach, Heather Igloliorte, Julie Nagam, Leanne Simpson, and Linda Tuhiwai Smith.

9 This point is further teased out by Nagam (2011, 2017, 2020) and by Taunton (2011, 2020).

10 See https://www.mmiwg-ffada.ca/

11 Ursula A. Johnson, "Ľnuwelti'k (We Are Indian)," n.d., https://ursulajohnson.wordpress.com/lnuweltik-we-are-indian/.

12 Johnson, "Ľnuwelti'k (We Are Indian)."

13 Jeff Thomas, "Aboriginal Portraits," Library and Archives Canada, Exhibition Text, 1996.

14 See Igloliorte, Nagam, and Taunton 2021.

Curatorial Insiders/Outsiders: *Speaking Outside* and Collaboration as Strategic Intervention

Toby Katrine Lawrence

In July 2016, *Speaking Outside*, an exhibition of collaborative video and performance-based work, took place on the beach, in the streets, and on the land across Lekwungen (Esquimalt and Songhees), W̱SÁNEĆ, and Kómoks territories (Victoria and Courtenay, Vancouver Island, British Columbia, Canada). Working as an unaffiliated curator for this project, I was joined by Steven Thomas Davies, a filmmaker of Snuney-muxw/Coast Salish and European descent, and Iroquois Mohawk multi-disciplinary artist Lindsay Katsitsakatste Delaronde to produce a series of public interventions. Davies's *Written In My Blood* and Delaronde's *Bondage* were each produced through collaborative processes, working with performance, dance, and film as modes of storytelling. Founded on the pedagogical potential of occupying public space through art, *Speaking Outside* addresses fundamental questions around who is and who has been historically allowed to speak, including where and in what forms, and how this has determined contemporary understandings of history and knowledge practices. Occurring as a stand-alone exhibition project and as part of the Comox Valley Art Gallery summer exhibition program, *Speaking Outside* supported artists, curators, and creative practitioners working inside and outside of gallery spaces, conventions, and positions while simultaneously working together across layered collaborations to share knowledge, input, and perspectives as cultural insiders and outsiders.

FIGURE 10.1 Steven Thomas Davies, *Written In My Blood*, HD video, 2016. *Speaking Outside*, installation view, Langley Street, Victoria, BC, July 18, 2016. Photo courtesy of Toby Lawrence.

FIGURE 10.2 Steven Thomas Davies, *Written In My Blood*, HD video, 2016. *Speaking Outside* installation view, Comox Valley Art Gallery, Courtenay, BC, July 22, 2016. Photo courtesy of Toby Lawrence.

Speaking Outside took the form of a multi-day, multi-site outdoor exhibition over three days throughout July 2016 with a live performance on the beach along Dallas Road near Holland Point Park in Victoria; a video installation with two films projected onto the Langley Street exterior wall of the Yates Street parkade in downtown Victoria (Figure 10.1); a second outdoor screening of both films accompanied by a solo performance, as part of a symposium and accompanying exhibition program at the Comox Valley Art Gallery (CVAG) in Courtenay (Figure 10.2); and then shifting the format again, the films were presented on a television monitor embedded within the gallery space at CVAG for the duration of their summer exhibition. Such activations of site shift Davies's and Delaronde's collaborative projects away from the cultural hegemony of Western gallery or museum structures, where, rather than privileging an assumed colonial narrative of static Indigeneity, these projects dually assert Indigenous self-determination and Indigenous/non-Indigenous collaboration and relationships. In the initiation of *Speaking Outside*, a formative aim was to disrupt the "dominant culture space" (Garneau 2016, 35) through collaboration as a decolonial methodology pointedly unsettling the authoritative and colonial framing and practices that exist within contemporary art systems. Despite the goal of disruption, the complexities of insiders/outsiders politics remained in play. Therein, participants worked from various cultural positions, both Indigenous and non-Indigenous, as well as oscillating professional, institutional, and spatial boundaries.

As a settler-Canadian curator, it is imperative to acknowledge the limits of my personal perspective (Hargreaves and Jefferess 2015), and therefore collaboration and consensus function as interventionist strategies to uphold Indigenous voices and direction. These strategies also underscore the complexities of shared authorship and an inherently collaborative nature that suspends the mythic singularity of ideation and curation. Here, I write from my personal perspective as a Canadian of mixed European-settler ancestry, through my role as curator, and as the initiator of the *Speaking Outside* project, the British Columbia Arts Council project grant holder, and both the facilitator of and a participant in the process of development and presentation. Importantly, the artists and their collaborators each approached the project through their own intentions and interpretations of the process. Furthermore, the many layers of collaboration meant that not all the participants

FIGURE 10.3 Lindsay Katsitsakatste Delaronde, *Bondage*, performance, 2016. Beach at Holland Point Park, Victoria, BC, July 12, 2016. Photo courtesy of Toby Lawrence.

were direct collaborators; yet there was continuous effort and significance in acknowledging and honouring these voices in the relay of information. An active practice of consultation and collaboration was therefore imperative in determining how and where to best present the artworks and support the range of perspectives of the artists involved. This chapter takes *Speaking Outside* as a point of departure to consider collaboration within curation and art production as a decolonial strategy and as one that necessitates ongoing negotiation of the boundaries and overlap across the numerous roles occupied in the production and exhibition of art.

Bondage (Figure 10.3) comprised two distinct performances and an HD video projection installation, under the direction of Delaronde. The primary component was a co-choreographed performance produced through the collaborations of Delaronde, Margaret August, Naomi Kennedy, and Erynne Gilpin, a group of women and two-spirit artists who identify as Iroquois Mohawk, Shíshálh, mixed European ancestry, and Saulteaux-Cree/Métis/Filipina/Irish/Scottish. The narrative is drawn from Delaronde's own personal experiences and the extensive pre-existing relationships she has with each of her collaborators.

FIGURE 10.4 Lindsay Katsitsakatste Delaronde, *Bondage*, video, 2016. *Speaking Outside*, installation view, Langley Street, Victoria, BC, July 18, 2016. Photo courtesy of Toby Lawrence.

Focused on the experience of co-creation, each of the characters were developed and performed by the group. *Bondage*, in Delaronde's words,

> transmutes the oppression and colonial history of the people and land through body movements and dance. It is a story that embraces the power of the human spirit. The spirit we all carry within us desires the universal teachings to fully understand itself. *Bondage* is a collaborative work bringing together multiple narratives, personalities, and experiences, co-creating a new narrative that is reflective of our multi-cultural experiences on this territory of the Coast Salish peoples. ... We as Indigenous people are bound to the land, Mother-earth carries the oldest of stories and with those stories comes teachings and knowledge of how to live in harmony with all our relations. *Bondage* is a way of giving back the gifts that we all carry within us and the ever-changing narrative of Indigenous identities. (2016)

In the choreography of *Bondage*, each performer embodies a different character and teaching: the helper/guider, in the form of the Raven; the

cleanser/purifier; the extractor, represented by segments of red cloth; the builder, in the form of a horned beast; and Delaronde, as the central figure, representing the nature of the human soul in the form of a galaxy. At the outset of the performance, Delaronde's body is painted as though fully covered in earth's matter to signify our human origin from the earth and the love and nurture of being enshrouded in the darkness of the womb. The soul is guided by the helper and comes into her own through the rituals of birth, aided by the character of the cleanser, who cleanses the soul with the Salish Sea. Delaronde's interactions with each of the performers produce a new narrative through their public and private relational experiences, in addition to the transmission of experience between performer and viewer. In her artist statement Delaronde further explains the importance of situating the performance on the beach, in the land:

> This new narrative represents the in-between space of colonialism. The power of movement and rhythm of history are symbolic of breathing. Constantly extending our narrative as Indigenous people to the masses to respectfully reinforce our presence, is the motivation for this piece. Using archetypes, natural elements, and nature as storytellers in bringing forth an Indigenous approach to performance art, through dance. We acknowledge the interconnectedness we have to the land, spirit, and animals and value the teachings from all aspects of life. Dancing and performing our histories is what Indigenous peoples have been doing for centuries. (2016)

A second component of *Bondage* (Figure 10.4) was produced from video documentation and was screened as part of the projection installation in Victoria a few days later, alongside Davies's film, *Written In My Blood* (Figure 10.5).

Produced in collaboration with Jeanette Kotowich and Dani Zaviceanu, *Written In My Blood* is a non-linear exploration "honouring the importance, practices, and histories of Indigenous women that have been obscured by colonial agendas and records" (Davies 2016). Centring the matrilineal tradition of his Snuneymuxw ancestry, Davies's artist statement explains, "In this ode to the matriarch, a contemporary Indigenous woman in a colonial city transcends to the wilderness and back" (2016). Accompanied by "The Journey Home," a track by Dean

FIGURE 10.5 Steven Thomas Davies, *Written In My Blood*, HD video, 2016. *Speaking Outside* installation view, Langley Street, Victoria, BC, July 18, 2016. Photo courtesy of Toby Lawrence.

Hunt of the Heiltsuk Nation, the film features original choreography and performance by Kotowich, a Cree Métis contemporary dancer, influenced by traditional and contemporary dance forms. The work was filmed on private property in W̱SÁNEĆ territory, at Open Space in downtown Victoria, and in and around Bastion Square adjacent to the Yates Street parkade where it was first screened, creating a layered spatial experience through the screen imagery as it moves between interior and exterior urban spaces and the land in its natural state. Kotowich's artist statement communicates her distinct choreographic approach:

> Returning to an Indigenous knowing body our movement has the ability to transcend and decolonize previous patterning. *Written In My Blood* expresses longing and belonging through how we relate to the environment around us. At any moment, we arrive to where we are with all histories/territories accounted for—and we reference identity from this place. The movement score is derived from deep listening and reverence for land; all of that which sustains us. (2016)

The centralization of storytelling through performance, dance, music, and film in the works produced by Davies and Delaronde and their collaborators displaces the historical primacy of certain archival modes

and the perpetuation of dominant narratives of truths and justice within the colonial model of Canada. Carmen Robertson affirms: "Deciding who tells a story, how that story is told, and the roots of story remain central to the creative process because, perhaps more than any other epistemological tradition, the relationship between the visual, oral, and textual, implicitly informs Indigenous aesthetic traditions" (2016, 14). Correspondingly, stories impart belonging and support self-identity and self-determination. Further, for Marjorie Beaucage, "stories are medicine, they are our connection to the sacred power that is in all things" (2005, 139). Storytelling is significant in reflecting lived realities and the roles that identity and memory play in navigating the inseparability of relationships and reality (Beaucage 2005, 139; Wilson 2008, 7).

Delaronde's work extends her connection to Kahnawà:ke and participation in community and ceremony and is simultaneously positioned within a pronounced history of performance and media-based Indigenous artists. Equally, Davies's work follows a history of Indigenous artists working in film and media arts to address stories and issues significant to Indigenous communities, broadly, and specific to his personal communities. The aesthetic and conceptual elements of *Bondage* and *Written In My Blood*, developed through collaboration and story, and with community in mind, enact Robertson's theorization of Indigenous art, wherein "concepts that maintain the diversity of Indigenous arts in relation to notions of interconnectedness, considerations of future impact, performative gestures, elements of ceremony, and the realities of colonial oppression inform theoretical discussion of Indigenous art" (2016, 15). The symbolism in the costuming conceived by Kotowich for her performance—her carved silver and beaded bracelets and beaded earrings—finds balance and contrast in Delaronde's bold use of black paint covering her entire body to illustrate a direct tie between the human body and earth's matter. A swath of red fabric throughout *Bondage* weaves and binds bodies, alone and together, drawing visual parallels to Indigenous performance art history and works such as Dana Claxton's *Follow the Red Sinew* (2016) and Rebecca Belmore's *Vigil* (2002). As Delaronde moves into the Salish Sea, cleansing earth's matter from her body, *Bondage* establishes ties to the land, as well as a personal connection with the territory Delaronde and her collaborators currently inhabit. The story realized by Davies, Kotowich, and Zaviceanu presents a parallel linkage to home and territory through

choreographic and editorial decisions. Kotowich's movement back and forth between environments and the echoing gestures that bridge the oscillation express a contemporary reality of Indigenous lives. Each in their own approach, the geographical positioning, process, aesthetics, and stories captured in both artworks demonstrate the multi-vocality and continuum of Indigeneity connected to land and tradition in present-day forms (Rickard 2005, 70).

IN RELATION TO PLACE

Critique of the social and political frameworks of the archive, combined with ongoing issues around access—specifically the extent to which access is permitted or prohibited in public arts organizations and spaces, public archival holdings and collections, and even public outdoor space—is reflected in a number of exhibitions and artistic interventions that have taken place in and around Victoria in recent years. In particular, this line of inquiry calls to my mind conversations with Claxton while working on bringing a selection from her *Indian Candy* series to the Art Gallery of Greater Victoria (AGGV) in 2014,[1] as well as research and conversations with Charles Campbell in preparation for a catalogue essay for his Open Space exhibition, *Transporter*,[2] and the ways each of these projects call historical and colonial representation to task. Claxton's project mined the popular archive of the internet for images and documentation relating to buried histories of Indigenous peoples, enticing viewers to consider, among many things, the problematics of the adaption and appropriation of Indigenous culture and iconography for consumption and exploitation. Claxton intervenes through her enlargement and manipulation of the source images and documents, using saturated candy-like colours to draw viewers into the seriousness of the content. This work highlights the types of imagery and historical documents relating to significant events in Indigenous history that are accessible to the general public with relative ease. A month prior to the opening of the exhibition in Victoria, select works from *Indian Candy* were re-formatted and installed on billboards in six cities across Canada for the 2014 Scotiabank CONTACT Photography Festival.

Campbell's work for *Transporter* magnifies the politics of public spaces and the variant visibility of specific histories by reimagining Buckminster Fuller's iconic utopic geodesic dome to amplify Black histories and futures within the colonial spaces of the provincial capital. For

his *Declarations*, Campbell took the conversation outside. The politics of public space, public archive, and public narrative were palpable in aspects of the response. These works were installed as interventions, without pre-approval from the sites or the city. Some remained in place for quite a number of days, while others such as the piece that enveloped *Homecoming*, a bronze sculpture located along Victoria's inner harbour of a crouching naval officer with outstretched arms and a young girl running toward him, was removed almost immediately. Earlier interventions highlighting access and entitlement to public space were installed as part of the AGGV's group exhibition *Throw Down*.[3] Tyler Hodgins's *Sleeping Bag*, a series of coloured cast-ice sculptures of a human figure reposed inside a sleeping bag, were placed on sidewalks and benches around the city's downtown to draw attention to the realities of homelessness. Installed in January, the sculptures remained throughout the winter as daily reminders for regular and one-time passersby, until they melted. A "special event" permit allowed the ephemeral artworks to stay their course. At the same time, a City of Victoria bylaw prohibited homeless persons from sitting or lying on these same benches for longer than 30 seconds (Hodgins 2012).

In the context of *Speaking Outside*, following a history of interventionist art projects in public outdoor space in this region, the relative proximity of the original performances and screening of *Bondage* and *Written In My Blood* to significant historical landmarks functions both at once as a marker of colonization and as an intervention into the stability of the colonial narrative. In her discussion on the complexities of locational subjectivity and viewer engagement through site-specific projection, Shana MacDonald states: "These performative screens often dissolve boundaries between discrete media, spaces and viewing positions in order to underscore the charged relationship between art, politics and public space" (2014, 54). MacDonald further suggests that within this relationship, the tension of overlapping narratives offers space to "confront a range of marginalized discourses and histories" (54). While not exclusively composed of projected work, *Speaking Outside* nonetheless facilitates dialogue regarding a dissolution of boundaries through the layering of proximal and regional locations within the exhibition and production components, in conjunction with shared audience experience and the post-project activities that have enabled extensive reflection and analysis of the process and impact

(MacDonald 2014). Connection and meaning are made through the content of the artworks, as well as through the physical links to the histories of the locations and the individual and collective perspectives of the viewers. Certainly, the element of confrontation is present within the artists' response and use of the sites. Yet, its resonant impact across the general viewership is ultimately unquantifiable.

Bondage and Written In My Blood do not tell the stories of the project locations specifically; however, these locations are significant in several ways. Such "projection structures," returning to MacDonald, "produce a politics of space as a counterpoint to the different erasures embedded with the landscape they represent. The collaboration between screen, site and viewer [and the artists] in each work is both a performative gesture and an architectural intervention against the naturalized histories of spaces with urban development" (64). The beach where Bondage was first performed sits between two geographical points along Dallas Road in the provincial capital, now Holland Point Park and Ogden Point, a deep-water port facility with the busiest cruise ship terminal in Canada at the time of the performance.[4] Pre-contact, these geographical points were defensive sites used by the Lekwungen people, overseeing the entrance to the harbour. Delaronde was drawn to working in this specific location after learning about the traditional uses of the area from Songhees educator Mark Albany while working on The Unity Wall Mural project along the breakwater at Ogden Point in 2013. Additionally, Delaronde's choice was influenced by the potential of activating this location used extensively by tourists with "Indigenous bodies on the land and water, intersecting and dismantling colonial ideas of tourism, place, and sightseeing."[5] The agency of the performers offers a stark contrast to the static tourist items found across the city. Instead, the many facets of Bondage speak to the dynamism and interrelationality of Indigenous performance.

The Langley Street exterior wall of the Yates Street parkade where the projection installation took place is adjacent to Bastion Square, a location used in Written In My Blood, and loosely flanked by the original site of Fort Victoria to the west and the famously haunted Supreme Court Building built in 1889 at the eastern edge of the square. Among a handful of possible options in Victoria's downtown core, the parkade wall offered the best, unimpeded surface for projection and was on a side street with minimal vehicle traffic and ample room for spectators. Also

determined through conversations between me, Davies, and Delaronde, the parkade wall was not further complicated by historical or political association, as in the option of projecting onto the side of the court-house. This freed the artists from having to respond to the history of the building itself. For *Written In My Blood*, the decisions regarding location were made through conversation between Davies, Kotowich, and Zaviceanu based on several available sites scouted by Davies that reflected Kotowich's choreographic vision: the expansive empty gallery at Open Space, the alley joining the mural-clad rear exterior of Open Space to Bastion Square, the Square itself, and the field of camas and Garry Oaks signalling the Kwetlal ecosystem, an important food sys-tem cultivated for millennia by local Indigenous communities. Footage was taken at other locations that was not used in the final piece.[6] Ultim-ately, *Bondage* and *Written In My Blood* re-inscribe these locations with Indigenous stories and histories on their own terms, replacing erasure with Indigenous presence through media and performance arts, which foreground the duration of Indigenous histories in these locations.

POLYVOCALITY AND PUBLIC SPACE

With *Speaking Outside*, the occupation of public space through art re-centred the conversation to draw attention to continuing Indigen-ous presence on unceded Indigenous lands. The project provided the opportunity to think purposefully about both the political and peda-gogical implications, as well as the precarity, of occupied public space. Additionally, working primarily outside the gallery framework was an intentional way to address the reality that many people will never enter a conventional art space, deterred or prohibited by any number of social, political, and economic factors. The project, in turn, made space for those who would not normally have, or enter into, an oppor-tunity to engage with contemporary art. At each site, *Speaking Outside* did not introduce any physical limitations to public access beyond those pre-existing in the environment. An overarching curatorial author-ity was strategically abandoned to uphold consultative processes that supported vulnerability and reciprocity in the continuous negotiation of insider/outsider boundaries. Through the process, the curatorial structure became one of dialogue and mediation. A practice of deci-sion by consensus was employed in an effort to disrupt conventional curator/artist power dynamics and refuse a hierarchy of authority, and

ultimately drive the final format and concerns of the exhibition. Davies and Delaronde each worked extensively with me and through their separate collaborations, but not with each other. Therefore, not all the participants were direct collaborators, but all were contributors to the overall form. Additionally, Corey Bryson was instrumental in sourcing and overseeing the technical needs of the video projection in downtown Victoria, as was Angela Somerset, curator at the Comox Valley Art Gallery, to collectively determine the location and format of the presentation in Courtenay that joined *Speaking Outside* with the *Make/Art/ Place* program that included video, installation, and performance works by Liz Carter and George Littlechild.

Throughout the project, I engaged the term "collaborative curator" to decentre the singularity of assumed curatorial authority and draw attention to the dialogical development of the exhibition as a whole. These methodologies are, of course, long-standing components of curatorial output and discourse. Nonetheless, as Eva Fotiadi suggests, "the dominant single-author model in curating has concealed the importance of collective and collaborative practices in the brief history of making art exhibitions as a distinct profession" (2014, 2). Moreover, Terry Smith's systematic mapping of contemporary curation and exhibition production underscores the frequency of overlap and oscillation between the roles of artists, curators, and directors, citing nearly five decades of continuous "*interaction between its elements*" (2017, 174). Regardless of the historical merging of artist/curator positionality, the notion and understanding of the singular, creative genius (artist or curator) remains prominent across the wider public as the primary structural and discursive framework of art and exhibition production, echoing Fotiadi. The concept of collaborative curation, therefore, intervenes in the singularity of voice and explicitly troubles a finite understanding of curator—not to entirely relinquish its managerial positionality, but rather to emphasize the many facets of collaboration and dialogue as instrumental to a non-hierarchical and ethical praxis of curation.

The strategic weight on collaboration places the role of dialogue in public view. Responsibility and accountability are shared, and the conditions and processes of collaboration inherently require collaborators to work outside their own position of expertise, though they are rarely enacted the same twice. Through collaborative and interventionist frameworks, the structure and conceptual specifics of *Speaking Outside*

were determined in tandem with the development of the artworks and independently, without an overseeing art gallery or organization. A contradictory position of this project, however, lies within its subsequent integration into the gallery system as part of the *Where Is Here? Small Cities, Deep Mapping, Sustainable Futures* symposium and the summer *Make/Art/Place* exhibition program at CVAG and the support it received from institutional infrastructure for funding, legalities, and historicization. The institutional apparatuses are present through the financial support of a British Columbia Arts Council project grant; the need for permits to ensure the events could take place on City of Victoria property without risk of being shut down and the grant wasted; the approval of event and parking permits obtained through the City of Victoria's Arts, Culture and Events Liaison, to whom I had access through a previous position as a member of the City's Art in Public Places committee; and the requirement of liability insurance in order to obtain permits. Historicization continues through the events around the second presentation at CVAG, the public discussions at conferences in Perth, Australia; Tulsa, Oklahoma; and Toronto, Ontario, and the publication of this chapter.[7]

INSTITUTIONAL PRESENCE/ABSENCE

An audience question posed to me at the Native American Art Studies Association conference in Tulsa is worth exploring further in relation to the notion of insiders/outsiders and the role of the institution. To the best of my recollection, the question was, "Where, or when, is the institution still present?" As an independent project also incorporated into public art gallery programming, this question is dually relevant. The institution here is not exclusively in reference to the logistics detailed above, but also in the institutional/ized mechanisms of power that are continually exercised within the arts, within colonial structures, and within our dialogue, even in these collaborative and decolonizing disruptions. Maria Lind's extensive work on collaborative art practice draws such a position further into view: "Collaborations often constitute a response to a specific, sometimes local situation, and they run a constant risk of becoming incorporated into the system they are reacting against" (2009, 53). In always pushing boundaries and applying pressure to the systemic restrictions from outside and within, it is important to acknowledge and continually reflect on the subject

positions from which the "we" is expressed, and further, from which the imagining of new possibilities for decolonial futures takes root, thus reinforcing the established necessity for collaborative, consultative, and relational curatorial processes. In the Western art paradigm, borrowing from Andrea Fraser, "Every time we speak of the 'institution' as other than 'us,' we disavow our role in the creation and perpetuation of its conditions. ... It's not a question of being against the institution: We are the institution" (2005, 283). Placing the focus on curation, Peter White similarly speculates, "Curatorial activity, wherever it is located and however it is constituted, necessarily involves structural and organizational prerogatives that imply some kind of institutional form and process" (1996, 3). Nevertheless, in efforts to unhinge the institutionalized strongholds of the dominant art spaces, Candice Hopkins offers an alternative. Her thinking is not limited to band-aid solutions or the reconfiguration of the existing institutional model, but rather she imagines new terms altogether.

Reinscribing the operational fluidity of institutions, Hopkins states, "We need to shape these spaces in the way we want to see them shaped ... as opposed to thinking that we are always having to react or subvert them, because we can do something else" (2018). Correspondingly, in an earlier publication, she suggests, "Maybe it's not a matter of getting Native people *into* the gallery but a matter of getting a Native audience to engage with contemporary art on their own terms—an encounter that often occurs in a space outside the gallery's physical and conceptual confines" (2004, 193). Significantly, Hopkins's suggestions speak to the politics of public art gallery space and circle back to questions of accessibility and relevance within the Western art systems that have been shaped primarily through colonization. Again, the reality is that many people will never enter an art gallery or museum, and the Western-centric narratives that remain prolific in these spaces do not accurately reflect or engage the diversity and dynamics of culture across Turtle Island.

The collection of audience response data was limited without the institutional infrastructure to manage such labour. Even still, observing the audiences in Victoria and Courtenay and noting the enthusiastic response of passersby and frequent users of those spaces, in conjunction with the occurrence of this exhibition across the multiple sites and cities, became a clear way of reiterating the subjectivity of public space

and calling to question the manner within which knowledge is classi-
fied, accessed, and interpreted in differing contexts, and for whom.
This is coupled with "the awareness that collaboration entails contact,
confrontation, deliberation and negotiation to a degree which goes
beyond individual work, and that this produces subjectivity differ-
ently," as stated by Lind (2009, 63). These opportunities also locate and
establish the collaborative work produced by these artists through this
project within the broader discourses and histories of art. In doing so,
the resonance of the project additionally addresses how collaborative
methods and non-affiliated modes of presentation impact art history
and exhibition practices, moving beyond conventional museum struc-
tures of patriarchy and cultural hegemony that most often uphold the
singularity of an artist or an artwork within Western exhibitionary
structures and re-inscribe de-contextualized and exoticized representa-
tions of culture. By contrast, *Bondage* and *Written In My Blood* generate
spaces of Indigenous epistemology, as Indigenous art theory (Robertson
2016) and as conciliatory action (Garneau 2016). As a vehicle for these
works, *Speaking Outside* stands as creative research engaged in critical
discussion around curatorial ethics, public art practices, and the essent-
iality of building relationships and knowledge through conversation,
collaboration, and consensus-driven actions between Indigenous and
non-Indigenous creative practitioners.

DECISIONS BY CONSENSUS

By centring and taking lead from the Indigenous epistemologies of the
artists involved, *Speaking Outside* refuses the dominance of colonial
narratives that continues within the art institutions and in the Can-
adian imaginary by intervening in the collective memory and archive
of the critical arts activities of these cities, Victoria and Courtenay. In
correlation with Hopkins's reimagining of the terms of praxis, pres-
entation, and engagement, "the political will of decolonization," argues
Rachel Flowers, "refuses to reproduce the present and affirms alterna-
tive futures" (2015, 36). For Eve Tuck and K. Wayne Yang, "refusal is
not just a 'no,' but a redirection to ideas otherwise unacknowledged or
unquestioned" (2014, 239). By performing and projecting the works out-
side in public spaces, institutional barriers are potentially removed. In
Speaking Outside, the practice of decision by consensus further disrupts
conventional power dynamics and a historically established hierarchy

of authority—disarming privilege and ideally allowing change to occur, moving away from prescribed narratives, and establishing precedent to further open up modes of practice. In thinking further through refusal in relation to curation, the emphasis on dialogical development and production ultimately establishes co-learning through vulnerability, reciprocity, and the building of trust. Nonetheless, even in the act of renegotiating the power dynamics of artist/curator/community through collaboration and consultation, these power dynamics are still present and are equally inseparable from socialized constructs of gender, race, age, and culture—a fact that always needs to be engaged. In the need and the call for decolonial options, I am cognizant, as a facilitator and mediator of art, that collaborators, colleagues, and audience members alike will enter into and both accept and resist dialogue at many different stages of this challenging process.

Speaking Outside as a whole aimed to bring together diverse communities through uninhibited audience access while supporting artistic voice purposely intended for Indigenous audiences, alongside non-Indigenous audiences. It also brought in many people from the art communities across the various locations to discuss and consult on the format, production, and content, in formal and informal ways. The public result was an ability to make recurring space for Indigenous voices through curatorial and artistic facilitations. Additionally, Delaronde's solo performance during the presentation in Courtenay invited the audience to participate directly, creating new narratives once again. In this performance, she stood in the street, closed to traffic, as *Bondage* was projected on the exterior wall of the building behind her. After carefully unravelling her ceremonial objects and drum from a length of red fabric used in the initial performance, Delaronde performed a smudge for each person that approached her (Figures 10.6 and 10.7). In the development and presentation of *Speaking Outside*, collaboration and consensus made visible the shared authority, as we worked from our various subject positions, traversing professional, institutional, and spatial parameters and trusting in each other's commitment. Shifting to the shoreline and urban outdoor spaces, *Speaking Outside* intervened to reassert artistic practice as part of everyday life and to foster vital relationships between the creative practitioners, the artworks, the audiences, and each site (Marsden 1996). Such relationality, performed and projected—returning to MacDonald—renegotiates

FIGURE 10.6 In the middle of Duncan Avenue, temporarily closed to traffic, Lindsay Katsitsakatste Delaronde unravels her drum and ceremonial objects during her second performance iteration for *Bondage*, as part of *Speaking Outside*, Comox Valley Art Gallery, Courtenay, BC, July 22, 2016. Photo courtesy of Toby Lawrence.

institutional boundaries and the discrepancies of documented histories. In coming together at each site, the stories told and artists supported through Davies's and Delaronde's work speak to the cultural politics of settler/Indigenous and artist/audience dynamics as they uphold Indigenous epistemologies, creative collaboration, and audience accessibility in order to challenge the fixity of the archive and site histories.

NOTES

1 *Indian Candy*, Art Gallery of Greater Victoria, June 27 to September 7, 2014, curated by Toby Lawrence.

2 *Transporter*, Open Space, Victoria, BC, March 1 to April 6, 2013, and Modern Fuel, Kingston, ON, May 4 to June 13, 2013.

3 *Throw Down*, Art Gallery of Greater Victoria, January 28 to May 6, 2012, curated by Nicole Stanbridge.

4 Ogden Point was the busiest cruise ship port in Canada prior to the novel coronavirus (COVID-19) global pandemic.

5 Delaronde, email correspondence with author, June 8, 2021.

6 Davies, email correspondence with author, June 17 and 18, 2021.

7 I have presented this material in Courtenay, BC, in conjunction with the second screening and performance of *Speaking Outside* at the Comox Valley Art Gallery through the invitation of the gallery's curator, Angela Somerset; in Perth, Australia as part of a panel titled *Ruminations, Reconciliations, Remediations: Through a Canadian Looking Glass* organized by Ashok Mathur for the 2016 International Australian Studies Association conference, *Re-Imagining Australia: Encounter, Recognition, Responsibility*; in Tulsa, Oklahoma, at the 21st Biennial Native American Art Studies Association conference as part of the panel *Unsettled Territories: Art That Interrupts the Colonial Narrative* organized by Anya Montiel; and in Toronto, Ontario, for a Q&A panel with Steven Davies accompanying a screening of *Written In My Blood* for *(Re)claiming Space*, the 2018 Intersections | Cross-sections Graduate Conference and Art Exhibition co-hosted by York University and Ryerson University.

The Generative Hope of Indigenous Interactive Media: Ecological Knowledge and Indigenous Futurism

Michelle Stewart

> By observing snow paths and ice melting it's clear the warming is happening from beneath. The land and water are warmer. These are my thoughts.
> You could see these amazing glaciers, they were visible on mountains of surrounding communities. These massive glaciers that covered this land have disappeared. We live amongst these glaciers. We saw the effects of melting permafrost when it broke. Permafrost degradation, caused by climate change was the reason.
> — Zacharias Kunuk, *Inuit Knowledge and Climate Change*, 2010

From the opening of *Inuit Knowledge and Climate Change*, Inuit Elders give their accounts of climate change, while underscoring the power of experience and observation in assessing the world around them. In a largely traditional documentary format of talking head interviews, Kunuk elaborates an aesthetics of instruction, shifting between past and present tense, alternating between memories and observations of nature, and valorizing the insights of the speaking Elders as transmitters of ecological knowledge about the North. In the process, Kunuk stages a lively and compelling dialogue between local or traditional knowledge[1] and official or scientific knowledge of Inuit lands. Specifically, the Elders differ in their perspectives regarding the size of polar bear populations

and whether or not the earth has tilted on its axis. The testimony of the Elders is so consistent and persuasive that the film compels its audience to do more research regarding each issue. The artful filmmaking behind *Inuit Knowledge and Climate Change* underscores the relevance of local, ecological perspectives in general. The strengths of Kunuk's documentary style foreground Inuit ways of knowing the world. The film planted the seed that would grow into the animating questions of this chapter: Given the power of Kunuk's documentary style, which art forms might promote an even richer dialogue between Indigenous knowledge and larger conversations about our shared ecological futures? How might other, more interactive forms[2] of new media express Indigenous epistemologies for a wider audience, thus fostering intercultural dialogue?

In a special issue of *Cultural Anthropology*, William Lempert (2018) addresses Indigenous Futurism, considering both the future of Indigenous artmaking, and the genre of Indigenous Futurism: fiction, filmmaking, and new media that project Indigenous experience into the future (173). Lempert situates Indigenous knowledge across time to emphasize its dynamism, richness, and wisdom for human experience, now, then, and in a shared future. His work on Indigenous Futurism "engages the ways in which anthropological understandings of Indigenous media can be expanded and reimagined through a focus on futurity" (173). Lempert describes the groundbreaking digital and multimedia work of Indigenous artists such as Skawennati (Mohawk) and Jason Edward Lewis (Hawaiian, Samoan), creative and playful work that "disrupts historical authority" and counters historical mis- and under-representation (175). As Lempert sees it, in the hands of Indigenous futurist artists, new media forms participate in the sovereign act of imagination as powerful assertions of cultural and political agency (173).

In the same issue, Faye Ginsburg (2018) sees the power of Indigenous Futurism in its ability to generate an "ethics of possibility," what she considers to be creative thinking about the future that avoids instrumentalizing forms of governmentality that count and calculate "probability" in relation to human and natural life. Linking ethics, aesthetics, and political strategy, the ethics of possibility posed by Indigenous Futurism offers critique, imagines political alternatives, and "extend[s] the horizons of hope" (225). In what follows, I wish to highlight how ecological knowledge suffuses Indigenous Futurism, extending horizons of hope by connecting earthly fates and projecting past and contemporary Indigenous experiences into the future.

In its most direct form, an ecological approach to the world underscores the interdependence of humans and their environment, stressing ethical relations between humans, other forms of life, and the earth itself. Such an ethos resonates with many Indigenous beliefs and practices. At first flush, the pairing of ecological knowledge and interactive new media as a window onto Indigenous Futurism might seem incongruous, as the field of traditional or local ecological knowledge represents an academic exploration of the richness of other ways of knowing the world. The academic study of local ecological knowledge emerged in the encounter between Indigenous perspectives and scientific ones to facilitate the implementation of public policies. Anthropologist Julie Cruikshank (2001) fears that "codified in government reports, information formulated as TEK [traditional or local ecological knowledge] tends to reify and reinforce a Western dualism—prying nature from culture—that local narratives challenge in the first place. Sentient landscapes shift their shape once they are engulfed by these frameworks and transformed into 'land and resources'" (378). A second model, as Cruikshank describes it, pursues an "incorporation of indigenous perspectives into scientific ones" (378), something of a supplementation of scientific perspectives with reference to local knowledge. In either practice, Cruikshank notes the potential to decontextualize or instrumentalize local ecological knowledge. With *Inuit Knowledge and Climate Change*, however, director Zacharias Kunuk shows how creative audio-visual forms might challenge more instrumentalizing accounts of ecological knowledge.

In privileging the experiential knowledge of Inuit Elders and orienting the editing and aesthetics of the film to serve as observational evidence for their understanding of the changing climate in Inuit territory, Kunuk enacts an epistemological practice that Leanne Betasamosake Simpson (2014) names "land as pedagogy" (1). Across Simpson's writing, she models the power of storytelling as the basis for pedagogy and ways of knowing built upon exploration, self-determination, autonomy, experience, observation, kinship, collectivism and thus love. "Land as pedagogy" in this formulation expresses epistemologies and ecologies that describe and reinforce different interactions between humans, non-humans, and their environments. As Julie Cruikshank makes clear, the ecological practices emerging from Indigenous oral traditions are "referential and constitutive. They notice things and they create social relations and speak to the necessity

of human responsibility. … They "create a moral universe in which humans are embedded" (2001, 391). Thus among Tlingit, Athapascan, and Eyak speakers that Cruikshank chronicles, "we hear stories about the importance of human agency, human choice, human responsibility, and the consequences of human behaviour, and it is here that one of their contributions to climate change research may lie. Narratives underscore the social content of the world and the importance of taking personal and collective responsibility for changes in that world" (391).

Local, ecological knowledge decolonizes dominant ways of knowing, pointing to the often-invisible lines established between "insider" and "outsider" knowledge: epistemological, pedagogical, political, and social categories that delineate what gets counted as valid or invalid, credible or incredible, scientific or "folkloric." Likewise, interactive works of new media succeed in making Indigenous experience present to non-Indigenous majorities and in valorizing creative ways of knowing that have previously gone unrecognized. Further, works of Indigenous new media emphasize agency, presence, and connection via emerging interactive forms. Interactive media art, experimenting at the boundaries of form, presents Indigenous epistemologies as distinct without the necessity of relying on established genres. In so doing, it offers resources for avoiding the reification or romanticization of Indigenous cultures in relation to more easily recognized occidental genres.

In what follows, I hope to elucidate the ways in which Indigenous new media and Indigenous Futurism engage and reinvigorate interactive art by fashioning works based upon ecological knowledge. Indigenous Futurism marshals ecological knowledge to generate conversations across time, between generations, and grounded in ecological relations to place. As such, Indigenous Futurism counters and decolonizes the "allochronic" time—that remote, other, and often past time—to which Western anthropology has confined Indigenous peoples (Fabian 1983). Recent works of Indigenous Futurism use new media to address the spatial and temporal estrangement stemming from genocidal and assimilationist projects of settler colonialism that sought to wrest away lands and futures. It is this powerful marriage of decolonizing critique, creativity, and hope that has attracted attention to Indigenous Futurism in recent years.[3] Indigenous Futurisms set the task of bridging spatial and cultural distances while insisting on the temporal urgency of the ecological "bill" that is coming due for all

of us. In these pages, I highlight Indigenous new media art that brings Indigenous experience to the fore and connects cultural and ecological destinies, thus refusing the colonialist rhetoric that imagines Indigenous peoples as belonging to distant historical and geographical outposts. The bid for participation and meaningful engagement visible in online interactive art echoes the ethos of interdependence and ethical commitment that lies at the heart of ecological knowledge.

Creative works of Indigenous Futurism employ interactive modes of address that mobilize ecological knowledge to weave together ethics of possibility. The felt need to communicate contemporary Indigenous experiences becomes apparent in the aesthetic and epistemological practices of Indigenous new media artists, as they present oral histories and testimonial narratives, while privileging personal memories and the observations of Elders. Recent Indigenous online art offers at least three interactive modes of address that emerge from common practices of ecological knowledge transmission. These modes serve to engage non-Indigenous audiences in a shared reality narrated from Indigenous perspectives. These approaches—testimony (narration/chronicle), dialogue (reconciliation), and a prophetic mode (admonition or bellwether)—comprise aesthetic and political appeals to counter the effects of cultural distance, political neglect, and environmental racism. These works are futurist in their embrace of new technological forms for creating visual and narrative means of reterritorializing and reimagining ecological futures. They are ecological in their interpretation and enactment of "interactivity" at the heart of Indigenous new media art. They are also futurist in their creative production of hope as a salve for the intergenerational disruptions suffered by Indigenous peoples and as visionary and vanguard interventions into the dystopian trajectories of the present.

TESTIMONY AND ORAL HISTORY

One of the earliest works of Indigenous interactive art emerged from a partnership between Acadia University, the Government of Nunavut, Canadian Heritage, and several community groups in Nunavut. The name of the site, *Inuit Qaujimajatuqangit*[4] bespeaks its mission. Also called *IQ Adventure*, the site relies on interactivity and an Inuit love of games to convey Inuit Qaujimajatuqangit, which could be translated as "Inuit traditional knowledge," "Inuit traditional technology," or more literally, "that which has long been known by Inuit" (White 2006, 402).

In both English and Inuktitut, the objective of the game is to give the players the experience of and training to be "stewards of the land" and to familiarize them with Inuit art and the landscape of Nunavut, Inuit territory of the eastern Arctic of Canada. Elders share stories and players build "inukshuk," or Inuit stone markers, as they pursue the challenges offered by the game. The project presents a playful form of oral history and intercultural ways of knowing, and is composed of small educational games/challenges, videos recording Inuit knowledge, and 360-degree virtual reality (VR) photos of Nunavut. Beyond discovery, the interactivity offers users the chance to wander, explore, and engage—to be led by curiosity and reflection upon Inuit ways of knowing.

Interactive documentary lends itself to language revitalization and oral history projects, as searchable and explorable database forms, thus serving the dual functions of language preservation and dynamic pedagogy, as well as constituting a form of cultural outreach.[5] Interactive documentary also serves as a platform for testimony that quickly opens into dialogue. Like *Inuit Knowledge and Climate Change*, IQ is local and collaborative and meant to foster, via direct address, dialogue between southern and Inuit views (Figure 11.1).

DIALOGUE AND RECONCILIATION

In reconciliation processes, there is an important link between testimony and dialogue. Reconciliation must be understood as a multidirectional process, not merely the offering of apologies, nor the conferral of forgiveness. Testimony and histories must be told and heard. Experiences must be acknowledged with empathy and understanding, and dialogue must begin with the intention of meaningful institutional change. In the interactive modes of storytelling discussed above, we see what Kirmayer et al. (2012) call the ecology of storytelling—interactive modes of storytelling that foster cultural resilience in the face of trauma and precarity. Storytelling that supports cultural resilience "has a communal or collective dimension, maintained by the circulation of stories invested with cultural power and authority" (401).

Interactive forms mirror and transform modalities of healing and learning via storytelling, as well as by interaction—design that promotes learning via experience, kinship, and community. In this sense, interactive artworks draw on local ecological knowledge by "model[ling] ethical relationships," linking players/users, and implicating the body in

the performance and reception of stories (Hearne 2017, 6). These inter-active forms constitute an eclectic reimagining of cultural forms past and present, both of which are already in conversation with dominant forms.

For this reason, the essentialist tendency to make levelling analogies between the digital and the oral tradition conceals more than it illumin-ates. New media forms have contributed much to the revitalization of identity and language. But while there is cultural continuity across oral and digital forms, artists and activists consciously transform and engage technology with contemporary cultural and political goals in view. Art-ist and curator Jolene Rickard (Tuscarora Nation) eloquently expresses this dynamic in her description of *CyberPowWow* (1996), the pioneer-ing graphic chat room and website for Indigenous creation of the 1990s:[6] "Inside the flat pulsing electronic magenta tipis the artists are doing what people in our communities have always done. They are trans-forming our cultures into the language of the future. It does not mean that anybody is going to give up on going to an actual pow-wow, it just means that another pow-wow has joined the circuit" (2001, n.p.).

Never Alone / Kisima Iŋitchuŋa (Iñupiat Cook Inlet Tribal Coun-cil and E-Line Media, 2015), a social impact game, presents a playful example of how thoughtful interaction design can implement such an ecological model of knowledge transmission. *Never Alone / Kisima Ingitchuna* was developed in collaboration with Iñupiat people of northern Alaska. The game transforms the traditional Iñupiat tale "Kunuuksaayuka," into an interactive gaming experience that allows users to play as either Nuna, a young Iñupiat girl, or as an arctic fox. Players can play in single-player or cooperative mode in order to find the "source of the eternal blizzard which threatens the survival of every-thing they have ever known" (neveralonegame.com/game/).

Tribal council president Gloria O'Neil said the idea for the project was to create a game that would "connect with the younger generation, given high drug use and dropout rates in Alaska Native populations" and also speak to an audience beyond the community (Takahashi 2015, n.p.). Inuit and Iñupiat art suffuse the visual design of the game. The story draws on Iñupiat legend recounted by local Elders and includes a series of 40 videos accessible at different moments in the gameplay (and often aiding players to pass a challenge) (Takahashi 2015). An ethos of cooperation informed both the production methods (the partner-ship between E-Line, the Tribal Council, and Cook Inlet Elders) and

FIGURE 11.1 Nuna and Fox encounter the Owl Man in *Never Alone / Kisima Inŋitchuŋa*. Screen grab courtesy E-Line Media.

the gameplay design, underscoring Indigenous new media artist and scholar Jason Lewis's insight that "technology designers and developers design much more than mere functionality. Rather, they design the epistemological protocols through which culture operates" and "choose what counts as knowledge" (2014, 61). Media studies professor Joshua Miner (2017) views these protocols "as a call to imagine new ways of computing—enacting, not just representing—Indigenous ecological ethics" (para. 1). In describing *Never Alone* and other games, Miner points out, "developers utilize critical games' ability to pose alternative values, seeking to reorient players' relationship to diegetic environments" (para. 1). Such games "express critique through gamic action by which players learn protocols for behaviour. These games posit ethical conflicts that disrupt settler society's instrumentalization of environment" (para. 2). Like other social impact games, *Never Alone* is both informative and entertaining, functioning as a "catalyst" for "reimagining" local contexts and power structures (Fisher 2016, 43).

In this subarctic landscape, both the storytelling and the experimental practice called forth by the interactive protocols contribute to the transmission of knowledge. *Never Alone* models the ways in which "storytelling is fundamental to orienting oneself in a landscape, to

upholding codes of morality, and to soothing or smoothing over community discord or ills" (Wachowich 2010, 15).[7] Nancy Wachowich's (2010) work on Inuit new media stresses the importance of the body in learning and how material practices (protocols of behaviour offline) are linked by game protocols to epistemological protocols, transforming the "rhythmic practice of [skills] into play with the transmission of less material knowledge, mythic tales that confer identity and impart knowledge. ... The Inupiat and Yupiit technologies of the body are forged through rhythmic practice of land-skills, the products of which are both material (meat and baskets) and immaterial (social cohesion, healing, individual, and community wellbeing)" (Wachowich 2010, 16).

These are, as Wachowich (2010) observes, "adaptive strategies." To mirror these strategies, games that strive to enact ecological knowledge-practice condition behaviours via interactive play. In this sense, these interactive forms move beyond standard documentary witnessing as the sole mode for ethical engagement, instead modelling ethical engagements "through narrative practice" whenever possible.[8] The stories often turn attention to strengths, resources, strategies, and positive outcomes. The space for collective engagement and transmission of stories offered by interactive forms, then, promotes such "narrative resilience" (Kirmayer et al. 2012, 401). Trial and error via multiple experiences of *Never Alone* links stories to the body, teaching the player how to elicit more aural information, and promoting a kind of ethical engagement via the attention players must pay to the 40 videos contributed by Iñupiat Elders. These modes of learning recall Leanne Betasamosake Simpson's (2014) discussion of land as pedagogy and the transmission of Indigenous ecological knowledge via active practice, love, and kinship within and ultimately between communities, a cultural practice that Simpson elsewhere describes as a "decolonial ethics of love" (Nixon 2016).

Given the ways in which augmented and virtual reality experiences situate storytelling in 3-D spaces and draw upon bodily practice, they activate ethical modes of knowledge transmission in dynamic engagement with material spaces. In so doing, augmented reality (AR) works demonstrate what interactive forms might offer to processes of cultural reconciliation and historical redress. For example, in the creation of the mobile application *Wikiupedia*, Adrian Duke was attracted to AR as a means of channelling play and experience in real time/space

in order to facilitate learning: "*Wikiupedia* is a location-based mobile application for smart phones and other hand-held digital devices. Youth reach out to Indigenous Elders, Traditional Knowledge Holders and content experts to 'Catch Stories' to be published on this, first of its kind, Indigenous Knowledge Network".[9] The name draws on the Proto-Algonquian word for wigwam, "wakeup," and Duke notes that "wiki" might also be taken as a reference to the Hawaiian ('Ōlelo Hawai'i) word for "quick" (Bambury 2017).

Via GPS, *Wikiupedia* permits traditional knowledge holders to anchor stories and Indigenous experiences of space to specific places. The urban landscape is seeded with Indigenous testimony. To Duke's mind, AR has the advantage of imprinting spaces with histories, so that even after the AR stories have been told, the stories will remain attached to the user's experience of those places. *Wikiupedia* reinvests contemporary spaces with Indigenous knowledge, or as David Gaertner eloquently puts it, "We're not being asked to step through the frame and into the art, we're being asked to experience the land around us in different ways" (qtd. in Devlin 2017, n.p.).

Duke also built opportunities for mentorship into the project, conceiving of *Wikiupedia* as a process that might engage youth at each level of production, from programming to providing content to enjoying the experience. Equally important, the project folds in the expertise of Elders, whom he calls "authenticators" of cultural knowledge. At the same time, Duke lets the multiplicity of experiences shine through by attaching diverse versions of stories to various place markers and trails. Through these interactions, Duke also sees AR as contributing to forms of narrative resilience and the potential for storytelling to promote reconciliation through art and dialogue between generations (Devlin 2017, n.p.). The utility of interactive forms for invigorating cultural forms underwrites Indigenous digital arts workshops such as Indigenous Routes (Susan Blight, Meagan Byrne, Ben Donoghue, and Archer Pechawis) and Skins Workshops on Aboriginal Storytelling and Video Game Design (Jason Lewis and Skawennati). Both projects teach Indigenous youth to produce their own interactive media from interactive documentaries and websites to video games.[10]

Anishinaabe/Métis artist Elizabeth LaPensée's work suggests that interactive games afford opportunities for deepening guided cultural

instruction. Pensée began writing for PocketWatch Games' SIM-type game set in the arctic ecosystem. With visual art and music drawn from Inuit aesthetics, *Venture Arctic* (2007), as PocketWatch bills it, "challenges the player to act as Mother Nature, with both terrible and beautiful powers. Use the powers of the sun and fertility to grow food for herds of caribou and pods of whales, and then use the force of the wind and cold to collect the spirits of the deceased so that your polar bears and wolverines can live to see another Summer" (PocketWatch 2007).

Following *Venture Arctic*, LaPensée soon began writing, designing, and programming her own social impact games to preserve First Nations cultural heritage via storytelling and play. Games such as *Survivance* (2011) and *Honour Water* (2016) (Figure 11.2) promote healing and cultural revitalization via storytelling. In this regard, LaPensée also draws on Vizenor's notion of survivance to underscore the ways in which contemporary creative Indigenous art forms support Indigenous communities in "thriving rather than merely surviving" (2016a, 180). Citing Vizenor, LaPensée emphasizes that "games, which are made of varying levels of code, design, art, and audio, can provide spaces for expressing self-determination so long as, within the context of Indigenous art, they stand 'against colonial erasure ... [and mark] the space of a returned and enduring presence'" (180). *Survivance* encourages self-determination in the form of quests that stretch over multiple sessions of gameplay and even beyond the limits of the game universe. To this end, LaPensée incorporates "acts of survivance" into the game, building in tasks and structures that allow users to bring insights back to other game players and, following completion of the quests, guide users to create works of reflection offline in order to promote "recovery of knowledge, community, and self" (180).

Honour Water also enacts an aesthetics of survivance, by inspiring users to learn songs about water in Anishinaabemowin after listening to versions recorded by Sharon Day, the Oshkii Giizhik Singers, and Elders at the Oshkii Giizhik. Pedagogical and archival, *Honour Water* draws internauts[11] into a project at once archival and pedagogical, while they enjoy the interactive graphics designed by LaPensée. *Survivance* and *Honour Water* each participate in dynamic and enjoyable forms of preservation of cultural heritage. LaPensée uses the game format explicitly to promote active transmission and learning. Of course, production

FIGURE 11.2 *Honour Water*, homepage (Elisabeth LaPensée 2016). Screen grab courtesy Elisabeth LaPensée.

style also matters to LaPensée. As such, she works with affordable or no-cost software and incorporates a DIY ethos into her pedagogical philosophy (LaPensée 2016b).

Following these projects, LaPensée experimented with a more inter-active documentary format, *Thunderbird Strike* (2017), "a 2-D scroller" named after the Thunderbird, a mythic being that appears across sev-eral Indigenous North American cultures. In Ojibwe stories, "Animkiig ('Thunderbirds') are among the most powerful spiritual beings in Anishinaabe ('Ojibwe) cosmology. They maintain a special, protective relationship to Anishinaabeg (the Anishinaabe people). Although they are invisible forces, Animkiig reveal themselves through stories" (Powell 2011). In *Thunderbird Strike*, LaPensée mobilizes the Thunderbird as a unifying character meant to prompt reflection regarding environmental issues from the pollution of the Great Lakes to the tolerance of toxins in local communities, to the ecological impact of exploiting the tar sands. Each place includes a short, animated film and a list of reflection ques-tions regarding potential ecological actions in local settings. The still and moving drawings liken the snake to pipelines and our propensity

for environmental destruction, recalling prophecies and forewarning catastrophe, but suggesting the possibility of resistance:

> There would be a generation when there would come to be a snake that would threaten to swallow us whole, a snake with a hunger which could never be satisfied, brought forth from under Grandfather Rocks by the grabbing hands of another people.
>
> The women, they would hold the ground, and with their songs and good intentions would care for the waters just as the waters care for us, bringing forth a gathering of those who walk as lightning. (LaPensée 2017)

LaPensée seeks to inspire young users to adopt the mission of the Thunderbird in reflecting upon how they might protect their own communities from environmental threats. With each project, new media draws upon and revitalizes ecological histories and knowledge in the service of collective futures.

Across LaPensée's work, we see an attention to the importance of storytelling and active learning via play for cultural resilience and ecological awareness. We also begin to see the contours of Indigenous Futurism—speculative fiction and interactive art forms that, as LaPensée defines them, "[recognize] space-time as simultaneously past, present, and future, and therefore futurism is as much about the future as it is about right now. In my work, it means telling alternate histories, dreaming about liquid technology, imagining a future where unceded territories are taken back, and, ya know, space canoes" (LaPensée 2017, n.p.).

LaPensée's artistic creation gives priority to "blood memory and of course medicinal plant knowledge, among other science" (Roanhorse 2017, para. 10). For LaPensée, these priorities constitute an effort to promote Grace Dillon's notion of "Indigenous scientific literacies, meaning the way in which science is shared through storytelling and art" (qtd. in Roanhorse 2017, para. 10). As LaPensée describes her work, "Teachings are infused in Anishinaabemowin because phrases are relational and descriptive" (LaPensée, qtd. in Roanhorse 2017, para. 10). Such work relocates modernity both spatially and temporally and LaPensée's ecological, interactive mode of storytelling, specifically, tackles "modernity's most destructive forces" (Guzman 2015, para. 4).

Following testimony and dialogue (reconciliation), it is here that we see the third interactive mode of Indigenous storytelling emerge: admonition/prophecy. This prophetic mode engages in dialogues between the past, present, and future, dialogues that are meant to instruct all of us to nurture ecological practices before it is too late (or even if it is indeed already too late, how to survive, with the wisdom of cultural resilience encoded in past stories from First Nations cultures among others). Indigenous Futurism often employs this mode. It is not just about liberating Indigenous peoples from that allochronic time of the other—some bygone era—but envisioning a different reality by acknowledging the past to heal the ongoing legacy of colonial violence. Such a process entails rewriting futures against the scars of colonial dispossession and contemporary environmental crisis (Wikler 2016). As Lindsay Nixon acutely states: "Speculative visualities are used to project Indigenous life into the future imaginary, subverting the death imaginary ascribed to Indigenous bodies within settler colonial discourse" (2016, para. 2).

INDIGENOUS FUTURISM: PROPHECY

Virtual reality affords embodied protocols for learning and for speculative thought, or as filmmaker Loretta Todd notes, for "interrupting colonial ontologies" (qtd. in King 2016). Speculative fiction opens spaces of imagination, asking how technology might nurture tradition. Moreover, speculative fiction also explores how tradition has perhaps prefigured technological futures. In Indigenous speculative fiction, space becomes an imagined zone of repossession—cultural, linguistic, and environmental. Channelling "visionary fiction" writer Ursula Le Guin, Walidah Imarisha opines, "We can't build something we can't imagine" (2017).

In this vein, imagineNATIVE's artistic director Jason Ryle proposed 2167, an experimental VR workshop in response to Canada's 150th anniversary. Ryle created the workshop to give space to First Nations media artists to imagine Canada 150 years in the future from an Indigenous perspective. For 2167, Anishinaabe new media artist Scott Benesiinaabandan produced *Blueberry Pie Under a Martian Sky*, which transforms the Anishinaabe origin legend of the Spider Woman, who "wove a long thread along which the Anishinaabe people travelled to Earth."[12] Seeing the spider web as a metaphor for a wormhole, Benesiinaabandan

wanted to draw on Anishinaabemowin words for contemporary notions such as blueberry pie (pie being a recent technology), as well as wormholes and event horizons—to examine the ways in which language maps the boundaries of the possible. The VR experience leads the user through a colourful and abstract wormhole knit geometrically from a spider web with a teapot floating in the middle (see Figures 12.3 and 12.4 in Chapter 12). On the journey, we hear stories and interviews with "elders from Manitoulin Island and Manitoba to consider how to build new words that might exist 150 years from now" (McGinn 2017). Benesiinaabandan designed the experience so that we might hear these Anishinaabe "words from the future." The viewer is immersed in spoken Anishinaabemowin in order to feel how "language is encoded in our histories [and] in how we see the world" (Benesiinaabandan, qtd. in McGinn 2017).

For Benesiinaabandan, *Blueberry* was really a test, an artistic experiment to allow him to get to know VR and to make art depicting time as spatial, not linear. These are concepts of time Benesiinaabandan hears in Anishinaabe stories: "That time, rather than being like an arrow or a river, is actually more like a blanket: it can fold, and two points can even touch, connecting two points in time via wormholes" (Benesiinaabandan 2016b). The very spatiality of VR held great appeal for him, because Benesiinaabandan has always felt limited by the photographic frame. As with the mise-en-scène of his installation work, Benesiinaabandan sees VR as fully spatial and offering forms of interaction with objects and story that provoke psycho-geographic experiences and critical reflection. As Benesiinaabandan describes these aims, VR contributes a new means to explore the "continuing development and creation of a deeper personal cosmology. The impact of relationships and familial/communal ties, non-conventional ways of knowing (i.e. dreaming, intuition, blood memory), underlying threats and danger inherent in searching for truth and how these impacts radiate out into wider communities."[13] The effect of this short experimental VR is a kind of repossession of the future, thinking of space as a final frontier, not of conquest, but of the rediscovery of Indigenous science and thought.

Mi'kmaw director Jeff Barnaby was also one of the original participants in the TIFF/imagineNATIVE 2167 workshop. With the backing of the NFB, Barnaby's 2167 project became the prototype for *Westwind*. The work is described as "a VR experience of being a refugee on Dec 24,

2167. Global warming has turned most of the planet into a desert. State surveillance is constant. An expert smuggler Sora is hired by 2 sisters, Conner and Pris, to get them into one of the walled cities reserved for the affluent" (NFB press release 2017).

Barnaby purportedly wasn't entirely at home in the VR process, having previously worked in the more hands-on style of an independent film director. On the film set, an independent film director controls the visual look, working directly with the camera and the actors. Barnaby considers editing to be his principal narrative tool, but VR production meant organizing the narrative quite differently, without the use of cuts. Most significantly, VR required him to rethink how one might manipulate point of view (POV), a crucial film tool for advancing narrative in film, but a wholly different experience in VR.

The relationship between the game designers who were tasked with programming and designing the virtual environments and the Indigenous directors in the TIFF/imagineNATIVE initiative was also complicated by a clash of different cultural perspectives: gamer/filmmaking and First Nations/non-First Nations. Several of the directors expressed frustration that the VR designers spoke a different visual language and were perhaps not quite as open as they ought to have been to the artistic visions of the workshop participants. Indeed, between the different ways of approaching art and storytelling, the contours of significant epistemological differences come into view.

Barnaby's vision for *Westwind* draws from the aesthetics of prophecy:

> "Lpa gaqi'sg tegs'g ula tet," in Mi'gMaq that translates "the wind often blows from the west," an expression that means we can see change coming. Canada has been a country for 150 years, and the human learning curve has spun circles enough to see patterns so as to not make the same mistake twice. There's an incredible meta statement being made about using advanced technology to create a virtual reality of an environmental and spiritual wasteland 150 years into the future and not having the wherewithal to stop the prophecy. Tegs'g is a warning, do not let the next 150 years be the repeat [of] themselves going forward, take off the helmet, and change things from now till then. (*Westwind* Press Release 2017)

To date, only the first two scenes of the *Westwind* script have been produced as a prototype for a larger project. The VR experience opens

outside the walls of a protected city. Sora is smuggling two people in. The user occupies the perspective of a flying craft—a moving, machinic POV that moves toward the walled city through an imposing latticework of structures. Out the front window of the craft, the user can consult arrays of screens emerging in front of the craft. The "ownership" of the POV remains purposefully concealed, though our view is aligned with the occupant of the craft, who is reading the screens within the screen. It is only as we arrive at the platform when Sora looks at us and shoots that we realize that our POV was aligned with that of a drone that she hopes to shoot out of the sky. In this critical, dystopic prophecy, we risk standing on the wrong side of history.

Barnaby's plans for *Westwind* resonate with Lindsay Nixon's description of Indigenous Futurisms and their goals:

> The future imaginary and its catalogue of science fictive imageries afford Indigenous artists a creative space to respond to the dystopian now, grounding their cultural resurgence in contextual and relational practices. We have realized the apocalypse now, and we are living in a dystopian settler-occupied oligarchy fuelled by resource extraction and environmental contamination, completely alternative to our traditional ways of being and knowing. (2016, para. 3)

Anishinaabe director, producer, and writer Lisa Jackson began experimenting with 360-degree video with her documentary project *Highway of Tears* (2016). Jackson was attracted to the sense of presence offered by 360-degree technology. As she explains, "I've always given a lot of attention to the spaces I create in my work. I want them to be specific and have a certain feeling. Also, I've been moving towards bringing a sense of the physical and concrete to my films and they can be quite visceral" (Jackson, qtd. in Astle 2018). *Highway of Tears* aimed to create a powerful documentary built around the direct address of Mathilda Wilson, mother of a young Indigenous woman, Ramona Wilson (Gitxsan), who went missing from Highway 16 in 1994. Jackson makes Wilson's story the emotional centre of the film, seeking justice for the many young women who have disappeared from this highway without explanation or sufficient attention from the public authorities. The personal experience of Wilson and the fate of her daughter are honoured by the filmmaking of Jackson, while also evoking the structural

problems that have led to an epidemic of missing and murdered Indigenous women and girls. In interviews, Jackson makes clear that "the problem isn't that these Indigenous communities are in the middle of nowhere—they're actually in the middle of their territory" (qtd. in Berman 2017). Jackson's 360-degree photography brings home this point, as the intimate storytelling of Mathilda Wilson is intercut with beautiful aerial landscape shots of lush forest on the stretch of Highway 16 near Smithers, BC, where Ramona Wilson was last seen.

With her first fully virtual reality work, *Biidaaban: First Light* (2018, Figure 11.3), Jackson builds upon the intimacy and presence of *Highway* to lead viewers through an alternative version of the future. As Jackson elaborates in her own words,

> *Biidaaban: First Light* is an extension of those concerns, and also adds in a new piece, which is my desire to give the viewer more agency in experiencing the work—making them meet it halfway in a sense, rather than passively receive it. Physically being able to move around in such a hyper-real environment is thrilling and puts us in the driver's seat. It really feels like you've visited this future Toronto, rather than having "watched" something. We even see people reach out to touch elements of the world, so complete is their immersion. (qtd. in Astle 2018)

VR, in Jackson's hands, is an aesthetic and ethical resource offering agency and connection. *Biidaaban*, produced with the NFB, is a unique VR experience, neither pressed, nor visually busy, nor goal-oriented. Her VR style encourages modes of interaction considerably different from those with more narrative or game aesthetics. Rather, Jackson engages the aesthetic possibilities of VR to encourage viewers to situate Indigenous experience in contemporary time and space and to see territory differently.

Originally imagined as part of a multimedia installation (Astle 2018), *Biidaaban* is an approximately eight-minute voyage situated in the imagined future of Nathan Phillips Square, Toronto, and, originally, available for the public to experience in that very spot.[14] *Biidaaban* opens against the backdrop of a deserted, future Toronto cityscape. The scene soon fades to black, shifting the viewer's sensory focus to the aural landscape. A question frames our experience of the VR, as a question

FIGURE 11.3 *Biidaaban: First Light*, Lisa Jackson (2018). Courtesy Robert McLaughlin.

scrolls across our field of vision, first in Wendat, then English: "Where did the creator put your people?" This question, projected into a future vision of Canada, seems to ominously invert the affirmative language of the "Declaration of First Nations":

> We the Original Peoples of this land know the Creator put us here.
>
> The Creator gave us laws that govern all our relationships to live in harmony with nature and mankind.
>
> The Laws of the Creator defined our rights and responsibilities.
>
> The Creator gave us our spiritual beliefs, our languages, our culture, and a place on Mother Earth which provided us with all our needs.
>
> We have maintained our Freedom, our Languages, and our Traditions from time immemorial.
>
> We continue to exercise the rights and fulfill the responsibilities and obligations given to us by the Creator for the land upon which we were placed.

The Creator has given us the right to govern ourselves and the right
to self-determination.

The rights and responsibilities given to us by the Creator cannot
be altered or taken away by any other Nation. (Assembly of First
Nations 2015)

The weaving of time, space, and Indigenous languages will carry this
opening question through the three major scenes of the virtual real-
ity experience. The viewer first enters an abandoned subway station,
Osgoode station (Figure 11.4), with few signs of human life: a map of
the network, a discarded *Toronto Star* reading, "Ford blasts OPP dep-
uty over complaint," a chair, a canoe and paddle, bags of sand or grain.
From there, the viewer will proceed to a rooftop and then gaze into the
night sky.

While the visual landscape of *Biidaaban* suggests little human pres-
ence beyond the viewer's own corporal experience, urban landmarks
connect contemporary denizens of Toronto into familiar (though
temporally defamiliarized) sites seemingly empty and quiet by urban
standards, but suffused with visual and aural cues of Indigenous pres-
ence. As Jackson states, among the aesthetic strengths of virtual reality
for this project was its ability to highlight that "the Indigenous roots of
this place continue even here, in the city centre" (qtd. in Everett-Green
2018). The Toronto of *Biidaaban* evokes that continuous Indigenous
presence with Indigenous objects, text, and narration.

The VR user navigates out of the station, leaving the sounds of drip-
ping water to follow the signs to the street. Everywhere, vegetation
pushes through the cracks in the cement. The continuity of life in this
transformed city becomes apparent: a woman digs in the earth, the
first human we have seen. But natural life is most vivid in the form of
an immersive soundscape, a rich tapestry of birds, insects, and frogs.
Emerging on a rooftop, the viewer can scan the city. Many critics
interpreted the image of nature reclaiming the city in *Biidaaban* as a
post-apocalyptic vision of Toronto (Figure 11.5). Designed by 3D artist
Matthew Borrett and modelled after his *Hypnagogic City* series (2017)
(Everett-Green 2018), Borrett himself sees the return of nature to the
"bland" urban environment as giving it "beauty, maybe even dignity"
(qtd. in Cheng 2017). Borrett's view of the ascendancy of nature in the

FIGURE 11.4 The first scene, *Biidaaban: First Light*, Lisa Jackson (2018). Courtesy Robert McLaughlin.

city echoes Jackson's, who also refuses the interpretation of the work as "post-apocalyptic." In her hands, VR art serves specifically as a means of countering allochronic time and timeworn stereotypes. As Jackson eloquently explains:

> My work requires a certain amount of ingenuity to escape mainstream stereotypes about indigeneity. One of the most prevalent ones is that anything native has and can only exist in the past. Of course, Indigenous cultures continue and have no trouble co-existing with hip-hop, cortados and pop culture. Indigenous Futurism is a way to step past those stereotypes to something more thoughtful and sophisticated where we imagine our cultures and thought systems in the future. For example, lately I'm hearing a lot of discussion around the nature of time itself as a linear construct and how indigenous concepts of time are circular and what that means.
>
> It's about building a world that can show us something fresh and shake us out of our inability to envision a future different from where we are without calling it "post-apocalyptic." Because if you take a different perspective, the apocalypse has already happened. (qtd. in Astle 2018)

Within this vision of the potential of VR to trouble inherited views and shift perspectives, Jackson's definition of Indigenous Futurism takes form: "It's about taking these ideas that everyone thinks are stuck in the past, and projecting them into an imagined future. This is an Indigenous city as well. It's not just the small reserves and remote places that are Indigenous" (qtd. in Ngabo 2018). The peaceful, overgrown ruins of Toronto in *Biidaaban* depict the continuity of Indigenous presence in Toronto and Canada, from past to present, and VR allows Jackson to dislodge that temporally fixing, allochronic gaze that relegates Indigenous perspectives and cultures to a pre-technological past: "VR offers a way of projecting Indigenous values into an imaginary future that feels physical and real, and of getting through this intractable sense that we're relegated to a past that is dying" (qtd. in Everett-Green 2018).

The grown-over city of *Biidaaban* de-emphasizes human presence, a creative undoing of the *anthro* in the Anthropocene. Instead, human presence in *Biidaaban* re-emerges via the soundscape of Indigenous languages, offering prayers of thanksgiving. Language carries this future vision of human survival and flourishing Indigenous cultures. "Biidaaban" is the Anishinaabemowin word for "the first light before dawn" (Astle 2018), representing a moment of transition and, as Jackson notes, one of hope, "that feeling of that very first light and the sense that anything's possible" (qtd. in Johnson 2018). Language makes the vital link between past, present, and future in *Biidaaban*. Wendat, Kanien'kehá (Mohawk), and Anishinaabe (Ojibwe) suffuse the soundscape with the aural presence of language and culture as intergenerational forces of agency and renewal. Indeed, language reinforces the agency that Jackson feels VR can offer, as the viewer can only move forward through space of the VR by focusing on the text.

In several interviews, Jackson speaks of the excitement of hearing the text brought to life by Wendat, Anishinaabemowin, and Kaneyn'keha speakers: "Hearing the languages is very moving for many who experience the piece and knowing that young indigenous people can listen to their languages spoken in a future world like this is very exciting. I can't wait for it to travel to communities" (qtd. in Astle 2018). The words, as both language and heritage, connect past and future, winding with the vines through the edifices of modernity (the modern metropolis, now quasi-defunct, or repurposed by ecological reimagining of a moment we imagine to follow extractive capitalism).

FIGURE 11.5 Night scene, *Biidaaban: First Light*, Lisa Jackson (2018). Courtesy Robert McLaughlin.

Much like Scott Benesiinaabandan, Jackson also sees Indigenous languages as animating different experiences of the world, of time, and of being. In this sense, VR serves ecological knowledge well, situating viewers between different cosmologies, with Indigenous languages offering "a window on a different way of being in the world, different experiences of time and relationships" (Jackson, qtd. in Everett-Green 2018). Among the texts inviting VR users to understand time and territory by listening to Indigenous languages are the Haudenosaunee Thanksgiving Address (adapted by Jeremy Green and spoken by Kawennakon Bonnie Whitlow, Tehanenhrakhas Green, and Tehahenteh) and Margaret Ann Noodin's poem "Nayendamowin Mitigwaaking" (recited in Anishinaabemowin by Gabe Desrosiers). As literary scholar, Shanae Aurora Martinez avers, "To read Noodin's collection of poems is to tread carefully within a firmly positioned Anishinaabe world that includes all relations, cosmic and earthly, human and nonhuman. This intricately connected world is epitomized in 'Nayendamowin Mitigwaaking/Woodland Liberty' by the 'I' narrating the poem as they journey into the woods for the gift of sustenance brought by reconnecting to one's relations" (2017, 125). The texts, visible and audible against a backdrop of the cosmos at night, are alive, materializing and flying away like fireflies (Figure 11.5). The VR experience of

Biidaaban is largely aural, but in merging the poems and prayers with the natural landscape, Jackson emphasizes, "These languages grow on this land in the same way that plants do. The languages have been spoken here for thousands of years; they capture this land more than any other languages" (qtd. in Johnson 2018).

The VR aesthetic suggests the continuity of Indigenous presence in Tkaronto, while leading the viewer through experiential pedagogy and quiet contemplation of interconnectedness. Far from the dark dystopias imagined by post-apocalyptic science fiction, this virtual reality connects territory and language across time. The final credits bear this out:

> *Biidaaban: First Light* was created in Toronto, on the traditional territories of the Wendat, the Anishinaabeg, Haudenosaunee, Métis and the Mississaugas of the New Credit First Nation, as well as in Vancouver on the unceded territory of the Coast Salish peoples, including the territories of the X̱,ma9kwayam (Musqueami), Skwxwu7mesh (Squamish), Sto:io and the Salitwato?/Seliiwituth Taleil-Woututhi Nations. (*Biidaaban: First Light* 2018)

In the spirit of both dialogue and prophecy, *Biidaaban* artistically confirms Indigenous presence in this space. But the production team also hoped that *Biidaaban* would create the occasion for positive change, establishing the screenings as "part of an initiative to increase Indigenous presence in the city" (Ngabo 2018).

CONCLUSIONS

In Benesiinaabandan's, Barnaby's, and Jackson's work, as well as the other interactive modes of storytelling discussed above, kinship and language are often positioned as technologies of resurgence. Speculative VR adds another dimension, the possibility of reconfiguring national spaces in dialogue with Indigenous ecologies (LaPensée 2016a, 180). For example, Danis Goulet's entry for 2167 folds these two dimensions together in *The Hunt* (2017), a VR experience set in "postwar North America in 2167 that lies in ruin, where the law is enforced by a fleet of automated orbs that patrol the skies. When an orb interferes with a man and his son on a goose hunt on sovereign Mohawk territory, it forces an altercation."

Kinship lies at the heart of cultural resilience and resistance in *The Hunt*, as the Mohawk family defends its territory, overrun by surveillance

drones. In allying the user's POV with that of the Mohawk family, Goulet decentres sovereignty and imagines kinship built on the recognition of shared ecological and democratic fates. Indeed, for Goulet, creating kinship amid catastrophe will be essential to surviving the excesses and errors of the Anthropocene. As she points out, "Canada 150 is problematic, to say the least. But 2167 reminds us that the only way to solve problems is to do so together. ... The thing about imagining a future is that I think it's going to take creativity for us to dream and imagine and then make real the futures that we want to see happen. ... These questions of how we move forward are not just for Indigenous people. They are for all Canadians to grapple with" (qtd. in McGinn 2017).

As communicative forms, games and interactive media art work as open-ended stories and summon participation in Indigeneity in ways defined by the artists. As such, games strive to both define Indigeneity while insisting upon the relevance of Indigenous perspectives to mainstream culture. As William Lempert (2015) points out in his discussion of Indigenous Science Fiction, these works "help reimagine the assumptions that inform the social and policy treatment of contemporary Indigenous peoples," drawing in users via curiosity and epistemophilia, but also demanding more meaningful forms of interaction in the process. Part of the essential work of interactivity is to enact a sensorial experience of interconnection and interdependence. The force of this ecological approach comes into focus in interactive works of Indigenous Futurism. The genre of science fiction—in both its utopian and dystopian strains—pushes spatial, temporal, and bodily frontiers, pressuring political and personal notions of autonomy. Works of Indigenous Futurism reject the ever-expanding, genocidal frontier of manifest destiny, while vigorously defending Indigenous sovereignty.

One could argue that Indigenous works of speculative, futurist art aim to redefine the terms of belonging and interdependence without sacrificing the right to self-determination, a complicated dance that plays on the margins and the binaries (frontier/interior; insider/outsider; citizen/alien; recognized/unrecognized) that undergird settler colonialism, while squarely rejecting them. William Lempert (2018) calls attention to the relationship between Indigenous Speculative Fiction and the resurgence of Indigenous activism (178). In the same spirit, Faye Ginsburg (2018) reminds us that Indigenous media artists produce works of "generative hope" that rely extensively on intergenerational work and

deep collaborations (228–31). The sovereign work of the imagination is fundamental in bringing this interdependence into focus. Indigenous Futurism and interactive new media art support a transformative vision by bringing non-Indigenous audiences into contact with contemporary Indigenous experience in creative ways, and emphasizing the value of Indigenous cultures for our shared fate. In marshalling the interactive and spatial possibilities of new media, First Nations, Inuit, and Métis media artists draw upon the strengths of situated, experience-based pedagogies, featuring local Indigenous knowledge as a mode of ethical knowing and as a pathway toward cultural reconciliation and concerted ecological intervention. These works promote deeper modes of inter-activity that enact virtual kinship as an ethical response to the predations of what Povinelli (2017) has called toxic sovereignties.

NOTES

1 Anthropologist Marie Roué (2012) makes a compelling argument for the use of "local" over "traditional" ecological knowledge, as a way to avoid the baggage that comes with the dismissal of positioning Indigenous traditions as premodern, folkloric, or superstitious. In short, she argues that the term "local knowledges" casts off the implication that such forms of knowing are inferior to Western, modern epistemological modalities built upon science and technology. As she says, "Local Knowledge allows us to talk about knowledge anchored in a tradition. This term also encompasses the know-ledge gained by peasants, sailors, and other local people who possess a body of knowledge about their natural environment, even those who might not otherwise be considered indigenous"(4).

2 New media artists who incorporate some manner of interactivity in their online art generally seek forms of meaningful engagement and partici-pation from the user. The quality of that interaction, in other words the extent to which the user can engage with and affect content, varies greatly between works. Sandra Gaudenzi's PhD thesis (2013) offers a description of interactive documentary categories and names the different types of interactivity afforded by online works, from online exchanges between users ("conversational mode"), to online worlds allowing for somewhat preprogrammed exploration ("the hitchhiking mode"), to works allowing users to both explore and alter some content ("the participatory mode"), to works offering more sensory and embodied engagement ("the experiential

mode") with the goal of moving the user emotionally and intellectually (Gaudenzi 2013, passim).

3 Cf. W. Lempert, "Indigenous Media Futures: An Introduction." *Cultural Anthropology* 33, no. 2 (2018): 173–79.

4 *IQ Adventure* is over a decade old and has followed the fate of many interactive forms: the embedded elements no longer work (http://www.inuitq.ca/).

5 The interactive site playfully transmits Inuit societal values, as outlined by the government of Nunavut's cultural heritage webpage:

- Inuuqatigiitsiarniq: Respecting others, relationships and caring for people.
- Tunnganarniq: Fostering good spirits by being open, welcoming and inclusive.
- Pijitsirniq: Serving and providing for family and/or community.
- Aajiiqatigiinniq: Decision making through discussion and consensus.
- Pilimmaksarniq/Pijariuqsarniq: Development of skills through observation, mentoring, practice, and effort.
- Piliriqatigiinniq/Ikajuqtigiinniq: Working together for a common cause.
- Qanuqtuurniq: Being innovative and resourceful.
- Avatittinnik Kamatsiarniq: Respect and care for the land, animals and the environment.

(https://www.gov.nu.ca/information/inuit-societal-values)

6 And discussed at length in chapter 12, pp. 334–36, of this volume.

7 "Stories can stimulate meaningful connections between the present and the past, or spark exchange between local, global, and scientific communities. For the Inuit, words are tools that act upon the world; in this fashion, they can be as efficient as sakkuit ('harpoon heads')" (Wachowich 2010, 15).

8 Kate Nash (2017) notes the ways in which such VR complicates witnessing, leading to improper distance that stands potentially to overwhelm the subject, and leaves little space for ethical reflection and action. Instead, here I suggest that ecological modes of interactivity move away from witnessing to other forms of engagement.

9 From the WikiupAR reference guide.

10 To enjoy the works, visit Indigenous Routes (http://www.indigenousroutes .ca/) and Aboriginal Territories in Cyberspaces's Skins Workshops, part of AbTeC's Initiatives for Indigenous Futures (http://abtec.org/iif/workshops/).

11　"Internaut" is a neologism that has more currency in French. It strikes the author as preferable to the terms "user" or "user-spectator," as online interactive works interpellate participants as users, spectators, and explorers.

12　http://abtec.org/iif/residencies/scott-benesiinaabandan-2/

13　http://www.benesiinaabandan.com/about/

14　For a hint of what that multimedia presentation might have been, the VR experience at the 2018 Tribeca Festival featured the presence of a real turtle (Astle 2018).

Resurgent Media/Allies/Advocacy

Introduction to Part IV

Dana Claxton, Ezra Winton, Sasha Crawford-Holland, and Lindsay LeBlanc

RESURGENT MEDIA AND ITS ALLIES
Dana Claxton and Ezra Winton

We are sharing a two-part, multi-authored introduction to this last section of the book, in order to further contextualize the volume. When we read the prologue to Chapter 12 by Sasha Crawford-Holland and Lindsay LeBlanc we instantly knew this should be the introduction to Part IV of the collection. Their discussion, which follows, provides an excellent introductory commentary and critical intervention regarding settler research that explores resurgent media in Indigenous territories. We feel their analysis provides an excellent example of productive and self-reflexive allyship and collaboration among and between settlers and Indigenous scholars and cultural practitioners. Their chapter that follows their introductory text is an engaged and crucial interrogation that makes linkages between Indigenous sovereignty/territoriality and the digital/virtual realm, with an emphasis on digital artmaking.

In indirect conversation with Crawford-Holland and LeBlanc's chapter is another collaboration between two contributors. Eugenia Kisin and Lisa Jackson's exploration of the Gladue Video Project reminds us that "resurgence" comes from the Latin "lift oneself up" or "be restored," stemming from the verb *surgere*, "to rise, arise, ascend, attack." The notion of rising up is of course closely connected with the idea of

resurgence in Indigenous media arts and politics, as captured in the title of Tasha Hubbard's powerful documentary *nîpawistamâsowin*,[1] which roughly translates from the Cree to "we will stand up together." Kisin and Jackson's chapter explores the ways in which thoughtful and innovative uses of media arts technologies contribute to Indigenous resurgence, while Crawford-Holland and Leblanc's introduction below rightly points out any resurgence must be coupled with and informed by allied relations of reciprocity and respect. We turn to their attentive words now.

INTRODUCTION TO PART IV CONTINUED—LEARNING TO CONTEXTUALIZE KNOWLEDGE AS TERRITORY

Sasha Crawford-Holland and Lindsay LeBlanc

> Living as we do in the charred remnants of a time during which
> the voices of Indigenous peoples were siphoned out of the theatres
> of culture and into the wastelands of law and order, you, a white
> and settler you, are beholden to a project of lessening the trauma
> of description.
> —Billy-Ray Belcourt, "Fatal Naming Rituals," 2018

In Canada, the territorial acknowledgement has become an increasingly common practice since the announcement of the Truth and Reconciliation Commission's calls to action, and is today considered by many in our communities to be an important and necessary part of professional and sometimes personal gathering. It serves a purpose in reminding settlers of the violence that has been done to create the spaces we now work within; when performed with care and consistency, and in collaboration with the Indigenous folks on whose unceded lands we work and live, it demands accountability for the ongoing perpetuation of that violence. Territorial acknowledgements remind us that working on unceded territory comes with inherent responsibilities. Acknowledgement, then, should never operate as a performative utterance nor a closed system. Rather than thinking of it as an acknowledgement, we might understand it to be a reiterative call to action that refuses acknowledgement for its own sake, or worse, for the sake of performing good politics.

It will not come as news that the territorial acknowledgement runs the risk of being evacuated of its significance by those who offer it up as a housekeeping item. Métis thinker âpihtawikosisân observes in the 2016 blog post "Beyond Territorial Acknowledgement" that acknowledgements remain absent from many of the spaces where they hold the most potential—rural spaces in particular.[2] âpihtawikosisân also questions how acknowledgement functions for the settler speaker, arguing that verbal acknowledgement must not simply discomfit speaker and audience, but extend beyond itself to initiate relationships that support the intention that the verbal acknowledgement puts forth: "Perhaps you

understand the tension of your presence as illegitimate, but don't know how to deal with it beyond naming it." Making acknowledgements more personal and more particular is one of several ways to better activate critical spaces in which the complex legacies of settler colonialism can be confronted.

As scholars, we are attentive to the ways that colonial forces annex not only land but also knowledge. It is well known that the history of settler colonialism has been, among other things, a history of denigrating, criminalizing, and eradicating Indigenous ways of knowing; territorial dispossession has always been accompanied and rationalized by white-supremacist knowledge systems that claim for themselves the power to delineate "what does or does not constitute knowledge" (Moreton-Robinson 2015, 47). In the academy, this has meant that gatekeepers such as granting agencies and hiring committees continue to enforce disciplinary protocols that require Indigenous thinkers to make their work legible as value to the very institutions that have developed norms over centuries that are designed to apprehend precisely the contrary.

Ironically, within these same apparatuses that trivialize Indigenous epistemologies, trendy new philosophies surreptitiously appropriate them. Métis anthropologist Zoe Todd (2016a) has pointed out that the ontological turn toward new materialisms, object-oriented thought, actor-network theory, and posthumanism resonates profoundly with the knowledge systems that Indigenous thinkers have developed over the course of millennia. Rarely citing such histories or engaging their political implications, these mostly white scholars instead route their work through European intellectual traditions to enact what Quandamooka theorist Aileen Moreton-Robinson identifies as the logic of white possession upon Indigenous epistemological territories. As Todd puts it,

> Non-Indigenous scholars are not *sharing* or *ceding* space with/to us as Indigenous intellectuals. Indigenous knowledge is unceded. It is unceded because there was never a reciprocal and accountable framework to negotiate its entry into, and reification within, these spaces to begin with (2017).

One way, then, to begin to address the academy's erasure and deprecation of Indigenous knowledges is to strive toward such a reciprocal

and accountable framework—for instance, by entering into networks of conversation and citation that respect the intellectual histories from which we learn and benefit, not to mention the land on which we work and gather. Of course, citation itself should be called into question, extending as it does a logic of ownership to intellectual landscapes. Nonetheless, given the ways that Indigenous knowledges have been denigrated as lacking the kinds of citational rigour that they are routinely denied, we deem citation an important, if insufficient, practice of accountable acknowledgement. Our engagement with Indigenous artworks and epistemologies constitutes an occupation of territory, even if it is not a hostile one. We endeavour to work toward less violent and more accountable ways of inhabiting this territory and honouring its custodians by ceding space to Indigenous thinkers and by attending to the rich, often unjust histories that have unfolded here.

Skawennati, Âhasiw Maskêgon-Iskwêw, and Scott Benesiinaabandan, along with their communities and collaborators, occupy virtual space as Indigenous territory. Mohawk, Cree, and Anishinaabe systems of knowledge shape these spaces and access to them. Each artist speaks to an audience that they, not we, define. By writing about these works as settlers, we begin from a point of understanding the limits of our access and the inadequacy of unsettling colonialism through language alone.

As scholars of media, our engagement with these works is animated by the knowledge that the Indigenous artists we discuss make vital contributions to media art history and provide important correctives to theories of media that neglect histories of Indigenous thought. We are grateful for the opportunity to offer these works some of ourselves and our own ways of knowing. This engagement would not be possible without the generosity of educators, colleagues, and friends whom we continue to (un)learn from and with.

NOTES

1 Information on *nîpawistamâsowin: We Will Stand Up* can be found here: https://www.nfb.ca/film/nipawistamasowin-we-will-stand-up/.

2 https://apihtawikosisan.com/2016/09/beyond-territorial-acknowledgments/

"Making Things Our [Digital] Own": Lessons on Time and Sovereignty from Indigenous Computational Art

Sasha Crawford-Holland and Lindsay LeBlanc

In a famous scene from Robert Flaherty's "documentary" *Nanook of the North* (1922), Inuit hunter Nanook, who lives on the Ungava Peninsula of Nunavik, is baffled by the magic of a gramophone. Although an intertitle informs us that a trader has attempted to explain the technology to Nanook, he simply laughs, seemingly confused, and proceeds to bite a shellac record in an apparent attempt to eat it. In fact, Nanook—whose actual name was Allakariallak—was intimately familiar with this and other media technologies, having collaborated as the principal subject of Flaherty's film, the production of which also involved Inuit "technicians, camera operators, film developers, and production consultants" who knew the technology better than Flaherty did (Ginsburg 2002, 39; Barnouw 1974, 36). However, the image of a tech-savvy Inuk would have interrupted the colonial fantasy of Indigeneity that Flaherty's film embalmed. Often described as the first feature documentary, *Nanook of the North* folded nonfiction film into a long colonial tradition of displaying the "authentic Indian" as entertainment. The film denies Indigenous peoples' access to modernity by constructing them as precolonial luddites, despite the film's production process contradicting the fiction it claimed to document. *Nanook* typifies the practice of salvage ethnography, which presumes a people's impending extinction and ennobles attempts by colonizers to preserve Indigenous cultures in museums and libraries before it is "too late," thus framing erasure

and disappearance as inevitable, natural phenomena.¹ This representational violence, which seeks to obfuscate the ongoing material volition of colonial violence, has long been perpetuated through the ways that colonial powers measure, standardize, regulate, teach, and understand time. Nanook's infantilizing encounter with the gramophone demonstrates the central role that technologies have played in the colonial technique of relegating Indigenous life to the past tense.

The prevailing Western conception of time as a constant, unitary chronology is neither neutral nor universal, but emerges from a set of historical circumstances that can be grouped under the condition of modernity. In the late 19th century, the proliferation of industrial capitalism and the expansion of colonial infrastructures such as railways demanded that time become standardized and uniformly measurable. As Mark Rifkin explains, the ongoing imposition of this temporal order that he terms "settler time" constitutes a "denial of Indigenous temporal sovereignty, in the sense that one vision or way of experiencing time is cast as the only temporal formation—as the baseline for the unfolding of time itself" (2017, 2). Building on Mohawk anthropologist Audra Simpson's (2014) articulation of refusal as a decolonial alternative to the politics of recognition, Rifkin reads Indigenous temporalities as expressions of sovereignty that can interrupt and act on time beyond the hegemonic orders of settler colonial modernity. While *Nanook* illustrates the power of wielding media technologies to naturalize settler time, new media forms proliferating in the 21st century have imbued contemporary life with alternate temporal experiences that contradict the modern colonial chronometer.

Media theorists seeking to explain what is new about "new media" have often emphasized the layered, multidirectional experiences of time that contemporary technologies make possible.² We, as settler scholars engaging with Indigenous media art and scholarship, have come to understand that many of these ostensibly new experiences of time have been conceptualized by Indigenous knowledge systems, and lived by Indigenous people, for centuries. In this chapter we explore where those resonances occur, arguing, in the footsteps of scholars including Loretta Todd, Jason Edward Lewis, and Steven Loft, that digital media can enable forms of Indigenous refusal and temporal sovereignty. Concurrently, we recognize that digital media are thoroughly imbricated with the asymmetries of global capitalism that emerged from extractive

policies and practices of settlement and themselves cannot be disarticulated from the violence of the colonial project; these technologies are as much devices of exploitation and co-optation as they are tools of empowerment. By celebrating nonlinear experiences of time without understanding their histories, one risks colonizing them, depriving them of their cultural specificity, and overlooking their political significance for both imagining and making better, more livable worlds. Attending to these dynamics, we discuss computational artworks by Skawennati Tricia Fragnito (Mohawk from Kahnawà:ke), Âhasiw Maskêgon-Iskwêw (Cree/Métis from Peace River), and Scott Benesiinaabandan (Anishinaabe from Obishikokaang) as examples of how Indigenous artists have used digital media since the 1990s to facilitate embodied engagements with alternative temporalities that harness the political potentials of being "out of sync with settler time" (Rifkin 2017, xiii).

Although the concept of sovereignty has historically legitimated settler practices of domination and dispossession, we work with Simpson's (2014, 2020) insistence that, as a situated form of relationality, sovereignty also serves as an important means by which Indigenous peoples practise and theorize justice, protection, and responsibility. In contrast to colonial forms of sovereignty expressed in proprietary and individual rights, such as the divine right of kings or the right to kill, the sovereignties exercised in these artworks enact what Métis anthropologist Zoe Todd (2018) describes as the active process of refraction through which Indigenous peoples bend and distort colonial imperatives to suit their needs, as an act of survivance.[3] This refractive rendering of sovereignty is also at work in the ways that Indigenous artists engage digital technologies, a practice that Tlingit curator Candice Hopkins (Carcross/Tagish First Nation) calls "making things our own" (2004b).

Skawennati, Maskêgon-Iskwêw, and Benesiinaabandan engage computational media to imaginative ends and refract them through new lenses, making them their own. This is not simply a process of adapting Western technologies to Indigenous worldviews—a framework that obscures Indigenous histories of computation and risks reproducing stereotypical assumptions about autochthonous essence and originality.[4] Instead, we understand these arts practices as world-building practices, where technologies and traditions are both transformed through a dynamic process of change and exchange that Hopkins identifies as itself being a common characteristic of Indigenous

cultural traditions. Furthermore, rather than taking machines as passive instruments or tools, the artists demonstrate a collaborative approach toward the affordances and constraints that technical platforms introduce into creative practice, and grapple with the complicated entanglements often brought into being by technological devices. This dynamic process makes it possible to reconceptualize computational feedback as reciprocity, recalling that before interactivity was branded into a fantasy of user mastery over a digital commodity, it referred to a process of working collaboratively with a computer to solve problems (see Chun 2004, 40). In this sense, practices of digital refraction can model the process that artist and designer Jason Edward Lewis (Cherokee/Hawaiian/Samoan), Kanaka Maoli historian Noelani Arista, Cree artist Archer Pechawis, and Oglála Lakȟóta artist Suzanne Kite describe as "Making Kin with the Machines" (2018). They argue that many Indigenous epistemologies "are much better at respectfully accommodating the nonhuman" and encourage non-hierarchical and non-instrumentalizing human-machine relations that support more ethical, habitable futures. Guided by this ethos of reciprocal human-machine relations, digital refraction repudiates the logic of sovereignty as mastery but makes it possible for digital artists to express forms of temporal and territorial sovereignty in cyberspace, such as those we examine below.

SKAWENNATI: *TIMETRAVELLER*™ (2008–2013)[5]

Colonial histories enshrine settler time as the only accurate way of understanding temporal experience. In the dominant tradition of Western historicism, capitalist modernization is naturalized as the inevitable undertow to time's unfolding. As Rifkin observes, the temporal experience of modernity is "intimately connected to the decimation of Native peoples" (2017, 8) who are cast as its anachronisms while state sovereignty persists as the unquestioned foundation of historical progress. The historicist mode narrates this flow as though history were speaking for itself, erasing its own interpretive power. Mohawk historian Deborah Doxtator finds it striking that the writing of Canadian history is so firmly entrenched in such European intellectual traditions, given that these historical events were patently co-produced by Indigenous peoples and settlers; prior to the supremacy of the Canadian state, Indigenous knowledge and governance around trade and diplomacy

structured settler life. Doxtator notes, "Colonial documents bear testimony to the influence of Native names and languages, and Native concepts of seeing North America and living within it; yet the effects of colonial powers on Native cultures and their perceived cultural structures are usually central to the writing of history, rather than the other way around" (2001, 36). Dominant, colonial histories are characterized by the modality of European historicism that narrates the past as a chain of causally related events propelled forward by the volitional acts of great individuals. This way of making history, on which white supremacy depends, presents itself as indisputable and consigns other ways of knowing the past, especially Indigenous ones, to the ambiguous status of myth. Doxtator observes that the conventions of Western historical writing seem incapable of representing Indigenous perspectives, which leads her to ask: "Do Native conceptualizations of history, focused as they are on episodes, clash fundamentally with western notions of time as made up of separate segments joined in a strict chronological sequence?" (36).

This fundamental clash animates Mohawk artist Skawennati's *TimeTraveller*™ (2008–13), a multimedia project that unsettles the conventions of Western historicism by investigating the past without regard to colonial protocol. The project includes a series of "machinima," which is a portmanteau of "machine" and "cinema" used to describe films created and recorded in virtual environments. Shot on location at AbTeC Island in the virtual world of Second Life, the *TimeTraveller*™ machinima series follows the adventures of Mohawk protagonists Karahkwenhawi and Hunter, who live in the 21st and 22nd centuries respectively but use their TimeTraveller™ glasses to visit various important moments in the history of Turtle Island, such as the Dakota uprising of 1862, the 1969 reclamation of Alcatraz, and the 1990 Oka crisis.[6] Each episode provides anti-colonial accounts of these events, diverging from the dominant narratives that populate textbooks, mass media, and the settler imagination. They also reject the teleological flow of settler time by staging history as a labour of the imagination informed by the subjectivities of those who encounter it and are entangled in transversal relations to other times and places.

Unlike other historical eras, Western modernity and the intellectual scaffolding that supports it are sustained by a sense of historical exceptionalism that views the past as fundamentally different. Indigeneity

is often conscripted to embody that alterity within a paradigm of history-as-other that enables binary distinctions between traditional and modern, nature and technology, uncivilized and civilized. The figure of "the Indian" is thus temporally othered and constructed as being melancholically invested in the past, while Indigenous survivance is framed as a temporal glitch. Because Western historicism depends on chronology as the abstraction through which it can understand change, it is distinctly bad at telling histories of that which persists, such as colonialism and white supremacy. By contrast, Skawennati is very good at it.

In *TimeTraveller*™, Karahkwenhawi and Hunter show the histories of Indigenous life on Turtle Island to be dynamic, alive, and very much present because they directly influence our protagonists' selfhoods and ways of being in the world. For example, Karahkwenhawi is exhilarated to meet Algonquin-Mohawk Catholic saint Kateri Tekakwitha in Episode 5 and to take "a vacation from colonialism" by visiting the pre-contact Aztec capital Tenochtitlan in Episode 7, reminding us that the past is always configured by the people who apprehend it (Figures 12.1 and 12.2). When TimeTraveller™ users switch to "intelligent agent" mode, they can interact with history though they cannot alter it. Hunter tells us, "What I like most about [intelligent agent mode] is that you get to choose a side, so you know all the stuff your team knows, can speak and understand their language, and even feel some of what they feel." Like all historians, Hunter engages with the past in order to make sense of it, contradicting the Western historicist view of history as a fixed object that is unaffected by the historian's own assumptions, experiences, belongings, and commitments. Doxtator argues that while this intellectual tradition claims to access the past neutrally without the mediation of cultural myths or symbols, that very notion is "in itself a kind of belief system" (2001, 35). Instead, *TimeTraveller*™ centres the roles that belief, love, anger, curiosity, and countless other subjective experiences play in igniting our encounters with the past and structuring our understandings of it, for any desire to know history undermines the historicist notion that the past is settled. Stories, writes Tanana Athabaskan scholar Dian Million, transmit a "felt knowledge" that contains "the affective legacy of experience" (2014, 31–32). Skawennati's stories enact temporal sovereignty by tracing the reverberations of these affective legacies across time, demonstrating the past's contingency on the people, times, and places that animate it. The temporal vectors along

FIGURE 12.1 "Stepping Out" from Skawennati's *TimeTraveller*™ (machinimagraph, 2012). Screen grab courtesy Skawennati.

which Karahkwenhawi and Hunter travel refute the settler historicist construction of the past as an alterity that is epistemologically detached from our presents.

Skawennati's use of machinima embodies the complex temporal politics at play in *TimeTraveller*™'s stories. Machinima refers to the practice of creating movies with real-time computer graphics; as scholars such as Elizabeth LaPensée and Jason Lewis (2013) have pointed out, the multiple layers of mediation and remediation at work in this process open countless opportunities for critical reimaginings. Skawennati meticulously researched the histories in question and visited several of their locations. She then constructed replicas in the user-generated world of Second Life and filmed each episode therein (LaPensée and Lewis 2013, 205).[7] Every step of this process is rife with opportunities to practise the digital aesthetic that Hopkins calls "making things our own" (2004b). For example, in Episode 1, Hunter comes across a colonial panorama that depicts a racist, inaccurate account of the 1862 Dakota Uprising. Skawennati remediates that mediation of history in Second Life, then recontextualizes it in the machinima form through Hunter's experience. She demonstrates that history itself is constantly being remediated across various temporal trajectories as she analyzes the media politics that provoke Hunter's remark: "If there's one thing every Indian knows, it's this: when it comes to history, always get a second opinion." However,

rather than reducing this process to a linear chain of reinterpretations, Skawennati entangles history in a web of temporal connections, illustrating how the past comes to matter in relation to the moments from which it is investigated. Normatively, computing programs a future based on the past (see Chun 2011)—a technical form that sustains all the continuities that historicism fails to apprehend. However, by animating a past that is enlivened by a multitude of intersecting presents, Skawennati makes different kinds of futures available to the imagination.

One of the most pronounced violences of settler time is its imposition of a temporal order that relegates Indigeneity to the past tense and therefore renders Indigenous presence paradoxical. Against this paradigm that weaponizes time itself, imagining Indigenous futures becomes a radical act. Aboriginal Territories in Cyberspace (AbTeC), which produced *TimeTraveller*™, is a research-creation network co-founded by Skawennati and Lewis that harnesses the power of this act. Since its formation, a wave of creative projects such as 2167, *Biidaaban: First Light* (2018), the Initiative for Indigenous Futures, and several films developed through Cinema Politica's Documentary Futurism project have elaborated AbTeC's commitment to Indigenous futurity and temporal sovereignty by investing in what Tuscarora art historian Jolene Rickard calls "the apparatus of the imagination" (quoted in Raheja 2017, 172). Such projects build on the insights of Anishinaabe scholar Grace Dillon (2012), who sought to foreground the relevance of Indigenous epistemologies to discourses about science fiction and technoscience when first theorizing the term "Indigenous Futurisms." Artists participating in this tradition subvert the captivity of settler time by expressing alternate temporal formations and performing Indigenous futurity. For example, Lewis relates the future imaginary to the Haudenosaunee principle of seven generation stewardship, "a shorthand reminder of how our actions in the present will affect our descendants" (2016, 37). This principle conjures future realities into simultaneity with decision making in the present, confounding settler time's strict chronometry and settler governance's perpetual deferrals of responsibility to future generations. It also illustrates the pragmatism that informs non-chronological experiences of time such as remembrance, prophecy, intergenerational care, and trans-historical empathy, supporting an insight that Mohawk activist Ellen Gabriel shared with Skawennati: "Our people have always used time travel to figure out the problems of today" (quoted in Alice

FIGURE 12.2 "Kateri & Karahkwenhawi: BFFS" from Skawennati's *TimeTraveller*™ (machinimagraph, 2012). Screen grab courtesy Skawennati.

Ming Wai Jim 2015). However, problem solving through temporal experimentation is not inherently liberatory. Increasingly, capitalist speculation exercises colonial power over the future by policing what can be imagined as possible and planning for contingencies in order to secure the systematic injustice that attempts to make Black and Indigenous flourishing impossible (see Keeling 2019). By investing in an apparatus that supports alternate imaginaries, Indigenous futurists engage in a political struggle over what kinds of future worlds are possible.

It is against this backdrop that AbTeC is centrally concerned with how to increase Indigenous participation in new media production and technological development in order to build self-determined futures both within and beyond digital spaces. AbTeC works to assert Indigenous territorial sovereignty in cyberspace—metaphorically, but also quite literally, as when Skawennati defended AbTeC Island against colonization by squatting pirates in Second Life (see LaPensée and Lewis 2013). Recognizing that the politics of land prevail even in cyberspace, Cree/Métis artist Cheryl L'Hirondelle declares:

> Our connection to the land is what makes us Indigenous, and yet
> as we move forward into virtual domains we too are sneaking up
> and setting up camp—making this virtual and technologically

mediated domain our own. However, we stake a claim here too as being an intrinsic part of this space—the very roots, or more appropriately routes. So let's use our collective Indigenous unconscious to remember our contributions to the physical beginnings that were pivotal in how this virtual reality was constructed. (2014, 152)

L'Hirondelle alludes here to virtual territory's intrinsic connection to physical territory, reminding us that the material infrastructures that support the internet—and other communications networks before it—depended on Indigenous land, labour, and knowledge for their construction. Indeed, as the production history of *Nanook of the North* illustrates, the media technologies used to script Indigeneity as ineluctably historical have, paradoxically, always been existentially reliant on Indigenous knowledges and bodies. AbTeC strives to interrupt such exploitation in favour of self-determined digital futurity.

Digital spaces such as those created in Second Life tend to reproduce settler time's exclusion of Indigenous lives from cultural representations of the future. When Skawennati and her team were building avatars for *TimeTraveller*™ in Second Life, they found that pre-existing "Native" avatars and character features resembled the racist hallucination of the "Imaginary Indian" more faithfully than any referents inhabiting actuality (Lewis 2012, 20).[8] Accordingly, they designed new hairstyles, skin tones, clothing such as ribbon shirts and a T-shirt featuring the Haudenosaunee flag, sacred objects including a wampum belt and a smudge shell, and even custom movements such as drumming and jingle dancing. These acts of digital creation contributed to Indigenous representation in Second Life and to the creation of a self-determined future there as well as in cyberspace more broadly. Similarly, the seemingly capitalistic "™" that punctuates *TimeTraveller*™ expresses a cultural ownership that is commonly denied to Indigenous creators. TimeTraveller™, the multimedia project and the diegetic technology alike, afford experiences of complex temporal formations that contradict the march of settler time. Both disarm colonial modernity of the technological lever it uses to bifurcate past from present, Indigeneity from futurity, by imagining Indigenous futures that are animated by empathic relations to the past and asserting temporal, territorial, and cultural sovereignty in cyberspace.

ÂHASIW MASKÊGON-ISKWÊW: *SPEAKING THE LANGUAGE OF SPIDERS* (1996)[9]

In the late 1990s, Skawennati had an instrumental hand in launching the collaborative net art project *CyberPowWow*. Running over eight years, from 1997 to 2004, *CyberPowWow* showcased digital artwork and essays by Indigenous artists based in cities throughout North America, and also hosted events in physical spaces as a means of providing access to its virtually constructed ones. Mikhel Proulx, a member of AbTeC, revisits the significance of *CyberPowWow* in an essay published in tandem with the experimental online installation TERMINAL (hosted by artist-run centre Western Front in Vancouver, BC). Describing the relevance of *CyberPowWow*'s (or *CPW*'s) subversive, artistic explorations to the current culture of the internet, he writes:

> Where the dominant discourse of Internet-based art has often pointed to the globalizing aesthetics of an ostensibly World-Wide Web, *CPW* may exemplify a counterforce to this narrative, and to the imperial structures of the Internet itself. Demonstrably, its artworks and critical texts challenged the prevailing sense of the Internet as a neutral and "free" space, and have laid the groundwork for critical discussions of how power and control operate in the network age. (Proulx 2017)

Indeed, today the Internet can seem like little more than an engine designed to monetize user data for shareholder benefit, rather than a site to explore the radical possibilities of information sharing and collaboration online. As Yaqui scholar Marisa Duarte (2017) has elaborated, where the connectivity afforded by information and communication technologies is both unevenly experienced and frequently predicated on the continued dispossession of Indigenous lands, it is critical to understand the infrastructure that makes these technologies usable, as well as the forces that manage, control, and delimit their use to particular ends. Users are compelled to be complicit with the existing infrastructure, out of necessity or under the guise of self-expression through online personhood. How can we resist the capitalist and colonial imperatives driving so much of today's online activity, and make more rigorous claims to public, distributed access that refute the logics of property and privacy altogether? *CyberPowWow* demonstrated early understanding

of the internet's potential as a colonial, capitalist tool and corresponding site of resistance; and one of *CyberPowWow*'s participants in particular articulated, early and accurately, the complexities of living in relation to digital networks.

Cree/French/Métis artist Âhasiw Maskêgon-Iskwêw, who passed away in 2006—remembered as "a warm, loving, generous soul, one of the foremost thinkers on Aboriginal new media art and a true friend to all who knew him" (Loft 2006)—contributed to *CyberPowWow* in 1999 after already having investigated the conflicted nature of networked technologies in the years prior. His series of articles "Talk Indian to Me," for example, published between 1995 and 1996 for *MIX Magazine*, pushes back against the systematic exclusion of Indigenous knowledge from the academy. In the context of Indigenous temporality, the Canadian curriculum's denial of Indigenous modes of understanding becomes increasingly ironic, as the aims of technological development—and more broadly, those of information capitalism driven by the user data that technology companies harvest and sell—begin to align with the understanding that time moves in alternate ways. However, techno-capitalist forces only acknowledge the value of nonlinear temporalities based on their potential profitability, which benefits from the perception that they never existed before. By imagining Indigenous people as "irrelevant ghosts" (Maskêgon-Iskwêw 1995) and perpetuating the idea that new technologies alone promise an expanded corporeality, settler culture has disavowed the rich history of Indigenous theorizations of nonlinear and networked time; but, as writes Maskêgon-Iskwêw in the first installment of "Talk Indian to Me," "The old songs are loud, pounding and powerful again" (1995).

Though Maskêgon-Iskwêw had not yet turned his critical voice to networked culture while writing "Talk Indian to Me," at least not with the same directness that would come to shape his practice in the mid-late 1990s, he was already wary of the eagerness with which settler and European thinkers claimed ownership over network theory. "Ironically," says the artist in 1996, "the advent of hypertext literary concepts … took place during the decades when residential schools were undertaking their most virulent and vicious attacks on First Nations culture and language. These were oral cultures with long histories of development in the arts of nonlinear, fragmented storytelling and oration" (Maskêgon-Iskwêw 1996b). Now, the hypertext takes material form in

the hyperlink—and more than ever, dominant settler culture is ready to embrace the networks that have organized Indigenous nations and relations for millennia. Angela Haas (2007) has also underscored this irony by highlighting a series of conceptual and functional similarities between the digital hypertext and wampum—including their use of links, or connective pathways, and "digital rhetoric" (wherein Haas unpacks the relationship of digits to the flesh), and the way they each encode complex information in binary terms. Once again, we see that ostensibly "new" media technologies embody the very knowledges that settler society has consigned to the past and therefore obstructed from futurity.

In 1996, Maskêgon-Iskwêw organized his first large-scale web project, *Speaking the Language of Spiders*. A collaborative net art piece bringing together members of the Indigenous art community in Canada, similar to *CyberPowWow* but smaller in scale, *Speaking the Language of Spiders* is an interactive website that tells temporally driven stories—of "the time before language, the time of the pre-ancestors," for example, or the Sky Woman creation story—through web pages featuring the images and prose of 14 artists. On the website itself, Maskêgon-Iskwêw frames it as a "screenplay" and "storyboard"; it demands a certain level of engagement from its user, who is responsible for navigating its pages and uncovering the stories it holds. The website was first developed on the coding side by Sheila Urbanoski, a non-Indigenous friend and collaborator of Maskêgon-Iskwêw's and a participant in *CyberPowWow* (Pechawis et al. 2017).[10] In 2012 Cheryl L'Hirondelle, who was also one of the original collaborators for the project, updated and optimized the website for contemporary machines and audiences. The 2012 update was commissioned for a commemorative exhibition dedicated to Maskêgon-Iskwêw's practice at grunt gallery in Vancouver. (The exhibition, *Ghostkeeper*, also shares a name with Maskêgon-Iskwêw's archive at grunt.)

L'Hirondelle made several significant changes to the website for the exhibition, adding new and original audio, redesigning the navigation to resemble more of a spiral shape, and animating select graphic components, as well as contacting many of the original contributors to update their bios and edit or expand their contributions.[11] L'Hirondelle continues to care for the domain today, and as of this chapter's writing has been working on a new series of updates. The continued life of *Speaking the Language of Spiders*, then, beyond this writing, is being

shaped by ongoing acts of care that emphasize sustainability in a dialogical process of collaboration with machines. This might offer another path along which to think about how physical and virtual territories relate, and how decolonizing cyberspace necessitates similar types of labour and custodianship as it does on land. Further, as the declining state of the planet problematizes logics of planned obsolescence and inevitable waste, L'Hirondelle's continued engagement with this work might be thought of in terms of an ethics of sustainable media practices.

There are many notable characteristics to *Speaking the Language of Spiders*, all of them strikingly relatable for both of us as 21st-century users. Echoing media artist and university president Sara Diamond, who was one of Maskêgon-Iskwêw's early supporters during his time spent working at the Banff Centre in the nineties, "The powerful work speaks of the life cycle and different ways of living through experiences, immersed, contemplative, suffering, and filled with hope. It is a beautiful, multi-layered interactive experience that sustains its power many years later" (2008, 61). We experienced this ourselves. Of special relevance to our discussion is, firstly, that early net art by Indigenous artists and allies exhibited the ideals of decentralization and democratization that the internet promised in its earliest iterations. This is equally true of Maskêgon-Iskwêw's *Drumbeats to Drumbytes* website, launched in tandem with Mohawk scholar Steven Loft's *Language of Intercession* exhibition in 2003; the website was meant to act as a hub for the Indigenous media art community, and emerged out of the same collaborations at the Banff Centre that built *Speaking the Language of Spiders*. It is also true of the artist's editorial project *ConunDrum*, an online publishing platform that Maskêgon-Iskwêw co-managed with Loft. Maskêgon-Iskwêw's material practice thus brought his theoretical practice into being, exhibiting the best parts of the internet—namely, opportunities for conversation and collaboration across geographic and other physical limitations—while denouncing its worst. In doing so, he demonstrated a deep understanding of the ways that users (and as Jason Lewis notes [2014], programmers) can collaborate with technologies toward more desirable worlds both on- and offline.

The second aspect of *Speaking the Language of Spiders* that provides a meaningful platform on which to stage our discussion of time and how it is felt differently in the virtual spaces of Indigenous media, and leading us to our final case study, is the project's ability to structurally

manifest the nonlinear temporalities that occur in so many Indigenous histories and worldviews. In their first encounter with the site,[12] once entering through the landing page, users are faced with a grid of nine icons with no clear indication of where they lead. Each of these icons represents a temporal splice; rather than playing into the illusion of isolated temporal ruptures so fundamental to Western history, in its narrative of distinct movements or periods used as evidence of progress in a continuous march forward, each wedge of time represented by the website is simultaneously independent from and situated in proximity to the one before and the one after (and the home navigation, where all temporal paths converge). At any point, a user might go anywhere, and the stories presented alongside each icon or temporal event are written in a nonlinear, non-sequential poetics.

The first text a user encounters (if allowing the site to lead them organically) is a poem called "WHEN ALL SHE HAD WAS 7:00 A.M." It reads, "She sits there / aged beyond / her age / at someone / else's table. / Blouse / hanging loose / leaning / she says, Come / close, I have / something to show / you. / The faucet's / dripping." In this piece, time is extended and expanded by bodily, sensory experiences that belong to the past as much as the present. The contradictions of lived time, such as in the phrasing "aged beyond / her age / at someone / else's table," indicate partial histories and foreclosed futures, offering a sense of living in a world shaped by the violence of settler colonialism. As Doxtator and Rifkin (among others) describe, Indigenous temporalities tend to refute the notion of a point-in-time altogether, while settler time is reliant on fixed, isolable events. The contributing artists implement a poetics that emphasizes temporal plurality, where "7:00 A.M." will always contain more than and exceed itself. This approach suggests that temporality must be thought through bodies, because bodies are where cycles of history are differentially inscribed and reproduced. The conception of "the body" as a discrete unit—as it appeared in the modern formulation of the white, cisgendered, and able-bodied man as universalized, bounded subject—is therefore also inherently problematized through Indigenous temporalities. The artists' writings are suggestive of how historical and temporal violence make themselves known in felt, material violence.

The disavowal of settler time in *Speaking the Language of Spiders* is mimicked by the user's own bodily engagement with the website as a hypertext, where beginning, middle, and end are all made accessible.

In Skawennati's machinima, users are invited to interact with a series of videos that have fixed durations, whereas on Maskêgon-Iskwêw's website, one's experience of time is entirely pliable, even according to the settler chronometer of clock-time, as users choose when to accelerate or linger. Embodied encounters with the two works can be further distinguished in terms of the physical actions necessitated to actuate them; video can be built to loop, uninterrupted, but web-based works refuse to reveal themselves without a click. Furthermore, by describing the website as an "interactive screenplay and multi-media storyboard," Maskêgon-Iskwêw reinforces the fundamental role of dialogue in the project; though these genres might connote linear sequencing and chronology, they really only operate through simultaneity. Stories are told in a multiplicity of voices, from a multiplicity of perspectives, and are informed by a multiplicity of bodies and their lived experiences. Though we know that 14 arts practitioners had a hand in the production of *Speaking the Language of Spiders*, none of its individual pages are authored. The project puts forth, then, an early realization of the internet's capacity to dislodge the authority of a singular voice by redistributing the relations between who gets to speak and who gets heard, and who doesn't. Such an experimental online space displaces the single author precisely by facilitating the coalescence of many authors—including machines—into a diverse but unified discursive force. Ownership and possession are the imperatives of colonialism and white supremacy (Moreton-Robinson 2015).

Loft has pointed out that "cyberspace connects the past to the present and the spiritual to the material in ways that would make our elders laugh. They've always known this. It's in our stories and it's in our ways of communicating and remembering. In much of his writing, Âhasiw Maskêgon-Iskwêw would reiterate this point" (2014b, 175). Informed by Indigenous epistemologies, Maskêgon-Iskwêw anticipated key issues defining internet use today in the 1990s with "Talk Indian to Me." He saw Indigeneity and cyberspace as inextricably linked—in the way Loft describes, for example, as well as in concepts like the hypertext—and inherently at odds, given the internet's complicity with colonial, capitalist society. Importantly, Maskêgon-Iskwêw was grappling with the co-optation of Indigenous knowledge by techno-capitalist culture and used his deep understanding of networked time and space to decolonize virtual territories. He placed ancestral, Cree knowledge at the core of his

theorizations of the internet age, illustrating the dark irony of settlers' temporally inflicted violence. Doing anti-colonial media scholarship, for us, involves learning from and citing Indigenous thinkers' contributions toward understanding how time loops, layers, overlaps and intersects, reverses, skips, and fragments—only to meet again in the network, in the web, in the language of spiders.

SCOTT BENESIINAABANDAN: *BLUEBERRY PIE UNDER A MARTIAN SKY* (2016A)

Where we see Indigenous temporalities and media art converge most intimately, not only through theoretical resonances, visual elements, and participatory engagement, but also in an immersive, bodily, and dynamic way, is in virtual reality technologies (or VR). Here, the user's sense of space is confounded in the virtually constructed world, where the optical norms governed by gravity and perspective can be readily ignored in an otherwise believable environment—believable precisely because there is no sensory reprieve from the imaginary world represented. The VR headset overtakes the user's vision; a painting or website may function as an "opt-in, opt-out" system, but in VR, once you're in, you're in. Where Skawennati's *TimeTraveller*™ competes for the user's attention to communicate its message, and Maskêgon-Iskwêw's *Speaking the Language of Spiders* requests their active engagement through site navigation, VR blocks out the surrounding environment and ensures that no matter the level of viewer interest, their body remains invested while the headset is on, continually orienting itself to a different space and time. The way the body occupies and moves through space is largely determined by its understanding of how time moves, its ebbs and flows; virtual realities, by manipulating space, can therefore glitch linear temporality. VR users are able to develop a form of literacy—an embodied literacy—in other temporalities, because they are not only offered the conceptual tools to grasp the existence of nonlinear time through the technology, but are corporeally implicated in passages or flows that move out of sync with settler time. Jolene Rickard has spoken about the "continuous, multi-sensory engagement" that characterizes Indigenous cultures in contrast to Western ocular-centrism, through material sites of informatic inscription such as the wampum; this "complex, abstract symbol," says Rickard, "requires a multi-sensory embrace to activate" (2017). She continues that this type of profound,

bodily knowing cultivated by Indigenous productions of knowledge is one of the ways that Indigenous peoples are poised to shape the future. The multi-sensory embrace Rickard describes might be taken up in the context of VR as well. The question then becomes: In developing a more complex understanding of media and its entanglements, how do we reconcile the increasingly colonizing force of technology with its potential as a site for decolonial creation?

Scott Benesiinaabandan's *Blueberry Pie Under a Martian Sky* (2016a) illustrates VR's capacity to facilitate an embodied literacy of alternative time. Benesiinaabandan, an Anishinaabe artist and another AbTeC affiliate, produced this piece for the *2167* exhibition organized by the Initiative for Indigenous Futures (a programming offshoot of AbTeC), Pinnguaq, the Toronto International Film Festival, and the imagineNATIVE Film + Media Arts Festival.[13] In it, he takes us on a journey where images, language, voice, and narrative are all implemented to disrupt familiar coordinates of time and space. Benesiinaabandan threads a response to two Anishinaabe stories within the experimental narrative structure of *Blueberry Pie*. One tells of the Anishinaabe people's journey to Earth along a web woven by Spider Woman down from her home in the Seven Sisters; the other explains that one day, a young boy will travel back up the web and return to that place in the stars. Noticing that Spider Woman's web shares the properties of a wormhole, Benesiinaabandan envisions a future in which humans can travel through wormholes, and he invites users on a journey back up the web, to "the star world from where the original people descended." It is fitting that this tale of a journey to outer space—a story often structured according to the colonial tropes of a frontier narrative—is, for this Anishinaabe artist, a homecoming. The coupled stories told in *Blueberry Pie* are also mirrored in the double voice-overs, in English and Anishinaabemowin. Sometimes, these simultaneous audio tracks seem to be in conflict, rendering one another mutually unintelligible. On other occasions, their complementary rhythms bounce back and forth in polyphonic accord. Languages spoken simultaneously enunciate potentials for both conflict and coexistence while living together in multiplicity.

While the time travelling in *Blueberry Pie* is contextualized as such in voice-over, these informative words depart from the conventional voice-over that proclaims didactic authority. Instead, Benesiinaabandan uses voice-over to reflect on the ways that language itself is situated in

FIGURE 12.3 Untitled still from Scott Benesiinaabandan's *Blueberry Pie Under a Martian Sky* (360-degree video, 2017). Screen grab courtesy Scott Benesiinaabandan.

time. Rejecting the steady march of settler time, he looks back in order to imagine his future: "I considered 150 years in the past, and then tried to make a mental map of where we are as Anishinaabe people. ... How could we have conceived of where we are today 150 years ago?" (2017). Benesiinaabandan recalled taking language classes as a teenager and being amused by the Anishinaabemowin (Ojibwe) word for blueberry pie: *miini-baashkiminasigani-biitoosijigani-bakwezhigan* (see the *Ojibwe People's Dictionary* and Benesiinaabandan 2017). Whereas blueberry is simply *miin*, pie was not a concept familiar to the Anishinaabe people pre-contact—so they created a compound word combining roots from the Anishinaabemowin words for jam, layered, bread, and other terms. This word, and language in general, carries history within it. For people subjected to centuries of cultural genocide, to learn and speak Anishinaabemowin is to practice remembrance, sovereignty, and futurity. As our understandings of space, time, death, land, spirituality, and infinite other concepts become reconfigured in response to historical changes, language transforms accordingly. This reflection provoked Benesiinaabandan to consider: What concepts will Anishinaabemowin need to describe 150 years in the future? He collaborated with Indigenous language speakers Alan Corbiere and Roger Roulette to write the Anishinaabemowin voice-over for *Blueberry Pie Under a Martian Sky*, which in describing concepts like "wormhole" also had to consider

how Anishinaabe people's relationships to light, time, gravity, and home might be different in 150 years. Benesiinaabandan explains that he and Corbiere "built these narratives, in the scenes, around the idea that you're hearing future Anishinabemowin, or unheard Anishinabemowin from the future, which is just basically hundreds of light years away but simultaneously happening" (2017). Language in *Blueberry Pie* far exceeds its denotation, but like Spider Woman's wormhole, weaves the present toward a future that materializes the past.

The physical experience of *Blueberry Pie* is reinforced by its careful implementation of language, but initiated with its images, which are intended to reflect this distinct form of interstellar time travel: the wormhole. In her foundational essay "Aboriginal Narratives in Cyberspace," one of the first texts in which the possibilities for Indigenous resistance online were assessed, Cree/Métis scholar Loretta Todd points out that cyberspace's associations with escapism and disembodiment are both distinctly Western fantasies rooted in Cartesian logics, and must be rethought if digital media is to become an avenue for Indigenous self-determination. Indigenous transformation defies the myth of immateriality that governs digital imaginaries and instead "expresses how all life is interconnected; there is no disconnection from the material world" (1996, 182). Benesiinaabandan's *Blueberry Pie* takes up this Indigenous-futurist conception of history, implicating users' bodies in the constant passage from past to future—not constant in the sense of settler time's teleological rhythm, but constant because any action taken today simultaneously occurs and alters tomorrow. Though users of *Blueberry Pie* are immediately ripped from any coherent spatiotemporality and left to make sense of the virtual world Benesiinaabandan has built, the work hardly promotes disembodiment. Rather, it plays out a vision, one that maintains the body as an original site of experience but throws into question its familiar methods of orientation. (This is especially true for those habituated by settler epistemologies that regard space as a Euclidean grid, a series of longitudinal and latitudinal planes stretching across the world.) In VR, viewers must constantly negotiate the boundary between flesh and avatar, resulting in a form of embodied learning. What users initially see as a bird's nest in the opening moments of Benesiinaabandan's work quickly becomes the swirling, cyclic structure for our intergalactic travel through space and time (Figure 12.3). As the piece continues, our footing is never again established, and from

that first visual manipulation or cue, the artist takes us through various stages of unknowing. Making sense of the work is only possible through this active unknowing, which is primarily corporeal and contingent upon a willingness to abandon habituated modes of scalar orientation as the body gently passes over the surface of a teapot at the scale of a celestial object (Figure 12.4). Any clear distinction between time and space is eroded when we travel through a wormhole—a structure that enables time travel by folding incomprehensibly long spatiotemporal distances into one another. The understanding that time is passing, in whatever direction or many directions, cannot be distinguished from the body's occupation of space and the distinctly spatial movements that qualify—or allow us to recognize—change. As reads the Anishinaabemowin voice-over in *Blueberry Pie*, translated here into English, "We know that our minds will change. We know that we will forget things. That even these scrolls will not keep our descendants from forgetting some things about the original place. But there will be times when something inside them will stir. A frisson of connection between mind and body. And it is in that moment that we remember the original place."[14] In the Anishinaabe worldviews informing Benesiinaabandan's practice, time structures thought and especially memory through a corporeal interface, even as the body is also impacted by the temporal passageways Benesiinaabandan explores in *Blueberry Pie*. Likewise, VR foregrounds this synthesis of mind and body.

"Change," as Doxtator defines it in Rotinonhsyonni terms, "is not replacement, but incorporation and subsuming the structures of the past" (2001, 40). Because many Indigenous temporalities are distinctly spatial and material, they do not tolerate the repression of violent continuities that enables settler historicism's tactical amnesia—appearing tangibly in law, for example, in statutes of limitations and attempts to extinguish Aboriginal title. This logic of forgetting, or selective memory, has also motivated the exclusion of Indigenous histories and knowledges from the academy that Maskêgon-Iskwêw critiqued. In contrast to the settler view, intent on erasing its ongoing violence by emphasizing change, Loretta Todd uses the example of intergenerational teaching and knowledge acquisition as an exercise in memory that is fundamental to the notion of change over time in Indigenous cultures. She frames the multiplicity of Indigenous being-in-time as follows: "Each generation considers the consequences of its actions, of its presence not just on

FIGURE 12.4 Untitled still from Scott Benesiinaabandan's *Blueberry Pie Under a Martian Sky* (360-degree video, 2017). Screen grab courtesy Scott Benesiinaabandan.

the next generation, but often the generation five or seven times hence. What if with each technological advancement the question of its effect on the seventh generation was considered?" (1996, 185). This recalls Benesiinaabandan's questioning of how the Anishinaabe People's language will develop over 150 years, as well as the speculative narratives played out in *TimeTraveller*™ and the seventh-generation prerogative adhered to by AbTeC. In contrast to capitalist modes of speculation, *Blueberry Pie* stakes an Indigenous claim in the future not "for speed so much as sustainability, not so much for progress as balance, and not power but relation" (Cornum 2015). Benesiinaabandan, by foregrounding relationships between Indigenous futurities and VR's sensorium, answers the call of practice-based thinkers such as Jason Lewis, who has sought for Indigenous artists to "claim an agency" (2014, 63) in how new technologies are developed and implemented. Benesiinaabandan has alluded to this as a long-term goal, conveying to Anishinaabe curator Jaimie Isaac that his "highest aspiration" would be "If you can make it yourself … If you can have full control of your vision and image-making to expressly manifest exactly what you want to see, what you want to say … the individual future of new technologies" (2016c, 164). And we the authors are inclined to believe that the expansive understandings of space and time expressed by Indigenous artists and thinkers from various nations not only refuse the strangulation of settler time by performing temporal

sovereignty, but also wield the potential to reshape the ways we understand digital identity, representation, being, and relation.

CLOSING THE LOOP: FEEDBACK IN TIME, BODIES, COMPUTATION

"For Indigenous futurism," states Diné writer Lou Cornum, "technology is inextricable from the social" (2015). Even though we see in these works by Skawennati, Maskêgon-Iskwêw, and Benesiinaabandan a respective increase in the range of bodily engagement they each facilitate, made possible in large part by the formal structures that their chosen technologies (video, web, and VR) physically support, their true strength arises from an inherent sociality. This sociality is what allows the content of the works to reflect the multi-directional, nonlinear pathways of the technologies that host them. *TimeTraveller*™ is set in the shared online space of Second Life. Although it is experienced as linear media meant to be seen start to finish, it nonetheless activates a networked logic that refutes linear models of experience through, for example, its episodic format. Skawennati weaves an Indigenous future from the histories of relationships and stories so that the future is always in conversation with the past. *Speaking the Language of Spiders*, a collaborative net artwork, is equally composed by multiple authors, including the 14 artists cited in its development; it offers a view of time and temporality rooted in concurrent narratives, which fluctuate between those that are personal and those that are shared. The work's initial unifying force, Âhasiw Maskêgon-Iskwêw, brought the same social dynamic to subsequent projects *ConunDrum* and *Drumbeats to Drumbytes*. These different online territories allow us to see beyond the binary and imagine computation as an evolving network that is shaped by conversation and community. Benesiinaabandan's *Blueberry Pie*, though offline, is also the product of close collaboration between the artist and his community; the main output of that collaboration, the work's use of languages and voices—layered, overlapping, sometimes difficult to distinguish from each other—also stages a dialogical unfolding. These artists not only imagine but also afford experiences of simultaneity. They amplify their respective technologies' nonlinear foundations by involving a multiplicity of voices to mould and adapt to their respective projects. The projects are not only materialized by machines from design through reception but also co-produced by them, both enabled

and constrained by the possibilities that technical platforms open and foreclose. Crucially, the experiences they afford are out of sync with settler time, revealing how supposedly non-hegemonic ways of being in time occur, well, all the time. Like Allakariallak in *Nanook of the North*, they laugh at the colonial gatekeepers of technological modernity who fail to apprehend the continuities that ostensibly "new" media sustain—continuities in ways of knowing, relating to, and being in the world that far precede the colonization of the land we live and work on.

The potentials for computational technology—and the future itself—to house multiplicity are being stifled by a corporate technocracy that has extended the colonial project into cyberspace, driven by the imperatives of commensuration and profit. The artists and scholars we have highlighted here help us understand that seeking recognition within this circumscribed framework would only continue to deprive Indigenous people of opportunities for self-determination. Instead, Skawennati, Maskêgon-Iskwêw, and Benesiinaabandan offer visions of sovereign Indigenous futures governed by principles of responsibility and relationality. They show us that collaborating with digital technologies opens promising pathways along which to actualize those futures. In this work, we see an incentive for users to act in tandem with the imaginative foundations and possibilities of networks, and not necessarily the so-called information superhighway built on top of it (a distinctly colonial impulse, to build at any cost). Rather than attempting to keep pace with the accelerating logic of the update, these artists have used their histories and knowledge to manipulate digital movements, slow them down, and listen carefully to the environments that run beneath the noise. This is where we can locate the notion of digital corporeality. Time, in *TimeTraveller*™, *Speaking the Language of Spiders*, and *Blueberry Pie Under a Martian Sky*, is sculpted by bodies, human and other-than-human, and their social relationships. Just as the Western cultural dream of digitality yearns for disembodiment, settler society disengages from matters of the body, abstracting time from experience and casting it as a transcendent force unaffected by social and material relations. In contrast, the Indigenous temporalities we have examined make ample room for feedback—and in the process of building better worlds both virtual and physical, the importance of feedback cannot be overstated.

NOTES

1 The practice of salvage ethnography is often associated with the works of anthropologist Franz Boas and photographer Edward Curtis. For critical writings on this topic, see, for example, Fatimah Tobing Rony, *The Third Eye: Race, Cinema, and Ethnographic Spectacle* (Durham: Duke University Press, 1996) and Pauline Wakeham, *Taxidermic Signs: Reconstructing Aboriginality* (Minneapolis: University of Minnesota Press, 2008). On Indigenous artistic responses to this practice, see Carol Payne and Jeffrey Thomas, "Aboriginal Interventions into the Photographic Archives: A Dialogue between Carol Payne and Jeffrey Thomas," *Visual Resources: An International Journal on Images and Their Uses* 18, no. 2 (2002): 109–25.

2 For example, see Lev Manovich, *The Language of New Media* (Cambridge: MIT Press, 2001) and Mark B.N. Hansen, *New Philosophy for New Media* (Cambridge: MIT Press, 2004).

3 On the concept of "survivance" as a response to colonial representations of "the Indian," see Gerald Vizenor, *Manifest Matters: Narratives on Postindian Survivance* (Lincoln: University of Nebraska Press, 1999).

4 For a critique of this tendency, see "Tactic 3, Corollary," in Kavita Philip, Lilly Irani, and Paul Dourish, "Postcolonial Computing: A Tactical Survey," *Science, Technology, & Human Values* 37, no. 1 (2012): 15–17.

5 We refer to Skawennati Tricia Fragnito by her first name, Skawennati, the name she most commonly uses in a professional art context.

6 Turtle Island is a term derived from Haudenosaunee, Anishinaabe, and other Indigenous creation stories and is used to describe the North American continent without recourse to settler-colonial paradigms.

7 Second Life is one of the largest online virtual worlds, with approximately one million regular users. Users can create avatars, interact with one another, build three-dimensional virtual objects, and purchase virtual property. See Linden Lab, "Second Life," accessed December 15, 2018, www.secondlife.com.

8 On the Canadian cultural myth of the "Imaginary Indian," see Daniel Francis, *The Imaginary Indian: The Image of the Indian in Canadian Culture* (Vancouver: Arsenal Pulp Press, 1992).

9 Âhasiw Maskêgon-Iskwêw initiated the first version of this project in 1996. The version we describe and reference here is the most recently accessible version last updated in 2012.

10 This is according to an account given by their mutual colleague and a significant force in the development of Indigenous media art, Archer

Pechawis, from Mistawasis First Nation in Saskatchewan. See Pechawis et al. 2017.

11 These changes are as described by the artist in personal communication with one of the authors.

12 *Speaking the Language of Spiders* can be accessed at http://spiderlanguage .net/. It is currently under the care of Cheryl L'Hirondelle and was undergoing updates at the time this publication went to print.

13 The imagineNATIVE Film + Media Arts Festival is an Indigenous media arts organization, registered charity, and annual festival for Indigenous-made screen-based work. The organization is based out of Toronto, and is recognized both locally and internationally for its championing of Indigenous media producers. See http://www.imaginenative.org/.

14 Translation provided by Scott Benesiinaabandan. The Anishinaabe-mowin voice-over reads: "Gigikendaamin da-aanjisewan ayinendamang. Gigikendaamin giga-waniikemin gegoon. Abooshke ono baakiiginiganan, gaawiin gidaanikoobijiganinaanig oga-wiiji'igosiinaawaa' ji-waniikesigwaa gegoon wenjida-aya'iing. Apiichinaag idash gegoo obiinji-ayaawiniwaang da-ojijiseni. Gekendaagwak inendamowining zhigwa wiiyawing. Mii apii ge-maamikawiseyang wenjida-ayaawin."

Careful Images: Unsettling Testimony in the Gladue Video Project

Eugenia Kisin and Lisa Jackson

Billy is sitting in his living room, facing a video camera. Behind him, a rack displays neatly stacked pairs of shoes, and three works of art—a print, a Northwest Coast–style carving, and a weaving—decorate his wall. Billy's expression is amicable, softly illuminated as he speaks about his childhood in rural Newfoundland, and his complex Native identity.[1] He tells the story of his adoption by poor, evangelical white Christian parents who could not read. They taught him how to hunt, fish, and grow potatoes. Working with rabbit skins, he learned how to make moccasins from instructions in a book. Billy also describes the fear he felt as a child when his adoptive parents spoke in tongues, and notes his life-long struggle with depression.

Billy also speaks of his friendships with other Indigenous folks who left the reserve to live in the city, and of his emerging political consciousness: "I want to do something significant for Native causes," he says, suggesting that he would like to join an anti-pipeline protest in British Columbia. He talks about his art collecting, and unfurls and displays a "Greatest Indians" poster with the help of Zoe, his friend and legal surety, who is also being interviewed. "I trust [Billy] as a person," Zoe says. She has already explained that his fish are "actually descendants of mine," suggesting forms of kinship in Billy's life that include human and nonhuman relationships. Billy strokes his cat on his lap with both hands: "I just want to get my home back in shape, take care of my

cat, and see if I can finish the hepatitis [treatment], now that I'm [HIV] undetectable." He laughs. "A new liver, eh, kitty cat?"

The video documentation of Billy's interview, which was carried out by Lisa Jackson, filmmaker and co-author of this chapter, is a moving portrayal of a complex life. While it makes plain the hardships of Billy's situation, including his drug use, legal problems, and alienation from his community, these do not determine his personhood. Instead, Billy comes across as a generous man for whom collecting art, love for animals, and sense of justice for the marginalized are defining qualities.

This video is also a form of testimony, a sincere and legally legible document of truth. It is the first video that Jackson produced for a video advocacy pilot project with Osgoode Hall Law School at York University in Toronto in 2015 called the Gladue Video Project, after the reports and processes that are now mandatory in court cases involving Aboriginal offenders; the name for both the videos and the reports comes from the 1999 Supreme Court ruling *R. v. Gladue*. An experiment in legal video advocacy, the Gladue Video Project was an attempt to humanize offenders through the representational medium of film, situating their actions within a broader frame of marginalization, ongoing settler-colonial oppression, and potential for support and repair. As Lisa explains, "these videos aim to give judges a more complete sense of the person before them and their background, along with what community supports may be available, so that the court can come up with any appropriate alternatives to jail."[2] In this way, the Gladue Video Project was part of more widespread attempts to reduce the disproportionate numbers of Aboriginal people in prison through what is often called sentencing mitigation in a legal context.

The initial project did not go very far. To date, Billy's portrait is the only complete Gladue video in existence, and neither Lisa nor Osgoode Hall has any plans to make more. But what we want to suggest in this article is that Billy's video, and the project more generally, continue to be important media-based interventions, especially in light of recent devastating legal outcomes involving Indigenous people in Canada's courtrooms following the deaths of Colten Boushie, a 22-year-old Cree man, and Tina Fontaine, a 15-year-old First Nations girl. It has been powerfully argued elsewhere that these legal processes perpetuated white settler racist courtroom practices and draw on systemic biases against Indigenous people in Canadian legal contexts.[3] Citing these moments of

outrage in the context of the Gladue process, we do not mean to open up arguments about the fairness of the rulings in either case. Rather, we wish to point out how both events were experienced by many Indigenous people and non-Indigenous allies as evidence of deep flaws in the justice system, and as particularly at odds with the recent Truth and Reconciliation Commission's calls to action. This was especially true in the Fontaine case, whose outcome cast yet another shadow over the National Inquiry into Murdered and Missing Indigenous Women and Girls. Importantly, the perceived injustice of these rulings was also heavily mediated: it was amplified through live-tweeted protests, as critiques of the verdicts circulated widely through Aboriginal and non-Aboriginal news outlets. As a form of Indigenous media that has complex potential as legal evidence, Gladue videos like Billy's must be understood within this larger mediascape,[4] in which a pathologized Indigenous identity and inherited trauma continues to shape the "outsider" impression of Aboriginal persons, and also ideas of what counts as testimony in the current moment that is shaped by discourses of reconciliation.

In this chapter on the Gladue Video Project, we expand on this volume's emphasis on the dynamics of insiders and outsiders, as well as the notion of extraction in visual culture, in order to consider the legal context as a storytelling space, analogous to others in this book, that is shot through with persuasive power, theatricality, and complex social relations of production and circulation. We all sit under stories, and conflicts about who can tell which stories to claim persuasive power and voice at the heart of insider-outsider dynamics in the courtroom, too. In our analysis of the work of the visual in a legal setting, we propose the descriptive phrase "careful images" to think about the Gladue Video Project as a practice rather than just a formal outcome. In our usage, the "care" in careful signals more than mere patience; rather, we follow Métis anthropologist Zoe Todd's citation of Cree legal scholars Tracey Lindberg and Val Napoleon as she (Todd) defines care as integral to legal practices through "principles of loving accountability of reciprocity" (2016b). In this way, careful images are also those that have the capacity to enact justice across settler and Indigenous legal orders. Drawing on decades of engaged media scholarship on "visual sovereignty," a concept developed by Tuscarora art historian Jolene Rickard (1995) to articulate the relationship of visual culture to political self-determination,[5] we also follow a view of media-making that insists

on its political and social meaning beyond its capacity as representation. Media anthropologist Faye Ginsburg's (1998) idea of "embedded aesthetics" is also helpful here, as it locates part of Indigenous film's aesthetic value in its kin-making capacities off-screen. Building on such assertions of value beyond more quantifiable effects, we argue that images like Jackson's day-in-the-life portrait of Billy try to be both "careful" in the way that they enact compassion for their subject and also in how they are careful about re-enacting an Indigenous identity that is tied too uncomplicatedly to victimhood and trauma in many contexts of testimony.

At the same time, we also explain how the justice of such careful images may be profoundly at odds with legal regimes of knowledge and power—how a portrayal that over-emphasizes an offender's potential for rehabilitation, for instance, might be perceived as unfairly biasing a judge during sentencing. We are not dismissive of these potential pitfalls and the difficult questions they raise about objectivity in the justice system. On the contrary, we see these points of disjuncture between the need for careful images and the court's uneasiness as a generative space of dialogue between what may be, in the end, incommensurable ways of knowing the truth. However, we remain optimistic about video's role in intervening into long-held forms of systemic institutional bias, and also about smaller scale cultural outcomes, such as contributing to a sense of dignity on the part of the accused, and a reframing of themselves through the multiple points of intersection of storytelling and the law. Literary and Indigenous studies scholar Cheryl Suzack (2017) has powerfully argued that these intersections of legal, political, and personal narrative lead to the formation of critical Indigenous legal subjects in the settler state. Our project also raises the question of what an archive of careful images might enable in terms of recognizing mutual entanglement, complicity, and care. We argue that these less tangible or measurable aspects of the project should matter, too, in any reassessment of the project's outcomes and in its potential futures.

In this chapter, we present an interpretation of the Gladue Video Project first in relation to the broader frame of video legal advocacy; second, in terms of the formal characteristics that make it "careful" in several senses; and finally, in terms of the outcomes and futures that are suggested by this experiment in visual sovereignty, and how these may work against standardizing forms for testimony and its colonial context.

Finally, our collaboration in writing this initial analysis of the project also offers an insider/outsider perspective on Indigenous media worlds in Canada. Drawing on our complementary and overlapping but differently situated knowledges—Lisa as Indigenous filmmaker responsible for the Gladue pilot project, and Eugenia as non-Indigenous scholar of contemporary art and media worlds—this article also productively complicates both of our positions. Our collaboration reflects a shared commitment to the values of this project, and to articulating it for a broader audience; as a result of interviews and conversations with all those involved in the Gladue Video Project in writing this piece, we also feel accountable to telling Billy's story in a way that captures the truth of his experience, and of ours, as witnesses to a changing media and legal landscape.

THE *GLADUE* DECISION AND GLADUE VIDEOS

Starting in 1996, amendments to Canada's Criminal Code required judges to take into account the Aboriginal status of offenders in their sentencing in an effort to reduce the disproportionately high number of Aboriginal peoples in prison.[6] In 1999 the Supreme Court ruling in *R. v. Gladue*, a case on appeal involving an assault of an Aboriginal man by an Aboriginal woman, affirmed these sentencing procedures through an interpretation of the amended section of the Criminal Code. *Gladue* explicitly required that sentencing of Aboriginal offenders reflect the knowledge of how their experiences have been shaped by ongoing colonial violence and oppression in Canada, and led to an acknowledgement of "Gladue principles." This consideration is summarized in the *Gladue* decision in the following way:

> In sentencing an aboriginal offender, the judge must consider: (a) the unique systemic or background factors which may have played a part in bringing the particular aboriginal offender before the courts; and (b) the types of sentencing procedures and sanctions which may be appropriate in the circumstances for the offender because of his or her particular aboriginal heritage or connection.[7]

Gladue goes on to note that the sentencing judge will require specific information about the accused in order to take these social and systemic factors into consideration.[8] The decision is less clear on how

this information is to be assembled, suggesting that "judges may take judicial notice of the broad systemic and background factors affecting aboriginal people, and of the priority given in aboriginal cultures to a restorative approach to sentencing," while also considering "in the usual course of events" specific details about the accused's life experiences.[9]

From an interpretive perspective, the phrasing "in the usual course of events" and a provision of *Gladue* that "the offender may waive the gathering of that information" leave open a great deal of space and uncertainty for how this requirement is to be applied in practice. Indeed, Gladue principles and reports since the 1999 ruling have been very unevenly applied across the criminal justice system, and their effects have not yet been adequately studied.[10] Ontario, British Columbia, and Yukon have special Gladue courts and provincial funding dedicated to the writing of Gladue reports, while other provinces and territories have not implemented principles; Manitoba and Québec declined to participate in the Department of Justice's only cross-jurisdiction study of the implementation of Gladue principles, carried out in 2013. Almost 20 years after *R. v. Gladue*, lawyers and journalists are still pointing out the lack of national standards or even best practices for the application of Gladue principles and reporting.[11]

As a lawyer and Aboriginal Legal Services of Toronto (ALS) program director, Jonathan Rudin has argued the application of Gladue principles depends primarily on information, and that in practice, this information is difficult to procure for a variety of reasons including lack of funding, inadequate law school training for lawyers in Gladue report writing (and, on the whole, in pre-sentence reporting), and the fact that many legal aid plans end at a guilty plea. Indeed, counsel are not paid extra for sentencing, which poses a structural impediment to the gathering and preparation of information because there is less financial incentive to do so (Rudin 2008, 703). Rudin also points out that *Gladue's* uneven application and outcomes cannot be detached from the ways in which the decision has intersected with a number of live political questions. For example, as *R. v. Gladue* suggests that a different methodology of sentencing for Aboriginal offenders will not necessarily lead to reduced jail times, many interpreted cases involving violent crime as rendering the difference in sentencing procedures irrelevant—a reduction that Rudin points out is at odds with the problem that the decision was trying to solve, which *was* the over-incarceration of Indigenous

peoples, rendering this section of the decision confusing and open to political debate. Similarly, as Debra Parkes and David Milward have argued in their review of *Gladue*'s poor implementation in Manitoba, many "Gladue myths" persist in the province that have to do with this conviction that *Gladue* should not apply in violent cases, or, even more insidiously, make the argument that prison "works" for rehabilitating Aboriginal offenders (Parkes and Milward 2012). For all these reasons, applying *Gladue* has been a profoundly *social* challenge that goes far beyond its interpretation in the law.

FILM AT OSGOODE AND THE GLADUE VIDEO PROJECT

It was into this broader social and institutional context that the Gladue Video Project attempted to intervene. In 2011 the Law.Arts.Culture space at Osgoode Hall had hosted Regina Austin, a law professor from the University of Pennsylvania, to speak about her groundbreaking work with video advocacy for pardons in the American criminal justice system.[12] This work struck many at Osgoode as being a good fit for what then-dean Lorne Sossin, now Justice Sossin of the Court of Appeal for Ontario, saw as the school's focus on working with marginalized communities and its emphasis on experiential learning and legal aid clinics. Following this initial interest, in 2015 Osgoode Hall Law School received a donation from Kathryn Podrebarac of Podrebarac Barristers Professional Corporation, a litigation and arbitration firm, to establish an endowed Fund for Innovation in Law and Media (FILM). FILM was intended to develop experiential education programs for students that would connect law and social justice, and also contribute to public education and legal outcomes through video advocacy.[13] The Gladue Video Project, also called the Gladue Documentary Project in some of Osgoode's press materials, was the pilot program of FILM. Based on her award-winning work as a documentary filmmaker on Indigenous topics and social issues, Lisa received a fellowship from Osgoode to serve as the project's director and carry out an initial proof-of-concept video.

In preparation for the project, Lisa convened a roundtable in September of 2015 with representatives from the law school, including Sossin, as well as several members of the Indigenous Bar Association and the Criminal Lawyers' Association, to determine the project's goals and protocols. In an overview of the project that came out of the roundtable, Lisa and Sossin explain that the Gladue Video Project was an ideal fit

with the FILM program because it would advance social justice through media in several different ways. First, given the many barriers to implementing Gladue principles, it would support the Gladue report process by supplementing the written reports with another kind of first-person narrative that would enhance the judge's understanding of the offender's life. In general, such narratives would also permit the offender to have a voice in court that is less silenced by the rigid formality of the courtroom performance, enacting agency in what can be a profoundly alienating process. Second, the project would give visibility to the Gladue process overall, fulfilling the public education goals of the broader FILM program.

Finally—and of broader interest to us here—the project would embody larger goals of visual legal advocacy in the justice system, including extending the recent Truth and Reconciliation Commission (TRC) on Indian Residential Schools' unprecedented use of visual testimony.[14] In an interview with Eugenia, Sossin echoed the importance of this goal in relation to others, describing the project as "trying to make in-roads in our journey to Reconciliation, Indigenous rights, and, of course, the over-representation of Indigenous peoples in the criminal justice system." Reflecting on this logic, he went on, "Why not go where the needs are greatest and where the tradition of law and art being intertwined is also the deepest?"[15]

This connection to the "journey to reconciliation" and Indigenous traditions of art and law is significant, we suggest, as it reflects larger contexts of importance for the project, and, indeed, for the contested media landscape that this book documents. As Dylan Robinson and Keavy Martin have argued (2016), reconciliation in Canada has brought together opposing meanings of aesthetic experience as both detached contemplation and sensuous bodily experience through the practice of gathering and displaying testimony. We suggest that Osgoode's decision to move forward with a deliberate activation of such relations represents a shift in how the efficacies of images—and art—are understood in the wake of reconciliation. While many, including us, are rightly skeptical of the claim that simply including Indigenous understandings of art and law leads to reconciliation in the justice system, it does seem to be a space for thinking more expansively and creatively about unsettling current legal regimes that depend on particular understandings of knowledge and vision.

Two important premises from the project's beginnings related to the larger context of the *Gladue* decision also warrant emphasis. First, as Jackson has asserted elsewhere, the Gladue videos are *not* meant to replace written Gladue reports; rather, she describes video as a tool to bring depth to the offender's life story, particularly as it relates to their experience of their community, whether on or off reserve.[16] This capacity of film is particularly important to us in light of the *Gladue* decision's insistence that "community" be defined "broadly so as to include any network of support and interaction that might be available, including one in an urban centre,"[17] thereby allowing for a belonging-based rather than essentializing definition of Indigenous identity. This particular definition of community also suggests that although trauma is explicitly related to Indigenous identity in Gladue reporting, identity is not reduced to a pathologized victimhood, since the potential explored in the Gladue Video Project is the subject's capacity for interconnection rather than individualization of a traumatic social context.

Participants in the Osgoode roundtable also agreed that the initial selection of the subject for the pilot should be someone who has not been accused of a violent crime, and ideally would be involved in a court setting where there is a good relationship between Crown and defence counsel, in order to avoid raising the issue of *Gladue*'s more controversial interpretations as advancing a radical abolitionist approach within the justice system—which, as we have pointed out, is but one of many potential meanings of the video project's humanizing potential. This was how Billy, who had had little previous contact with the justice system and was not involved in any violent crime, was chosen for the pilot.

Yet the Gladue Video Project also raised several questions for those involved that are legible in these protocols and in the Memorandum of Understanding (MOU) between Osgoode Hall and Aboriginal Legal Services (ALS), a Toronto-based organization devoted to increasing Indigenous peoples' access to justice, which is signed by Jackson, Sossin, and also Rudin, in his capacity as director of ALS. Echoing the assertion that the video will supplement an already-existing written Gladue report, the MOU emphasizes that ALS will work with the defence and Crown counsel to obtain consent to show the video, and also that the video should *not* include a discussion of the subject's offence. While this is clearly evidence of a good working relationship between all parties

FIGURE 13.1 Close-up of Billy's hands. Video still courtesy Lisa Jackson.

involved, it also begs the question of why such particular standards need apply in the case of the pilot video, particularly since the implementation and guidelines for written Gladue reports are so differently interpreted across the legal landscape; indeed, although ALS has its own policies on writing such reports, they are not the only ones currently in use.[18]

We wish to be very clear that noting these divergences is not meant as a critique of the process of Gladue reporting. Rather, we suggest that the degree of thought, care, and work on these guidelines—which are still very much in flux—have partly to do with broader tensions around the role of video in legal advocacy, and the space that has been created for alternative forms of testimony in the wake of *Gladue* and the TRC.

LAW AND NARRATIVE

For all of its theatrical and ritual elements, law—at least in the traditions shaped by British common law—has always held a profound ambivalence toward images and their power. Art historians Costas Douzinas and Linda Nead connect this ambivalence to a tension between the notion of the self as a legal person before an impartial court, and the self in art, which is "free, desiring, corporeal, [possessing] gender and history" (1999, 3). They explain how "justice must be blindfolded to avoid the temptation to see the face that comes to the law and put the unique characteristics of the concrete person before the abstract law of the institutions" (3). This is not to say that this distinction is not challenged in

practice; indeed, in addition to the ways that the "desiring self" is, in fact, *always* present in courtroom arguments, the very existence of an interest in visual legal advocacy is a testament to an interest in overcoming this ambivalence. Speaking of legal doctrines as narrative arcs, Sossin goes so far as to assert that they "should be seen on this kind of continuum of different artistic expressions."[19]

This becomes, then, a question of how narrative power is to be wielded, and how conventions of what is considered admissible are changing. In a recent article about sentencing mitigation videos, Regina Austin, whose work in the Penn Law program on Documentaries and the Law inspired the Osgoode program, notes that such videos are a "hybrid of traditional legal advocacy and the effective use of audiovisual technology for the dissemination of evidence and for legal persuasion" (2014, 11). Because of this hybrid nature, Austin argues that sentencing mitigation videos must first and foremost meet *legal* standards of evidence, particularly those around consent and how best to represent *nonlegal* aspects of the person; indeed, as we saw in the Osgoode MOU, there was also a preoccupation with how consent could be determined across a range of institutions with interests in *Gladue*. Advocacy is itself also a problematized and much-discussed frame in the context of Gladue reporting practices. Indeed, while Jackson was working on the video project, she repeatedly had to assert the objectivity of the videos in distinction with visual advocacy, which is understood to be biased in favour of the accused rather than providing a contextualized vision of a human life in all its messiness, fallibility, and dignity. This is also a known issue that recent studies of the effectiveness of Gladue reports have raised. For instance, in a 2011 Legal Services Society of British Columbia study, some Crown counsels articulated their concern that written reports seemed to advocate for particular kinds of non-jail sentences, therefore biasing them toward defence positions.[20]

One could raise the objection following Rudin's analysis discussed above that this is a strange worry, since the whole point of the Gladue process is to correct bias that leads to over-incarceration—in other words, of course Gladue reports would advocate for, and most importantly, provide evidence for the subject's capacity to benefit from non-custodial sentences. Indeed, such paradoxes seem to be at the heart of how sentencing mitigation is worried about in legal contexts. To us, this suggests a profound uneasiness with "advocacy" that is tied up with

being able to tell *when* and *how* an argument has been constructed—a capacity for discernment that exists for text-based forms in legal contexts, but, as Austin argues, does not necessarily extend to visual literacy.

It is also significant that Austin's discussions of "image ethics," or procedures for ensuring that production is not exploitative, are rooted in visual anthropology. Specifically, she cites visual anthropologist Sarah Pink's emphasis on the norms of reciprocity, or "giving back," during the necessarily collaborative work that making video entails (Austin 2014, 11).[21] It is these collaborative requirements that have led Ginsburg and other anthropology of media scholars to argue that visual anthropology is itself a collaborative genre that has been forced to contend with the shared power and obligation of making representations that are accessible in a way that a scholarly monograph—or, for that matter, a written legal report—may not be.[22] To us, this recontextualization of image ethics from anthropology in law is intriguing, because it suggests that the off-screen relations of production are just as important to sentencing mitigation as a *practice* that has meaningful outcomes that are less tangible and measurable than just reducing the over-representation of Aboriginal offenders in prisons.[23]

CAREFUL CONVENTIONS

It is perhaps the intangibility or excess of the visual medium that leads to stricter formal conventions that surround the Gladue Video Project, particularly with regard to transparency. As outlined in the Osgoode document on the scope of the project, editing, and its perceived presence and extent, is a key problematic for the Gladue videos since there is a widespread acknowledgement that written Gladue reports are *not* edited; indeed, the latter are presented to judges in quotations, suggesting that they are affidavit-like in their status as personal statements. For this reason, the Osgoode document asserts its position that "transparency can be achieved by disclosing the fact of editing and ensuring the edited video meets the threshold of a fair and accurate portrayal of the interviews conducted." In other words, there is a self-consciousness of editing that is required in film in a way that is not expected with regard to the written reports.

What this "fair and accurate portrayal" meant in practice for the pilot was, on Lisa's part, an attempt at spare, minimal formal conventions. Although the narrative *is* temporally edited, inasmuch as it is pieced

together in an order different from which it was shot, there is no musical score in the video, and no transitions that would suggest creative interpretation on the part of the filmmaker. Twice, Billy's voice is layered over still photographs—one of him as a young boy, smiling, and two showing his reunion with his birth mother, whom he met for the first time when he was 19—to illustrate the period in his life that he is narrating, and how these changes are materialized in his family album. Zoe, his surety, is shown both speaking about Billy and speaking with Billy as they pick through gleaned items together on his bed; her dual portrayal gives the impression that she is not just providing an expert opinion on his capacity for rehabilitation—an allowable aspect of the video project—but is also there as someone who likes and cares deeply for him, and might indeed have been at his apartment on a typical "day-in-the-life"—the *cinéma-vérité* convention that Jackson cites for its minimal intervention. Crucially, the overall effect is one of possibility rather than argumentation: we see Billy's capacity for meaningful relations with his community as potentially rehabilitative, and in accordance with his wish to get his home back in shape and take care of his cat.

At the same time, it is also worth noting that argumentation—the shaping of a narrative to persuade—is present in even written reports. As Austin has argued, sentencing mitigation evidence is, by its very nature, "a mixture of fact, opinion, and a plea for mercy that can span a wide frame of time, distance, and relations" (2014, 48); in this capacity, they are meant to show an offender's rehabilitative potential, and not their irredeemable traumatization. This tension is *why* such images need to be seen as taking more care in displaying the complex, humanizing, and not always redemptive pieces of a person's life.

This is particularly the case with what are colloquially known in court as "Gladue factors," any individual, social, or systemic factors that bring an individual before the court, including systemic forms of trauma, such as residential school histories or forced removal from one's family and community by adoptive services. Such "factors" form a curious tautology in thinking about sentencing mitigation: they are the reasons that the Aboriginal offender may have been brought before the court and are barriers to the person's full functioning in society. At the same time, they are part of the evidence for a judge to be more open to rehabilitative options that reconnect an offender with the community. We see in these paradoxical expectations a troubling example of what Elizabeth

FIGURE 13.2 Billy's cat. Video still courtesy Lisa Jackson.

Povinelli (2002) calls the "cunning" of recognition in legal cases involving Aboriginal offenders in her work in Australia, which has many parallels with Canada in the settler adjudication of trauma in the case of the Stolen Generation. Povinelli identifies the impossible expectation of performing an "Aboriginality" that one does not have precisely because of colonial violence—as the only reliable evidence of possessing this identity in an authentic way. Here, the "cunning" of the law is to require a performance of *both* cultural loss that reduces the offender's individual moral culpability for the crime, and a potential for repair that is located beyond the individual in the broader community.

In recognizing why such a performance may be harmful, it is useful to connect it with a larger mediascape of testimony in the wake of the TRC, and the ways in which such paradoxical performances may be newly naturalized. In an article on *Blackwater v. Plint*, a landmark court case in which residential school survivors sued Canada and the United Church for injuries sustained as students, legal anthropologist Carole Blackburn (2012) makes the important theoretical point that connecting injury and Indigeneity risks reifying injury and harm as the default setting of what it means to be Indigenous in court. In this way, the Gladue process also runs the risk of both reifying an injured Aboriginality and requiring its performance in a way that may be, in fact, impossible, since

the same colonial dynamics that produce the conditions of loss and harm may also reduce the offender's capacity for rehabilitation.

Attending to video as a practice, however, allows us to see how such legal traps are also unsettled by people who must negotiate their position within the system of law and its normative forms of knowledge. For instance, reflecting on his own experience with the Gladue reporting process, Billy also troubled the equation of legal text with greater objectivity. Noting his sympathy for the process of gathering the written reports whose lack of resources mean that the process felt "rushed," he observed that it was much easier to represent memory and feelings on film. "What you say and what they write down is two different things," he explained. "[If] I only see on a piece of paper, writing down 'good morning' ... well, hearing the voice, 'good morning' can mean such a hell of a lot more. You could be pissed off, you could be jumping for fucking joy, you could be overwhelmed, you could be angry, or you could be downright sad ... that's emotions that could be played through speech or visual, which putting up a sign 'good morning' just doesn't work." He also described the written report as more "chronological" as focused on "cause and effect," rather than on the truth of his person or the complexity of his "mixed memories."[24]

Billy went on to note that this distance between what is transcribed and what it meant is often used deliberately in the courtroom, describing the proceedings as a "game" in which strategy, emotion, and documentation all play a role. "It's their own private party up there with the judge, the two lawyers, and the two stenographers." Including the stenographers in this formulation highlights his awareness of the powerful role played by text in court, which he also challenges more directly on the basis of its potential for manipulation, particularly in the case of already marginalized offenders who may be reticent or trying to think of anything to say to save themselves. Linking the potential for misrepresentation and coercion, he asks, "How many times have things been written down, documents signed illegally by people, and carried in, and okayed by the court, because 'it was written down, your Honour'?"

Billy's experience reveals the difference between fact and truth. Inasmuch as documentary film attempts to get at the latter, the Gladue videos tell a different kind of story, one that humanizes rather than represents a correlative relationship between "Gladue factors" and either criminal activity or potential for rehabilitation. We suggest that Billy's video

presents an alternative visual sovereignty that refuses these traps, troubling how we think about kin relations as either traumatic or redemptive. The moment in the film with the two photographs of Billy and his mother illustrates this particularly well. The first image is a photo-booth portrait, in which she appears glamorous and determined from behind her oversized sunglasses while a young adult Billy looks up from a slightly lower position in the frame, his long hair moving toward but not quite touching her cheek. In the second, which is framed and printed with a novelty text border that reads "WANTED: DEAD OR ALIVE," Billy and his mother are older, their hair greying, heads together as they look at the camera; in this one, Billy looks out over the top of a pair of aviator sunglasses, which adds to the playful quality of the photograph's framing, and to the conspiratorial trust that appears between them in this moment. Although Billy's voice-over is telling a painful story of the loss of his community—his adult reunion with his mother, her husband, and his brother is followed by an assessment of things as "rough, and up and down"—these images show another side of the repair of his relationship with his mother, which seems even more caring and genuine for the fact of its complicated nature, and her apparent strength.

In this context, it is also significant that the film refuses to choose between different kinds of kinship in narrating resilience. This emphasis very much extends on themes in Lisa's work as a filmmaker. For instance, two of her well-known short films, *Savage* (2009), which represents a young girl's experience in a residential school through a surreal mix of a mother's grief and schoolmates' playful solidarity in the face of abuse, and *Suckerfish* (2004), a moving and funny meditation on Jackson's own relationship with her mother's depression, focus on the complex ties and emotions that have been generated out of kinship networks scrambled by colonial violence.[25] Lisa describes this deliberate mixture of affect, humour, and loss as an ongoing concern in her work with both conveying and respecting the level of trauma as well as the human beyond the trauma of the person.

Much in this way, Billy's reunion with his Native birth mother is shown to be as complicated and *important* as his relationships with his white adoptive parents. Indeed, in the longer interview Lisa did with Billy, he speaks fondly of wanting to return to Newfoundland to visit his adoptive grandmother, and of his guilt at not being there for his adoptive father's death.[26]

We also learn in this longer interview that Billy's politicization around pipelines was formed through therapeutic work with a white counsellor in the wake of the Oka siege, the series of violent clashes between the Canadian armed forces and Mohawk citizens in 1990 that had resulted from long-standing settler exclusions and erasures of Indigenous sovereignty.[27] While this source is not necessarily relevant to the fact of Billy's wishing for greater political participation—and indeed did not make it into the final cut of the video—it is nevertheless significant as a document of the ways in which political identities and positions are entangled with broader therapeutic and historical contexts. In other words, it is important to emphasize that "Gladue factors" not only do the legal work of complicating moral responsibility for a crime, but also generate spaces for sentencing options through the multiple points of connection to social and political worlds.

In all these ways, film, and the relations it generates both on- and off-screen, may hold trauma and resilience together in the same frame without reducing one story to the other. Rather than an overreaching genre claim, this capacity is what we mean by careful images, and why we suggest that a reduction of Gladue reporting to "Gladue factors" is not the only thing sentencing mitigation techniques could be working toward.

Cut to another image, captured in our memories and reconstructed from an audio recording: Billy is in his living room with us and with Zoe, reflecting on his experiences with the video project. This time, his Indigenous art collection is beautifully showcased amid a Persian carpet, dark wooden furniture, and portraits of the Royal family, all of which he recently got from a hotel auction; he plans to sell the portraits that are neatly propped up against a wall. There is certainly an irony to this material evidence of the Crown; but sitting among these odd components feels cozy, an expression of a collector's delight in old and gleaned objects.

We all spoke about many things that afternoon, including how film is a more truthful medium, which can be good or bad, depending on the side of the camera one is on; about Billy's difficulty in finding work other than selling things he has collected; and about the possibility of him working in an Indigenous community garden. Lisa, Billy, and Zoe all remember the emotional power of the moment that Billy's Gladue video was shown during his sentencing—in Lisa's words, "something landed in that moment in the room." Billy and Zoe also express their

hopefulness that our writing about the Gladue Video Project will do the work of keeping it part of a national conversation about Indigenous sentencing and legal advocacy, including video advocacy. Zoe makes the important point that she was in fact able to recommend the Gladue reporting process to the son of a friend when his lawyer did not: "Just to have access, you need to have knowledge."[28]

CONCLUSIONS

We conclude with this exchange because it shows how the Gladue process is a space where emotion and law are entangled. It is perhaps this emotional capacity that continues to create trouble for visual legal advocacy more broadly, as the sentimental dimension of a person before you on film, shown at their most eloquent and reflexive about their own circumstances, is differently affecting than reading a written report in a courtroom. It is beyond the scope of this chapter to think about how the Gladue process might transform our expectations of admissible legal performance in ways that would move toward more restorative justice models; however, it is worth noting that scholars such as Austin, report writers, and legal activists are doing much to push these boundaries, and to trouble the presumed blindness of the law. And while we have argued largely against the setting of formal standards out of a worry for their reduction to mere "factors," or lists of traumatic injury that fail to account for the whole person, we also wish to emphasize that starting a conversation around standards *is* important, such that the knowledge that they convey of complex identities continues to be part of the conversation around testimony and its role in disrupting settler-colonial logics.

Much of what we have presented here in staying close to the material is an account of what the Gladue video adds to the legal landscape while raising complex questions about not only formal conventions of evidence, but also accountability and care. Indeed, Zoe's reminder of access also shows the uneven insider/outsider dynamics in this legal mediascape that structures many such collaborative projects: Lisa and Eugenia can leave the project relatively easily, whereas Billy and Zoe continue to be affected by its futures. This is why encouraging its reciprocal relations—the time required to make such a document, the active listening for what is shown but not said, and the legal valuing of such work—continues to be an important project for all of us invested in justice within and beyond the spaces of the law.

NOTES

1 Although we acknowledge the important solidarity and rootedness that "Indigenous" indexes, throughout this chapter, we use several different identity-based terms, including "Native," "Indigenous," and "Aboriginal," following context and speakers' own identifications and usages. For example, Billy refers to himself as "Native" rather than "Indigenous," and many contexts of law use the Canadian legal category of "Aboriginal" in their documentation. We also believe that using multiple terms, instead of only "Indigenous," is usefully destabilizing, as it ensures that no one term becomes reified or expected to encompass all identities.

2 Lisa Jackson in Mark Bourrie, "The Gladue Video Project: Q&A with Lisa Jackson," *National Magazine*, December 10, 2016, https://www.national magazine.ca/en-ca/articles/law/access-to-justice/2016/the-gladue-video -project-q-a-with-lisa-jackson.

3 For an account of the powerful response from the Indigenous legal community, see Naiomi Metallic, "I Am a Mi'kmaq Lawyer, and I Despair over Colten Boushie," *The Conversation*, March 18, 2018: http://theconversation .com/i-am-a-mikmaq-lawyer-and-i-despair-over-colten-boushie-93229. On broader issues of settler legal erasures, see Sherene Razack, *Race, Space, and the Law: Unmapping a White Settler Society* (Toronto: Between the Lines Press, 2002).

4 The term "mediascape" was first coined by Arjun Appadurai, and is used by media scholars as a shorthand for the non-homogeneous social and cultural worlds generated by globalizing media practices; see Arjun Appadurai, "Disjuncture and Difference in the Global Cultural Economy," *Public Culture* 2, no. 2 (1990): 1–24. On the risks of public representations of Indigenous trauma and grief in the wake of the TRC, see Jill Carter, "Discarding Sympathy, Disrupting Catharsis: The Mortification of Indigenous Flesh as Survivance/Intervention," *Theatre Journal* 67, no. 3 (2015): 413–32.

5 On visual sovereignty's elaboration in relation to broader Indigenous media worlds, see Kristin Dowell, *Sovereign Screens: Aboriginal Media on the Canadian West Coast* (Lincoln: University of Nebraska Press, 2013); Michelle Raheja, *Reservation Reelism: Redfacing, Visual Sovereignty, and Representations of Native Americans in Film* (Lincoln: University of Nebraska Press, 2010).

6 On this history of interpretation, see Jonathan Rudin, "Aboriginal Overrepresentation and *R. v. Gladue*: Where We Were, Where We Are and

Where We Might Be Going," *The Supreme Court Law Review: Osgoode's Annual Constitutional Cases Conference* 40 (2008): 687–713.

7 R. v. Gladue, 1 S.C.R. 688 (1999).

8 This point is clarified in a later Supreme Court case, *R v. Ipelee*, which states that judges *must* take judicial notice of this information. See *R v. Ipelee*, 1 SCR 433 (2012).

9 It is important not to conflate Gladue reports with other forms of pre-sentence reporting. In an interview with Lisa, Rudin explained that a pre-sentence report is a risk assessment of capacity for re-offence; it may therefore be very biased by precisely the systemic risk factors that Gladue reports attempt to mitigate. However, Rudin also notes that what constitutes a Gladue report has not been defined, which we interpret as another example of the significant room for interpretation around how and what kind of information judges are required to take notice of.

10 One Department of Justice study, from 2013, compares the application of Gladue principles in practice across provinces and territories. See Department of Justice, Research and Statistics Division, *Gladue Practices in the Provinces and Territories* (2013), http://www.justice.gc.ca/eng/rp-pr/csj-sjc/ccs-ajc/rr12_11/rr12_11.pdf.

11 See, for example, Gemma Karstens-Smith, "Nearly 20 Years After the Gladue Decision, Lawyers Say National Standards Lacking," *Globe and Mail*, May 13, 2018, https://www.theglobeandmail.com/canada/article-nearly-20-years-after-the-gladue-decision-lawyers-say-national/.

12 Lorne Sossin (outgoing dean of Osgoode Hall Law School), in discussion with Eugenia Kisin, May 8, 2018. See also Regina Austin, "'Not Just a Common Criminal': The Case for Sentencing Mitigation Videos," *Faculty Scholarship at Penn Law* (2014), http://scholarship.law.upenn.edu/faculty_scholarship/1232.

13 See Osgoode Hall Law School, "Osgoode Hall Law School Launches a New Visual Advocacy Initiative," news release, October 22, 2015, http://news.yorku.ca/2015/10/22/osgoode-hall-law-school-launches-film-a-new-visual-advocacy-initiative/.

14 Canada's TRC was unique among Truth Commissions in its collection of visual forms of testimony alongside oral testimony, both through National Gatherings and in its open call for artwork. Some of these may be accessed through the National Centre for Truth and Reconciliation in Manitoba: https://nctr.ca/archives.php.

15 Lorne Sossin in discussion with Eugenia Kisin, May 8, 2018.

16 See Jackson in Bourrie, "The Gladue Video Project."

17 *R. v. Gladue*, 1 SCR 688 (1999), 691.

18 One can request a Gladue report that follows these guidelines through ALS at https://www.aboriginallegal.ca/gladue-request-form.html. See also Legal Services Society of British Columbia, "Gladue Report Guide," March 2018, https://lss.bc.ca/resources/pdfs/pubs/Gladue-Report-Guide-eng.pdf.

19 Sossin in discussion with Kisin, May 10, 2018.

20 See Legal Services Society of BC, "Gladue Report Disbursement: Final Evaluation Report," 2011, https://lss.bc.ca/assets/aboutUs/reports /aboriginalServices/gladueReportDisbursementEvaluationJune2013.pdf.

21 On shared accountability and collaborative ethics and aesthetics in visual anthropology, see also Eugenia Kisin, "Terms of Revision: Contemporary Complicities and the Art of Collaboration," *Collaborative Anthropologies* 7, no. 2 (2015): 180–210.

22 It is important to note that collaborative, in this sense, doesn't necessarily imply equal positions in the power relations of film and knowledge production. Indeed, presenting Indigenous and non-Indigenous research encounters as "collaborative" after the fact can erase or efface many of the inequalities and does not automatically "decolonize" ethnographic film or the discipline of anthropology. However, film is much more accessible than scholarly monographs, so what we wish to signal here is that visual anthropologists have had to contend much earlier and more fully with this critique of power.

23 While a comparison is beyond the scope of this chapter, collaborative and humanizing use of technology in visual anthropology has an important precedent in the famous Challenge for Change project, inaugurated by the National Film Board of Canada in the 1960s to enable communities to tell their own stories on screen. See Thomas Waugh, Michael Brendan Baker, and Ezra Winton, eds., *Challenge for Change: Activist Documentary at the National Film Board of Canada* (Montréal and Kingston: McGill-Queen's University Press, 2010).

24 Billy in discussion with Lisa Jackson and Eugenia Kisin, July 20, 2018.

25 Lisa Jackson, dir., *Savage*, 6 minutes (Moving Images Distribution, 2009); Lisa Jackson, dir., *Suckerfish*, 8 minutes (Moving Images Distribution, 2004).

26 This is a moment in the full interview with Billy that did not make it into the final cut of the Gladue video; we have included both to remind readers

of the relationship between documentation and editing, and how complexity is always removed in this process, and to insist on the relevance of the off-screen in shaping Billy's full experience of the process.

27 For an account of Oka that is critical of its settler-colonial rendering as "crisis," see Audra Simpson, *Mohawk Interruptus: Political Life across the Borders of Settler States* (Durham: Duke University Press, 2014), 147–76.

28 Zoe in discussion with Kisin and Jackson, July 20, 2018.

Part 1: Beyond Words and Images

Dana Claxton and Ezra Winton

Never ones to follow rules obediently, we decided long ago to punctuate these last pages with two short concluding parts, which we agree are not really conclusions in the traditional sense—rather intervening points along the pathway we began when we set out on the journey that is this book. We've shared some general thoughts in the first part, and we are delighted to include more specific thoughts on Indigenous stories, and ethics, from Lisa Jackson in Part 2.

The study of Indigenous media arts includes several practices that traverse the electronic landscape, from video art to documentary and installation to feature narratives. Moving images featuring Indigenous bodies, cultures, and ways of being in the universe/world/Kanata/four directions are revealed. And through that visuality—that careful and deliberate act of seeing Indigenous lifeways—viewers are brought into a world, sometimes unlike their own and other times strikingly familiar. And what of the unknown? The unthought, the unseen, the unheard, the unwritten? In some ways the critical analysis of Indigenous media is still a developing field, which tracks on to the fact that access to production for so many Indigenous communities is still not a reality. The turn to consider social justice within the realm of self-presentation in image-making for Indigenous cultural producers in Canada largely via the cultural public purse (in both research and creative expression) still needs equal (re)distribution of funding, especially for feature

filmmaking and television shows. Is it always about funding and access we ask?

With established venues such as APTN and imagineNATIVE, these sharing destinations provide valuable sites for Indigenous production to reach communities and share Indigenous stories. Canada now has a 40-year history of artist-run production centres for video and film that are accessible and affordable. Still, within those spaces Indigenous participation is minimal. Along with accessibility to iPhones and YouTube, many communities still do not have access to the internet. We must ask, at this departure point along a book path that has lifted up, explored, celebrated, and honoured Indigenous media arts—why is this still the case?

Where clean water and internet access are mostly taken for granted across settler Canada, many Indigenous communities still do not have access to either. How can a deeper commitment to social justice and representation support and champion a much-needed shift toward equality and liberation? What is the role of the scholar and the media arts maker in manifesting this shift? Are their roles to write and make moving images that tell the stories of inaccessibility and injustice? And then what? Do words on a page, words in a book, or images on a screen really contribute to clean water and internet accessibility for Indigenous communities? How can those in academia and Indigenous creative producers work together to contribute something beyond our words or our moving images?

We believe, along with many others on this shared ground where both settler nationalism and Indigenous sovereignty continue to wrestle with colonial ghosts, that knowing is not enough. At the beginning of this book we talked about the doing, about lifting rocks in our gardens, and about, crucially, lifting together. Knowledge comes from the land and culture grows in its polysemic folds. The time of not-knowing is reaching its long fought-for nadir. We are in the throes of a new kind of knowing—the knowing of Indigenous histories, experiences, ways of life, words, images, stories. The top-selling books in the country known as Canada are Indigenous. Indigenous voices are leading in fields like politics, medicine, and academia. Countless media artworks are produced and circulate across the country each year—from feature fiction films to documentary journalism to podcasts to art installations to television shows. A new era of knowing is cresting at the break of dawn, and

we are both grateful to be present in its growing glow. But with each new era comes transition, upheaval—radical change even.

That is why, with this new epistemic dawn, we are hopeful the doing will follow the knowing. Along with books, films, music, and other forms of expression, we are optimistically watching an upsurge of feet on the shifting ground, hands clasped across blockades, and bodies on the frontlines. Equality and liberation have never manifested without a fight, and ignorance ensures a weak foe, so knowing must always be linked with doing. We hope those days of not-knowing are fast receding, and we hope the contents of this volume may in some way contribute to the sea change we seek in our imaginations, lives, creations, and relations. The knowing has arrived at the door—the doing needs to open with generosity and commitment. We'll be there, alongside the makers, sharers, and carers, until the last door is open wide and the fresh air carries us forward.

Part 2: Setting the Record Straight[1]

Lisa Jackson

I've done a fair bit of thinking about history and its telling. My first degree was in history honours at UBC and we did some deep thinking on history, especially the philosophy of history. Who's written it and why? What are its hidden—even subconscious—biases? How do we evaluate what we read in history as "true"? Like all human endeavours, these records are flawed, and most history tells us as much or more about its authors as it tells of the reality of what happened. It's also about who had the means to sit down and write a book, which meant who had some money.

These days much of the history we consume comes in film or television format. And of course, these are even more expensive to produce than books, and therefore even more skewed by who can get funding. So the gatekeepers include the whole funding and distribution apparatus, including film festivals.

Now, here in Canada we are in a process of Truth and Reconciliation, where we are unearthing some histories that were long buried or skewed by colonial or even racist views. There is an appetite to hear from the original people of these lands, including what really happened in the settling of this country. The gatekeepers are beginning to get on board.

One of my film heroes was the documentarian Donald Brittain as he approached history from a nuanced perspective, understanding that every character in a film is neither purely good nor evil. By unpacking

how good people did bad things and vice versa, he gave us insights into human nature, and by extension, his films allow us to examine ourselves more closely.

And though TV and film require drama, the least interesting characters are those that are simplified to be evil villains or innocent victims. This does a disservice to storytelling as an art as well as the necessary complexities of truth telling. And these complexities are very important when you're trying to reset misconceptions created by 100+ years of skewed stories.

I had a bit of a revelation a few years ago when thinking about the media's coverage of residential school stories, which started to come out in the 1990s, and how the villainizing of the clergy largely left out the role of the government that created and supported this inhumane system. Residential schools were sustained in part by many good people who were cogs in the wheel, just doing their job, turning a blind eye, not speaking up, et cetera. By focusing on the evil nuns and priests, it became easy to separate ourselves from what happened at those schools. Those black-suited historical figures become ciphers onto which we could project the worst in human nature and condemn it, keeping ourselves wholly separate. We would never do those awful things.

And then there is the portrayal of victims. Victims are often voiceless, helpless, and also one-sided characters. Their role is to suffer. This dehumanizes and infantilizes them, taking away their agency and complexity. This is generally how Indigenous people are portrayed even in the most well-meaning stories created by non-Indigenous people. In fact, and unfortunately, there can be a strong correlation between the well-meaning desire to condemn what happened and lift up the victims and the over-simplification of storytelling into the good/evil dichotomy, which gives us the twin satisfaction of being better people than the terrible villains and feeling sorry for the victims, who become sort of childlike and in need of care.

Why am I writing this very long post? I've realized that because historical films and television are some of the most expensive media to make, they are subject to a higher level of gatekeeping. And because the higher up the ladder you go, the less diverse the gatekeepers get, I'm concerned that this era of renewed interest in our stories will yield these simplified stories that are stripped of the humanity that allows us to see ourselves in some ways in the perpetrators and to have to engage

meaningfully with the perhaps challenging complexities of the Indigenous experience beyond our role as victims. In the rush to fund stories that set the record straight (with "safe" fundable teams), I pray we do not fill screens with these modern-day colonial narratives.

Our stories may not make immediate or obvious sense to the gatekeepers in the ways that the good versus evil stories do. They may not give us the easy guilt-expiating narrative that allows us to pat ourselves on the back for doing the right thing. It may mean getting familiar with our cultures and communities and their storytelling traditions, which are complicated and rich and may at times frustrate the desire for simple cultural signifiers that are easily digested. But they will be more compelling and authentic stories that will stay with audiences for much longer and provoke meaningful conversations and reflections, not just about the Indigenous experience but the settler one as well.

They will also be better history and a beginning to setting the record straight.

Three questions many filmmakers are asked by the gatekeepers are: "Why this film? Why now? Why are you the person to tell it?"

And I would now ask that the gatekeepers keep in mind: "Is this an inside job or an outside job?" And if you can't tell, then get someone who can. Because when it's an outside job, we know it even when you don't, and it is not part of the solution.

I hope that in a few years the Indigenous film scene will include features and TV series where we can see the kind of authentic, powerful storytelling we've seen flourishing in the Indigenous literature scene. There is much goodwill, which is very heartening. Where it is matched by a willingness to listen, I think we can get some great things done.

NOTES

1 This is an edited version of a social media post that was subsequently adapted for *The Globe and Mail* newspaper.

About the Contributors

ALETHEA ARNAQUQ-BARIL is an Inuit filmmaker from the Canadian Arctic, where she runs Unikkaat Studios Inc. In her award-winning APTN documentary *Tunniit: Retracing the Lines of Inuit Tattoos* (imagineNATIVE 2011 premiere), Alethea travelled across the Arctic to speak with Elders about Inuit tattoo practices and the causes of their near disappearance, before getting her own traditional face tattoos. Alethea directed the well-travelled ICSL short *Inuit High Kick* and co-produced with White Pine Pictures *Experimental Eskimos*, a Barry Greenwald feature documentary (Hot Docs, DGC Allan King Award 2010). Alethea directed the NFB animation *Lumaajuuq: The Blind Boy and the Loon* (Best Canadian Short Drama—imagineNATIVE 2010, Golden Sheaf Award for Best Aboriginal—Yorkton 2011). Alethea directed the animated short *Sloth*, one of 15 shorts selected by renowned film programmer Danny Lennon for Telefilm's *Perspective Canada* screenings at the Cannes Film Market. Alethea was also an executive producer on Miranda de Pencier's award-winning *Throat Song*, produced by Stacey Aglok MacDonald (TIFF 2012 premiere, Canadian Screen Award—Best Live Action Short Drama, Academy Awards shortlist 2014). Alethea co-produced *Arctic Defenders*, a feature documentary by John Walker (nominee for DGC Allan King Award 2014, Best Doc—Atlantic Film Fest). Most recently, Alethea directed *Aviliaq: Entwined*

as part of the Embargo Project, premiering at imagineNATIVE 2014. Currently, Alethea is directing *Angry Inuk* (NFB co-production in association with EyeSteelFilm), a feature doc for broadcast on Superchannel about how Inuit are coming up with new and provocative ways to deal with international seal-hunting controversies.

SHANE BELCOURT is an award-winning and two-time Canadian Screen Award–nominated filmmaker based in Toronto, Ontario. As a writer and director on many Indigenous works, both narrative and factual, Shane has a vested interested in creating works that speak to his Métis heritage. Notable work includes the feature film *Tkaronto*; shorts such as *A Common Experience, Keeping Quiet*, and *Pookums*; the dance-documentary *Kaha:wi—The Cycle of Life* (2015 CSA Best Direction Nomination); and two Historica Canada Minutes, *Chanie Wenjack* and *Naskumituwin (Treaty)*. Recent works include the award-winning 2018 CBC Firsthand documentary *Indictment* (co-directed with Lisa Jackson; 2017 imagineNATIVE Best Documentary), the music documentary series *AMPLIFY* for APTN (series creator, executive producer, and show-runner), and the dramatic feature *Red Rover* (co-writer, director). He is an alumna of the TIFF Talent Lab and NSI's Totally Television programs, and a member of the Directors Guild of Canada.

KARINE BERTRAND is an Associate Professor in the Film and Media Department of Queen's University. She is also a member of the Maniwaki Aboriginal Métis Community (Communauté Autochtone Métis de Maniwaki). Her research interests are centred around Indigenous film and poetry, Québec cinema, road movies, transnational cinemas, and oral practices of cinema. She is a member of the Vulnerable Media Lab at Queen's and lead researcher for the Archive Counter Archive research project (financed by SSHRC), working with the Arnait Video Productions collective of Inuit women. Her latest publications include book chapters on the rock group U2 (Mackenzie and Iversen, 2021) and on the exploration of Indigenous lands (Cahill and Caminati, 2020), an article on Indigenous women and testimonies (*Canadian Journal of Film Studies*, 2020), an article on Québécois cinema and Americanité (*American Review of Canadian Studies*, 2019), and a book chapter on Canadian and Québécois Indigenous cinemas (*Oxford Handbook to Canadian Cinema*, 2019).

DANA CLAXTON (Hunkpapa Lakota [Sioux]) was born in Yorkton, Saskatchewan, and works in film, video, photography, single- and multi-channel video installation, and performance art. Her practice investigates beauty, the body, the socio-political, and the spiritual. Claxton's work has been shown internationally at venues including the Museum of Modern Art, New York City; Walker Art Center, Minneapolis; Sundance Film Festival; Eiteljorg Museum; the Museum of Contemporary Art, Sydney; and the Toronto Biennial of Art 2019. Claxton's first major survey show opened at the Vancouver Art Gallery in 2018. She is Department Head and Associate Professor in the Department of Visual Art at the University of British Columbia, Vancouver.

SASHA CRAWFORD-HOLLAND is a PhD student and Social Sciences and Humanities Research Council (SSHRC) Doctoral Fellow with the Department of Cinema and Media Studies at the University of Chicago. Sasha's research on documentary politics and the visual cultures of militarism and imperialism has been published in *Television & New Media* and *Synoptique*.

DANIS GOULET is an award-winning writer and director. Her films have screened at festivals around the world including Berlinale, Sundance, MoMA, and the Toronto International Film Festival (TIFF). She is a former programmer for TIFF and a former director of the imagineNATIVE Film + Media Arts Festival. She is an alumna of the National Screen Institute and the TIFF Filmmaker Lab and a former board member for the Toronto Arts Council and the Images Festival. In 2018, she joined the Academy of Motion Picture Arts and Sciences. She currently serves on the board for TIFF. Her debut feature, *Night Raiders*, premiered in the Panorama section of the 2021 Berlinale and was selected as a Gala Presentation at TIFF 2021, where Danis was recognized with a TIFF Tribute Award. She was also awarded the Directors Guild of Canada's Discovery Award in 2021 and the film won the Grand Prix at the Festival du nouveau cinéma de Montréal. Danis also completed production on a Netflix thriller in 2021. She is Cree/Métis, originally from La Ronge, Saskatchewan, and now lives in Toronto.

BRETTEN HANNAM is a two-spirit L'nu filmmaker living in Kespukwitk, L'nuekati (Nova Scotia), where they were raised. Their films deal

with themes of community, culture, and language with a focus on two-spirit and LGBTQ+ identity. They wrote and directed *North Mountain*, a two-spirit thriller that won Best Original Score at the Atlantic Film Festival and the Screen Nova Scotia Award for Best Feature. They also wrote and directed the short film *Wildfire*, which premiered at BFI Flare and went on to play at Frameline LGBT Film Festival, Vancouver International Film Festival, imagineNATIVE, and Inside Out LGBT Film Festival. Recently, they wrote and directed *Wildhood*, the feature version of the short *Wildfire*, which premiered at TIFF 2021.

JOANNA HEARNE is Associate Professor of film studies in the English Department at the University of Missouri, where she was the founding director of the Digital Storytelling program in the School of Visual Studies. She has published a number of articles on topics in Indigenous film and media, and on representational politics in westerns, documentary film, animation, and digital media. In 2017 she edited a special issue of *Studies in American Indian Literatures (SAIL)* on "Digital Indigenous Studies: Gender, Genre, and New Media," and in 2012 she published two books about Indigenous film history: *Native Recognition: Indigenous Cinema and the Western* (SUNY Press) and *Smoke Signals: Native Cinema Rising* (University of Nebraska Press).

TASHA HUBBARD is a writer, filmmaker, and Associate Professor in the Faculty of Native Studies at the University of Alberta. She is from Peepeekisis First Nation in Treaty Four Territory and has ties to Thunderchild First Nation in Treaty Six Territory. She is also the mother of a 13-year-old son. Her academic research is on Indigenous efforts to return the buffalo to the lands and Indigenous film in North America. Her first solo writing/directing project, *Two Worlds Colliding*, about Saskatoon's infamous Starlight Tours, premiered at imagineNATIVE in 2004 and won the Canada Award at the Gemini Awards in 2005. In 2016 she directed an NFB-produced feature documentary called *Birth of a Family* about a Sixties Scoop family coming together for the first time during a holiday in Banff. It premiered at Hot Docs International Film Festival and landed in the top ten audience choice list. It also won the Audience Favourite for Feature Documentary at the Edmonton International Film Festival and the Moon Jury prize at imagineNATIVE. Her

latest feature documentary is called *nîpawistamâsowin: We Will Stand Up*, a personal exploration of the impact of the death of Colten Boushie that premiered in the spring of 2019. It opened the prestigious Hot Docs Festival and won the top Canadian documentary prize. It also won the Colin Low Award for the top Canadian film at the DOXA International Film Festival.

LISA JACKSON is a Toronto-based filmmaker and artist whose work has shown at top film festivals, exhibited in galleries, garnered awards including a Genie and Canadian Screen Award, and aired widely on television. Her films range from documentary to fiction, animation to 3D IMAX, and she's made two virtual reality works, including *Biidaaban: First Light*, which is travelling the world and is a sister project to her installation *Transmissions*. She was Director of the Gladue Video Project with Osgoode Hall Law School and programming consultant for Hotdocs Festival, she sits on the NFB's Indigenous Advisory Committee, and she has been the Director Mentor for the National Screen Institute's IndigiDocs Program. She is mixed settler and Anishinaabe from the Aamjiwnaang First Nation, has a BFA in Film Production from SFU and an MFA from York University, and is an alumna of the Canadian Film Centre's Directors Lab. She's a sought-after public speaker, and has been featured on CBC Radio's *The Current* and in *The Globe and Mail, Now Magazine, The Georgia Straight*, and others. See more at lisajackson.ca.

EUGENIA KISIN is Assistant Professor of Art and Society at New York University's Gallatin School of Individualized Study. She teaches classes about contemporary art and environmental justice, with a particular interest in materials, collaboration, and museums. Her forthcoming book, *Aesthetics of Repair*, considers how Indigenous artists extend ancestral protocols for bringing about just relations between persons, things, and territories in the extractive economies of the Pacific Northwest. With Kirsty Robertson (Western University), she co-organizes *A Museum for Future Fossils*, a project on curating in the Anthropocene.

JULES ARITA KOOSTACHIN is an InNiNew IsKwew (Swampy Cree woman) and a band member of Attawapiskat First Nation located in what is now called northern Ontario. Jules was raised by her

Cree-speaking grandparents in Moosonee, as well as in Ottawa with her mother, a residential school warrior. She is a graduate of Concordia University's Theatre program and Ryerson University's Documentary Media Master's program. In 2010 Jules was awarded an Award of Distinction and an Academic Gold Medal for her thesis documentary film, *Remembering Inninimowin*. She is the mother of four wonderful sons, a published writer, a performance artist, an academic, and an award-winning filmmaker. She completed her PhD with the Institute of Gender, Race, Sexuality, and Social Justice program at the University of British Columbia with a focus on Indigenous documentary practices. Jules is represented by The Characters Talent and Lucas Talent in Vancouver, and she is the voice of Layla (Molly's mom) on the award-winning animated series *Molly of Denali*. Jules has also been actively working with Indigenous community supporting women and children who face barriers.

TOBY KATRINE LAWRENCE is a white settler-Canadian curator living and working between Snuneymuxw, Lekwungen, and W̱SÁNEĆ territories. Her practice centres a collaborative approach focused on anti-racist, decolonial, and intersectional feminist methodologies. Toby has held curatorial and programming positions with the Vancouver Art Gallery, Art Gallery of Greater Victoria, Nanaimo Art Gallery, and Kelowna Art Gallery. She was also a contributing curator for the inaugural Contingencies of Care Virtual Residency hosted by OCAD University, Toronto Biennial of Art, and BUSH Gallery and a curatorial resident at the Otis College of Art and Design Emerging Curators Retreat in Los Angeles. Toby is a curator at Open Space in Victoria, BC, and a PhD candidate in Interdisciplinary Graduate Studies at the University of British Columbia Okanagan, supported by the BC Arts Council Scholarship and Social Sciences and Humanities Research Council Doctoral Fellowship.

LINDSAY LEBLANC is a PhD student in the Women and Gender Studies Institute at the University of Toronto, where she is also a member of the Technoscience Research Unit. Her dissertation research works to think broadly about reproductive justice by investigating the mechanical reproduction of human vital signs. Lindsay is a white settler living and working on Indigenous lands in Toronto/Tkaronto.

BRENDA LONGFELLOW is Professor of Cinema and Media Studies in the Department of Film, York University, and an award-winning filmmaker. She has published articles on documentary, feminist film theory and Canadian cinema in *Public*, *CineTracts*, *Screen*, *Camera Obscura*, and the *Journal of Canadian Film Studies*. She is a co-editor (with Scott MacKenzie and Tom Waugh) of the anthology *The Perils of Pedagogy: The Works of John Greyson* (2013) and *Gendering the Nation: Canadian Women Filmmakers* (1992). Her documentaries have been screened and broadcast internationally, winning Best Cultural Documentary for Tina in Mexico at the Havana International Film Festival (2002); a Canadian Genie for *Shadowmaker/Gwendolyn MacEwen, Poet* (1998), and the Grand Prix at Oberhausen for *Our Marilyn* (1988). She was the 2018 recipient of the inaugural Faculty Research Award in the School of Arts, Media, Performance and Design at York University. Her most recent project, the interactive documentary *Offshore*, is available at http://off shore-interactive.com.

JULIE NAGAM (Métis/German/Syrian) is Canadian Research Chair in Indigenous Arts, Collaboration and Digital Media and is an Associate Professor in the History of Art Department at the University of Winnipeg. She was the former Chair of the History of Indigenous Arts of North America, a joint appointment with the Winnipeg Art Gallery. Dr. Nagam's SSHRC research includes digital makerspaces + incubators, mentorship, digital media + design, international collaborations, and place-based knowledge. She is a collective member of GLAM, which works on curatorial activism, Indigenous methodologies, public art, digital technologies, and engagement with place. As a scholar and artist she is interested in revealing the ontology of land, which contains memory, knowledge, and living histories. Dr. Nagam's scholarship and curatorial and artistic practice has been featured nationally and internationally. She is the Concordia University and Massey University (NZ) Scholar in Residence for 2018/19, and is building an Indigenous Research Centre of Collaborative and Digital Media Labs in Winnipeg, Manitoba.

MARGARET ROBINSON, PhD (she/her), is a two-spirit bisexual scholar and a member of the Lennox Island First Nation. She works as an Assistant Professor at Dalhousie University in K'jipuktuk (Halifax), where she coordinates the Indigenous Studies program. Margaret grew up on the

land in Eski'kewaq, Nova Scotia, in a family that likes to yell suggestions to characters onscreen.

CLAUDIA SICONDOLFO lives and works as a guest in Tkaronto. She is a Vanier Scholar and PhD candidate in Cinema and Media Studies at York University. Her research projects address film festivals, screen publics, youth and digital media cultures, decolonizing research methodologies, and affect in the creative industries. Her doctoral research project examines educational and community outreach strategies within contemporary Canadian digital screen institutions and digital engagement in film festivals. Her publications have appeared in *Public* and *Senses of Cinema*, in addition to various book anthologies. Claudia has worked intimately with educational communities across Canada and has published educational companion curriculum for documentaries. She is the co-chair for the Toronto Film and Media Seminar and is a researcher on the Archive/Counter-Archive SSHRC Partnership Project.

MICHELLE STEWART is a Professor in the Department of Social and Public Communication at the University of Québec, Montréal. With Pam Wilson, she is co-editor of *Global Indigenous Media* (Duke UP, 2008). Her publications have appeared in various film and media journals, including *JumpCut*, TOPIA, and *Film Quarterly*. She has been a Fulbright Scholar, Kempner Distinguished Professor at Purchase, a fellow at the Institute for Advanced Studies in Marseille (2013–2014), and a Visiting Professor at the University of Montréal (2015–2016). Her work addresses digital heritage and digital cinema, in particular, the ways in which internet art and culture complicate our expectations and standards for self and cultural representation. She is currently the principal investigator for the cross-national study "Viral Populism: The Amplification of Right-Wing Extremism Online" (SSHRC / Canadian Heritage 2021–2024).

CARLA TAUNTON is an Associate Professor in the Division of Art History and Contemporary Culture at the Nova Scotia College of Art and Design University and the Special Advisor to the VP Academic and Research, Social Justice and Decolonization. She co-edited with Dr. Julie Nagam and Dr. Heather Igloliorte *PUBLIC 54: Indigenous Art*, the first special issue on global Indigenous new media and digital arts, and with

Igloliorte *RACAR: Continuities Between Eras: Indigenous Arts* (2017). She is an independent curator and was a curatorial team member for Àbadakone | Continuous Fire | Feu Continuel at the National Gallery of Canada (2019). Taunton's recent collaborative research projects include the GLAM Collective; the Pilimmaksarniq/Pijariuqsarniq Project: Inuit Futures in Arts Leadership; The Space Between Us: Co(lab)orations within Indigenous, Circumpolar and Pacific Places Through Digital Media and Design; and the Archive/Counter-Archive: Activating Canada's Moving Image Heritage. Forthcoming publications include "Beyond Unsettling: Methodologies for Decolonizing Futures," a special issue of *PUBLIC Journal* co-edited with Leah Decter.

JESSE WENTE is an Ojibwe writer, broadcaster, producer, and speaker. Born and raised in Toronto, his family hails from Chicago and the Serpent River First Nation. He has been a culture critic on CBC Radio's *Metro Morning* for over 20 years. In 2018 Jesse became the first Director of the Indigenous Screen Office. Jesse is currently co-producing a screen adaptation of Thomas King's best-selling book *The Inconvenient Indian.* Jesse currently serves on the board of directors for the Canada Council for the Arts and the Toronto Arts Council. In 2017 he was named the inaugural recipient of the Reelworld Film Festival's Reel Activist Award. Jesse recently published his first book, *Unreconciled: Family, Truth, and Indigenous Resistance* (Penguin Random House Canada).

EZRA WINTON is Assistant Professor of Journalism and Mass Communication, American University in Bulgaria, and holds a PhD in Communication Studies from Carleton University. His research and teaching interests include film festivals; documentary and alternative media, as well as settler and Indigenous cinemas. Ezra is the co-founder, with Svetla Turnin, and Director of Programming of Cinema Politica, the world's largest grassroots documentary screening network, and is a contributing editor at *POV Magazine*. Recent publications include *Documentary Film Festivals* (2020, Palgrave Macmillan). He is currently working on a monograph for Arbeiter Ring Press entitled *Rules for Documentary Radicals: Provocations and Interventions for a Non-fiction Cinema Beyond Colonial Capitalism.*

References

Aboriginal Territories in Cyberspace (AbTeC). 2017. "CyberPowWow and the First Wave of Indigenous Media Arts." Roundtable discussion with Jason Edward Lewis, Archer Pechawis, Ryan Rice, and Skawennati.

Acland, Charles, and Haidee Wasson, eds. 2011. *Useful Cinema*. Durham: Duke University Press.

Adzani, R. 2017. "Individualism Values of Cowboy in the Film *Open Range* (2003)." PhD diss., Diponegoro University.

"Alanis Obomsawin the Activist." 1966. *Telescope*. Aired February 10, 1966, on Canadian Broadcasting Corporation. http://www.cbc.ca/player/play /1525086815.

Alfred, Taiaiake. 2017. "It's All About the Land." In *Whose Land Is It Anyway? A Manual for Decolonization*, edited by Peter McFarlane and Nicole Schabus, 10–13. Federation of Post-Secondary Educators of BC.

Alia, Valerie. 2010. *The New Media Nation: Indigenous Peoples and Global Communication*. New York: Berghahn Books.

Allen, Chadwick. 2002. *Blood Narrative: Indigenous Identity in American Indian and Maori Literary and Activist Texts*. Durham: Duke University Press.

Amnesty International. 2004. *Stolen Sisters: A Human Rights Response to Discrimination and Violence against Indigenous Women in Canada*. London: Amnesty International Publications.

———. 2009. *No More Stolen Sisters: The Need for a Comprehensive Response to Discrimination and Violence against Indigenous Women in Canada*. London: Amnesty International Publications.

Angel, Naomi, and Pauline Wakeham. 2016. "Witnessing *In Camera*: Photographic Reflections on Truth and Reconciliation." In *Arts of Engagement, Taking Aesthetic Action In and Beyond the Truth and Reconciliation Commission of Canada*, edited by Dylan Robinson and Keavy Martin, 93–134. Waterloo: Wilfrid Laurier University Press.

âpihtawikosisân. 2016. "Beyond Territorial Acknowledgement." Personal blog. September 23, 2016. Accessed September 15, 2019. https://apihtawikosisan .com/2016/09/beyond-territorial-acknowledgments/.

Archibald, Jo-ann. 2008. *Indigenous Storywork: Educating the Heart, Mind, Body, and Spirit*. Vancouver: UBC Press.

Assembly of First Nations. 2015. "Declaration of First Nations." Updated January 6, 2015. https://www.afn.ca/about-afn/declaration-of-first-nations/.

Astle, Randy. 2018. "'Our Culture Is in Our Language': Lisa Jackson on Her VR Film *Biidaaban: First Light* and Indigenous Futurism." *Filmmaker Magazine*, July 23, 2018. https://filmmakermagazine.com/105184-our-culture-is-in-our -language-lisa-jackson-on-her-vr-film-biidaaban-first-light-and-indigenous -futurism/#.YNUnXhNKhE4.

Austin, Regina. 2014. "'Not Just a Common Criminal': The Case for Sentencing Mitigation Videos." *Faculty Scholarship at Penn Law*, 1–49.

Ball, Jessica. 2014. "On Thin Ice: Managing Risks in Community-University Research Partnerships." In *Learning and Teaching Community-Based Research: Linking Pedagogy to Practice*, edited by Catherine Etmanski, Budd L. Hall, and Teresa Dawson, 35–44. Toronto: University of Toronto Press.

Bambury, Brent. 2017. "Tech Entrepreneur Adrian Duke Is Building an Augmented Reality App to Tell Indigenous Stories." Produced by CBC Radio. *Day 6*. March 10, 2017. Podcast. http://www.cbc.ca/radio/day6/episode -328-cia-secrets-leaked-phyllis-diller-s-gag-file-virtual-indigenous-history -and-more-1.4015018/tech-entrepreneur-adrian-duke-is-building-an -augmented-reality-app-to-tell-indigenous-stories-1.4015037.

Banning, Kass. 1991. "Local Channels: Zach Kunuk Remodels T.V." *Parallelogramme* 17 (1): 13–16.

Barclay, Barry. 1990. *Our Own Image: A Story of a Maori Filmmaker*. Auckland: Longman Paul.

———. 2003. "Celebrating Fourth Cinema." *Illusions* 35: 7–11.

Barnaby, Jeff. 2017. *Westwind* (beta). Montréal: National Film Board of Canada. Virtual reality.

Barnouw, Erik. 1974. *Documentary: A History of the Nonfiction Film*. Oxford: Oxford University Press.

Barthes, Roland. 1977. "The Death of the Author." In *Image, Music, Text*, translated by Stephen Heath, 142–47. London: Fontana.

Battiste, Marie, ed. 2000. *Reclaiming Indigenous Voice and Vision*. Vancouver: UBC Press.

Battiste, M., & J. Youngblood Henderson. 2009. "Naturalizing Indigenous Knowledge in Eurocentric Education." *Canadian Journal of Native Education* 32 (1): 5–18.

Beaucage, Marjorie. 2005. "Aboriginal Voices: Entitlement Through Storytelling." In *Transference, Tradition, Technology: Native New Media Exploring Visual and Digital Culture*, edited by Dana Claxton, Steven Loft, and Melanie Townsend, 138–51. Banff, AB: Walter Phillips Gallery.

Belcourt, Billy. 2018. "Fatal Naming Rituals." *Hazlitt*, July19, 2018. Accessed September 15, 2019. https://hazlitt.net/feature/fatal-naming-rituals.

Bell, Lynne. 2010. "From a Whisper to a Scream: Dana Claxton Teaches Art and a Revised Version of North American History." *Canadian Art* 27, no. 4 (Winter): 102–7.

Belleau, Mona. 2009. Preface to *Jeunesses Autochtones*, by Natasha Gagné and Laurent Jérôme, 9. Québec: Presses de l'Université Laval et Presses Universitaires de Rennes.

Benesiinaabandan, Scott. 2016a. *Blueberry Pie Under a Martian Sky*. Initiative for Indigenous Futures. Virtual reality.

———. 2106b. *Blueberry Pie Under a Martian Sky*. Aboriginal Territories in Cyberspace. http://abtec.org/iif/residencies/scott-benesiinaabandan-2/.

———. 2016c. "In Dialogue: Scott Benesiinaabandan's *waabana'iwewin* (Exhibition)." Interviewed by Jaimie Isaac. *Public* 54 (Winter): 158–71.

———. 2017. "2167: Indigenous Storytelling in VR." Panel Discussion at imagineNATIVE Film + Media Arts Festival, TIFF Bell Lightbox, Toronto, October 20, 2017. https://www.youtube.com/watch?v=g7dTlB2ZjbY.

———. 2018. Interview with author. OBX Labs, Montréal, QC. February 16, 2018.

Bergstrom, A. 2015. "The Indigenous New Wave: A Populist Stage of Indigenous Cinema." *Toronto Film Scene* 11 (November 1). http://thetfs.ca/article/the-indigenous-new-wave-a-populist-stage-of-indigenous-cinema/.

Berman, Sarah. 2017. "Why an Indigenous Filmmaker Directed a VR Documentary about the Highway of Tears." *Vice Magazine*, January 27, 2017. https://www.vice.com/en/article/5353gd/why-an-indigenous-filmmaker-directed-a-vr-documentary-about-the-highway-of-tears.

Bertrand, Karine. 2018. Entrevue avec Sonia Bonspille Boileau, Kingston, ON.

Betz, Mark. 2009. *Beyond the Subtitle: Remapping European Art Cinema*. Minneapolis: University of Minnesota Press.

Bird, E.S. 1999. "Gendered Construction of the American Indian in Popular Media." *Journal of Communication* 49 (3): 61–83.

"Birth of a Family: The Sixties Scoop Explained." 2017. CBC-TV Docs POV, November 10, 2017. http://www.cbc.ca/cbcdocspov/features/the-sixties -scoop-explained.

Blackburn, Carole. 2012. "Culture Loss and Crumbling Skulls: The Problematic of Injury in Residential School Litigation." *PoLAR* 35 (2): 289–307.

Blunt, A., and G. Rose. 1994. "Introduction: Women's Colonial and Postcolonial Geographies." In *Writing Women and Space: Colonial and Postcolonial Geographies*, edited by A. Blunt and G. Rose, 1–25. New York/London: Guilford Press.

Brady, Miranda J., and John M.H. Kelly. 2017. *We Interrupt This Program: Indigenous Media Tactics in Canadian Culture*. Vancouver: UBC Press.

Bredin, Marian. 2010. "APTN and Its Audience." In *Indigenous Screen Cultures in Canada*, edited by Sigurjón Baldur Hafsteinsson and Marian Bredin, 69–86. Winnipeg: University of Manitoba Press.

Bridges, E. 2018. "A Genealogy of Queerbaiting: Legal Codes, Production Codes, 'Bury Your Gays' and 'The 100 Mess.'" *The Journal of Fandom Studies* 6 (2): 115–32.

Brown, Leslie Allison, and Susan Strega. 2015. *Research as Resistance: Revisiting Critical, Indigenous, and Anti-Oppressive Approaches*. 2nd ed. Toronto: Canadian Scholars' Press.

Carroll, G., D. Giler, and W. Hill, prods., and R. Scott, dir. 1979. *Alien*. United States: Brandywine Productions and Twentieth Century Fox. Motion picture.

CBC. 2017. "New Summer Series Reclaimed to Explore Indigenous Next-Wave Music." *CBC Music*, May 15, 2017. https://www.cbcmusic.ca/posts/18513 /indigenous-new-wave-reclaimed-summer-series.

Chagnon, Karina. 2016. "Entrevue avec Chloé Leriche, réalisatrice du film Avant les rues." *Trahir*, April 12, 2016, 3–11. https://trahir.wordpress.com /2016/04/12/chagnon-leriche/.

Chandler, M.J., and C.E. Lalonde. 2008. "Cultural Continuity as a Protective Factor against Suicide in First Nations Youth." *Horizons* 10 (1): 68–72.

Chandler, M.J., C.E. Lalonde, B. Sokol, and D. Hallett. 2003. "From Self-Continuity to Cultural Continuity: Aboriginal Youth Suicide." *Monographs of the Society for Research in Child Development* 68 (2): 61–76.

Chawla, Devika, and Ahmet Atay. 2018. "Introduction: Decolonizing Autoethonography." *Cultural Studies, Critical Methodologies* 18 (1): 3–8.

Cheng, Jennifer. 2017. "Here's What Toronto Would Look Like After the Apocalypse." *Toronto Life*, March 22, 2017. https://torontolife.com/city/toronto -apocalypse-mathew-borrett/.

Chilisa, Bagele. 2012. *Indigenous Research Methodologies*. Thousand Oaks, CA: Sage.

———. 2021. *Indigenous Research Methodologies*. 2nd ed. London: Sage.

Chin-Yee, A., and J. Christou, prods., and J. Barnaby, dir. 2013. *Rhymes for Young Ghouls*. Canada: Prospector Films and Canadian Film Centre. Motion picture.

Chow, Rey. 1995. *Primitive Passions: Visuality, Sexuality, Ethnography, and Contemporary Chinese Cinema*. New York: Columbia University Press.

———. 2014. *Not Like a Native Speaker: On Languaging as a Postcolonial Experience*. New York: Columbia University Press.

Chun, Wendy Hui Kyong. 2004. "On Software, or the Persistence of Visual Knowledge." *Grey Room* 18: 26–51.

———. 2011. *Programmed Visions: Software and Memory*. Cambridge: MIT Press.

Claxton, Dana. 2005. "Re-Wind." In *Transference, Tradition, Technology: Native New Media Exploring Visual and Digital Culture*, edited by Melanie A. Townsend, Dana Claxton, and Steve Loft, 60–68. Banff, AB: Walter Phillips Gallery Editions.

Claxton, Dana, Steven Loft, and Melanie Townsend, eds. 2005. *Transference, Tradition, Technology: Native New Media Exploring Visual and Digital Culture*. Banff, AB: Walter Phillips Gallery Editions.

Clover, Darlene E. 2014. "Facilitating and Teaching Feminist Visual Arts-Based Research." In *Learning and Teaching Community-Based Research: Linking Pedagogy to Practice*, edited by Catherine Etmanski, Budd L. Hall, and Teresa Dawson, 135–49. Toronto: University of Toronto Press.

Cole, Douglas. 2000. "The Invented Indian/The Imagined Emily." *BC Studies: The British Columbia Quarterly* 125/6 (Spring/Summer): 147–62.

Columpar, Corinn. 2010. *Unsettling Sights: The Fourth World on Film*. Carbondale: Southern Illinois University Press.

Cook Inlet Tribal Council and E-Line Media. 2014. *Never Alone*. New York: E-Line Media, 2014. neveralonegame.com/game/.

Cornellier, Bruno. 2011. "La « chose indienne »: Cinéma et politiques de la représentation autochtone dans la colonie de peuplement libérale." PhD diss., Concordia University, Montréal.

Cornum, Lou. 2015. "The Space NDN's Star Map." *The New Inquiry* 36. Accessed May 14, 2018. https://thenewinquiry.com/the-space-ndns-star-map/.

Costner, K., dir. 1990. *Dances with Wolves*. United States: Tig Productions, Majestic Films International, Orion Pictures. Motion picture.

Coulthard, Glen. 2012. "Decolonization and #IdleNoMore in Historical Context." *Decolonization, Indigeneity Education & Society*, December 24, 2012. https://decolonization.wordpress.com/2012/12/24/idlenomore-in -historical-context/.

———. 2014. *Red Skin, White Masks: Rejecting the Colonial Politics of Recognition*. Minneapolis: University of Minnesota Press.

Crosby, Marcia. 1991. "Constructing of the Imaginary Indian." In *Vancouver Anthology: The Institutional Politics of Art*, edited by Stan Douglas, 267–91. Vancouver: Talon.

Cruikshank, Julie. 2001. "Glaciers and Climate Change: Perspectives from the Oral Tradition." *Arctic* 54, no. 4 (January): 377–93.

CyberPowWow. 1998–2002. Nation 2 Nation. http://cyberpowwow.net/.

Davies, Lyell. 2016. "Documentary Film Festivals as Ideological Transactions: Film Screening Sites at Hot Docs." *Canadian Journal of Film Studies* 25 (1): 88–110.

Davies, Steven Thomas. 2016. Unpublished artist statement.

Davis, T. 2014. "Between Worlds: Indigenous Identity and Difference in the Films of Darlene Johnson." *Camera Obscura: Feminism, Culture, and Media Studies* 85, 29 (1): 81–109.

Delaronde, Lindsay Katsitsakatste. 2016. Unpublished artist statement.

De Niro, R., J. Rosenthal, and J. Fusco, prods., and M. Apted, dir. 1992. *Thunderheart*. USA: Tribeka Productions. Motion picture.

Denzin, Norman K., and Yvonna S. Lincoln. 2008. *The Landscape of Qualitative Research*. Los Angeles: Sage.

Denzin, Norman, Yvonna S. Lincoln, and Linda Tuhiwai Smith, eds. 2008. *Handbook of Critical and Indigenous Methodologies*. Los Angeles: Sage.

Deshler, K.M. 2017. "Not Another Dead Lesbian: The Bury Your Gays Trope, Queer Grief, and *The 100*." Honours thesis, Whitman College. https:// arminda.whitman.edu /islandora/object/arminda%3A38462/datastream /PDF/download.

Desjardins, Denis. 2014. "Maïna, voyage au pays des glaces." *Séquences* 290 (May–June): 57.

De Valck, Marijke. 2007. *Film Festivals: From European Geopolitics to Global Cinephilia*. Amsterdam: Amsterdam University Press.

Devlin, Megan. 2017. "This Augmented Reality App Tells Indigenous Stories in Canadian Cities." *Vice Magazine*, February 15, 2017. https://motherboard .vice.com/enus/article/8qk9w5/augmented-reality-vancouver-indigenous.

Diamond, N., J. Bainbridge, and C. Hayes, writers and dirs. 2009. *Reel Injun*. Canada: National Film Board of Canada. Motion picture.

Diamond, Sara. 2008. "Reframing the Cathedral: Opening the Sources of Technologies and Cultural Assumptions." In *Critical Digital Studies: A Reader*, edited by Arthur Kroker and Marilouise Kroker, 56–70. Toronto: University of Toronto Press.

Dillon, Grace. 2012. "Imagining Indigenous Futurisms." In *Walking the Clouds: An Anthology of Indigenous Science Fiction*, edited by Grace L. Dillon, 1–12. Tucson: University of Arizona Press.

Douzinas, Costas, and Lynda Nead. 1999. "Introduction: Law and Aesthetics." In *Law and the Image: The Authority of Art and the Aesthetics of Law*, edited by C. Douzinas and L. Nead, 1–16. Chicago: University of Chicago Press.

Dowell, Kristin. 2013. *Sovereign Screens: Aboriginal Media on the Canadian West Coast*. Lincoln: University of Nebraska Press.

Doxtator, Deborah. 2001. "Inclusive and Exclusive Perceptions of Difference: Native and Euro-Based Concepts of Time, History, and Change." In *Decentring the Renaissance: Canada and Europe in Multidisciplinary Perspective 1500–1700*, edited by Germaine Warkentin and Carolyn Podruchny, 33–47. Toronto: University of Toronto Press.

Druick, Zoë. 2007. *Projecting Canada*. Montréal: McGill-Queen's University Press.

Duarte, Marisa Elena. 2017. *Network Sovereignty: Building the Internet across Indian Country*. Seattle: University of Washington Press.

Dwyer, Tessa. 2017. *Speaking in Subtitles: Revaluing Screen Translations*. Edinburgh: Edinburgh University Press.

Egoyan, Ian, and Ian Balfour, eds. 2004. *Subtitles: On the Foreignness of Film*. Cambridge, MA: MIT Press and Technology and Alphabet City Media.

Eigenbrod, Renate, and Renée Hulan. 2008. *Aboriginal Oral Traditions: Theory, Practice, Ethics*. Halifax: Fernwood.

Elawani, Ralph. 2018. "Alanis Obomsawin: Voices of Dignity" (documentary). *In the News NFB Blog*, National Film Board of Canada. August 24, 2018. https://blog.nfb.ca/blog/2018/08/24/pause-alanis-obomsawin-music/.

Eleftheriotis, Dimitris. 2010. *Cinematic Journeys: Film and Movement*. Edinburgh: Edinburgh University Press.

Emberley, Julia V. 2007. *Defamiliarizing the Aboriginal: Cultural Practices and Decolonization in Canada*. Toronto: University of Toronto Press.

———. 2014. *The Testimonial Uncanny: Indigenous Storytelling, Knowledge, and Reparative Practices*. Albany: SUNY Press.

Evans, Michael Robert. 2008. *Isuma: Inuit Video Art*. Montréal and Kingston: McGill-Queen's University Press.

Everett-Green, Robert. 2018. "Is Virtual Reality About to Break Through as an Artists' Medium?" *The Globe and Mail*, June 8, 2018. https://www.theglobeandmail.com/arts/art-and-architecture/article-canadian-artists-lead-the-way-in-realizing-the-artistic-promise-of-vr/.

Fabian, Johannes. 1983. *Time and the Other: How Anthropology Makes Its Object*. New York: Columbia University Press.

Faucher, Jean-Robert. 2012. "'Kateri Tekakwhita' Documentary Made for the Television Show *Second Regard*." Radio-Canada. Accessed February 18, 2018. http://www.radio-canada.ca/widgets/ mediaconsole/medianet/6096263.

"Female Eye Film Festival Presents: Alive with Breath." 2012. Vistek: The Visual Technology People. Last modified February 29, 2012. Accessed February 5, 2018. http://prophotoblog.ca/community/events/female-festival-alive-breath/.

Fisher, Jolene. 2016. "Toward a Political Economic Framework for Analyzing Digital Development Games: A Case Study of Three Games for Africa." *Communication, Culture & Critique* 9, no. 1 (March): 30–48.

Fixico, Donald Lee. 2003. *The American Indian Mind in a Linear World: American Indian Studies and Traditional Knowledge*. New York: Routledge Press.

Flowers, Rachel. 2015. "Refusal to Forgive: Indigenous Women's Love and Rage." *Decolonization: Indigeneity, Education & Society* 4, no. 2 (December): 32–49.

Foster, Stephen, and Mike Evans. 2014. "The Prince George Metis Elders Documentary Project: Matching Product with Process in New Forms of Documentary." In *Reverse Shots: Indigenous Film and Media in an International Context*, edited by Wendy Gay Pearson and Susan Knabe, 221–32. Waterloo: Wilfrid Laurier University Press.

Fotiadi, Eva. 2014. "The Canon of the Author: On Individual and Collective Authorship in Exhibition Curating." *Journal of Art Historiography* 11 (December): 11–EF1.

"*Four Faces of the Moon* with Amanda Strong." 2017. Grunt: Indigenous Stories + Screenings. Last modified May 31, 2017. Accessed February 5, 2018. http://grunt.ca/indigenous-storytelling-and-screening-night/.

Francis, Daniel. 1992. *The Imaginary Indian: The Image of the Indian in Canadian Culture*. Vancouver: Arsenal Pulp Press.

Fraser, Andrea. 2005. "From the Critique of Institutions to the Institution of Critique." *Artforum* 44, no. 1 (September): 278–83.

Fred, Randy. 1992. Foreword to *The Imaginary Indian: The Image of the Indian in Canadian Culture*, by Daniel Francis. Vancouver: Arsenal Pulp Press.

Freeman, John. 2015. *Remaking Memory: Autoethnography, Memoir and the Ethics of Self*. Faringdon, UK: Libri.

Freud, S. (1919) 1955. "Das Unheimliche." In S. Freud, *The Standard Edition of the Complete Psychological Works of Sigmund Freud*, Vol. 11, *Five Lectures on Psychoanalysis Leonardo Da Vinci and Other Works*, edited by J. Strachey and A. Richards, translated by J. Strachey, in collaboration with A. Freud, 219–52. London: Hogarth Press.

Gaertner, David. 2016. "'Aboriginal Principles of Witnessing' and the Truth and Reconciliation Commission of Canada." In *Arts of Engagement: Taking Aesthetic Action In and Beyond the Truth and Reconciliation Commission of Canada*, edited by Dylan Robinson and Keavy Martin, 135–56. Waterloo: Wilfrid Laurier University Press.

Gaines, Jane. 1999. "Political Mimesis." In *Collecting Visible Evidence*, edited by Jane M. Gaines and Michael Renov, 84–102. Minneapolis: University of Minnesota Press.

Gardner, K., and D. Clancy. 2017. "From Recognition to Decolonization: An Interview with Glen Coulthard." *Upping The Anti* 19 (September). http://uppingtheanti.org/journal/article/19-from-recogntion-to-decolonization.

Garneau, David. 2016. "Imaginary Spaces of Conciliation and Reconciliation: Art, Curation, and Healing." In *Arts of Engagement: Taking Aesthetic Action In and Beyond the Truth and Reconciliation Commission of Canada*, edited by Dylan Robinson and Keavy Martin, 21–42. Waterloo: Wilfrid Laurier University Press.

Gaudenzi, Sandra. 2013. "The Living Documentary: From Representing Reality to Co-creating Reality." PhD Diss., University of London.

Gauthier, Jennifer L. 2013. "Dismantling the Master's House: The Feminist Fourth Cinema Documentaries of Alanis Obomsawin and Loretta Todd." In *Native Americans on Film: Conversations, Teaching, and Theory*, edited by M. Elise Marubbio and Eric L. Buffalohead, 89–15. Lexington: University Press of Kentucky.

Gilchrist, K. 2010. "'Newsworthy' Victims?" *Feminist Media Studies* 10 (4): 373–90. https://doi.org/10.1080/14680777.2010.514110.

Ginsburg, Faye. 1998. "Embedded Aesthetics: Creating a Discursive Space for Indigenous Media." *Cultural Anthropology* 9 (3): 365–82.

———. 2002. "Screen Memories: Resignifying the Traditional in Indigenous Media." In *Media Worlds: Anthropology on New Terrain*, edited by Faye D. Ginsburg, Lila Abu-Lughod, and Brian Larkin, 39–57. Berkeley: University of California Press.

———. 2018. "The Road Forward." *Cultural Anthropology* 33, no. 2 (May): 224–32.

Ginsburg, Faye D., Lila Abu-Lughod, and Brian Larkin. 2002. *Media Worlds: Anthropology on New Terrain*. Berkeley: University of California Press.

Gobert, Céline. 2014. "3 histoires d'Indiens. Onirisme politique." *24 Images*. Accessed February 15, 2018. http://revue24images.com/critics-article-detail /1902.

Goeman, Mishuana. 2008. "From Place to Territories and Back Again: Centering Storied Land in the Discussion of Indigenous Nation-Building." *International Journal of Critical Indigenous Studies* 1 (1): 34.

———. 2011. "Introduction to Indigenous Performances: Upsetting the Terrains of Settler Colonialism." *American Indian Culture and Research Journal* 35 (4): 1–18.

———. 2013. *Mark My Words: Native Women Mapping Our Nations*. Minneapolis: University of Minnesota Press.

Goulet, Danis. 2017. *The Hunt*. Montréal: National Film Board of Canada. Virtual reality.

Goulet, Danis, and Kerry Swanson. 2013. *Indigenous Feature Film Production in Canada: A National and International Perspective*. Toronto: imagineNATIVE.

Government of Nunavut. n.d. "Inuit Societal Values." https://www.gov.nu.ca /information/inuit-societal-values.

Guzman, Alicia Inez. 2015. "Indigenous Futurisms." *InVisible Culture: An Electronic Journal for Visual Culture,* March 25, 2015. https://ivc.lib.rochester .edu/indigenous-futurisms/

Haas, Angela. 2007. "Wampum as Hypertext: An American Indian Intellectual Tradition of Multimedia Theory and Practice." *Studies in American Indian Literatures* 19 (4): 77–100.

Hacker, Karen. 2013. *Community-Based Participatory Research*. Thousand Oaks, CA: Sage.

Hall, Budd L., Teresa Dawson, and Catherine Etmanski. 2014. *Learning and Teaching Community-Based Research: Linking Pedagogy to Practice*. Toronto: University of Toronto Press.

Hallett, D., M.J. Chandler, and C. Lalonde. 2007. "Aboriginal Language Know-ledge and Youth Suicide." *Cognitive Development* 22 (3): 392–99.

Hanich, Julian. 2018. *The Audience Effect: On the Collective Cinema Experience.* Edinburgh: Edinburgh University Press.

Hannam, B., and K. Kincaid, prods., and B. Hannam, dir. 2015. *North Mountain.* Canada: Mazeking Pictures. Motion picture.

Hansen, Mark B.N. 2004. *New Philosophy for New Media.* Cambridge: MIT Press.

Hanson, Aubrey Jean. 2016. "Reading for Resurgence: Indigenous Literatures, Communities, and Learning." Unpublished PhD diss., University of Calgary.

Harbord, Janet. 2016. "Contingency, Time, and Event: An Archeological Approach to the Film Festival." In *Film Festivals: History, Theory, Method, Practice,* edited by Marijke de Valck, Brendan Kredell, and Skadi Loist, 69–82. London and New York: Routledge.

Hargreaves, Allison, and David Jefferess. 2015. "Always Beginning: Imagining Reconciliation Beyond Inclusion or Loss." In *The Land We Are: Artists and Writers Unsettle the Politics of Reconciliation,* edited by Gabrielle L'Hiron-delle Hill and Sophie McCall, 200–10. Winnipeg: ARP Books.

Hassannia, Tina. 2017. "The Story of How a New Era of Indigenous Filmmaking Began in Canada." *CBC Arts,* February 24, 2017. http://www.cbc.ca/arts/the-story-of-how-a-new-era-of-indigenous-filmmaking-began-in-canada-1.3997754.

Hearne, Joanna. 2006. Interview with Alanis Obomsawin.

———. 2017. "Native to the Device: Thoughts on Digital Indigenous Studies." *Studies in American Indian Literature* 21, no. 9 (April): 3–26.

Henderson, Jennifer. 2013. "The Camp, the School and the Child: Discursive Exchanges and (Neo) Liberal Axioms in the Culture of Redress." In *Reconciling Canada: Critical Perspectives on the Culture of Redress,* edited by Jennifer Henderson and Pauline Wakeham, 63–86. Toronto: University of Toronto Press.

Henderson, Jennifer, and Pauline Wakeham. 2013. Introduction to *Reconciling Canada: Critical Perspectives on the Culture of Redress,* edited by Jennifer Henderson and Pauline Wakeham, 3–30. Toronto: University of Toronto Press.

Hodgins, Tyler. 2012. "*Sleeping Bag* Artist Statement." Accessed April 13, 2018. https://tylerhodgins.ca.

hooks, bell. 1992. *Black Looks: Race and Representation.* London: Routledge.

Hopkins, Candice. 2004a. "How to Get Indians into an Art Gallery." In *Making Noise! Aboriginal Perspectives on Art, Art History, Critical Writing*

and Community, edited by Lee-Ann Martin, 192–205. Banff, AB: Banff Centre Press.

———. 2004b. "Making Things Our Own." *Horizon Zero, Issue 17: Aboriginal Story in Digital Media*. Banff, AB: Banff New Media Institute. Accessed May 14, 2018. http://www.horizonzero.ca/textsite/tell.php?is=17&file=4&tlang=0.

———. 2006. "Making Things Our Own: The Indigenous Aesthetic in Digital Storytelling." *Leonardo* 39 (4): 341–44.

———. 2017. "Giving Indigenous Media-Makers a Voice: A Curatorial Statement on *IsumaTV*." *Visible*. http://www.visibleproject.org/blog/giving -indigenous-media-makers-a-voice-a-curatorial-statement-on-isumatv-by -candice-hopkins/.

———. 2018. "Beyond the Guest Appearance: Continuity, Self-Determination, and Commitment to Contemporary Native Art." Panel featuring artists Nicholas Galanin, Ashley Holland, Candice Hopkins, and Steven Loft, moderated by Dyani White Hawk, Walker Art Centre, Minneapolis, February 27, 2018.

Hubbard, Tasha, dir. 2004. *Two Worlds Colliding*. Saskatoon: National Film Board of Canada. Motion picture.

Hubbard, Tasha, and Sherene Razack. 2011. "Reframing Two Worlds Colliding: A Conversation between Tasha Hubbard and Sherene Razack." *Review of Education, Pedagogy, and Cultural Studies* 33 (4): 318.

Huhndorf, Shari M. 2001. *Going Native: Indians in the American Cultural Imagination*. Ithaca: Cornell University Press.

Igloliorte, Heather. 2016. "Tillutarniit: History, Land, and Resilience in Inuit Film and Video." *Public* 54 (Winter): 104–9.

Igloliorte, Heather, Julie Nagam, and Carla Taunton. 2021. "Incubator as Methodology: Public Art Exhibition." In *Holding Ground: Nuit Blanche and Other Ruptures*, edited by Julie Nagam and Janine Marchessault, 80–91. Toronto: PUBLIC Press.

imagineNATIVE. 2015, October 14. *2015 imagineNATIVE Catalogue*. https:// issuu.com/imaginenative/docs/compressed_2204_in_catalog-2/1

Imarisha, Walidah. 2017. "Liberated Archive Keynote." Personal blog. August 22, 2017. http://www.walidah.com/blog/2017/8/22/transcript-of-walidahs -liberated-archives-keynote.

IMDb. n.d.a. *North Mountain* (2015). https://www.imdb.com/title/tt3856100/.

———. n.d.b. *Rhymes for Young Ghouls* (2013). https://www.imdb.com/title /tt2385195/.

———. n.d.c. *The Spirit of Annie Mae* (2002). https://www.imdb.com/title /tt0469833/.

Jackson, Lisa. 2018. *Biidaaban: First Light.* Montréal: National Film Board of Canada. Virtual reality.

Jefferys, C.W. 1939. "The Reconstruction of the Port Royal Habitation of 1605–13." *Canadian Historical Review* 20 (4): 369–77.

Jim, Alice Ming Wai. 2015. "Technologies of Self-Fashioning: Virtual Ethnicities in New Media Art." *Proceedings of the 21st International Symposium on Electronic Art.*

Johnson, Rhiannon. 2018. "Anishinaabe Artist's New VR Experience Takes an Indigenous Futurist Look at Toronto." *CBC News*, April 14, 2018. https://www.cbc.ca/news/indigenous/lisa-jackson-biidaaban-vr-future-toronto-1.4619041.

Jones, Alison. 2008. "Rethinking Collaboration: Working the Indigene-Colonizer Hyphen." In *Handbook of Critical and Indigenous Methodologies,* edited by Norman Denzin, Yvonna S. Lincoln, and Linda Tuhiwai Smith, 471–86. Los Angeles: Sage.

Jones, Stacy Holman, Tony E. Adams, and Carolyn Ellis, eds. 2013. *Handbook of Autoethnography.* Walnut Creek, CA: Left Coast Press.

Jusino, T. 2015. "Alison Bechdel Would Like You to Call It the 'Bechdel–Wallace Test,' ThankYouVeryMuch." *The Mary Sue*, August 25, 2015. https://www.themarysue.com/bechdel-wallace-test-please-alison-bechdel/.

Kalafatic, Carol. 1999. "Keepers of the Power: Story as Covenant in the Films of Loretta Todd, Shelley Niro, and Christine Welsh." In *Gendering the Nation: Canadian Women's Cinema,* edited by Kay Armatage, Kass Banning, Brenda Longfellow, and Janine Marchessault, 109–19. Toronto: Toronto Press.

Keeling, Kara. 2019. *Queer Times, Black Futures.* New York: New York University Press.

Keeshig-Tobias, Lenore. 1990. "Stop Stealing Native Stories." *The Globe and Mail, January 26, 1990, reprinted May 19, 2017.* https://www.theglobeandmail.com/news/national/cultural-appropriation-stop-stealing-native-stories/article35066040/.

Kilpatrick, Jacquelin. 1992. *Celluloid Indians: Native Americans and Film.* Lincoln: University of Nebraska Press.

King, Sarah. 2017. "In/Consequential Relationships: Refusing Colonial Ethics of Engagement in Yuxweluptun's Inherent Rights, Vision Rights." *BC Studies: The British Columbian Quarterly* 193 (Spring). https://bcstudies.com/?q=inconsequential-relationships-refusing-colonial-ethics-engagement-yuxweluptun%E2%80%99s-inherent-rights.

Kirmayer, Laurence, Stéphane Dandeneau, Elizabeth Marshall, Morgan Kahentonni Phillips, and Karla Jessen Williamson. 2012. "Toward an Ecology of

Stories: Indigenous Perspectives on Resilience." In *The Social Ecology of Resilience: A Handbook of Theory and Practice*, edited by M. Ungar, 399–414. New York: Springer.

Knopf, Kerstin. 2008. *Decolonizing the Lens of Power: Indigenous Films in North America*. Amsterdam and New York: Rodopi.

Konigsberg, E. 2014. "Who Killed Anna Mae?" *The New York Times Magazine*, April 25, 2014. https://www.nytimes.com/2014/04/27/magazine/who-killed-anna-mae.html.

Koostachin, Jules, dir. 2010. *Remembering Inninimowin*. Toronto: V Tape Distribution.

———. 2012. "Remembering Inninimowin: The Language of the Human Being." *Canadian Journal of Law and Society* 27 (1): 75–80.

Kopacz, Maria, and Bessie Lee Lawton. 2011. "The YouTube Indian: Portrayals of Native Americans on a Viral Video Site." *New Media & Society* 13 (2): 330–49.

Kotowich, Jeanette. 2016. Unpublished artist statement.

Kovach, Margaret. 2010. *Indigenous Methodologies: Characteristics, Conversations, and Contexts*. Toronto: University of Toronto Press.

———. 2015. "Emerging from the Margins: Indigenous Methodologies." In *Research as Resistance: Revisiting Critical, Indigenous, and Anti-Oppressive Approaches*, edited by Leslie Brown and Susan Strega, 43–64. Toronto: Canadian Scholars' Press.

Kubik, Wendee, Carrie Bourassa, and Mary Hampton. 2009. "Stolen Sisters, Second Class Citizens, Poor Health: The Legacy of Colonization in Canada." *Humanity and Society* 33 (1–2): 18–34.

Lacey, Liam. 2014. "*Rhymes for Young Ghouls* Is a Grim Story of Survival." *The Globe and Mail*, January 13, 2014. Accessed March 22, 2018. https://www.theglobeandmail.com/arts/film/ film-reviews/rhymes-for-young-ghouls-is-a-grim-story-of-survival/article16613452/.

LaGrand, James B., M. IndianKopacz, and B. Lee Lawton. 2011. "The YouTube Indian: Portrayals of Native Americans on a Viral Video Site." *New Media & Society* 13 (2): 330–49.

Landzelius, Kyra. 2004. *Native on the Net*. New York: Routledge.

LaPensée, Elizabeth. 2011. *Survivance*. http://www.elizabethlapensee.com/games/.

———. 2014. "Indigenously-Determined Games of the Future." Special Issue: "Indigenous Futurisms." *Kimiwanzine* 8 (November). http://kimiwanzine.com/.

————. 2016a. "Games as Enduring Presence." *PUBLIC* 27, no. 54 (December): 178–86.

————. 2016b. *Honour Water.* http://www.honourwater.com/.

————. 2017. *Thunderbird Strike.* https://www.thunderbirdstrike.com/stories/.

LaPensée, Elizabeth, and Jason Edward Lewis. 2013. "Call It a Vision Quest: Machinima in a First Nations Context." In *Understanding Machinima*, edited by Jenna Ng, 187–206. London: Bloomsbury Academic.

Lawrence, Bonita. 2003. "Gender, Race, and the Regulation of Native Identity in Canada and the United States: An Overview." *Hypatia* 18 (2): 3–31.

Leal, Melissa. 2015. "*Rhymes for Young Ghouls* Written and Directed by Jeff Barnaby." *Comparative Education Review* 59 (2): 383–85.

Lee, Toby. 2016. "Being There: Taking Place: Ethnography at the Film Festival." In *Film Festivals: History, Theory, Method, Practice*, edited by Marijke de Valck, Brendan Kredell, and Skadi Loist, 122–37. London and New York: Routledge.

Lempert, William. 2014. "Decolonizing Encounters of the Third Kind: Alternative Futuring in Native American Science Fiction Film." *Visual Anthropology Review* 30 (2): 164–76.

————. 2015. "Navajos on Mars." *Medium* (blog). September 21, 2015. https://medium.com/space-anthropology/navajos-on-mars-4c336175d945.

————. 2018. "Generative Hope in the Postapocalyptic Present." *Cultural Anthropology* 33, no. 2 (May): 202–12.

Leuthold, Steven. 1998. *Indigenous Aesthetics: Native Art, Media, and Identity.* Austin: University of Texas Press.

Lewis, Jason Edward. 2012. "Time Travelers, Flying Heads, and Second Lives: Designing Communal Stories." *Interactions* 19 (2): 20–23.

————. 2014. "A Better Dance and Better Prayers: Systems, Structures, and the Future Imaginary in Aboriginal New Media." In *Coded Territories: Tracing Indigenous Pathways in New Media Art*, edited by Steven Loft and Kerry Swanson, 49–78. Calgary: University of Calgary Press.

————. 2016. "A Brief (Media) History of the Indigenous Future." *Public* 54 (Winter): 36–50.

Lewis, Jason Edward, Noelani Arista, Archer Pechawis, and Suzanne Kite. 2018. "Making Kin with the Machines." *Journal of Design and Science.* Accessed July 8, 2021. https://doi.org/10.21428/bfafd97b.

Lewis, Randolph. 2006. *Alanis Obomsawin: The Vision of a Native Filmmaker.* Lincoln: University of Nebraska Press.

L'Hirondelle, Cheryl. 2014. "Codetalkers Recounting Signals of Survival." In *Coded Territories: Tracing Indigenous Pathways in New Media Art,*

edited by Steven Loft and Kerry Swanson, 147–68. Calgary: University of Calgary Press.

Liboiron, Max. 2021. *Pollution Is Capitalism*. Durham: Duke University Press.

Lind, Maria. 2009. "Complications: On Collaboration, Agency and Contemporary Art." In *New Communities*, edited by Nina Möntmann, 52–73. Toronto: Public Books.

Linden Lab. 2018. "Second Life." Accessed December 15, 2018. https://second life.com/.

Little Bear, Leroy. 2000. "Jagged Worldviews Colliding." In *Reclaiming Indigenous Voice and Vision,* edited by Marie Battiste, 77–85. Vancouver: UBC Press.

Loft, Steven. 2006. "For Iktomi." Ghostkeeper. Accessed January 29, 2019. http://ghostkeeper.gruntarchives.org/essay-for-iktomi-steve-loft.html.

———. 2014a. "Introduction: Decolonizing the 'Web.'" In *Coded Territories: Tracing Indigenous Pathways in New Media Art*, edited by Steven Loft and Kerry Swanson, xv–xvii. Calgary: University of Calgary Press.

———. 2014b. "Mediacosmology." In *Coded Territories: Tracing Indigenous Pathways in New Media Art*, edited by Steven Loft and Kerry Swanson, 170–86. Calgary: University of Calgary Press.

Logan, Tricia. 2017. "Indian Residential Schools, Settler Colonialism and Their Narratives in Canadian History." Unpublished PhD diss., University of London, Royal Holloway. https://pure.royalholloway.ac.uk/portal/en/public ations/indian-residential-schools-settler-colonialism-and-their-narratives -in-canadian-history(d3d82b38-f712-4578-b369-b5efe1264877).html.

Loist, Skadi, and Ger Zielinski. 2012. "On the Development of Queer Film Festivals and Their Media Activism." In *Film Festival Yearbook 4: Film Festivals and Activism*, edited by Dina Iordanova and Leshu Torchin, 49–62. St. Andrews, UK: St. Andrews Film Studies.

Longfellow, Brenda. 2004. "The Great Dance: Translating the Foreign in Ethnographic Film." In *Subtitles: On the Foreignness of Film*, edited by Atom Egoyan and Ian Balfour, 335–54. Cambridge, MA: MIT Press and Technology and Alphabet City Media.

Loppie, C., & F.C. Wien. 2007. *The Health of the Nova Scotia Mi'kmaq Population: A Final Research Report*. Mi'kmaq Health Research Group.

Low, Bronwen, Chloë Brushwood-Rose, and Paula M. Salvio. 2017. *Community-Based Media Pedagogies: Relational Practices of Listening in the Commons*. New York and London: Routledge.

Lowman, Emma Battell, and Adam J. Barker. 2015. *Settler: Identity and Colonialism in 21st Century Canada*. Halifax: Fernwood.

MacDonald, Shana. 2014. "On Resonance in Contemporary Site-Specific Projection Art." *Performance Research* 19, no. 6 (December): 64–70. http://dx.doi.org/10.1080/13528165.2014.985101.

Mamula, Tijana, and Lisa Patti. 2016. *The Multilingual Screen: New Reflections on Cinema and Linguistic Difference.* New York: Bloomsbury Academic.

Manovich, Lev. 2001. *The Language of New Media.* Cambridge, MA: MIT Press.

Maracle, Lee. 2017. *My Conversations with Canadians.* Toronto: BookThug.

Marsden, Scott. 1996. "Negotiations: Curatorial Sites and Community Arts." In *Naming a Practice: Curatorial Strategies for the Future,* edited by Peter White, 193–202. Banff, AB: Banff Centre Press.

Marshall, Bill. 2001. *Quebec National Cinema.* Montréal and Kingston: McGill-Queen's University Press.

Martin, Catherine. 2008. "The Little Boy Who Loved with Muin'skw (Bear Woman)." In *Aboriginal Oral Traditions: Theory, Practice, Ethics,* edited by Renee Hulan and Renate Eigenbrod, 53–59. Halifax: Fernwood.

Martin, K., prod., and C. Martin, dir. 2002. *The Spirit of Annie Mae.* Canada: National Film Board of Canada. Motion picture.

Martinez, Shanae Aurora. 2017. "Listening to the Good People: A Review of Margaret Noodin's *Weweni: Poems in Anishinaabemowin and English.*" *Cream City Review* 41 (1): 125–27.

Marubbio, M.E. 2006. *Killing the Indian Maiden: Images of Native American Women in Film.* Lexington: University of Kentucky Press.

Masayesva, Victor. 2001. "Indigenous Experimentalism." In *Magnetic North,* edited by Jenny Lion, 228–39. Minneapolis: University of Minnesota Press.

Maskêgon-Iskwêw, Âhasiw. 1995. "Talk Indian to Me #1." *MIX: The Magazine of Artist-Run Culture* 21. Read via Ghostkeeper (grunt gallery archive). Accessed January 31, 2019. http://ghostkeeper.gruntarchives.org/publication-mix-magazine-talk-indian-to-me-1.html.

———. 1996a. *Speaking the Language of Spiders.* Accessed January 31, 2019. http://spiderlanguage.net/ (updates by Cheryl L'Hirondelle ongoing).

———. 1996b. "Talk Indian to Me #4: Speaking Spider Languages." *MIX: The Magazine of Artist-Run Culture* 22. Read via Ghostkeeper (grunt gallery archive). Accessed January 31, 2019. http://ghostkeeper.gruntarchives.org/publication-mix-magazine-talk-indian-to-me-4.html.

———. 2003. *Drumbeats to Drumbytes.* Accessed February 1, 2019. http://drumbytes.org/.

McCall, Sophie. 2011. *First Person Plural: Aboriginal Storytelling and the Ethics of Collaborative Authorship.* Vancouver: UBC Press.

McCaslin, Wanda, and Denise C. Breton. 2008. "Justice as Healing: Going Outside the Colonizer's Gaze." In *Handbook of Critical and Indigenous Methodologies,* edited by Norman K. Denzin, Yvonna S. Lincoln, and Linda Tuhiwai Smith, 511–30. Los Angeles: Sage.

McGee Jr., H. 2021. "Mi'kmaq." In *The Canadian Encyclopedia.* https://www .thecanadianencyclopedia.ca/en/article/micmac-mikmaq.

McGinn, Dave. 2017. "Indigenous Artists Create Virtual Reality Vision of a Future Canada." *The Globe and Mail,* June 22, 2017. https://www.theglobe andmail.com/arts/indigenous-artists-create-virtual-reality-vision-of -canada-in-the-future/article35436268/.

McMaster, Gerald, and Lee-Ann Martin, eds. 1992. *Indigena: Contemporary Native Perspectives in Canadian Art.* Tortola, BVI: Craftsman House.

McMillan, Robert. 1991. "Ethnology and the N.F.B.: The Laura Boulton Mysteries." *Canadian Journal of Film Studies* 1 (2): 67–82.

McNeil-Seymour, Jeffrey. 2017. "Two-Spirit Resistance." In *Whose Land Is It Anyway? A Manual for Decolonization,* edited by Peter McFarlane and Nicole Schabus. Federation of Post-Secondary Educators of BC.

Menzies, Charles R. 2001. "Reflections on Research With, For, and Among Indigenous Peoples." *Canadian Journal of Native Education* 25 (1): 19.

———, dir. 2009a. *In Our Grandmother's Garden.* Gitxaala Village, BC . Streaming video. https://www.youtube.com/watch?v=-npk_X1pD5Q.

———, dir. 2009b. *People of the Cedar.* Gitxaala Village, BC. Streaming video. https://www.youtube.com/watch?v=PksAApEORDs

———, dir. 2009c. *Stories from the Smokehouse.* Gitxaala Village, BC. Streaming video. https://www.youtube.com/watch?v=PJ3GPCzDqMo.

———, dir. 2009d. *The Things That Are Given to You.* Gitxaala Village, BC. Streaming video. https://www.youtube.com/watch?v=AhZs7O3oPtA.

———. 2016. "*In Our Grandmothers' Garden*: An Indigenous Approach to Collaborative Film." In *Participatory Visual and Digital Research in Action,* edited by Aline Gubrium, Krista Harper, and Marty Otañez, 103–14. Walnut Creek: Left Coast Books.

Menzies, Charles, and Jennifer Rashleigh, dirs. 2008. *Weather the Storm.* Oley: Bulldog Films. DVD.

Miller, Mary Jane. 2001. "Where the Spirit Lives: An Influential and Contentious Drama about Residential Schools." *American Review of Canadian Studies* 31 (1–2): 71–84.

———. 2008. *Outside Looking In: Viewing First Nations Peoples in Canadian Dramatic Television Series.* Vol. 53 of *McGill-Queen's Indigenous and Northern Studies.* Montréal and Kingston: McGill-Queen's University Press.

Million, Dian. 2013. *Therapeutic Nations: Healing in an Age of Indigenous Human Rights*. Tucson: University of Arizona Press.

———. 2014. "There Is a River in Me: Theory from Life." In *Theorizing Native Studies*, edited by Audra Simpson and Andrea Smith, 30–42. Durham: Duke University Press.

Miner, Joshua. 2017. "Ecological Protocols in Indigenous Game Design." *In Media Res*, May 12, 2017. http://mediacommons.futureofthebook.org/imr /2017/05/12/ecological-protocols-indigenous-game-design.

Moore, Rick Clifton. 1987. "Canada's Challenge for Change: Documentary Film and Video as an Exercise of Power through the Production of Cultural Reality." Unpublished PhD diss., University of Oregon.

Moreton-Robinson, Aileen. 2011. "Bodies That Matter: Performing White Possession on the Beach." *American Indian Culture and Research Journal* 35 (4): 57–72.

———. 2015. *The White Possessive: Property, Power, and Indigenous Sovereignty*. Minneapolis: University of Minnesota Press.

Morin, Peter. 2016. "this is what happens when we perform the memory of the land." In *Arts of Engagement: Taking Aesthetic Action In and Beyond the Truth and Reconciliation Commission of Canada*, edited by Dylan Robinson and Keavy Martin, 67–92. Waterloo: Wilfrid Laurier University Press.

Mowitt, John. 2005. *Re-takes: Postcoloniality and Foreign Film Languages*. Minneapolis: University of Minnesota Press.

Mulvey, L. 1989. *Visual and Other Pleasures*. Basingstoke, UK: Palgrave Macmillan.

Mutua, Kagendo, and Beth Blue Swadener. 2004. *Decolonizing Research in Cross-Cultural Contexts: Critical Personal Narratives*. Albany: State University of New York Press.

Nagam, Julie. 2011. "(Re)Mapping the Colonized Body: The Creative Interventions of Rebecca Belmore in the Cityscape." *American Indian Culture and Research Journal* 35 (4): 147–66.

———. 2017. "Traveling Soles: Tracing the Footprints of Our Stolen Sisters." In *Canadian Voices on Performance Studies/Theory*, edited by Laura Levin and Marlis Schweitzer, 115–36. Montréal and Kingston: McGill-Queen's University Press.

———. 2020. *Embodied Practices and Acts of Exchange. O le ūa na fua mai Manu'a*. Sydney: University of New South Wales Gallery Press, 2020.

Nagam, Julie, and Jaimie Isaac. 2017. *Insurgence/Resurgence*. Winnipeg: Winnipeg Art Gallery.

Nahdee, A. 2017. "Does She Pass The Aila Test? A Page Dedicated to Films and Characters That Pass The Aila Test." Tumblr. https://the-aila-test.tumblr.com/about.

Nash, Kate. 2017. "Virtual Reality Witness: Exploring the Ethics of Mediated Presence." *Studies in Documentary Film* 12 (2): 119–31.

National Film Board of Canada. 2018. *Biidaaban: First Light* Press Kit. http://mediaspace.nfb.ca/epk/biidaaban/?_gl=1*187prg8*_ga*NzM1MjU4MTgoLjE2MjQ1NjcwMjk.*_ga_EP6WV87GNV*MTYyNDczMjYzOC4xLjEuMTYyNDczNTE1Mi4w.

Native Women's Association of Canada. 2021. NWAC *Action Plan: Our Calls, Our Actions.* https://www.nwac.ca.

"The NFB Inuit Film Collection." 2017. National Film Board of Canada. Last modified August 15, 2017. Accessed February 5, 2018. http://onf-nfb.gc.ca/en/unikkausivut-sharing-our-stories/the-nfb-inuit-film-collection/.

Ngabo, Gilbert. 2018. "The Subway Tracks Are Flooded, Highrises Crumbling: Step into a Toronto Reclaimed by Nature in Indigenous Artist's Highly Realistic Virtual Reality Film." *Toronto Star,* September 18, 2018. https://www.thestar.com/news/gta/2018/09/18/the-subway-tracks-are-flooded-highrises-crumbling-step-into-a-toronto-reclaimed-by-nature-in-indigenous-artists-highly-realistic-virtual-reality-film.html.

Nichols, Bill. 1994. "Discovering Form, Inferring Meaning: New Cinemas and the Film Festival Circuit." *Film Quarterly* 47 (3): 16–30.

———. 2008. "Documentary Reenactment and the Fantasmatic Subject." *Critical Inquiry* 35, no. 1 (Autumn): 72–89.

Nickerson, Marcia. 2018. *On-Screen Protocols and Pathways: A Media Production Guide to Working with First Nations, Métis and Inuit Communities, Cultures, Concepts and Stories.* Toronto: imagineNATIVE.

Niezen, Ronald. 2017. *Truth and Indignation: Canada's Truth and Reconciliation Commission on Indian Residential Schools.* 2nd ed. Toronto: University of Toronto Press.

Nixon, Lindsay. 2016. "Visual Cultures of Indigenous Futurisms." *GutsMagazine,* May 6, 2016. http://gutsmagazine.ca/visual-cultures/.

Nornes, Abé Mark. 1999. "For an Abusive Subtitling." *Film Quarterly* 53, no. 3: 17–34.

———. 2007. *Cinema Babel: Translating Global Cinema.* Minneapolis: University of Minnesota Press.

Obomsawin, Alanis. 2006. "Image vs. Sound: Are We Really Listening?" True/False Film Festival, Columbia, MO, February 24, 2006. http://archives.truefalse.org/2006/workshops/image.htm.

O'Brien, Michelle. 2014. "Alternative Narrative Forms, Exposure, and the Limits of Formalized Truth-Telling: Giving Accounts through New Methods in Indigenous Art." *Excursions* 5 (1): 1–16.

The Ojibwe People's Dictionary. n.d. Created and updated by the Department of American Indian Studies and university libraries at the University of Minnesota. https://ojibwe.lib.umn.edu/.

Palmater, C. 2010. *The Candy Show*. April 27, 2010. https://www.thecandyshow.com/2010/04/.

Parkes, Debra, and David Milward. 2012. "*Gladue*: Beyond Myth and Towards Implementation in Manitoba." *Manitoba Law Journal* 35 (1): 84–110.

Patti, Lisa. 2016. "Programming Latin American Cinema in the United States: An Interview with Carlos A. Gutiérrez." In *The Multilingual Screen: New Reflections on Cinema and Linguistic Difference*, edited by Tijana Mamula and Lisa Patti, 351–58. New York: Bloomsbury Academic.

Pearson, George, and Anthony Kent. 1977/1978. "Grass Roots Distribution" (*Cold Journey*, booklet insert). *Cinema Canada* 43 (December 1977/January 1978). http://cinemacanada.athabascau.ca/index.php/cinema/article/view/4577/4607.

Pearson, Wendy G., and Susan Knabe. 2014. *Reverse Shots: Indigenous Film and Media in an International Context*. Waterloo: Wilfrid Laurier University Press.

Pechawis, Archer, Jason Edward Lewis, Ryan Rice, and Skawennati. 2017. "CyberPowWow and the First Wave of Indigenous Media Arts." Panel discussion, *Filling in the Blank Spaces* exhibition programming, Leonard and Bina Ellen Art Gallery, Concordia University, Montréal, November 6, 2017. Accessed January 25, 2019. https://vimeo.com/242625394.

Peers, Laura. 2007. *Playing Ourselves: Interpreting Native Histories and Historic Reconstructions*. Plymouth, UK: Altamira Press.

Pewenofkit Jr., S. 2016. "Review: 'Rhymes for Young Ghouls' and Surviving the Apocalypse." *Fourth Cinema: A Blog About Native American Film*. February 22, 2016. https://fourth-cinema.com/tag/rhymes-for-young-ghouls/.

Philip, Kavita, Lilly Irani, and Paul Dourish. 2012. "Postcolonial Computing: A Tactical Survey." *Science, Technology, & Human Values* 37 (1): 3–29.

Pick, Zuzana. 1999a. *Gendering the Nation: Canadian Women's Cinema*. Toronto: University of Toronto Press.

———. 1999b. "Storytelling and Resistance: The Documentary Practice of Alanis Obomsawin." In *Gendering the Nation: Canadian Women's Cinema*, edited by Kay Armatage, Kass Banning, Brenda Longfellow, and Janine Marchessault, 76–93. Toronto: University of Toronto Press.

PocketWatch Games. 2007. *Venture Arctic*. http://www.pocketwatchgames.com/games.html.

Poliandri, S. 2011. *First Nations, Identity, and Reserve Life: The Mi'kmaq of Nova Scotia*. Lincoln: University of Nebraska Press.

Popovic, Jelena. 2018. Producer, *Westwind*. Interview with author. National Film Board of Canada, Montréal, QC, February 15, 2018.

Povinelli, Elizabeth. 2002. *The Cunning of Recognition: Indigenous Alterities and the Making of Australian Multiculturalism*. Durham: Duke University Press.

———. 2017. "Toxic Assets: Frontier Imaginaries." E-flux, New York, October 18, 2017.

Powell, Timothy. 2011. "Gibagadinamaagoom: An Ojibwe Digital Archive." University of Pennsylvania. https://ojibwearchive.sas.upenn.edu/thunderbird-cultural-context.

Prins, Harald, L. 2002. "Visual Media and the Primitivist Perplex: Colonial Fantasies, Indigenous Imagination, and Advocacy in North America." In *Media Worlds: Anthropology on New Terrain*, edited by Faye D. Ginsburg, Lila Abu-Lughod, and Brian Larkin, 58–74. Berkeley: University of California Press.

Proulx, Mikhel. 2017. "CyberPowWow: Digital Natives and the Early Internet." *Terminal 3.0*. Accessed May 14, 2018. http://terminal.front.bc.ca/.

Raheja, Michelle H. 2007. "*Reading Nanook's Smile: Visual Sovereignty, Indigenous Revisions of Ethnography, and Atanarjuat (The Fast Runner)*." *American Quarterly* 59: 1159–85.

———. 2010. *Reservation Reelism: Redfacing, Visual Sovereignty, and Representations of Native Americans in Film*. Lincoln: University of Nebraska Press.

———. 2017. "Imagining Indigenous Digital Futures: An Afterword." *Studies in American Indian Literatures* 29 (Spring): 172–75.

Ramond, Charles-Henri. 2014. "Maïna: Sous la glace les feux de l'amour." *Films du Québec*. Accessed March 22, 2018. http://www.filmsquebec.com/critique-film-maina/.

Razlogova, Elena. 2015. "The Politics of Translation at Soviet Film Festivals during the Cold War." *SubStance* 44 (2): 66–87.

Regan, P. 2010. *Unsettling the Settler Within: Indian Residential Schools, Truth Telling, and Reconciliation in Canada*. Vancouver: University of British Columbia Press.

Reichertz, J. 2007. "Abduction: The Logic of Discovery of Grounded Theory." *Forum: Qualitative Social Research* 11 (1): 214–28. http://www.qualitative-research.net/index.php/fqs/article/view/1412/2902.

Richards, Thomas. 1993. *Imperial Archive: Knowledge and the Fantasy of Empire.* London: Verso.

Rickard, Jolene. 1995. "Sovereignty: A Line in the Sand." *Aperture* 139 (Summer): 50–59.

———. 2001. "First Nation Territory in Cyber Space Declared: No Treaties Needed." CyberPowWow2. http://www.cyberpowwow.net/nation2nation /jolenework.html.

———. 2005. "Rebecca Belmore: Performing Power." In *Rebecca Belmore: Fountain*, edited by Jessica Bradley and Jolene Rickard, 68–76. Kamloops and Vancouver: Kamloops Art Gallery and Helen and Morris Belkin Art Gallery.

———. 2006. "The Local and the Global." In *Vision, Space, Desire: Global Perspective and Cultural Hybridity*, edited by Elizabeth Kennedy Gische, 59–28. Washington, DC: Museum of the American Indian.

———. 2017. "Traditional Indigenous Practices of 'Seeing.'" Presentation at Third Annual Symposium on the Future Imaginary, Winnipeg, MB, November 29–December 2, 2017.

Rifkin, Mark. 2017. *Beyond Settler Time: Temporal Sovereignty and Indigenous Self-Determination.* Durham: Duke University Press.

Roanhorse, Rebecca. 2017. "Decolonizing Science Fiction and Imagining Indigenous Futures: An Indigenous Futures Roundtable." *Strange Horizons*, January 30, 2017. http://strangehorizons.com/non-fiction/articles/decolon izing-science-fiction-and-imagining-futures-an-indigenous-futurisms -roundtable/.

Robertson, Carmen. 2016. "The Beauty of a Story: Toward an Indigenous Art Theory." In *The Routledge International Handbook of Intercultural Arts Research*, edited by Pamela Burnard, Elizabeth Mackinlay, and Kimberly Powell, 13–23. London: Routledge.

Robertson, Joanne. 2014. *Making Movie History—Alanis Obomsawin.* National Film Board of Canada. Interview. https://www.nfb.ca/film/making_movie _history_alanis_obomsawin/.

Robinson, Dylan. 2020. *Hungry Listening: Resonant Theory for Indigenous Sound Studies.* Minneapolis: University of Minnesota Press.

Robinson, Dylan, and Keavy Martin, eds. 2016. *Arts of Engagement: Taking Aesthetic Action In and Beyond the Truth and Reconciliation Commission of Canada.* Waterloo: Wilfrid Laurier University Press.

Rony, Fatimah Tobing. 1996. *The Third Eye: Race, Cinema, and Ethnographic Spectacle.* Durham: Duke University Press.

Rosaldo, Renato. 1989. *Culture and Truth: The Remaking of Social Analysis.* Boston: Beacon Press.

Rosenthal, N.G. 2005. "Representing Indians: Native American Actors on Hollywood's Frontier." *Western Historical Quarterly* 36 (3): 328–52.

Roué, Marie. 2012. "Histoire et épistémologie des saviors locaux et autochtones." *Revue d'ethnoécologie* 1 (November): 2–14.

Rudin, Jonathan. 2008. "Aboriginal Over-representation and R. v. Galdue: Where We Were, Where We Are and Where We Might Be Going." *The Supreme Court Law Review: Osgoode's Annual Constitutional Cases Conference* 40: 687–713.

Ryle, Jason. 2017. "Indigenous Existence Is Resistance." Roundtable with Jason Ryle, Danis Goulet, Scott Benesiinaabandan, and Raven, Toronto International Film Festival, October 18, 2017. https://www.tiff.net/the-review/indigenous-existence-is-resistance/.

Salazkina, Masha. 2016. "Translating the Academe: Conceptualizing the Transnational in Film and Media." In *The Multilingual Screen: New Reflections on Cinema and Linguistic Difference,* edited by Tijana Mamula and Lisa Patti, 17–35. New York: Bloomsbury Academic.

Seixas, P. 1994. "Confronting the Moral Frames of Popular Film: Young People Respond to Historical Revisionism." *American Journal of Education* 102 (3): 261–85.

Sewell, R.G. 2014. "Representing the Confederation Bridge." Master of Arts thesis, Saint Mary's University, Halifax, NS. http://library2.smu.ca/xmlui/bitstream/handle/01/25871/sewell_raymond_g_masters_2014.pdf?sequence=1&isAllowed=y.

Shohat, Ella, and Robert Stam, eds. 2003. *Multiculturalism, Postcoloniality and Transnational Media.* New Brunswick, NJ: Rutgers University Press.

———. 2006. "The Cinema After Babel: Language, Difference, Power." In *Taboo Memories, Diasporic Voices,* edited by Ella Shohat, 106–38. Durham and London: Duke University Press.

Simonds, V.W., and S. Christopher. 2013. "Adapting Western Research Methods to Indigenous Ways of Knowing." *American Journal of Public Health* 103 (12): 2185–92.

Simpson, Audra. 2007. "On Ethnographic Refusal: Indigeneity, 'Voice,' and Colonial Citizenship." *Junctures* 9 (December): 67–80.

———. 2014. *Mohawk Interruptus: Political Life across the Borders of Settler States.* Durham: Duke University Press.

———. 2016a. "Consent's Revenge." *Cultural Anthropology* 31 (3): 326–33. https://doi.org/10.14506/ca31.3.02.

————. 2016b. "Savage States: Settler Governance in an Age of Sorrow." Public talk at the Wheeler Centre, February 22, 2016. https://www.wheelercentre.com/broadcasts/audra-simpson.

————. 2017. "The Ruse of Consent and the Anatomy of 'Refusal': Cases from Indigenous North America and Australia." *Postcolonial Studies* 20 (1): 18–33. https://doi.org/10.1080/13688790.2017.1334283.

————. 2020. "The Sovereignty of Critique." *South Atlantic Quarterly* 119 (4): 685–99.

Simpson, Leanne Betasamosake. 2011. *Dancing on Our Turtle's Back: Stories of Nishnaabeg Re-Creation, Resurgence, and a New Emergence.* Winnipeg: ARP Books.

————. 2014. "Land as Pedagogy: Nishnaabeg Intelligence and Rebellious Transformation." *Decolonization: Indigeneity, Education & Society* 3, no. 3 (November): 1–25.

————. 2017. *As We Have Always Done.* Minneapolis: University of Minnesota Press.

Singer, Beverly. 2001. *Wiping the War Paint Off the Lens: Native American Film and Video.* Minneapolis: University of Minnesota Press.

Skawennati. 2009. *TimeTraveller™.* Aboriginal Territories in Cyberspace. Accessed May 14, 2018. http://www.timetravellertm.com/.

Smith, Graham H. 2000. "Protecting and Respecting Indigenous Knowledge." In *Reclaiming Indigenous Voice and Vision,* edited by Marie Battiste, 209–24. Vancouver: UBC Press.

Smith, Linda Tuhiwai. 1999. *Decolonizing Methodologies: Research and Indigenous Peoples.* London, UK, and Dunedin, NZ: Zed Books and University of Otago Press.

————. 2008. "On Tricky Ground: Researching the Native in the Age of Uncertainty." In *The Landscape of Qualitative Research,* edited by Norman K. Denzin, 113–43. 3rd ed. Thousand Oaks: Sage.

————. 2012. *Decolonizing Methodologies: Research and Indigenous Peoples.* 2nd ed. London: Zed Books.

Smith, Linda Tuhiwai, Eve Tuck, and K. Wayne Yang, eds. 2019. *Indigenous and Decolonizing Studies in Education: Mapping the Long View.* New York: Routledge.

Smith, Orla. 2019. "TIFF interview: *Kuessipan* Filmmakers on Their Innu Coming-of-Age Story." *Seventh Row,* September 17, 2019. Accessed June 7, 2021. https://seventh-row.com/2019/09/17/kuessipan-interview/.

Smith, S., and M. O'Connor. 2005. *Canadian Fiction: A Guide to Reading Interests.* Westport, CT: Libraries Unlimited.

Smith, Terry. 2017. "Mapping the Contexts of Contemporary Curating: The Visual Arts Exhibitionary Complex." *Journal of Curatorial Studies* 6, no. 2 (October): 170–80. https://doi.org/10.1386/jcs.6.2.170_1.

Stewart, Michelle. 2007. "The Indian Film Crews of Challenge for Change: Representation and the State." *Canadian Journal of Film Studies* 16, no. 2 (Fall): 49–81.

Sturken, Marita, and Lisa Cartwright. 2002. *Practices of Looking: An Introduction to Visual Culture*. Oxford: University of Oxford Press.

Suzack, Cheryl. 2017. *Indigenous Women's Writing and the Cultural Study of Law*. Toronto: University of Toronto Press.

Swain, M., and C. Vowel. 2016. "Buffy Pangs." *Métis in Space*. April 2, 2016. Podcast. http://www.metisinspace.com/episodes/2016/4/2/mtis-in-space-ep1-buffy-pangs.

Sylliboy, J.R. 2019. "Using L'nuwey Worldview to Conceptualize Two-Spirit." *Antistasis* 9 (1): 96–116.

Tahmahkera, Dustin. 2017, October 9. "Becoming Sound: Tubitsinakukuru from Mt. Scott to Standing Rock." *Sounding Out!* https://soundstudiesblog.com/2017/10/09/becoming-sound-tubitsinakukuru-from-mt-scott-to-standing-rock/.

Takahashi, Dean. 2015. "Alaska Natives Join Game Devs on Never Alone Game to Spotlight Cultural Traditions." *VentureBeat*, February 5, 2015. https://venturebeat.com/2014/08/19/native-alaskan-tribe-invests-heavily-in-never-alone-survival-platform-game/.

Tascón, Sonia, and Tyson Wils. 2017. *Activist Film Festivals: Towards a Political Subject*. Bristol, UK, and Chicago: Intellect.

Taunton, Carla. 2011. "Performing Resistance/Negotiating Sovereignty: Indigenous Women Performance Art in Canada." PhD thesis, Queen's University, Kingston, ON.

———. 2020. "Embodied Resurgence: Global Indigenous Performance." *Abadakone: International Indigenous Art*, National Gallery of Canada.

Taylor, Diana. 2003. *The Archive and the Repertoire: Performing Cultural Memory in the Americas*. Durham and London: Duke University Press.

Thagard, P., and C. Shelley. 1997. *Abductive Reasoning: Logic, Visual Thinking, and Coherence*. Waterloo: University of Waterloo. http://cogsci.uwaterloo.ca/Articles/Pages/%7FAbductive.html.

Therrien, Gilles, ed. 1995. *Figures de l'Indien*. Montréal: Typo.

Thomas, Jeffrey, and Carol Payne. 2002. "Aboriginal Interventions into the Photographic Archives: A Dialogue between Carol Payne and Jeffrey

Thomas." *Visual Resources: An International Journal on Images and Their Uses* 18 (2): 109–25.

Thomas, Robina. 2015. "Honouring the Oral Traditions of the Ta't Mustimuxw (Ancestors) through Storytelling." In *Research as Resistance: Revisiting Critical, Indigenous, and Anti-Oppressive Approaches*, edited by Leslie Brown and Susan Strega, 177–98. Toronto: Canadian Scholars' Press.

Thornley, Davinia. 2017. "imagineNATIVE Film + Media Arts Festival: Collaborative Criticism through Curatorship." In *Activist Film Festivals: Towards a Political Subject*, edited by Sonia Tascón and Tyson Wils, 199–212. Bristol, UK, and Chicago: Intellect.

Todd, Loretta. 1992. "What More Do They Want from Us?" In *Indigena: Contemporary Native Perspectives in Canadian Art*, edited by Gerald McMaster and Lee-Ann Martin, 71–81. Tortola, BVI: Craftsman House.

———. 1996. "Aboriginal Narratives in Cyberspace." In *Immersed in Technology: Art and Virtual Environments*, edited by Mary Anne Moser with Douglas MacLeod, 179–94. Cambridge: MIT Press.

Todd, Zoe. 2016a. "An Indigenous Feminist's Take on the Ontological Turn: 'Ontology' Is Just Another Word for Colonialism." *Journal of Historical Sociology* 29 (1): 4–22.

———. 2016b. "Relationships." *Theorizing the Contemporary, Cultural Anthropology*, January 21, 2016. https://culanth.org/fieldsights/799-relationships.

———. 2017. "Indigenous Stories, Knowledge, Legal Traditions, Ontologies, Epistemologies as Unceded Territory (or: Hands Off of Our Teachings)." Personal blog. Accessed September 15, 2019. https://zoestodd.com /2017/04/27/indigenous-stories-knowledge-legal-traditions-ontologies -epistemologies-as-unceded-territory-or-hands-off-of-our-teachings/.

———. 2018. "Refracting the State through Human-Fish Relations: Fishing, Indigenous Legal Orders and Colonialism in North/Western Canada." *Decolonization: Indigeneity, Education & Society* 7 (1): 60–75.

Topash-Caldwell, B. 2020. "Sovereign Futures in Neshnabé Speculative Fiction." *Borderlands* 19 (2): 29–62.

Trepanier, France, and Chris Creighton-Kelly. 2012. *Understanding Aboriginal Art Today*. Ottawa: Canada Council for the Arts.

Truth and Reconciliation Commission of Canada. 2015. *Truth and Reconciliation Commission of Canada: Calls to Action*. Ottawa: Truth and Reconciliation Commission of Canada. https://publications.gc.ca/site/eng /9.801236/publication.html.

Tuck, Eve. 2013. "Commentary: Decolonizing Methodologies 15 Years Later." *AlterNative: An International Journal of Indigenous Peoples* 9, no. 4 (December): 365–72.

Tuck, Eve, and K. Wayne Yang. 2012. "Decolonization Is Not a Metaphor." *Decolonization: Indigeneity, Education & Society* 1 (1): 1–40.

———. 2014. "R-Words: Refusing Research." In *Humanizing Research: Decolonizing Qualitative Inquiry with Youth and Communities*, edited by D. Paris and M.T. Winn, 223–47. Thousand Oaks, CA: Sage.

Turner, Dale. 2013. "On the Idea of Reconciliation in Contemporary Aboriginal Politics." In *Reconciling Canada: Critical Perspectives on the Culture of Redress,* edited by Jennifer Henderson and Pauline Wakeham, 100–14. Toronto: University of Toronto Press.

UN General Assembly. 2007. *United Nations Declaration on the Rights of Indigenous Peoples.* https://www.un.org/development/desa/indigenous peoples/wp-content/uploads/sites/19/2018/11/UNDRIP_E_web.pdf.

UN Human Rights Council. 2015. *United Nations Declaration on the Rights of Indigenous Peoples.* https://www.un.org/development/desa/indigenous peoples/declaration-on-the-rights-of-indigenous-peoples.html.

Urban, A. 2011. "Indigenous New Wave." *Urban Cinefile,* June 9, 2011. http://www.urbancinefile.com.au/home/view.asp?a=17870&s=Features.

Vizenor, G. 1994. *Manifest Manners: Narratives on Postindian Survivance.* Lincoln: University of Nebraska Press.

———. 2008. *Survivance: Narratives of Native Presence.* Lincoln: University of Nebraska Press.

Vowel, Chelsea. 2016. *Indigenous Writes: A Guide to First Nations, Métis and Inuit Issues in Canada.* Winnipeg: Highwater Press.

Wachowich, Nancy. 2010. "Creative Technologies: Experimentation and Social Practice in Arctic Societies." Études/Inuit/Studies 34, no. 2 (January): 5–19.

Waggoner, E.B. 2017. "Bury Your Gays and Social Media Fan Response: Television, LGBTQ Representation, and Communitarian Ethics." *Journal of Homosexuality* 65 (13): 1877–91.

Wakeham, Pauline. 2008. *Taxidermic Signs: Reconstructing Aboriginality.* Minneapolis: University of Minnesota Press.

Waugh, Thomas, Michael Brendan Baker, and Ezra Winton, eds. 2010. *Challenge for Change: Activist Documentary at the National Film Board of Canada.* Montréal: McGill-Queen's University Press.

Westwind press release. 2017. National Film Board of Canada, Montréal, QC.

White, Graham. 2006. "Cultures in Collision: Traditional Knowledge and Euro-Canadian Governance Processes in Northern Land-Claim Boards." *Arctic* 59, no. 4 (December): 401–14.

White, Jerry. 1999. "Alanis Obomsawin, Documentary Form and the Canadian Nation(s)." *CineAction!* 49: 26–36.

White, Peter. 1996. Introduction to *Naming a Practice: Curatorial Strategies for the Future*, edited by Peter White, 1–4. Banff, AB: Banff Centre Press.

Wikler, Alexandra. 2016. "Indigenous Futurism: Reimagining 'Reality' to Inspire an Indigenous Future." *Exploring Indigenous Knowledge Systems* (blog). November 28, 2016. https://blogs.ubc.ca/fnis401fwikler/2016/11/28/indigenous-futurism-reimagining-reality-to-inspire-an-indiginous-future/.

Williams, Raymond. 1976. *Keywords: A Vocabulary of Culture and Society*. New York: Oxford University Press.

Wilson, Shawn. 2008. *Research Is Ceremony: Indigenous Research Methods*. Halifax: Fernwood.

Winton, Ezra. 2020. "Frames of Counterpower: The Politics of Film Programming." In *Contemporary Radical Film Culture: Networks, Organisations and Activists*, edited by Steve Presence, Mike Wayne, and Jack Newsinger. London: Routledge.

Winton, Ezra, and Svetla Turnin. 2017. "The Revolution Will Not Be Festivalized: Documentary Film Festivals and Activism." In *Activist Film Festivals: Towards a Political Subject*, edited by Sonia Tascón and Tyson Wils, 83–103. Bristol, UK, and Chicago: Intellect.

Wood, Houston. 2013. "Dimensions of Difference in Indigenous Film." In *Native Americans on Film: Conversations, Teaching, and Theory*, edited by M. Elise Marubbio and Eric L. Buffalohead, 35–57. Kentucky: University Press of Kentucky.

Xiiem, Jo-ann Archibald Q'um Q'um, Jenny Bol Jun Lee-Morgan, and Jason De Santolo, eds. 2019. *Decolonizing Research: Indigenous Storywork as Methodology*. London: Zed Books.

Yellowhead Institute. 2019. *Land Back: A Yellowhead Institute Red Paper*. https://redpaper.yellowheadinstitute.org.

———. 2021. *Cash Back: A Yellowhead Institute Red Paper*. https://cashback.yellowheadinstitute.org.

Zielinski, Ger. 2016. "On Studying Film Festival Ephemera: The Case of Queer Film Festivals and Archives of Feelings." In *Film Festivals: History, Theory, Method, Practice*, edited by Marijke de Valck, Brendan Kredell, and Skadi Loist, 138–58. London and New York: Routledge.

Index